# PHILIP IV AND THE DECORATION OF
# THE ALCÁZAR OF MADRID

OVERLEAF:
Diego de Velázquez, *Philip IV*

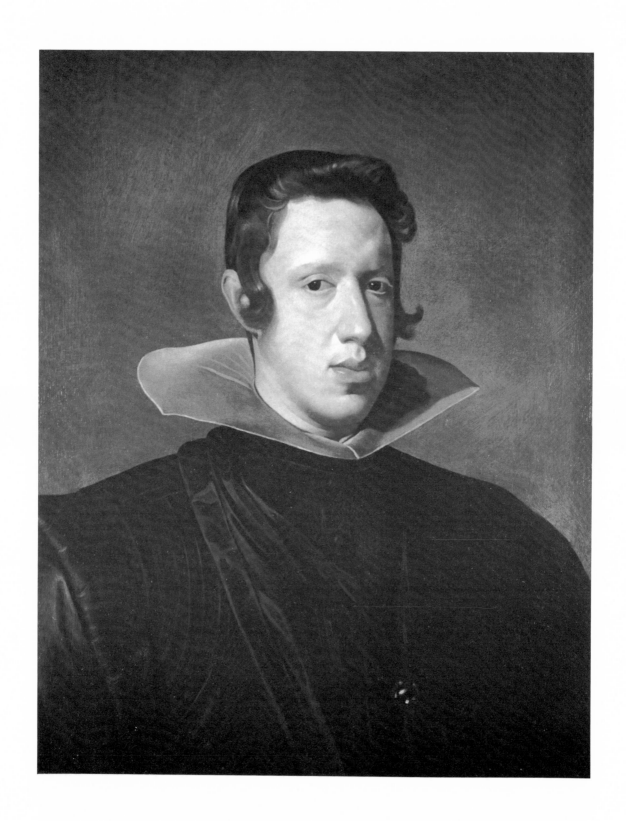

# Philip IV and the Decoration of the Alcázar of Madrid

BY

STEVEN N. ORSO

PRINCETON, NEW JERSEY

PRINCETON UNIVERSITY PRESS

COPYRIGHT © 1986 BY PRINCETON UNIVERSITY PRESS
PUBLISHED BY PRINCETON UNIVERSITY PRESS, 41 WILLIAM STREET
PRINCETON, NEW JERSEY 08540
IN THE UNITED KINGDOM: PRINCETON UNIVERSITY
PRESS, GUILDFORD, SURREY

\*

LIBRARY OF CONGRESS CATALOGING IN PUBLICATION DATA

ORSO, STEVEN N., 1950-
PHILIP IV AND THE DECORATION OF THE ALCÁZAR OF MADRID
REVISION OF THESIS (PH.D.)—PRINCETON UNIVERSITY, 1978
BIBLIOGRAPHY: P.
INCLUDES INDEX
1. PHILIP IV, KING OF SPAIN, 1605-1665—ART
COLLECTIONS. 2. ALCÁZAR (MADRID, SPAIN) 3. DECORATION
AND ORNAMENT, BAROQUE—SPAIN—MADRID. 4. PHILIP IV,
KING OF SPAIN, 1605-1665—PALACES—SPAIN—MADRID
5. MADRID (SPAIN)—BUILDINGS, STRUCTURES, ETC
I. TITLE
N5277.2.P4507 1986  709'.4'0740641  85-19442
ISBN 0-691-04036-2 (ALK. PAPER)

\*

THIS BOOK HAS BEEN COMPOSED IN LINOTRON GARAMOND

CLOTHBOUND EDITIONS
OF PRINCETON UNIVERSITY PRESS BOOKS ARE
PRINTED ON ACID-FREE PAPER, AND
BINDING MATERIALS ARE CHOSEN
FOR STRENGTH AND
DURABILITY

PRINTED IN THE UNITED STATES OF AMERICA
BY PRINCETON UNIVERSITY PRESS, PRINCETON, NEW JERSEY

*In*
*Memory of My Mother*
*and for*
*My Father*

# CONTENTS

# LIST OF ILLUSTRATIONS

*(Photographs have been supplied by the owners, except as noted.)*

# PREFACE

SEVERAL years ago, in a short-lived burst of enthusiasm, I undertook a doctoral dissertation on the iconography of Velázquez's paintings of antique subjects. I soon realized that I had embarked on a life's work, and the necessity of completing my degree sometime before my retirement required that I find a more manageable topic. My preliminary study of Velázquez's *Mercury and Argus* had already convinced me of the need to reconstruct the Hall of Mirrors in the Alcázar of Madrid, for which it was painted, and that realization led to a thesis that analyzed the seventeenth-century decoration of the Alcázar as an expression of the ideals and aspirations of Philip IV of Spain. The present volume is a much-revised version of that dissertation that I cannot conceive of having completed without the assistance of friends and colleagues that I gladly acknowledge here.

My greatest debts are to Jonathan Brown and John R. Martin, who supervised the original dissertation with a steady stream of thoughtful criticisms and perceptive suggestions, and who have continued to provide me with invaluable guidance and unflagging encouragement since then. The good examples of their respective researches on Habsburg patronage, invariably expressed with lucidity and insight, have proved a constant source of inspiration.

I am indebted as well to Rocío Arnáez, Matías Díaz Padrón, John H. Elliott, Véronique Gérard, Robert Herzig, Hendrik J. Horn, Thomas DaC. Kaufmann, Linda Klinger, Piero Morselli, Alfonso E. Pérez Sánchez, Edward J. Sullivan, Carl Van de Velde, and Barbara von Barghahn for providing helpful advice and welcome assistance in a variety of ways as my work progressed. The staffs of numerous archives, libraries, and museums facilitated my research, and it is with particular pleasure that I recall my time spent at the Archivo General de Simancas, the Museo del Prado, and the Marquand Art Library, Princeton University.

I gratefully acknowledge financial assistance from several institutions. My research abroad as a graduate student in 1975-1976 was generously supported by a grant funded by the Samuel H. Kress Foundation and awarded by the Department of Art and Archaeology, Princeton University. Subsequent research in Spain and Great Britain that proved critical to revising the dissertation

was funded by a National Endowment for the Humanities Summer Stipend in 1979 and an American Council of Learned Societies Grant-in-Aid in 1980.

Finally, thanks are also due to Carol Bolton Betts, who edited my manuscript with care and good humor, and to Christine K. Ivusic, Marilyn Campbell, and Tam Curry, who deftly shepherded this first-time author through the rites of publication at Princeton University Press.

*Urbana, Illinois*
*Labor Day, 1984*

# ABBREVIATIONS

## Archives and Libraries

| | |
|---|---|
| AGS | Archivo General de Simancas |
| AGS, CM3 | ——, Contaduría Mayor, 3ª época |
| AGS, CM3, leg. 723 | ——, legajo 723, Pagador Juan Gómez Mangas, 1626-1635 |
| AGS, CM3, leg. 756 | ——, legajo 756, Pagador Francisco de Villanueva, 1645-1648 |
| AGS, CM3, leg. 784 | ——, legajo 784, Pagador Juan Gómez Mangas, 1618-1625 |
| AGS, CM3, leg. 1362 | ——, legajo 1362, Pagador Francisco de Arce, 1665-1675 |
| AGS, CM3, leg. 1373 | ——, legajo 1373, Pagador Francisco de Arce, 1648-1653 |
| AGS, CM3, leg. 1461 | ——, legajo 1461, Pagador Francisco de Villanueva, 1640-1644 |
| AGS, CM3, leg. 2825(1) | ——, legajo 2825(1), Pagador Francisco de Arce, 1648-1650 |
| AGS, CSR | Archivo General de Simancas, Casas y Sitios Reales |
| AGS, Estado | ——, Secretaría de Estado |
| AGS, TMC | ——, Tribunal Mayor de Cuentas |
| AHPM | Archivo Histórico de Protocolos de Madrid |
| APM | Archivo del Palacio Real, Madrid |
| APM, Libro de pagos | ——, Sección Histórica, Reinados, Felipe IV, I[bis], legajo 2916 |
| APM, SA | ——, Sección Administrativa |
| APM, SH | ——, Sección Histórica |
| AVM | Archivo de Villa, Madrid |
| BAV | Biblioteca Apostolica Vaticana |
| BLL | British Library, London |
| BNM | Biblioteca Nacional, Madrid |
| BNP | Bibliothèque Nationale, Paris |

| | |
|---|---|
| ONV | Oesterreichische Nationalbibliothek, Vienna |
| RAH | Real Academia de la Historia, Madrid |

*Other Abbreviations*

| | |
|---|---|
| *AB* | *Art Bulletin* |
| *AEA* | *Archivo Español de Arte* |
| *AEAA* | *Archivo Español de Arte y Arqueología* |
| *AIEM* | *Anales del Instituto de Estudios Madrileños* |
| *BH* | *Bulletin Hispanique* |
| *BM* | *Burlington Magazine* |
| *BRAH* | *Boletín de la Real Academia de la Historia* |
| *BSEE* | *Boletín de la Sociedad Española de Excursiones* |
| CDIHE | Colección de Documentos Inéditos para la Historia de España |
| CRLB | Corpus Rubenianum Ludwig Burchard |
| *GBA* | *Gazette des Beaux-Arts* |
| *JWCI* | *Journal of the Warburg and Courtauld Institutes* |
| leg. | legajo |
| MHE | Memorial Histórico Español |
| reg. | registro |
| *RH* | *Revue Hispanique* |
| *VV* | *Varia velázqueña* (see Bibliography) |
| *ZfK* | *Zeitschrift für Kunstgeschichte* |

*Note on Documentation*

In determining the form in which to summarize the findings of my archival researches into the seventeenth-century financial accounts of the Spanish Crown as they pertain to this study, I have had to address three difficulties. First, the royal bureaucracy generated mountains of paper, and with the duplication of accounts it is possible to "discover" the same record of payment several times. There is little need to document the same item twice in one archive, but there are many instances in which the same payment is recorded at both

the Archivo General de Simancas and the Archivo del Palacio Real, Madrid, the two archives that proved most useful to this study. Second, many of the documents that I have used have already been published—variously in summary, in part, or in full—with accompanying footnotes of varying precision. Third, the most common form in which the accounts were written was in four-page *folletos*, each bearing a single identifying number.

Accordingly, in the notes I have adopted the following conventions. First, I have limited duplicate references to a given item to one reference each for the archives at Simancas and at the Royal Palace in Madrid for the convenience of others who might work at either institution in the future. Second, where another scholar has already published that item in some form—including another duplication—I have cited that work so as to accord him or her just credit for pioneering research. Third, in citing items from four-page *folletos*, I have differentiated the pages with the terms "verso" and "bis." Thus, the four pages in *folleto* 2 would be numbered, in sequence, fols. 2, 2$^v$, 2bis, and 2bis$^v$. Although this makes for some lengthy footnotes, I believe that bringing together a full and precise body of sources for the use of those who pursue further research on the history of the Alcázar of Madrid and its decoration justifies these decisions.

PHILIP IV AND THE DECORATION OF

THE ALCÁZAR OF MADRID

# INTRODUCTION

O N OCTOBER 20, 1659, the Marshal-Duke of Gramont, an ambassador extraordinary sent by Louis XIV of France to the court of Philip IV of Spain, paid a visit to the Alcázar of Madrid accompanied by his two sons and other members of his ambassadorial party. Four days earlier the Alcázar had been the setting for a public ceremony in which Gramont had asked Philip for the hand of his elder daughter, the Infanta María Teresa, on behalf of his sovereign. The return visit to the palace enabled the marshal-duke and his companions to view at greater leisure the enormous art collection kept there. The Frenchmen's guide was Philip's principal painter, Diego de Velázquez, who was intimately familiar with the royal collection and ideally suited to point out the finest works. Evidently he made a good impression on the visitors, for Gramont subsequently sent him an opulent gold clock as a gift.[1] Years later the marshal-duke's younger son, the second Duke of Gramont, recalled the visit:

> The palace of the King is large; all the apartments are quincuncial and barely lighted. They are built in that way because of the excessive heat that prevails in the summer at Madrid. In all the apartments there is no ornament, excepting the hall where the king receives ambassadors. But what is admirable are the pictures that all the chambers are full of; and the superb tapestries, many more beautiful than those of the crown of France, of which His Catholic Majesty has eight hundred hangings in his furniture repository. Once this compelled me to say to Philip V, when I was an ambassador extraordinary to him, that he ought to sell four hundred of them in order to pay his troops and fight the war, and that enough of them would still remain to him to furnish four palaces like his.
>
> The situation of and the view from the palace are beautiful, and the plaza that is in front of it is magnificent.[2]

[1] Antonio Palomino de Castro y Velasco, *El museo pictórico y escala óptica* (1715-1724; rpt. Madrid, 1947), 929.
[2] *Mémoires du Maréchal de Gramont*, ed. A. Petitot and Monmerqué, Collection des Mémoires Relatifs à l'Histoire de France, 2nd ser., vols. 56-57 (Paris, 1826-1827), 2:57-58.

The duke's generous praise of the collection is all the more remarkable when it is compared to his withering assessments of other royal dwellings in Madrid and its vicinity.[3] The Gallic reluctance to praise anything not French is legend, and the duke was in fine form when he set down his recollections. At Aranjuez he admired the gardens and the site, but, he continued, "As for the house, there isn't a *petit bourgeois* on the outskirts of Paris who does not have one that is more comfortable, more beautiful, and more embellished." The royal monastery at El Escorial, he allowed, was greater than the sum of its parts: "the whole creates a surprising richness and magnificence."

He disliked the Buen Retiro, of which he said, "It is large enough; the apartments are passably comfortable, but badly fashioned, and in bad taste." He conceded there were three or four large rooms of the most beautiful pictures by Titian and Raphael; but after Philip IV's death, he charged, his widow replaced them with copies and sold the originals for almost nothing. (This assertion has no basis in fact.) The Pardo Palace was pleasantly sited and featured small apartments that he found comfortable enough, but to him it lacked any sense of being a royal dwelling. As for the Casa del Campo, it had a few small gardens that he considered badly maintained, and the house struck him as more like a tavern than anything else.

Whatever distaste the duke might have felt for these dwellings, he had to concede the extraordinary size and quality of the art collection assembled in the Alcázar by Philip IV, the Habsburg king who ruled Spain and her dominions from 1621 to 1665 (frontispiece).[4] It was just to achieve such a reaction that Philip had invited the marshal-duke and his party to view the collection, free from the burdensome demands of state ceremony and attended by the most esteemed painter in the royal service. The king's paintings, sculptures, tapestries, and other furnishings were visible manifestations of his splendor, wealth, and refinement, qualities that he relied upon his visitors to make known upon their return to France. The greatness of the collection signaled the greatness of its owner.

[3] *Ibid.*, 56-58.

[4] Martin Hume, *The Court of Philip IV: Spain in Decadence* (London-New York, 1907), surveys the whole of Philip's career, but his approach is anecdotal and outdated. For shorter, more rigorous reviews of Philip's reign, see Antonio Domínguez Ortiz, *The Golden Age of Spain 1516-1659*, tr. James Casey (New York, 1971), 88-111; and John H. Elliott, *Imperial Spain 1469-1716* (London, 1963), 318-54. The latter's *The Revolt of the Catalans: A Study in the Decline of Spain (1598-1640)* (Cambridge, 1963) examines crucial aspects of Philip's reign in depth.

Philip could take justifiable pride in the collection, too, because he had done so much to assemble it. At the very least he had had to approve the expenditure of untold sums to acquire the thousands of works of art that he had added to the royal holdings. Yet collecting was not something that he unthinkingly left to subordinates whose decisions he rubber-stamped, for a host of his actions attest to his genuine interest in the world of art. As a youth he studied drawing under the guidance of the painter Juan Bautista Maino, and both he and his brothers Carlos and Ferdinand learned to paint.[5] As a father he saw to it that his son Baltasar Carlos had a drawing master, the painter Juan Bautista del Mazo, and that he learned to paint as well.[6] As a patron, he delighted not only in acquiring works by two of the foremost artists of the day, Velázquez and Peter Paul Rubens, but also in visiting their studios to speak with them and to watch them work.[7]

In his love of art Philip found a pleasurable escape from the demanding responsibilities of kingship. To be King of Spain in the seventeenth-century was not to rule a single, unified state; rather, it entailed the Herculean task of governing the *monarquía*, or Monarchy, a fragmented empire that stretched around the world. It was a federation of realms with differing laws and customs that were bound together by the person of the King of Spain, who had inherited sovereignty over each. In Iberia alone Philip claimed not one but three great crowns: the Crown of Portugal; the Crown of Aragon, which consisted of the kingdoms of Aragon and Valencia, and the principality of Catalonia; and the Crown of Castile and León, which was composed of the remaining lands of the peninsula. In addition, Philip exercised sovereignty over the Spanish Netherlands, the Duchy of Milan, the Kingdom of Naples and Sicily, the Spanish and Portuguese territories in the New World, and a smattering of lesser realms.

Preserving the territorial integrity of their empire against their enemies, maintaining their authority over their many realms, and promoting the welfare

---

[5] Jonathan Brown and J. H. Elliott, *A Palace for a King: The Buen Retiro and the Court of Philip IV* (New Haven-London, 1980), 44; Vicente Carducho, *Diálogos de la pintura: su defensa, origen, esencia, definición, modos y diferencias*, ed. Francisco Calvo Serraller (Madrid, 1979), 446; Palomino, *El museo pictórico*, 186 and 251; Francisco Pacheco, *Arte de la pintura*, ed. Francisco J. Sánchez Cantón, 2 vols. (Madrid, 1956), 1:171; and Juan A. Ceán Bermúdez, *Diccionario histórico de los mas ilustres profesores de las bellas artes en España*, 6 vols. (1800; rpt. Madrid, 1965), 2:81.

[6] Francisco J. Sánchez Cantón, *Los pintores de cámara de los Reyes de España* (Madrid, 1916), 94; and Palomino, *El museo pictórico*, 186.

[7] Palomino, *El museo pictórico*, 904; Pacheco, *Arte*, 1:161; and Peter Paul Rubens, *The Letters of Peter Paul Rubens*, tr. and ed. Ruth S. Magurn (Cambridge, Mass., 1955), 292.

of their subjects posed endless challenges to the Habsburgs who ruled the Monarchy, and in Philip's case, they were challenges that he failed to meet. During his reign the Spanish economy was devastated by ruinous inflation, burdensome taxation, devaluations of the currency, and bankruptcies of the royal treasury. A succession of debilitating civil and foreign wars sapped the Monarchy of its manpower, wealth, and morale. Worst of all, the Monarchy itself was dismembered. The Crown of Portugal revolted against the royal authority in 1640, and the king's armies failed to bring it to heel. By the Treaty of Münster (1648) the Dutch rebels of the United Provinces secured their independence from Madrid after eighty years of protracted warfare. French power, meanwhile, was in the ascendant, and when Spain and France agreed to the Peace of the Pyrenees in 1659, thereby ending hostilities that had raged since 1635, the price of peace included the Spanish cession of Catalan territory to the enemy. The marriage of Philip's daughter, María Teresa, to Louis XIV the following year not only sealed the peace, but also signaled that France had superseded Spain as the dominant player in European affairs.

Although Philip cannot be accounted a successful ruler, he was by no means the hopeless case that he is often made to seem. No monarch had better intentions for the government of his people, the preservation of his empire, or the promotion of his faith. Under the tutelage of his *valido* (royal favorite), don Gaspar de Guzmán, Count-Duke of Olivares, the inexperienced sixteen-year-old who ascended the throne in 1621 earnestly sought to master the arts of kingship.[8] An intelligent pupil, he read widely in history, geography, and languages, learned to apply himself to the onerous paperwork that the administration of a far-flung empire required, and, at Olivares's prodding, adopted ambitious programs of reform in both domestic and foreign affairs.

Moreover, Olivares groomed his sovereign to present himself to the world as the model of princely magnificence: a statesman whose reserved, dignified manner never failed to impress visitors to his court; a pious Catholic unfailingly opposed to the enemies of the Faith; an enthusiast for the royal sports of hunting and horsemanship, at which he excelled; and a connoisseur of the literary, visual, and performing arts who united discerning taste with generous

[8] For Olivares and the king, see Brown and Elliott, *Buen Retiro*, 13-54; and John H. Elliott and José F. de la Peña, *Memoriales y cartas del Conde-Duque de Olivares*, 2 vols. (Madrid, 1978-1980).

patronage. Philip's epithet, *el rey planeta* (the Planet King), referred not only to the global extent of his dominions but also to the magnitude of his personal glory. Because he was Philip the *Fourth*, court panegyrists identified him with the sun, the fourth planet in the Ptolemaic universe. As that most brilliant of heavenly bodies warmed and illuminated the earth, so the splendid personage of the king would protect and nurture the well-being of his subjects.

Such a monarch was essential to Olivares's plans to restore Spain to greatness. The reign of Philip's grandfather, Philip II (1556-1598), was regarded as a golden age when Spanish might, purpose, and prestige were unquestioned. If, as Olivares believed, the ministers of the king's father, Philip III, had betrayed and debased that heritage with their corrupt and incompetent conduct of the affairs of state, the new monarch might yet undo the damage and return Spain to her rightful station with thoughtful, vigorous leadership.[9] Thus, Philip IV ascended the throne as a reformer, and, particularly in the early years of his reign, Spain enjoyed periods of renewed optimism and military triumph. His tragedy—and the Monarchy's—was that the complexity of the problems that he faced at home, the cumulative might of his enemies abroad, the inadequacies of the governmental bureaucracy, his own chronic lack of will, and sheer bad luck all conspired to undermine his dreams. In the end, the empire that he bequeathed to his heir, Charles II, was far weaker than the one that he had inherited forty-four years before.

This cheerless bequest was mitigated, however, by a happier legacy that remained immune to the shifts of political fortune. The flowering of arts and letters at Philip's court is a glorious chapter in the cultural history of Spain's Golden Age. The poet Quevedo, the playwrights Lope de Vega and Calderón de la Barca, and the painters Rubens and Velázquez were but a few of the multitude of writers and artists whom Philip employed to create literary and pictorial masterworks to edify and entertain both himself and his court.

Nowhere was Philip's delight in the arts more evident than in his activity as a collector. In his love of the visual arts, above all painting, he followed in the footsteps of his great-grandfather, the Holy Roman Emperor Charles V, and his grandfather, Philip II. Indeed, his two ancestors' devoted patronage

[9] John H. Elliott, *El Conde-Duque de Olivares y la herencia de Felipe II*, Colección Síntesis, no. 2 (Valladolid, 1977), 55-100.

of one painter, Titian, alone would have sufficed to guarantee them honored places in the history of collecting. Although Philip III lacked his predecessors' enthusiasm for art, his son more than compensated for him. Philip IV added thousands of paintings, sculptures, and tapestries to the magnificent art collection that he had inherited, and to show them to advantage he renovated many of the royal dwellings in which they were displayed. He supplemented these holdings by commissioning temporary decorations for all manner of special occasions: baptisms of his children, theatrical spectacles, religious processions, state ceremonies of national and international consequence, and solemn exequies following the deaths of members of the royal family. Merely on the basis of the quantity of works that he acquired, Philip would have to be judged one of the most ambitious art collectors of the seventeenth century, but his acquisitions of Old Masters and contemporary works were informed by a sophisticated eye for quality as well. Philip the Statesman might have been a failure, but Philip the Maecenas was triumphant.

The king has seldom received credit for the full extent of this achievement. More often his patronage has been treated as an adjunct to studies of Rubens and Velázquez, thereby reducing his role to that of a man who, by some lucky accident, happened to employ two of the leading painters of his time. In part, this can be blamed on his political reputation, which has obscured his more admirable accomplishments. Moreover, the loss of the settings within which he displayed his treasures has obscured the context within which Philip collected. The interior decorations of his surviving dwellings have long since been altered, if not stripped bare, and the two residences that are most important for understanding his patronage no longer exist. One, the Alcázar of Madrid, was the foremost repository of the royal collection until it burned in 1734. The construction and decoration of a second palace in Madrid, the Buen Retiro, had been the most ambitious artistic enterprise of Philip's reign, but it was destroyed almost completely during the Peninsular War. (We can gauge the devastating impact of these losses by imagining how our knowledge of French royal patronage would have suffered if the Louvre had burned in 1734 and the Palace at Versailles had been demolished during the Napoleonic era.) In like manner, the absence of a tradition of documentary printmaking in seventeenth-century Spain comparable to that in Italy or the Low Countries has left the

present-day audience with few visual records of the festivals, processions, and ceremonies that enlivened the routine of court life. The fundamental difficulty of determining the appearance of Philip's court has been one of the greatest obstacles to a rounded assessment of his achievements as a patron and collector.

This unfortunate situation has at last begun to change. Recent monographs concerning two of the king's residences—the Buen Retiro[10] and the Torre de la Parada, a hunting lodge outside Madrid[11]—have demonstrated that it is possible to re-create, at least in part, the sights and pleasures of life at the Habsburg court. What is more important, these studies have advanced beyond assembling catalogues of works—i.e., determining what objects were shown, where they were displayed, and when they were installed there—to investigating how the king used art to proclaim the values and aspirations of his regime. Philip brought both a connoisseur's eye for quality and a politician's instinct for self-promotion to his activity as a collector. Like his Habsburg predecessors and his counterparts on other European thrones, he recognized that he could use art to express his social, political, and religious beliefs in the vibrant language of visual imagery. The design of a royal dwelling, its use, and its decoration could be interwoven to create elaborate statements of the ideals of the Monarchy. In this, Philip's collecting attained its most profound significance.

When Philip II selected Madrid as his permanent capital in 1561, the Alcázar effectively became the principal dwelling of the Spanish Habsburgs. Until its destruction in 1734, it yielded its primacy only once, when Philip III translated the court to Valladolid from 1601 to 1606. Thereafter, the preeminence of the Alcázar was never in doubt. To Philip IV, it was home. However long he might linger at the Buen Retiro, or at El Escorial, or at any of the other royal palaces, lodges, and apartments scattered across Iberia, he eventually returned to the Alcázar. He spent more of his days in its chambers and galleries than in those of any other building, and over the course of his reign he transformed their appearance and imprinted upon them his own distinctive taste.

[10] Brown and Elliott, *Buen Retiro*; see also Barbara von Barghahn, "The Pictorial Decoration of the Buen Retiro Palace during the Reign of Philip IV" (Ph.D. diss., New York University, 1979).

[11] Svetlana Alpers, *The Decoration of the Torre de la Parada*, CRLB, pt. 9 (London-New York, 1971).

It is with that metamorphosis of the Alcázar that the present volume is concerned. By choice I seek neither to compile an architectural history of the entire building, nor to reconstruct and analyze the decoration of its every nook and cranny. Instead, my aim is to examine a selection of the public and private chambers within the king's household in order to demonstrate how the carefully ordered ensembles of paintings, sculptures, and other furnishings that brightened Philip's surroundings also proclaimed his princely magnificence and trumpeted his royal ideals. By no means will the selection exhaust the treasures of the Alcázar. Rather, the ensembles have been chosen to illustrate the different ways in which the decoration of a palace could express the ideas of the Crown. By restricting ourselves to this course, we may yet be able to recapture a sense of the special ways that the decoration of the Alcázar enriched life in the presence of the Planet King.

# CHAPTER I

# *The King's Apartments*

PHILIP IV was unexpectedly thrust into kingship at the early age of sixteen by the premature death of his father on March 31, 1621. During the period of official mourning that followed the young heir retired from public view to the royal apartments maintained in the monastery of San Jerónimo at the eastern edge of Madrid. It was not until May 9 that he made his formal, public entry into the capital as king. Setting out from San Jerónimo, a royal procession made its way westward through the richly decorated streets of Madrid, a heavy rainfall notwithstanding. The new king, mounted on horseback beneath a brocaded white canopy, was accompanied by a cortege of servants and courtiers—among them heralds who sounded his approach; mace-bearers, major-domos, and kings-at-arms; the three companies of royal guards; gentlemen of the court, titled nobility, and the most exalted of Spanish aristocrats, the grandees. The parade route brought the king to the parish church of Santa María, where the Patriarch of the Indies celebrated a Te Deum, and from there the procession turned northward to the king's home, the Alcázar.[1]

## THE ROYAL DWELLING

It was fitting that a new king should occupy the Alcázar when the palace itself was presenting a new aspect to the city.[2] By 1621 the construction of a new

[1] For the entry, see Antonio León Pinelo, *Anales de Madrid (desde el año 447 al de 1658)*, ed. Pedro Fernández Martín (Madrid, 1971), 235-36; *Relacion de las Honras del Rey Felipe Tercero que esta en el cielo, y la solene entrada en Madrid del Rey Felipe Quarto, que Dios guarde* (Madrid, 1621), unpaged; and *Relaciones breves de actos públicos celebrados en Madrid de 1541 a 1650*, ed. José Simón Díaz, El Madrid de los Austrias, Serie Documentación, no. 1 (Madrid, 1982), 129-32.

[2] The basic bibliography for the architectural history of the Alcázar under the Habsburgs, on which the following summary depends, includes, in chronological or-der, Eugenio Llaguno y Amirola, *Noticias de los arquitectos y arquitectura de España desde su restauración*, ed. Juan A. Ceán Bermúdez, 4 vols. (1829; rpt. Madrid, 1977), 2:3-6; *Catálogo de la exposición del antiguo Madrid* (Madrid, 1926), 39-48; Miguel Velasco, "Iconografía y transformaciones del Alcázar de Madrid (de la Exposición del Antiguo Madrid)," *Arte Español* 8 (1927), 225-30; Carl Justi, *Diego Velazquez und sein Jahrhundert*, 2nd edn. (Zurich, 1933), 183-86; José Simón [Díaz], "Fraudes en la construcción del antiguo Alcázar madrileño," *AEA* 18 (1945), 347-59; Francisco Iñiguez Almech, *Casas reales y jardines de Felipe II*, Cuadernos de Trabajo de la Escuela

façade overlooking the great plaza in front of the palace was virtually complete, and work on the interior was underway. This was the latest project in a series of modifications of a building that had first been raised more than seven centuries earlier. As its name suggests, the Alcázar—from the Arabic *al qaṣr,* "the castle"—was originally a Moorish fortress built around 875 and later captured by the Christian forces of the Reconquest. Little is known of its history before the Habsburg accession except that the kings of Castile had used it as one of the temporary residences for their itinerant courts. A turning point in its history came in 1537, when Charles V directed the architects Alonso de Covarrubias and Luis de Vega to design and construct new works in the *alcazares* of Madrid, Seville, and Toledo. At Madrid that led to a considerable expansion of the old medieval structure. Work continued under Philip II, taking on new importance after he selected Madrid as his permanent capital.

The original use of the Alcázar as a fortress accounted for its location at the western edge of Madrid. As a sixteenth-century view (fig. 1) shows, the palace overlooked a steep precipice that would have hampered any assault on its garrison. In fact, the plain below the cliff had been called the Campo del Moro (Moor's Field) since 1109, when the fortress withstood an attack by Muslim forces.[3] The four towers lining its west façade also attested to its past as a medieval stronghold. A later view (fig. 2) shows that the main entrance was guarded by two projecting square towers, the *torre del homenaje* (Homage Tower) to the west, and the *torre del bastimento* (Provision Tower), also called

Española de la Historia y Arqueología, 2nd ser., no. 1 (Madrid, 1952), 62-100 and 133-34; Yves Bottineau, "L'Alcázar de Madrid et l'inventaire de 1686," *BH* 58 (1956), 421-52, and 60 (1958), 30-61, 145-79, 289-326, and 450-83; George Kubler, *Arquitectura de los siglos XVII y XVIII,* trans. Juan-Eduardo Cirlot, Ars Hispaniae, Vol. 14 (Madrid, 1957), 57; Yves Bottineau, *L'Art de cour dans l'Espagne de Philippe V 1700-1746* (Bordeaux, [1960]), 220-31; Juan J. Martín González, "El Alcázar de Madrid en el siglo XVI (nuevos datos)," *AEA* 35 (1962), 1-19; and the following articles by Véronique Gérard: "Les Problèmes artistiques de l'Alcázar de Madrid (1537-1700)," *Mélanges de la Casa de Velázquez* 12 (1976), 307-22; "L'Alcázar de Madrid et son quartier au XVIᵉ siècle," *Colóquio,* 2nd ser., 39 (December 1978), 36-45;

"La fachada del Alcázar de Madrid (1608-1630)," *Cuadernos de Investigación Histórica* 2 (1978), 237-57; and "Los sitios de devoción en el Alcázar de Madrid: capilla y oratorios," *AEA* 56 (1983), 275-84. Moreover, Gérard's *De Alcázar a Palacio: el renacimiento en el Alcázar de Madrid* (Madrid, forthcoming) promises to expand our knowledge of the Alcázar in the sixteenth century considerably.

For the later history of the Alcázar under the Bourbon dynasty, see the following works by Yves Bottineau: "Antoine du Verger et l' Alcázar de Madrid en 1711," *GBA* 6th ser., 77 (1976), 178-80; *L'Art de cour,* pp. 268-80; and "Philip V and the Alcázar of Madrid," *BM* 98 (1956), 68-75.

[3] Carl Justi, *Diego Velazquez and His Times,* tr. A. H. Keane, rev. edn. (London, 1889), 98.

the *torre del sumiller* (Groom of the Stole's Tower), to the east. At the southwest corner stood the *torre dorada* (Gilded Tower), a five-story addition erected between 1562 and 1568, so named for the gilding of its balconies and weather-vanes. As a consequence of its construction, the already undistinguished appearance of the south façade was thrown out of balance.

Under Philip III a succession of schemes was undertaken to reform the south front, culminating in a project conceived and executed by his chief architect, Juan Gómez de Mora.[4] His solution was to construct a corresponding tower at the southeast corner in order to balance the Gilded Tower, and to conceal the remainder of the old façade behind a new one. The architect's maquette (fig. 3) shows two four-story arms that link the towers to a frontispiece framing a new main entrance brought forward from the recess between the old square towers. A square panel bearing the royal coat-of-arms crowns the central bay and identifies the building as the king's residence. Although the design does not achieve perfect symmetry—discrepancies in the placements of doors and windows in the lower stories are readily apparent—it conveys an overall impression of unity and balance that is far more attractive than the façade that it was intended to replace.

In 1626 Gómez de Mora drew plans of the main floor of the palace (fig. 6, the third floor by American numbering) and of the floor below it (fig. 7), which show how the old exterior with its thick-walled square towers was masked by the new screen façade. Each of the side arms linking the end towers with the central frontispiece contained twelve bays rather than the ten shown on the maquette, and other details of ornamentation differed as well. By and large, however, the spirit of the maquette design had been followed faithfully. Completion of a few aspects of the façade was deferred until the reign of Charles II, when the southeast tower was finally completed and the top of the old *torre del sumiller* was cleared from the roof (fig. 4).

Pedro de Teixeira's 1656 *Map of Madrid* relates the Alcázar of Philip IV to its surroundings (fig. 5).[5] To the south lay the Plaza de Palacio, the great public square through which one approached the main entrance of the palace. Its western limit was defined by an arcade that linked the palace to the royal

---

[4] Gérard, "La fachada del Alcázar," traces this evolution in detail.

[5] For Teixeira's map, see Miguel Molina Campuzano,

*Planos de Madrid de los siglos XVII y XVIII* (Madrid, 1960), 247-79.

stables and separated the plaza from a small garden in front of the Gilded Tower. This *jardín de los emperadores* (Garden of the Emperors), which took its name from twenty-five sculptures of emperors displayed there, was destroyed when the plaza was expanded and enclosed by new arcades in 1674 (cf. fig. 4).[6] A series of dependencies that provided the Alcázar with supporting services surrounded three courtyards to the east of the palace. Beginning at the southeast tower of the Alcázar, the *pasadizo de la Encarnación* (Passage to the Church of La Encarnación) ran through these dependencies, curved north, and terminated at the royal convent of La Encarnación. This enclosed passage bordered one side of the *jardín de la priora* (Prioress' Garden) that occupied the land between the convent and the palace. North of the Alcázar were open spaces for plays, bullfights, equestrian exercises, and other entertainments, as well as additional dependencies attached to the north wing of the palace proper.[7]

In plan the Alcázar was essentially a great rectangle with an off-center cross-arm that divided the smaller *patio del rey* (King's Courtyard) to the west from the larger *patio de la reina* (Queen's Courtyard) to the east.[8] These names reflected the fundamental division of life in the palace into two households headed by the king and queen, each with its own hierarchy of servants. The king ordinarily lived on the main floor in the *cuarto del rey* (King's Quarter), an extensive suite that surrounded his courtyard. The queen resided on the same floor in the smaller Queen's Quarter, which overlooked the other courtyard. Both courtyards were cloistered, and during the day the King's Courtyard was alive with the bustle of clerks and officials who worked in the secretarial offices and council chambers that occupied much of the lower stories of the palace, and with the commerce of merchants vending their wares.[9] The Alcázar was not only the home of the royal family, but also the office building from which the Monarchy was governed.

The destruction of the palace in the eighteenth century has deprived the modern spectator of the opportunity to walk through its halls and inspect first-

[6] For the history of the garden, see J. E. Varey and N. D. Shergold, eds., *Los celos hacen estrellas*, by Juan Vélez de Guevara (London, 1970), lvi-lix; and Gérard, "Problèmes artistiques," 315.

[7] For the grounds and structures behind the palace, see Carducho, *Diálogos*, 427-30; and Mary C. Volk, "Rubens in Madrid and the Decoration of the King's Summer Apartments," *BM* 123 (1981), 514 and 519.

[8] The King's Courtyard, nine-by-six bays in plan, measured 140 × 101 Castilian feet (about 40 × 28 meters)—see Martín González, "El Alcázar," 3. The Queen's Courtyard was nine bays square.

[9] Justi, *Velazquez und sein Jahrhundert*, 186-87; and Brown and Elliott, *Buen Retiro*, 35-36.

hand the chambers in which Philip IV conducted affairs of state and pursued his private pleasures. Nevertheless, much can be learned of the interior disposition of the Alcázar from six floor plans that were made between 1626 and 1713.[10] Although four of these plans postdate the Bourbon accession to the Spanish throne, they remain useful because they record many names of rooms and structural changes that date from the Habsburg era:

1. The aforementioned *Gómez de Mora plans* (figs. 6-7): These are dated July 15, 1626, and bear the architect's signature and rubric. His inscriptions identify the third-story, main floor (fig. 6) as the *planta alta* (upper floor) and the second story (fig. 7) as the *planta baja* (lower floor). The two plans are part of a handwritten *relación* describing royal dwellings throughout Iberia that was evidently prepared as a gift to Cardinal Francesco Barberini, who visited Spain as a papal legate in 1626.[11] The text of the *relación* includes a detailed key to each of the plans.

2. The *Ardemans plan* (figs. 8-9): Entitled *Orthographia de el Real Alcazar de Madrid*, this map of the palace and its environs was prepared by Teodoro Ardemans (an *arquitecto mayor* to Philip V), who signed and dated it in 1705.[12] Its numbered key identifies the principal rooms on the main floor of the palace.

3. The *Justi plan* (fig. 10): This partial plan of the main floor was published by Carl Justi, who never disclosed the location of the original. It has been dated to the period 1705-1709.[13]

4. The *Verger plan* (fig. 11): This plan was drawn by the French amateur Antoine du Verger during November and December of 1711. Unlike the other plans it is oriented with the east to the left. Verger also drew five sections of suites on the main floor (among them figs. 54 and 68) and provided both the plan and the sections with accompanying *explications*.[14]

5. The *parquet plan* (fig. 12): This anonymous plan charts some of the

[10] A sixteenth-century plan of the Alcázar has also survived, but it is not pertinent to this study; see Gérard, "L'Alcázar de Madrid," 38, fig. 2.

[11] Juan Gómez de Mora, "Relaçion de las cassas que tiene el Rey en españa y de algunas de ellas se an eccho tracas que se an de ber con esta Relaçion Ano de 1626," BAV, Ms. Barb. lat. 4372, fols. 1-6ᵛ and figs. A and B. On the tie to Barberini, see Iñiguez Almech, *Casas reales*, 42; and Enriqueta Harris, "Cassiano dal Pozzo on Diego Velázquez," *BM* 112 (1970), 368.

[12] BNP, Cabinet des Cartes et Plans, GE. AA. 2055; first published by Bottineau, *L'Art de cour*, 220 n. 93 and 270, and pls. VI-VII.

[13] Justi, *Velazquez and His Times*, between pp. 96 and 97; and Varey and Shergold, *Los celos*, p. lxvi.

[14] BNP, Cabinet des Estampes, Hd 135b (the *explications*), Vb 147 fol. (the sections), and Vd 29 (the plan). See Bottineau, "Philip V"; id., *L'Art de cour*, 270-80 and 622-23; and id., "Antoine du Verger."

rooms on the south side of the main floor with detailed measurements of their dimensions. It was prepared during the period 1712-1713 to be sent to the Paris workshop of the architect and designer Robert de Cotte for use as a guide to making parquet flooring that was to be shipped back to Madrid.[15]

To supplement what these plans reveal about the disposition of the King's Quarter, one can turn to the *etiquetas*—the written rules of court etiquette that governed life in the king's household. Charles V had introduced the elaborate etiquette of the Burgundian court into Spain, and his successors had revised and supplemented it as the need had arisen. Philip IV initiated the most important reform on May 22, 1647, when he appointed a *junta* to undertake a thorough review of the rules, which it carried out over the next four years. The resulting *etiquetas* of 1647-1651 addressed two concerns.[16] One was to describe the organization of the king's household by setting forth the qualifications, duties, and benefits of each office within the hierarchy of royal servants. The other was to codify the protocols to be observed at various royal ceremonies, such as the ordering of participants in royal processions; the styles in which newly arrived ambassadors, cardinals, and papal legates were to be granted their first audiences with the king; the intricacies of serving the king a meal in public; and the manner in which members of the royal family were to be baptized. The etiquette for a particular occasion might be set forth in a straightforward recital of procedures to be followed, or it might be implied

[15] BNP, Cabinet des Estampes, Vd 29. Bottineau first signaled the existence of this plan in his "Philip V," 68 n. 3; and his *L'Art de cour*, 276.

[16] For a list of extant copies of the *etiquetas*, including versions predating the reform of 1647-1651, see J. E. Varey, "L'Auditoire du Salón Dorado de l'Alcázar de Madrid au XVIIᵉ siècle," in *Dramaturgie et société: rapports entre l'oeuvre théâtrale, son interprétation et son public aux XVIᵉ et XVIIᵉ siècles*, ed. Jean Jacquot with Élie Konigson and Marcel Oddon (Paris, 1968), 1:81-83; the same list with related documents appears in Varey's "La mayordomía mayor y los festejos palaciegos del siglo XVII," *AIEM* 4 (1969), 165-68. For the present study I have consulted "Etiquetas generales de la Casa Rˡ del Rey nr̃o Sᵗ para el Uso y exerzicio de los oficios de sus Criados," BNM, Mss. 10.666, a copy of the 1647-1651 *etiquetas* dating from Charles II's reign to which other useful material concerning court etiquette has been appended.

There is no thorough study of ceremonial at the Spanish Habsburg court, but Antonio Rodríguez Villa, *Etiquetas de la Casa de Austria* (Madrid, 1913), summarizes another copy of the 1647-1651 *etiquetas*. See also Yves Bottineau, "Aspects de la cour d'Espagne au XVIIᵉ siècle: l'étiquette de la chambre du roi," *BH* 74 (1972), 138-57; José Deleito y Piñuela, *El rey se divierte (Recuerdos de hace tres siglos)*, (Madrid, 1935), esp. 97-160; and two studies by J. E. Varey: "Processional Ceremonial of the Spanish Court in the Seventeenth Century," in *Studia Iberica: Festschrift für Hans Flasche*, ed. Karl-Hermann Körner and Klaus Rühl (Bern-Munich, 1973), 643-52; and "Further Notes on the Processional Ceremonial of the Spanish Court in the Seventeenth Century," *Iberoromania*, n.s., 1 (1974), 71-79.

in an account of a particular event that was to serve as the precedent for comparable occasions. Because many of these ceremonies were assigned to specific rooms in the Alcázar, the *etiquetas* reveal much concerning the layout and use of the King's Quarter.

## A SURVEY OF THE KING'S QUARTER

With the assistance of Gómez de Mora's *planta alta* (fig. 6) and its key, augmented by the other plans and the *etiquetas*, it is possible to re-create a room-by-room tour of the King's Quarter.[17] The principal approach to the main floor was by a monumental staircase between the courtyards. After reaching the point marked "n° 1." on Gómez de Mora's plan, one proceeded along the upper cloister of the King's Courtyard and passed between members of the Spanish (2) and German (3) companies of royal guards into the *sala de la guarda* (Guard Room; 4). During the day members of the Guard of Archers stood on duty there, and in the evenings the guards assigned to night duty slept there.

The room beyond that, the *saleta* (Small Hall; 5), led to the *antecámara* (Antechamber; 6), where a variety of functions took place. Every Friday Philip consulted there with the Royal Council (also called the Council of Castile) on matters of governance and justice within the Crown of Castile.[18] When it was necessary to convene the Cortes, or parliament, of Castile, its first session was held there so that the king could formally present to the *procuradores* the proposition to be considered.[19] On Gómez de Mora's plan a dotted rectangle containing a small arc signifies the king's chair and canopy at such events. Most of the meals that the king ate "in public" (i.e., in the presence of privileged courtiers) were served in the Antechamber, whether they were "ordinary" public meals marking no special event, or those celebrating Easter or some other solemn occasion.[20] As the commander of the Order of the Golden

---

[17] Where not otherwise noted, my remarks on the uses of rooms are based on Gómez de Mora, "Relaçion de las cassas," fols. 1-3ᵛ. Of previous accounts of the interior disposition of the Alcázar, the most thorough are Bottineau, "L'Inventaire de 1686," passim; and Iñiguez Almech, *Casas reales*, 72-100.

[18] "Etiquetas," 459.     [19] *Ibid.*, 303.

[20] *Ibid.*, 425 and 440-41. One special meal served there was the annual fulfillment of the privilege that John II had granted to the Counts of Rivadeo of dining with the king on the Feast of the Epiphany (*Ibid.*, 572-75).

Fleece, Spain's most prestigious confraternity of knights, the king dined there annually with the members of the order after they had attended Vespers together on the feast day of their patron, Saint Andrew.[21] It was fitting that this room, where the king was so often served his meals, should be the setting for the Maundy Thursday observance at which he displayed his Christian humility by ceremonially washing the feet of thirteen poor persons and then serving them a meal.[22]

A door at the northwest corner of the Antechamber furnished access to a "room in which the King keeps his books" in the northernmost of the four semicircular towers lining the west façade (19). This was the *torre de Francia* (Tower of France), so named because Francis I of France had been imprisoned there after his capture at the Battle of Pavia in 1525. During Philip IV's reign it became known as the *torre del hermafrodita* (Tower of the Hermaphrodite; cf. fig. 10) because a bronze *Hermaphrodite* that Velázquez had acquired for the king during his second trip to Italy (1649-1651) had been installed there.[23] Tables for playing *trucos* (a kind of billiards) were found in the adjacent *galería del cierzo* (Gallery of the North Wind; 20). Gómez de Mora describes the space at its eastern end (21) as a "room in which one of the painters has a workshop, and he is regularly present in it." Documents dated December 3, 1632, identify the studio as Velázquez's, and there is no reason to doubt that it was already his in 1626.[24]

Adjoining the south side of the Antechamber were two rooms associated with ambassadorial ceremonies. Court envoys accompanying the king to hear Mass in the Royal Chapel or to attend other events awaited him in the *ante-camarilla de los embajadores* (Small Antechamber of the Ambassadors; 7). The king ordinarily granted a new ambassador his first interview in the *cámara* (Bedchamber; 8), a general audience chamber (Ardemans plan 5: "Room where the King grants an audience to all") with a ceremonial bed that is indicated on Gómez de Mora's plan. Members of the royal councils went there to kiss the king's hand on the second day of Christmas and on other solemn or

[21] *Ibid.*, 538.        [22] *Ibid.*, 371.        de Francisco I de Francia," *AIEM* 7 (1971), 121-47.

[23] Bottineau, "L'Inventaire de 1686," 170-71; Enriqueta Harris, "La misión de Velázquez en Italia," *AEA* 33 (1960), 117; and Amada López de Meneses, "El Alcázar y no la Torre de los Lujanes fue la prisión madrileña

[24] APM, Libro de pagos, fols. 644-44ᵛ; for similar documentation in AGS, see José María de Azcárate, "Noticias sobre Velázquez en la corte," *AEA* 33 (1960), 363-64.

celebratory occasions. The Order of the Golden Fleece used the Bedchamber for chapter meetings that the king might call, for its annual meeting preceding Vespers on the Feast of Saint Andrew, and for the investiture of a newly appointed chancellor of the order.[25]

Describing the Bedchamber, Gómez de Mora states, "And from here no class of gentlemen [caballeros] pass within except those [who are gentlemen] of the bedchamber, grandees, and the King's major-domos." Access to the King's Quarter was governed by a strict sense of propriety and social hierarchy, and the degree to which one could penetrate the west wing was a measure of one's standing at the court. The porteros (doorkeepers) stationed at the doors of the Guard Room and the Small Hall allowed few to pass into the Antechamber, and the ushers of the bedchamber on duty in the Antechamber permitted even fewer to proceed any farther.[26] This concern to regulate access to the king's apartments was reflected in the titles of many of his servants. For example, there might have been more than one pintor del rey (painter to the king) in the royal service, but the single pintor de cámara (literally "painter to the bedchamber"—i.e., first painter to the king) outranked them all.

Advancing farther into the west wing, one reached three rooms that Gómez de Mora numbered "9" on his plan. His legend identifies the first two only as passages to the third (i.e., the southernmost), where the king ate dinner and granted private audiences to ambassadors, and where viceroys and captains-general swore their oaths of office. The relación neglects to mention that the king granted visiting cardinals their first reception in this suite. On such occasions the cardinal approached the Dining Room by way of the Antechamber, Small Antechamber, and Bedchamber. The king went to meet him in the middle of the cubillo (the small room in the semicircular tower), and after they exchanged greetings, they proceeded to the Dining Room for the audience (Ardemans 8: "Room where an audience is given to cardinals").[27]

---

[25] "Etiquetas," 515, 524-25, and 543. On rare occasions another prestigious confraternity, the Military Order of Santiago, used the room. If a newly elected member of the Trece (Council of Thirteen), which governed the order, was not present at the time of his election, then when he became available to swear his oath of office, he did so in the Bedchamber (ibid., 561-62).

[26] Ibid., 143-45, 148-49, and 172-74.

[27] Ibid., 510-11. Ardemans plan 7 ("Room where cardinals are received for an audience") puts the meeting in the second of the three rooms, which reflects either a change in etiquette under Philip V or a misunderstanding on Ardemans's part.

The gradation of status associated with the different chambers was never more evident than in the etiquette that the court observed when the king went to attend Mass "publicly" in the Royal Chapel.[28] Philip would set out from his innermost apartments accompanied by the grandees and his major-domos. Cardinals were permitted to wait for him in the Bedchamber, and ambassadors in the Small Antechamber. Among those joining the procession in the Antechamber were the *gentileshombres de la boca* (the officials principally concerned with attending to the king's meals), titled nobility, equerries, pages with their governor, and the *alcaldes* (justices) of the household and the court. *Acroes* and *costilleros* (two other ranks of gentlemen of the household), captains, and mace-bearers waited in the Small Hall. There a woman of quality might speak to the king, provided that she had first obtained the permission of the king's chief major-domo. The Archers waited to escort the king in the Guard Room along with a few guards from the other two companies, the rest of whom waited in the corridor of the upper cloister. From there the assembled cortege passed to the Royal Chapel.

Beyond the various reception chambers a *galería dorada* (Gilded Gallery; 10) or *galería del poniente* (West Gallery; Ardemans 9) extended half the length of the west wing and linked additional rooms in the king's suite. Among them were the alcove (11) where Philip usually ate supper and a bedroom (12) where he sometimes slept. The latter came to be called the *pieza oscura* (Dark Room; Ardemans 10) because the new façade of the palace that Gómez de Mora had constructed had cut off its southern exposure. There Philip also granted audiences to the presidents of the royal councils, notably the president of the Council of Castile, whom he received every Friday after his session with the full council in the Antechamber.[29] A passage (35) linked the Dark Room to the chamber where the wardrobe of the king and that of his brother, the Infante Don Carlos, were kept (34). Farther up the passage was a storeroom (32) for the tables that were used at the king's meals.[30]

The West Gallery adjoined two of the semicircular towers on the west façade and terminated in the Gilded Tower at the southwest corner of the palace. One semicircular tower (17) contained a "small room where different

[28] *Ibid.*, 350-58.     [29] *Ibid.*, 462.

[30] Iñiguez Almech, *Casa reales*, 73-74, considers the ambiguous identification of room 33 as a *retrete*.

things that are pleasing or useful to the King are kept"; its contents have yet to be identified. Gómez de Mora describes the interior of the other tower (18) as a "room in which are all the plans of the royal residences for the [royal] works and accounts of the roads belonging to the kingdoms of Spain. These are in the charge of the King's *trazador mayor* [chief architectural designer] and master of his works." In 1626 that official was Gómez de Mora himself. Besides the plans of roads and residences (some of which the architect must have consulted to illustrate his *relación*) the collection included plans and accounts of processions, of catafalques that had been erected for royal exequies, and of other court ceremonies.[31]

Gómez de Mora lauds the views from the Gilded Tower's terrace and main room (15), which he identifies as the king's office: "In this room the King dispatches every kind of official communication." For this reason, the tower was sometimes called the *torre del despacho* (Dispatch Tower).[32] When Philip paused from his paperwork, he might have relaxed by contemplating his prospect of the distant Sierra de Guadarrama. Were he in need of spiritual comfort, he had only to retire to his private oratory (14) to pray. (A cross in a rectangle designates its altar.)

Many of the chambers in the west wing featured permanent decoration in fresco and stucco. These ensembles were created in the sixteenth century, first under the direction of Gaspar de Becerra and later under that of Giovanni Castello ("El Bergamasco") with the assistance of Romulo Cincinnato and Patricio Cajés. Little is known of the appearance of these decorations, but a few of the subjects represented there have been recorded. One of the semicircular towers (9) featured stuccoes and grotesques, and the Four Elements embellished the room (Ardemans 7) connecting the tower to the Dining Room (Ardemans 8), where a *Burning of Troy* had been frescoed above the fireplace. Inside another tower (18) frescoes of the Liberal Arts occupied the upper vault while grotesques adorned the walls.[33]

Five rooms of exceptional importance for their use in court ceremonies and the quality of their decorations dominated the south side of the King's Quarter

[31] Carducho, *Diálogos*, 431-32.

[32] Bottineau, "L'Inventaire de 1686," 448.

[33] For these decorations, see AGS, CM3, leg. 784, Pintores, 1621, fols. 4bis v-5 v (first cited in José María de Azcárate, "Algunas noticias sobre pintores cortesanos del siglo XVII," *AIEM* 6 [1970], 46); APM, Libro de pagos, fol. 160bis; Carducho, *Diálogos*, 431-32; and Gérard, "L'Alcázar de Madrid," 41.

(fig. 13). Two were created when Gómez de Mora's screen façade was built: the *galería del mediodía* (South Gallery; 13) and the "large room over the entrance" (26) that at first was called the *pieza nueva* (New Room) or *salón nuevo* (New Hall), and later the *salón de los espejos* (Hall of Mirrors). Behind them lay the huge *salón grande* (Great Hall; 23), later renamed the *salón dorado* (Gilded Hall), and the *pieza de las furias* (Room of the *Furias*; 24), which took its name from a set of four paintings that had hung there until the mid-1620s. The fifth chamber, the *pieza ochavada* (Octagonal Room), was not constructed until the late 1640s, when it was carved out of the shell of the former Homage Tower. It appears on the Ardemans (16), Justi, and Verger (K) plans. Three of the rooms—the South Gallery, the Octagonal Room, and the Hall of Mirrors—enjoyed southern exposures that made them well suited for the display of works of art. As the five rooms will be the principal concerns of the three following chapters, we may defer considering their uses here.

In 1626 the Homage Tower still encased part of the suite occupied by the younger of the king's two brothers, the Cardinal-Infante Ferdinand. Partitions separated his winter bedroom (87) from the rest of the apartment (86) on the main floor, and a staircase (85) descended to his other rooms on the story below. The suite was probably absorbed into the King's Quarter when the cardinal-infante left Madrid to become the Viceroy of Catalonia in 1632.

A few other rooms rounded out the King's Quarter on the main floor. The bedroom (28) of Philip's brother Carlos was situated behind the South Gallery in what once had been Philip III's oratory.[34] Beside it was the room in which Philip IV kept music books and instruments. The *real capilla* (Royal Chapel; 30) occupied the cross-arm separating the two courtyards of the palace. The king regularly heard Mass in the oratory of his Tribune (29) overlooking the Chapel. When he was present in the Chapel itself, the queen and the *infantes* used the Tribune.[35]

The remainder of the main floor was given over to the apartments of others. In 1626 these included the queen, Isabella of Bourbon (40-57); her daughter, the Infanta María Eugenia (58-65); the Countess of Olivares, wife of the king's

[34] An inventory of 1623 known to me only from a transcript in the Museo del Prado lists the contents of an "Oratory of the King our lord, may he be in heavenly glory, that they removed so that the Most Serene Infante Don Carlos could sleep in it."

[35] For the Royal Chapel and its tribunes, see Bottineau, "L'Inventaire de 1686," 439-46; and Gérard, "Los sitios de devoción," 276-82.

favorite and María Eugenia's governess (66-69); the Duchess of Gandia, the queen's mistress of the bedchamber (70-74); and the Count-Duke of Olivares (75-85).[36]

Also at the king's disposal were clusters of rooms on other floors of the palace. During the summer he retreated from the sweltering Castilian heat to apartments shielded from direct exposure to the sun on the north side of the Alcázar. These were organized into two suites below the second story—the *cuarto bajo del verano* (Lower Quarter for Summer Use) and, beneath that, the *bóvedas del verano* (Vaulted Rooms for Summer Use). Philip reached these suites from his main floor apartments by a staircase near the east end of the Gallery of the North Wind (fig. 6, no. 22; continued on fig. 7, no. 117). The precise arrangement of the suites is unknown, but they seem to have occupied an L-shaped space extending from the northeast corner tower through the eastern side of the short projection off the north wing of the palace.[37] In the later years of Philip's reign another cluster of rooms, sometimes called the *bóvedas del Tiziano* (Vaulted Rooms of Titian) owing to the masterpieces by Titian that were installed there, came to be considered part of the king's apartments. They were located in the ground floor of the southern wing of the palace, looking onto the Garden of the Emperors.[38]

The Alcázar that Gómez de Mora charted in 1626 retained its eminence as the main residence of the kings of Spain for more than a century, until it caught fire on Christmas Eve 1734. A desperate effort was mounted to contain the blaze and to rescue relics, works of art, and other valuables, but the damage

[36] The number 85 appears twice on the *planta alta* marking both the staircase in the cardinal-infante's apartments and Olivares's bedroom.

[37] For these apartments, see Carducho, *Diálogos*, p. 427; and Volk, "The King's Summer Apartments." Although Volk convincingly proposes the L-shaped disposition of the suites, she does not distinguish the *cuarto bajo* as occupying a separate level from that of the *bóvedas* below. Inventories of the Alcázar confirm this superposition with descriptive names of some rooms and references to staircases connecting the two levels; e.g., see Bottineau, "L'Inventaire de 1686," 289, 303, and 310. John F. Moffitt, "Velázquez in the Alcázar Palace in 1656: The Meaning of the *Mise-en-scène* of *Las Meninas*," *Art History* 6 (1983), 281, confuses the king's Summer Office

in these apartments with his regular office in the Gilded Tower; in fact, they were distinct.

It should be noted that the *bóvedas del verano* were not subterranean apartments even though they were two stories below what I have hitherto referred to as the second floor of the Alcázar. Because the land behind the Alcázar was considerably lower than the plaza in front of it, the ground floor in the north wing was a story below the ground floor of the south wing. In this study the numbering of floors is based upon their levels in the south wing.

[38] Bottineau, "L'Inventaire de 1686," 316; and Harold E. Wethey, *The Paintings of Titian: Complete Edition*, 3 vols. (London, 1975), 3:81-83.

was extensive. It has been calculated that 537 of 1,575 pictures that were recorded in the king's collection in the palace in 1700 were destroyed.[39] The building itself was so badly damaged that Philip V decided to have the remains demolished and to build the present Royal Palace in its place.

## THE EVIDENCE FOR RECONSTRUCTION

The calamitous fire that destroyed so many valuable works of art also disrupted the arrangement of the king's collection in ensembles that had expressed the ideas and tastes of their successive owners. Because interior views of the Alcázar are rare and written descriptions are far from complete, the appearances of only a few chambers can be reconstructed, and even then only partially. Fundamental to the task is identifying works of art with the specific rooms in which they were displayed, and for that, four inventories of the king's collection that were compiled in 1636, 1666, 1686, and 1700 are crucial. They were assembled when a king died or when the responsibility for overseeing the collection passed from one administrator to another. Because the officials and experts who prepared these lists proceeded through the Alcázar in an orderly fashion, the inventories supplement the *etiquetas* and the floor plans as sources for the names and locations of specific rooms.

That four lengthy inventories have survived is all the more fortunate because the royal accounts of the expenses incurred for decorating and maintaining the Alcázar contain surprisingly few references to works of art. They are far more concerned with recording the costs of building materials and the fees and wages paid to artisans and unskilled laborers. The few entries dealing with paintings and sculptures usually note the costs of cleaning them, of constructing frames or pedestals for them, or of installing them; seldom do they note the costs of purchasing them in the first place. Why so few records exist for the acquisition of works of art remains a mystery.

To review the inventories in chronological order:

1. The *inventory of 1636* was evidently compiled late in that year when the responsibility for the king's collection was transferred from Gómez de Mora

---

[39] Bottineau, *L'Art de cour*, 491.

to Simón Rodríguez, an *ayuda de la furriera* (a kind of steward in the administrative bureau that supervised most of the furnishings in the Alcázar). It is not certain that he compiled the text himself.[40] For each room the inventory first lists the paintings and then the sculptures and other furnishings found there in unnumbered entries, but it makes no estimate of their values. The itinerary through the palace that it describes began on a Queen's Staircase and then entered the Passage to La Encarnación. Next, starting with the Room of the *Furias*, it proceeded clockwise around the King's Quarter to the Gallery of the North Wind, where it descended to the two levels of summer apartments. After that came the Garden of the Emperors, the adjacent *bóvedas*, a gallery and an oratory of the queen, and, finally, a room just off the South Gallery (fig. 13; no. 16 or 28).

2. The *inventory of 1666* was taken under the direction of don García de Medrano beginning September 17, 1666, exactly one year after Philip IV died.[41] The final pages of the inventory are lost; the last entries that have been preserved were written on October 25, 1666. Like the inventory of 1636, Medrano's text lists the paintings first and then the sculptures and other objects, room by room, but unlike the earlier survey it also assigns values to each piece.

[40] APM, SA, Inventarios, leg. 768; hereafter cited as the "inventory of 1636." The same *legajo* contains a contemporary copy of the inventory with numerous orthographic errors, some of which change the meanings of individual entries. The evidence for precisely dating the original is complicated. Rodríguez signed the last page of its text on March 20, 1637; according to the last paragraph, he was supposed to have been joined in this by Gerónimo de Villafuerte, who held an unspecified position in the king's *guardajoyas* (the office of the keeper of the crown jewels). The inventory itself seems to have been compiled in 1636. The upper right corner of its first page has been torn, cutting off the final digit in the year of its date, which is also inscribed there. A modern hand has added "1636" there, and that year is also given on the first page of the copy of the original. *Legajo* 768 also contains a six-page memorandum listing fifty-two items of furniture that Rodríguez took charge of from Gómez de Mora on November 26, 1636.

The circumstances that led to Rodríguez's assuming responsibility for the royal collection have yet to be clarified. Contemporary sources suggest that Gómez de Mora

was banished to Murcia in 1636 after being found guilty (possibly on false charges) of stealing a Titian from the royal holdings—see José María de Azcárate, "Datos para las biografías de los arquitectos de la corte de Felipe IV," *Revista de la Universidad de Madrid* 11 (1962), 520; José Fradejas Lebrero, "Diario madrileño de 1636 (24 de mayo a 27 de diciembre)," *AIEM* 16 (1979), 99 and 135; and Antonio Rodríguez Villa, *La corte y monarquía de España en los años de 1636 y 37* (Madrid, 1886), 44-45. However, Virginia Tovar Martín, *Arquitectura madrileña del s. XVII (datos para su estudio)* (Madrid, 1983), 137 and 139, refutes the rumors of the architect's banishment by establishing that although he left for Murcia early in 1637, he was back in Madrid by August of that year. Because Gómez de Mora did not enjoy Olivares's favor, his career remained under a cloud until the count-duke fell from power in 1643; nevertheless, the architect continued to work on royal projects in the interim.

[41] APM, SA, Bellas Artes, leg. 38; hereafter cited as the "inventory of 1666." Medrano's position in the royal household is unknown.

These were provided by two experts who assisted Medrano: the *pintor de cámara* Juan Bautista del Mazo, who appraised the paintings, and Sebastián de Herrera Barnuevo, *maestro mayor* (chief architect) of the royal works and an *ayuda de la furriera*, who appraised the sculptures and other furnishings.

Medrano and his consultants began their survey in the two suites of summer apartments, ascended to the Gallery of the North Wind, and proceeded counterclockwise around the King's Quarter to the Octagonal Room. From there they descended to the *bóvedas del Tiziano*. It is in that suite that the manuscript breaks off. Comparing the 1636 and 1666 inventories reveals that the decoration of the Alcázar was transformed markedly during the intervening thirty years.

3. The *inventory of 1686* was the work of don Bernabé Ochoa, the *jefe de la cerería* (chief of the royal chandlery).[42] Ochoa first listed the paintings, sculptures, and furnishings in the Royal Chapel, its sacristy, and selected oratories. Then, considering paintings only, he worked clockwise from the Hall of Mirrors to the Gallery of the North Wind, whence he descended to the king's summer apartments. From there he returned to the south wing and descended the staircase by the Octagonal Room to the *bóvedas del Tiziano*. Next he examined a second-floor suite called the *cuarto bajo del príncipe* (Prince's Quarter below the Main Floor) that included rooms that had overlooked the Garden of the Emperors until it was paved over in 1674. After that he reviewed the paintings in the Passage to La Encarnación and the apartment of the *aposentador de palacio* (the administrator in charge of the *furriera*) in the Casa del Tesoro, one of the dependencies to the east of the palace. His consideration of the paintings concluded with a list of pictures that were distributed among several rooms but were not hanging. Ochoa then repeated his tour in order to list the *alhajas y adornos* (sculptures and showy furnishings) in the same rooms.

The inventory entries are unnumbered, and Ochoa did not appraise the values of the works. However, he did place three useful summaries at the head of his text. The first lists each room and the number of paintings that he had seen in it; the second lists the totals of the different kinds of *alhajas y adornos*

---

[42] APM, SA, Bellas Artes, leg. 38; hereafter cited as the "inventory of 1686." Bottineau, "L'Inventaire de 1686," is a critical edition of this inventory that collates the paintings and *adornos* room by room, identifies works that are still extant, and makes frequent comparative references to the inventories of 1636, 1666, and 1700. In most cases I have cited his edition rather than the original manuscript.

that he had found; and the third lists the numbers of pictures that he had attributed to individual artists, to their followers, and to national schools of painting.

Comparing this inventory with the previous one reveals that between 1666 and 1686 the size and arrangement of the king's collection underwent few changes. In a separate memorandum Ochoa counted thirty-two paintings and two andirons that had been removed, and thirty-five paintings that had been added.[43] Consequently, the inventory of 1686 can be regarded as a reasonably accurate guide to the contents in 1666 of the rooms that are missing from the surviving fragment of the earlier year's inventory.

4. The *inventory of 1700* is part of the *Testamentaría del rey Carlos II*, a massive accounting of the king's possessions in all the royal dwellings that was assembled after the death of Charles II and the accession of Philip V. Its sections pertaining to the paintings and *alhajas* in the Alcázar are based upon the lists that Ochoa compiled in 1686, and they seldom depart from the order of rooms followed in the earlier text.[44] So closely does the inventory of paintings follow its predecessor that the very wording of the entries is virtually duplicated. The numbered entries of the *Testamentaría* state the values of the works, except in the cases of royal portraits, which were not appraised out of respect for their subjects.[45] Limited changes in the collection of paintings between 1686 and 1700 were made chiefly to accommodate works that had been acquired from Luca Giordano, who had arrived in Spain in 1692 and who served as one of the expert appraisers consulted when the inventory was taken.[46]

Of course, inventories are dim reflections of the works they record. Fortunately, a sizable body of paintings and sculptures from the Alcázar has survived, and most are conserved in the Museo del Prado. Ultimately they, not mere verbal descriptions, are the components from which a few ensembles can be re-created most effectively.

[43] APM, SA, Inventarios, leg. 768.

[44] APM, reg. 240. This volume, dealing solely with the Alcázar, has been transcribed as the first volume of *Inventarios reales: Testamentaría del rey Carlos II 1701-1703*, ed. Gloria Fernández Bayton, 2 vols. (Madrid, 1975-1981); see 1:7-10 and 13-18 for full specifications on the inventory and its compilers.

[45] APM, SA, Inventarios, leg. 768, contains a copy of the inventory of 1686 that bears appraisals of the values of works and notations about pieces that were moved after 1686. This copy must have been used as the guide for preparing the inventory of 1700.

[46] Yves Bottineau, "A propos du séjour espagnol de Luca Giordano," *GBA*, 6th ser., 56 (1960), 249-60; and *Inventarios reales*, 1:15.

The four inventories establish that during Philip IV's reign the king's collection in the Alcázar was arranged in an installation that remained essentially unchanged under Charles II. This involved a multitude of paintings—the inventory of 1686 records 1,547 of them. The Spanish Habsburgs had collected art avidly for generations, and over the years a large share of their holdings had gravitated to their principal residence. Because only a small number of these paintings had been created for specific sites in the Alcázar, those responsible for hanging the collection had to select works for each chamber from the enormous stockpile at their disposal. Obviously they would have been subject to such restrictions as fitting pictures within the available wall spaces, seeing that Philip IV's favorite pictures were displayed prominently, and leaving room for the much smaller number of sculptures and furnishings that also adorned the palace. Beyond meeting those requirements, they would have sought to compose ensembles that were unified by one or more common characteristics.

Yet, there were often deviations from complete harmony in the selections of works for particular ensembles. Consider, for example, the twenty-three paintings that were displayed in the *pieza de la torre* (Tower Room) of the *bóvedas del verano* in 1666. Twenty-two of them were portraits, mostly of royalty, but the twenty-third was a *Venus and Adonis* copied after Titian.[47] The presence of that lone mythological subject would not have disguised the fundamental conception of the Tower Room as a portrait gallery. Why the *Venus and Adonis* was shown there remains a matter of conjecture, but whatever the reason, such inconsistencies cropped up repeatedly in a palace where more than 1,500 paintings had to be accommodated. Another consideration in attempting to understand the adornment of the Alcázar is that the painted and sculpted decorations in a given room were not necessarily related. In the Tower Room, for example, the *adornos* in 1666 consisted of sixteen earthenware figures of unrecorded subjects, two clay reliefs of children's bacchanals, a bronze medallion of Charles V that was mounted on a pedestal, and five tables.[48] Only the medallion can be identified firmly as another portrait.

Bearing these considerations in mind, one can discern three approaches that underlay the decoration of the Alcázar: random selection, unity through

[47] Inventory of 1666, fols. 17-17ᵛ and 18ᵛ.          [48] *Ibid.*, fols. 18-18ᵛ.

common traits, and unity through programmatic meaning. Randomness was the simplest of the three because it required no organization. In the Passage to La Encarnación, where 490 pictures had been gathered by 1686, the sheer quantity of works precluded any basis for thematic unity, even within the subdivisions of the lengthy gallery.[49] To judge from the inventory compiled that year, the passage had become a storage area for paintings that were not displayed in the royal quarters of the Alcázar. There are many indications that the works assembled there suffered second-class status. Ochoa assigned specific attributions to a much smaller proportion of them than he did for those in the main building. An inordinate number of maps, depicting such diverse subjects as fortresses, cities, and entire kingdoms, suggests that old-fashioned types of pictures were moved there. Numerous inventory entries describe works on paper and parchment, materials that are far less durable than wooden panels and canvas. Inferior quality and condition may have been grounds for consigning a picture to the passage, for Ochoa characterizes many items as damaged, unframed, or school pieces.

Against this image of the passage as a warehouse, it must be acknowledged that some works of apparent quality found their way there. A few pictures are known to have been cleaned and repaired before they were transferred there in 1619.[50] Attributions to such artists as Bosch, Cano, Pantoja de la Cruz, and Velázquez are scattered through the 1686 listings. For the most part, however, the passage seems to have evolved into a depository for works that were out of favor or thought to be inferior. Hanging them there put them out of the way and relieved the monotony of the lengthy walk from the Alcázar to La Encarnación.

Works that were assembled randomly were not always inferior in quality. The decoration of the Gallery of the North Wind is a case in point, for of fifty-nine pictures on view there in 1666, twenty-five were attributed to Flemish, Italian, and Spanish masters including Annibale Carracci, El Greco, Lanfranco, Leonardo da Vinci, Mor, one of the Procaccini, Reni, Rubens, Teniers the Younger, Tintoretto, Van Dyck, and Veronese.[51] Although some coherent

[49] Bottineau, "L'Inventaire de 1686," 455-73.

[50] AGS, CM3, leg. 784, Pintores, 1619, fols. 7bis v-8; first cited by Azcárate, "Algunas noticias," 57. For the framing of maps to be put in the passage in 1619,

see the same *legajo*, Destajos, 1619, fols. 23bis v-24.

[51] Inventory of 1666, fols. 33-38 v. One must allow for errors in the attributions; e.g., a picture ascribed to Pietro da Cortona has since been identified as a work by Viviano

groups (sets showing papal ceremonies and Flemish peasant festivals) were
present among the assorted genre scenes, landscapes, portraits, and subject-
pictures that filled the gallery, no common trait united all fifty-nine works.
Apparently the pictures were brought together simply because Philip IV liked
them.

A more sophisticated approach to decorating a room was to assemble
paintings with an easily recognized, shared characteristic. One common de-
nominator was subject matter. As already noted, the Tower Room in the
*bóvedas del verano* was conceived as a portrait gallery. In 1636 a staircase in the
Tower of France was decorated with seventeen maps on paper.[52] As one would
expect, in 1686 all the paintings in the Royal Chapel, its sacristy, and the
oratories depicted religious subjects.[53] The unifying trait to an ensemble could
even have been numerical, for under Philip III the decorative scheme of the
Room of the *Furias* was based upon paintings that came in sets of four.[54]

The name *bóvedas del Tiziano* suggests another unifying basis, collections
of works by single artists. In 1686 thirty-four paintings hung in these *bóvedas*,
nineteen of which were attributed to Titian (a twentieth was considered to be
a copy after him).[55] His name was applied to the suite in recognition of both
the quantity and quality of his paintings there. Titian enjoyed a numerical
dominance—the second most frequently represented artist was Veronese, with
a mere three paintings—that was matched by the high caliber of his works,
which included some of his most famous mythologies. From organization
around a single artist it is a small step to assembling works by national school.
Under Philip IV the South Gallery and the Octagonal Room became respec-
tively halls of Venetian and Flemish painting.[56]

By no means was a decorative scheme necessarily limited to a single shared
characteristic. The inventory of 1686 describes one passage in the *cuarto bajo
del verano* as follows: "In the Passage of the lower apartments that leads to the
Staircase of the Gallery of the North Wind there are ten portraits on panel,

---

Codazzi. On the other hand, many of the attributions of
the surviving pictures were correct—see Bottineau, "L'In-
ventaire de 1686," pp. 172-79.

[52] Inventory of 1636, fol. 23bis.

[53] Bottineau, "L'Inventaire de 1686," 439-52.

[54] See Chapter IV.

[55] Bottineau, "L'Inventaire de 1686," 318-25. I treat
a seven-part ceiling painting by Tintoretto as one work.
The inventory of 1686 lists another forty-six pictures in
the same *bóvedas* as not hanging (*desmontadas*)—*Ibid.*, 475-
77.

[56] See Chapter IV.

a *vara* in height, all of common women, with black and gilded frames, by the School of Albrecht Dürer."[57] There were two shared traits, the subject (common women) and the style (School of Dürer).

The third and most sophisticated approach to decoration was the programmatic one. A programmatic ensemble may or may not have been stylistically homogeneous; in either case, it derived its unity from the interplay of the subjects of the paintings that comprised it. Considered as a group, the pictures conveyed an elaborate combination of themes—a program—that no single picture could communicate alone. This capacity to express complex ideas provided the Spanish Crown with an appealing way to promote itself through pictorial means. In the Alcázar this practice was exemplified by the decoration of the Hall of Mirrors.

[57] Bottineau, "L'Inventaire de 1686," 299.

# CHAPTER II

# *The Decoration of the Hall of Mirrors*

B Y EXTENDING a new façade across the southern flank of the Alcázar, Gó-
mez de Mora created an important new chamber between the square
towers of the old façade (fig. 13; no. 26). It was an imposing space, two stories
high and 69 × 38 Castilian feet (19.32 × 10.64 meters) in plan, with three
balconies overlooking the great square lying before the palace.[1] In his *relación*
the architect describes it as a "large room over the main entrance, and from
here the king and queen see the festivals and processions that pass through
the Plaza de Palacio."[2] It is ironic that in 1626 the hall was considered more
noteworthy for its view than for any interior feature or use, because over the
course of Philip IV's reign this chamber, at first called simply the New Room,
evolved into a sumptuously decorated setting for some of the most extraordinary
diplomatic ceremonies to occur at the court. Two portraits by Juan Carreño
de Miranda, a *pintor de cámara* to Charles II, provide tantalizing glimpses of
this chamber: one of *Charles II* (fig. 14) and one of his mother, *Mariana of
Austria* (fig. 15). Each is an early instance of a composition that Carreño and
his workshop employed in a succession of variants.[3] Both feature a pair of
gilded bronze eagles clutching ebony-framed mirrors with their talons. These
furnishings gave the New Room a more distinctive name: the *salón de los espejos*,
or Hall of Mirrors.[4]

## THE USE OF THE HALL

No significant court function was assigned to the New Room during its early
years, but there were many events, festive and grave, to be seen from its central

[1] Antonio Domínguez Ortiz, "Una embajada rusa en la corte de Carlos II," *AIEM* 15 (1978), 178.

[2] Gómez de Mora, "Relaçion de las cassas," fol. 1ᵛ.

[3] Rosemary Marzolf, "The Life and Work of Juan Carreño de Miranda (1614-1685)" (Ph.D. diss., University of Michigan, 1961), 77-81, 84-86, 156-61, and 165-69.

[4] The room is also cited in court records as the *saloncillo* (Little Hall), the *saloncillo dorado* (Little Gilded Hall), and the *salón dorado* (Gilded Hall). Because this last name was more frequently used to describe the Great Hall (see Chapter III), care must be taken when working with such references to be certain which room is under consideration.

*balcón grande* (Great Balcony) and the two smaller balconies at the sides. A royal birth inspired jubilant celebrations that usually included a *máscara* (masquerade)—a colorful equestrian display adopted from the Moors that incorporated a mock battle fought by squadrons of riders charging in formation[5]—in front of the Alcázar. After Philip IV's son and heir apparent, Baltasar Carlos, was born October 17, 1629, the king himself participated in the masquerade, which his first wife, Isabella of Bourbon, his brother Ferdinand, and his sister María witnessed from the Great Balcony.[6] During a masquerade celebrating the lesser occasion of a daughter's birth (María Antonia, born January 16, 1635) the king was content to appear "present in public in the Great Balcony."[7]

Other events were more solemn. On May 16, 1641, a procession of supplicants seeking divine relief from a drought and the wars that were then in progress carried the body of Saint Isidro, the patron saint of Madrid, from the parish church of San Andrés to the parish church of Santa María. Their route passed through the Plaza de Palacio, where clerics from the Royal Chapel sang a motet in reverence while the king and queen witnessed the ceremony from the Great Balcony.[8] When Charles II was acclaimed king in the palace square following his father's death in 1665, the child-monarch watched from the same balcony.[9]

The Great Balcony was put to its most dramatic use on November 4, 1629, when Baltasar Carlos was baptized in the church of San Juan, which was then the parish church of the Alcázar (fig. 5; F).[10] The procession that conveyed the infant to San Juan left the palace by way of the Great Balcony, descending to the plaza on a broad wooden staircase that had been constructed for the occasion. Placed above the balcony was an opulent brocade hanging bearing the royal coat of arms. The staircase, divided into four flights of nine steps each, was painted illusionistically to resemble dark grey granite. At the

[5] Brown and Elliott, *Buen Retiro*, 39.

[6] *Relaciones breves*, 387-88.

[7] "Diferentes sucesos y noticias desde el año de 1629 hasta el año de 1636," BNM, Mss. 9404, fol. 46ᵛ; and "Papeles varios" [*noticias* for 1632-1635], BNM, Mss. 9406, fols. 148ᵛ-49.

[8] "Papeles varios" [*noticias* for 1640-1642], BNM, Mss. 8177, fols. 141-41ᵛ; and "Papeles varios" [*noticias* for 1637-1642], BNM, Mss. 9402, fols. 176-76ᵛ.

[9] *Aclamacion Real y Publica de la Coronada Villa, y Corte de Madrid, en cuyo nombre leuantó el Pendon de Castilla . . .*

*por su Augusto, y Catolico Rey Carlos II. que Dios guarde* (Madrid, 1665), unpaged.

[10] For the following account, see "Epitome de todas las cosas suzedidas en Tiempo del señor Rei don phᵉ quartto," RAH, Ms. 9-3-5-G-32bis, fols. 97ᵛ-98; "Etiquetas," 289-303; *Relaciones breves*, 380-81 and 385-86; and Diego de Soto y Aguilar, "Tratado donde se ponen en Epilogo algunas fiestas que se han hecho por casos memorables que han sucedido en España, y fuera de ella, tocantes a la monarchia de España y su Corona," RAH, Ms. 9-3-5-G-32bis, fols. 53-53ᵛ.

foot of the stairs the procession entered an uncovered passage that ran to the church. Both structures were lined with balustrades on which the escutcheons of the Spanish realms were mounted at regular intervals, and the walls of the passage were adorned with fine tapestries from the king's collection. Both the staircase and the passage were as wide as a road that could accommodate three coaches, and the passage was 1½ *estados* (2.98 meters) tall.

Owing to the height of the passage, spectators in the Plaza de Palacio could only have seen the procession as it emerged onto the balcony and descended the staircase. The Great Balcony was not only a vantage point from which the royal family could survey the square below, but also a setting in which those in the square could see them. This function was inherent in Gómez de Mora's design of the south façade. By bringing the main entrance forward from its recess between the old square towers, he had improved the views of and from its balconies. Furthermore, he had surrounded it with elaborate ornamentation to make it a focus of attention. The square panel above it that bore the royal arms not only identified the Alcázar as the king's residence but also reminded spectators that the man who sometimes stood on the Great Balcony ruled the Monarchy. (The brocade hanging emblazoned with the royal arms that was displayed for Baltasar Carlos's baptism reiterated the point on behalf of the newborn heir apparent.) It was no accident that the Great Balcony and the two smaller balconies at its sides were the only ones on the south façade that Gómez de Mora indicated on his plan of the main floor. They were intended to be special.

Aside from its use as a gathering place for many of those who participated in Baltasar Carlos's baptismal procession, the interior of the New Room had no special function until September 23, 1638, more than a decade after its construction. On that day Francesco I d'Este, third Duke of Modena, formally entered Madrid on horseback. He was accompanied through the town from the Hermitage of the Magdalene (a pavilion in the gardens of the Buen Retiro near the Puerta de Alcalá) to the Alcázar by the Count-Duke of Olivares and an escort of noblemen and gentlemen of the court. At the Alcázar the king received the duke standing by a Florentine stone table near a window in the New Room.[11]

[11] *Cartas de algunos PP. de la Compañía de Jesus sobre los sucesos de la monarquía entre los años de 1634 y 1648*, MHE, vols. 13-19 (Madrid, 1861-1865), 3:61-62 and 68; and Matías de Novoa, *Historia de Felipe IV, Rey de España*, ed.

Later that year don Juan Alfonso Enríquez de Cabrera, the Admiral of Castile, returned to Madrid in triumph after having broken the French siege of Fuenterrabía. News of the victory had been received with jubilation at the court. His arrival in Madrid was greeted enthusiastically by the populace, and the palace guards were hard pressed to contain the mob that had gathered at the Alcázar to cheer him. When the admiral entered the palace, Philip, standing beside the same table in the New Room, received him with the same honors as he had paid to the Duke of Modena.[12]

Using the New Room for extraordinary receptions departed from the earlier practice of holding such events in the Great Hall. When the king's cousin, Princess Margarita of Savoy, Dowager Duchess of Mantua, had entered Madrid on November 4, 1634, Philip had met her at the Hermitage of the Magdalene and had escorted her to the Alcázar. There his wife, Isabella, had greeted the duchess in the Great Hall, not the New Room.[13] When the Princess of Carignano had arrived at Madrid on November 16, 1636, she had been received with the same honors as the duchess.[14] Why Philip decided to shift the receptions of distinguished visitors to the New Room in 1638 is not recorded. Perhaps he had grown dissatisfied with the Great Hall, which he ordered renovated and redecorated in 1639.[15]

Surely the most extraordinary visitor ever to be received in the New Room was Hamete Aga Mustafarac, an ambassador of the Grand Turk, in 1649. So unusual was this event that it was recorded in the *etiquetas* then under review by the king's *junta*.[16] On September 15 don Christóbal de Gaviria, the acting lieutenant of the Spanish Guard and the *conductor de embajadores* (guide to ambassadors), escorted Mustafarac and four members of his party from their lodgings in Madrid to the Alcázar. Curious spectators eager for a glimpse of

Marqués de la Fuensanta del Valle, José Sancho Rayon, and Francisco de Zabalburu, CDIHE, vols. 69, 77, 80 and 86 (Madrid, 1878-1886), 2:623. *Ibid.*, 629, asserts that on October 24 D'Este returned to the New Room, where Philip made him and Prince Baltasar Carlos knights of the Golden Fleece. That is partly contradicted by León Pinelo, *Anales*, 315, who says that the king granted membership in the order to Baltasar Carlos in the Bedchamber, "and later he gave it to the Duke of Modena." Whether the latter event occurred in the New Room or the Bedchamber has yet to be determined.

[12] Novoa, *Historia*, 2:634-35.

[13] *Ibid.*, 1:438-39; *Cartas de algunos PP.*, 1:107; and Brown and Elliott, *Buen Retiro*, 194-95.

[14] Fradejas Lebrero, "Diario madrileño," 151-52; Novoa, *Historia*, 2:218; and *Relaciones breves*, 447-48.

[15] See Chapter III.

[16] "Etiquetas," 645-64. For the following account, see also León Pinelo, *Anales*, 343-44; Novoa, *Historia*, 4:624-25 and 628-29; and "Tratados varios de las coronas de España," BLL, Ms. Add. 10,236, fols. 424-27.

the remarkable visitors lined their route. The Count of Puñoenrrostro, who was the king's major-domo of the week, and other officials of the king's household greeted the ambassador at the main entrance to the palace and conducted him up its monumental staircase. Members of the Spanish and German guards were stationed along their path to the Guard Room, where armed members of the Guard of Archers stood on duty. From there the dignitaries proceeded through the King's Quarter by way of the Small Hall, Antechamber, Bedchamber, Dining Room, West Gallery, Dark Room, South Gallery, and the newly constructed Octagonal Room, arriving at last on the threshold of the Hall of Mirrors.

The hall had been specially arranged for the occasion. Rather than granting Mustafarac an audience with the courtesies due an ordinary ambassador, Philip had elected to receive him in the same manner that the Holy Roman Emperor received embassies from the Grand Turk, and in which the Grand Turk met with embassies from Christian princes. A three-stepped dais covered with opulent carpets had been erected in the doorway to the queen's apartments at the middle of the east wall. The king's throne, adorned with a dossel and canopy, stood atop a small fourth step. The dossel, canopy, and throne, which had been used at the coronation of Charles V, were wondrous to behold because they were lavishly adorned with pearls, diamonds, rubies, emeralds, and ruby spinels.[17] Benches covered with carpets extended toward the center of the hall from the doorway in the middle of the north wall and from the window onto the Great Balcony, dividing the room in half. There was a gap between the benches at the center of the room to permit Mustafarac to approach the king. From the ends of the benches at this gap, other covered benches extended to the door to the Octagonal Room, defining the ambassador's path to the dais. The walls were decorated with their customary paintings and mirrors.

Before the ambassador arrived, Philip had entered the hall from the Room of the *Furias*, whereupon a screen had been placed in its doorway so that the Infanta María Teresa, Princess Margarita of Savoy, and other ladies at the court could observe the ceremony discreetly. The king, who was still in mourning for the death of his sister María, wore a friar's habit and the chain of the Order

[17] For a detailed description of the coronation throne ensemble, see Domínguez Ortiz, "Una embajada rusa," 179.

of the Golden Fleece. Grandees, senior officials of the government, and other privileged courtiers lined the walls behind the benches to witness the event.

Upon entering the room, Mustafarac bowed deeply three times as he approached the king, kissed the bottom step of the dais, mounted the platform with the Count of Puñoenrrostro, kissed the fourth step on which the king's throne stood, backed down the steps with the count, and addressed the king in Italian. He revealed that he had been sent on confidential business and accordingly requested a secret audience. Don Pedro Coloma, the secretary of the Council of State, then mounted the dais, knelt to receive Philip's answer, and descended to relate it to the ambassador: The secret audience would be granted the following day. Puñoenrrostro escorted Mustafarac through the Gilded Hall to the Dark Room, and from there they retraced their steps to the ambassador's carriage. Philip had remained seated through the entire ceremony. The next morning he received Mustafarac with comparable forms, but in the presence of only Coloma and the Council of State.

The next recorded reception in the Hall of Mirrors took place on January 17, 1656, when the Marquis of Priego came to the Alcázar.[18] He was to serve as Philip's special ambassador to Rome to acknowledge the king's obedience to the newly elected pontiff, Alexander VII. The king received the marquis standing beside a table and accorded him the honors of a grandee of the first class. It was said at the court that Priego would be made a knight of the Golden Fleece as well. Evidently the courtesies paid to the marquis were intended to increase his stature and thereby underscore the importance that the Crown attached to his mission—a mission he seems never to have fulfilled. By January 1658 no ambassador extraordinary had been sent to Rome, the pope was complaining, and it was rumored that the Count of Castrillo (then the Viceroy of Naples) would perform the duty in April.[19]

In 1659 Spain and France ended the war that had dragged on since 1635 by negotiating the Peace of the Pyrenees, which entailed the marriage of María Teresa to Louis XIV. This set the stage for another extraordinary reception in the Hall of Mirrors. Louis dispatched the Marshal-Duke of Gramont as his special ambassador formally to ask Philip for the infanta's hand, and on October

---

[18] Jerónimo de Barrionuevo, *Avisos*, ed. A. Paz y Mélia, Colección de Escritores Castellanos, vols. 94, 96, 99, and 103 (Madrid, 1892-1893), 2:98 and 271, and 3:156.

[19] *Ibid.*, 4:40.

16, 1659, the envoy's party staged a dramatic entrance into Madrid.[20] Mounted on horses that Philip had provided, the marshal-duke and forty-four companions galloped through the Puerta del Prado and raced across the town to the Alcázar. Their haste was intended to express Louis's passion and impatience for the marriage, and the throngs of *madrileños* who mobbed the streets cheered their arrival. At the entrance to the palace the Admiral of Castile, don Juan Gaspar Alonso Enríquez de Cabrera, and members of his house greeted the marshal-duke and escorted the French party up the monumental staircase, through the King's Quarter, and into the Hall of Mirrors.

Two members of the French delegation recorded their impressions of the reception. One was François Bertaut, a *conseiller-clerc* in the *parlement* of Rouen and prior of Mont-aux-Malades:

> It must be confessed that the manner in which the King ordinarily grants an audience in France is nothing in comparison with that in which Monsieur le Maréchal was received. In each room that we passed there were rows of people; and in the middle of the Hall there were two ranks of benches covered by carpets to restrain the crowd and to leave the path open. At the end there was still another rank set crosswise. All the persons of quality were [standing] the length of this Hall on one side and the other; but because they were all dressed in the same manner and very simply, the Grandees did not stand out from the others, except that they were wearing hats. The King of Spain was standing, wearing a quite simple outfit and strongly resembling all his portraits, beneath an opulent canopy that was at the end of the Hall without there being any person near him. Upon entering, we separated, most of us [going] to the two sides. As Monsieur le Maréchal entered from the far end, the King put his hand to his hat, and as he came closer, he did not stir. When Monsieur le Maréchal took off his hat from time to time and when he presented his letter, he [Philip] did not change his posture at all, so that he did not return his hand to his

[20] For the entry, see François Bertaut, "Journal du voyage d'Espagne (1659)," ed. F. Cassan, *RH* 47 (1919), 26-30; Alvaro Cubillo de Aragon, *Relacion breve, de la solemnissima entrada que hizo . . . el Excelentissimo Señor Duque de Agramont . . .* (Madrid, 1659); *Mémoires,* 2:47-54; *Relacion de la entrada, que en la villa de Madrid, Corte y Silla de los Catholicos Reyes de España, hizo el Excelentissimo señor Mariscal Duque de Agramont . . .* (Seville, 1659); and *Relacion de la venida y entrada en esta Corte del Excelentissimo señor Marescal Duque de Agramont . . .* (Madrid, 1659).

hat until Monsieur le Maréchal left. Before leaving, he made a sign to those that he had put on his list, and we went to bow to the King. As we found ourselves in no order and without any consideration of our [different] qualities, Monsieur le Maréchal named us all at the moment when we bowed to pay reverence.

To the left of that Hall there was a grille or blind where the Queen and the Infanta were.[21]

The other French witness to record his impressions was the marshal-duke's second son, later the second Duke of Gramont, who wrote in part:

It was thus with much difficulty [owing to the crowd] that the Marshal of Gramont reached as far as the apartment of the King, who was awaiting him at the audience in a great hall decked with the crown's most beautiful carpets [tapisseries]. He was at the end [of the room] on a dais covered with gold embroidery and huge pearls, seated in an armchair; and the space above the canopy [queue du dais] was covered by the portrait of Charles V on horseback done by Titian, so natural that one believed that the man and the horse were living . . .

While all these things took place, the Queen and the Infanta remained hidden behind a blind that had been put expressly for that purpose in a door that faced the King's chair, from which they watched all that occurred without being seen.[22]

The canopy and throne used by the king were probably the Charles V coronation ensemble. The arrangement of the furnishings for the ceremony had been the work of Velázquez (in the capacity of *aposentador de palacio*) and of the king's *tapicero mayor* (the chief of the office responsible for tapestries, hangings, carpets, and other textiles that adorned the royal household).[23]

The French party was escorted through the King's Quarter as Mustafarac had been ten years before, but the Spanish court had been conscious of a different precedent when it planned the marshal-duke's reception.[24] On Sep-

[21] Bertaut, "Journal," 28-29.

[22] *Mémoires*, 2:50-53.

[23] Palomino, *El museo pictórico*, 928-29. Palomino says Philip received Gramont standing beside a table; perhaps he confused this reception with others at which the king stood by a table rather than using a canopied throne.

[24] The following account draws upon documents in AGS, Estado, Francia: K1618 (C. 5), nos. 52 and 56; K1619 (C. 6), no. 57; and K1622 (C. 10), nos. 44, 48, 55, 59, 60, 65, 68, 69, and 74.

tember 3, 1659, the king's *valido*, don Luis de Haro, Marquis of Carpio, had written from Fuenterrabía, where he was negotiating the Peace of the Pyrenees with his French counterpart, Cardinal Mazarin, that the marshal-duke would be sent to Madrid to ask for María Teresa's hand. Haro had reported this so that Philip would have time to decide how Gramont was to be received and lodged at the court. The king consulted the Council of State on the matter and asked whether the marshal-duke should be received with the same honors or with less than those accorded a more distinguished predecessor who had performed a comparable function: Henri de Lorraine, Duke of Mayenne, whom Louis XIII had dispatched to Madrid in 1612 to sign the wedding contract betrothing the French monarch to Philip III's daughter, Anne of Austria.[25]

The Duke of Mayenne, in fact, had been granted two formal audiences by Philip III. At the first, on July 12, the duke came to express the *pesame* (a ceremonial offering of condolence) for the death of the king's wife, Margaret of Austria. At the second, on August 22, the king received the duke after the wedding contract had been signed. On the first occasion Mayenne was greeted at the main entrance to the Alcázar by the Duke of Uceda, the son of the king's *valido*, and on the second by the *valido* himself, the Duke of Lerma. Both times he was ushered through the King's Quarter before being admitted to the Great Hall, where Philip III granted him a public audience.

These receptions were to provide the model for the marshal-duke's welcome to the court, for the Council of State advised Philip IV that what mattered at such events was not the status of the person received but the representation that he had come to make. Allowances had to be made for differences in the circumstances of the embassies, such as the numbers of Frenchmen to be lodged in Madrid. Moreover, neither Haro nor his son was in a position to greet the marshal-duke at the palace entrance because, as Haro pointed out, most of his household was in Fuenterrabía. It was decided that because the marshal-duke was not of the same eminence as the Duke of Mayenne (a member of the House

[25] For Mayenne's embassy, see Luis Cabrera de Córdoba, *Relaciones de las cosas sucedidas en la córte de España, desde 1599 hasta 1614* (Madrid, 1857), 480-93; Duc de La Force, "L'Ambassade extraordinaire de Duc de Mayenne (1612): les fiançailles d'Anne d'Autriche," *Revue des Deux Mondes*, 7th ser., 14 (1923), 93-117; "Relaçion de las Capitulaçiones que se hiçieron para el Casamiento de Su Mg.d del Rey de françia con la Serenissima Infanta de Castilla . . . ," in "Sucesos del año de 1621," BNM, Mss. 2352, fols. 581-86$^v$; *Relaciones breves*, 80-84; and "Tratados varios," fols. 198-206.

of Lorraine whose father had been, in effect, King of France for four days under the Catholic League), it would suffice to have a distinguished grandee meet him instead of the *valido*. The Admiral of Castile was chosen owing to the high regard that his house enjoyed among the French. As for the change in location from the Great Hall to the Hall of Mirrors, that is easily explained: In 1612 the Hall of Mirrors did not exist, and since then the reception route through the King's Quarter had been adapted to end at the Hall of Mirrors for the visit of another extraordinary ambassador, Mustafarac.[26]

The reception of the marshal-duke was the last such event to be celebrated in the Hall of Mirrors while Philip IV lived, but after his death his widow, Mariana, maintained the practice as regent during the minority of Charles II. She also seems to have used the hall as her office because it was during those years that it came to be called the *salón del despacho* (Dispatch Hall).[27] The office in the Gilded Tower that Philip had used was at an inconvenient remove from the queen regent's apartments, whereas the Hall of Mirrors was right next to them. Carreño's state portraits of Mariana (e.g., fig. 15) show her using the chamber in that way. Modestly dressed in a nun's habit, the customary outfit of high-born Spanish widows, Mariana looks up from a writing table at which she has been conducting the affairs of state on behalf of her son.

Mariana and Charles employed the hall for three receptions of extraordinary visitors in 1668. On March 17 they granted an audience there to Piotr Ivanovich Potiemkin, an ambassador of the Russian czar, who was received in a manner patterned after the 1649 reception of Mustafarac. His route through the King's Quarter was changed, however: After mounting the monumental staircase to the main floor, he was guided along the corridor of the King's Courtyard to the Gilded Hall, down its length to the Dark Room, and from there into the South Gallery, where he proceeded along the southern flank of the palace into the Hall of Mirrors. Charles and Mariana awaited him seated on a dais beneath a dossel—probably that of Charles V—separated by a table.[28] On November

---

[26] For other ways of receiving Gramont that were considered, see José M. Pita Andrade, "Noticias en torno a Velázquez en el archivo de la Casa de Alba," in *VV*, 1:405-406.

[27] E.g., AGS, CM3, leg. 1362, Alcázar de Madrid, 1674-75, fols. 13ᵛ-13bis.

[28] Potiemkin's embassy lasted more than three months, and he returned to Madrid on another embassy in 1682. See Mijail Alekséev, *Rusia y España: una respuesta cultural*, tr. José Fernández Sánchez (Madrid, 1975), 26-29; "Clausulas del Testtamento del Senor Phelipe Quartto . . . y noticias de la Corte de Madrid desde el año 1669 hasta

7 and 20 the king and his mother received Cosimo III de' Medici, Grand Duke of Tuscany, but because he was officially traveling incognito, the audiences took place without public fanfare. On both occasions they welcomed the grand duke while standing beside a porphyry table.[29]

After attaining his majority, Charles continued to greet extraordinary visitors in the Hall of Mirrors. On December 11, 1687, he granted an audience to not one but three Russian ambassadors. (The czar, taking no chances, had provided for the mission to continue even if the first and second ambassadors had died before completing the journey from Moscow to Madrid.) Once again the reception was styled after that of Mustafarac, but the route along which the ambassadors were conducted through the Alcázar was the revised path that had been used for Potiemkin in 1668. Charles had commanded that the shorter itinerary be taken owing to the length of the old route and the difficulty of moving large numbers of persons through the suite of rooms in the west wing of the palace. At the end of the tour the ambassadors found the king waiting for them seated in the coronation throne and dossel of Charles V.[30]

The special use of the Hall of Mirrors had become so well established that it persisted after the Bourbon accession under Philip V. When Verger identified the room in the *explication* accompanying his plan of the main floor (fig. 11; L), he singled out the formal approach to it for comment: "another large hall in the far end of which will be the King's Throne, so that after having passed through the great *enfilade* [in the west wing] and entered hall I [the South Gallery], one will find this Throne the object of one's view through the two halls K [the Octagonal Room] and I."[31]

An understanding of the distinctive role that the Hall of Mirrors played in the ceremonial life of the court sheds new light on the portraits by Carreño that represent Charles II standing there (e.g., fig. 14). They are not merely likenesses of the king. They are truly state portraits because they show him performing a state duty: granting an audience to a distinguished visitor to the

1684," BNM, Mss. 2024, fols. 11ᵛ-13ᵛ; Const. Derjavin, "La primera Embajada rusa en España," *BRAH* 96 (1930), 877-96; "Epitome," fols. 812-14; and Emmanuel Galitzin, *La Russie du XVIIᵉ siècle dans ses rapports avec l'Europe* . . . (Paris, 1855), 221-26.

[29] *Viaje de Cosme de Médicis por España y Portugal (1668-*

*1669)*, ed. Angel Sánchez Rivero and Angela Mariutti de Sánchez Rivero, 2 vols. (Madrid, n.d.), 1:114-17, 123, and 136.

[30] Domínguez Ortiz, "Una embajada rusa."

[31] BNP, Cabinet des Estampes, Hd 135b.

court. To better engage the viewer's interest, Carreño has cast the spectator
in the role of the visiting dignitary. Were the visitor only an ambassador,
Charles would be shown enthroned on a dais. Instead, Carreño has posed the
king standing beside a porphyry table, thereby elevating the visitor to the
eminence of the Duke of Modena and the Grand Duke of Tuscany. In an
inventive variation on the traditional prerogative of the portraitist, Carreño
has flattered not only his subject, but the spectator as well.

## GATHERING AN ENSEMBLE: 1622-1636

The decoration of the Hall of Mirrors was not conceived and accomplished in
a single burst of activity. It evolved slowly from improvised beginnings in the
mid-1620s to a definitive installation that was achieved only in 1659. Even
then the ensemble still faced changes under Charles II and Philip V. Tracing
the history of this evolution is a vexing task, especially when considering the
1620s.[32] Early references to the decoration of the room in the financial accounts
of the royal household and in other sources are terse, fragmentary, and often
ambiguous. Moreover, the frequent delays by the Crown in paying artists and
artisans for their labors, and its practice of spreading those payments over
several installments, greatly complicate efforts to establish the chronology of
work in the room.

The scattered evidence for the early years can be drawn together coherently
by relating it to three accounts of the New Room that were written between
1626 and 1636. The first is a passage from an anonymous copy of a journal
kept by the Cavaliere Cassiano dal Pozzo, a member of the party that accom-
panied Cardinal Barberini on his legation to Madrid in 1626 (Appendix A).
On May 29 Barberini visited the Cardinal-Infante Ferdinand in his apartments
in the Alcázar (fig. 13; no. 86), and while they talked, Pozzo examined the
paintings and furnishings in the neighboring *pieza nueva*. Vicente Carducho
provides the second description in his *Diálogos de la pintura* (1633) in the course
of a review of the paintings by Titian that he had seen in the palace (Appendix

[32] In reconstructing this evolution, I have benefited
greatly from two pioneering studies of the room: Botti-
neau, "L'Inventaire de 1686," 34-47; and Harris, "Cas-
siano dal Pozzo." Some of my findings have been dupli-
cated in Mary C. Volk, "Rubens in Madrid and the
Decoration of the Salón Nuevo in the Palace," *BM* 122
(1980), 168-80, under circumstances that we have both
since commented upon—"Letters," *BM* 122 (1980), 507.

B). Neither of these sources provides a comprehensive list of the works displayed in the New Room. For the earliest complete accounting of its contents, one must turn to the third text, the inventory of 1636 (Appendix C). (Hereafter, appendix citations are by letter; thus, "A3" signifies "item 3 in Appendix A.")

Late in December 1622 the painter Domingo de Breyra collected 1,500 *reales* for gilding the cornice of the New Room—a sure sign that construction was nearing completion and that the room soon could be decorated.[33] One early idea for its adornment was set aside. In February 1625 the Italian painter Giulio Cesare Semini was paid 150 *reales* "for three drawings that he made for when it was intended to paint the new room above the main entrance."[34] Apparently it had been proposed that Semini would fresco the New Room— he had painted frescoes in the Pardo Palace for Philip III[35]—but he never carried it out. The death of Philip III in 1621 may have terminated the project. The late king had also wanted to have the new South Gallery painted with frescoes, but that plan was abandoned after the accession of Philip IV.[36] A delay in paying for Semini's drawings until 1625 would not have been unusual at the court.

Instead, the New Room was adorned with easel paintings. The initial selection consisted of pictures that were drawn from the royal collection. Four were transferred from the Pardo Palace sometime after May 18, 1623, when they were listed in an inventory of its artworks and furnishings.[37] Foremost among them was Titian's magnificent equestrian portrait of *Charles V at Mühlberg* (fig. 16; A4, B8, C1), which went on view in the New Room by or shortly after September 11, 1624, when the painter Bartolomé Saiz was paid for having gilded its frame.[38] The 1636 inventory attests that it was transferred from the Pardo expressly to hang in the New Room. The same must have been true for Titian's *Allegorical Portrait of Philip II after the Battle of Lepanto* (fig. 17; A10, B7, C6). Pozzo saw a third Titian from the Pardo, the *Religion Aided by*

[33] AGS, CM3, leg. 784, Pintores, 1622, fols. 2bis^v-3 (first cited by Azcárate, "Noticias sobre Velázquez," 360); similarly, APM, Libro de pagos, fol. 185bis^v.

[34] APM, Libro de pagos, fol. 272; similarly, AGS, CM3, leg. 784, Pintores, 1625, fols. 1^v-1bis (first cited by Azcárate, "Noticias sobre Velázquez," 360).

[35] Ceán Bermúdez, *Diccionario*, 4:366.

[36] See Chapter IV.

[37] "Ynventario de los Bienes muebles y menaxe de cassa que al Presente estan en la cassa Real del pardo para serbicio de su mag^d que son a cargo de carlos baldouin conserje de la dicha cassa," AGS, TMC, leg. 1560, fols. 2-3.

[38] APM, Libro de pagos, fol. 253^v.

*Spain* (fig. 18; A2), but by 1633 Carducho, who knew the work (B5), could not cite it as part of the New Room ensemble.[39] In like manner the fourth painting from the Pardo, Jan Sanders van Hemessen's *Cure of Folly* (fig. 19; A11), aroused Pozzo's interest, but later accounts of the room do not mention it.

Titian's works assumed a prominent role early in the evolution of the New Room. In addition to his three canvases from the Pardo, five others were brought there from within the Alcázar. Pozzo saw his *Adam and Eve* (fig. 20; A9), which in 1600 had been recorded in the sacristy of the Royal Chapel, but by 1633 (B6) it had been transferred elsewhere.[40] The *Furias*[41]—a suite of four paintings of *Ixion*, *Sisyphus*, *Tantalus*, and *Tityus* (A3, 5, 7, 8; B1-4; C2-5)—were shifted to the New Room from the adjacent Room of the *Furias*, to which they had lent their collective name. Unfortunately the authorship of the four had become the object of muddled connoisseurship that has yet to be clarified.[42] The early accounts of the New Room state that two were originals by Titian and two were copies by a Spanish painter; however, they fail to agree which two were the copies, and whereas Pozzo identifies Juan Fernández de Navarrete ("El Mudo") as the copyist, Carducho and the 1636 inventory credit Alonso Sánchez Coello. Whatever the case, the compositions of three of the *Furias* are known today. The *Sisyphus* (fig. 21) and *Tityus* (fig. 22) in the Museo del Prado are generally accepted as Titian's work. Although his *Ixion* and *Tantalus* have not survived, an engraving by Giulio Sanuto (fig. 23) preserves the appearance of the latter.

Some pictures selected for the New Room had to be repaired before they could be put on display. On December 24, 1625, Carducho, a frequent victim of the court's delays in settling its accounts with artists, was authorized to receive 34,000 *maravedís* "for extending, enlarging, and retouching" three large canvases for the New Room.[43] Two of them were Titian's *Allegorical*

---

[39] By 1636 it was in the King's Bedchamber in the *cuarto bajo del verano* (Inventory of 1636, fol. 37ᵛ).

[40] In 1636 it was in the Last Room of the *bóvedas del verano*. See *ibid.*, fol. 49bisᵛ; and Wethey, *Paintings of Titian*, 1:63.

[41] The name *Furias* in this context derives from the classical Roman *furiae*, meaning "evil men" or "criminals," not "Furies." See Wethey, *Paintings of Titian*, 3:61

n. 316.

[42] *Ibid.*, 156-60, summarizes the pertinent evidence.

[43] As it turned out, he was not paid the sum, which had to be authorized again on April 16, 1626. See AGS, CM3, leg. 1450, Pagador Juan Gómez Mangas, 1626-1635, Cargos, n.fol.; and APM, Libro de pagos, fol. 304bisᵛ. This commission was first discussed in José Moreno Villa, "Cómo son y cómo eran unos Tizianos del

*Portrait of Philip II* and his *Religion Aided by Spain*. The third, identified only as "another of the king Cyrus," was the *Queen Tomyris with the Head of Cyrus* that is cited in the 1636 inventory (C22). It has been identified as a lost, anonymous variant after the Master of Flémalle (fig. 24).[44]

The *Tomyris* was one of five pictures for which the joiner Lorenzo de Salazar made frames that Semini subsequently gilded in 1625.[45] In typically abbreviated fashion the royal accounts record Semini's assignment as one of "painting and gilding five wooden frames, one for a painting of the Birth of Our Lord that was don Rodrigo Calderón's; another for the canvas that came from Portugal that they call 'the arches'; another for the canvas that they call 'King Cyrus'; another for the Faith by the hand of Titian; and the other of Ulysses and Achilles that were to be hung in the new room of the Alcázar."

Three of these five pictures have survived. The "Faith" by Titian was the *Religion Aided by Spain*. The Nativity scene most likely was the *Adoration of the Magi* by Rubens that the city of Antwerp had given to don Rodrigo de Calderón, Marquis of Siete Iglesias, in 1612. Calderón, a protege of the Duke of Lerma during the reign of Philip III, was executed at the outset of Philip IV's regime, and the Crown acquired several objects from his estate (cf. C34-35). Rubens subsequently enlarged and repainted the canvas to its present state (fig. 25) when he visited the Spanish court in 1628 and 1629. The *Adoration* hung in the New Room for only a short time, if at all, before it was shifted to the king's summer apartments, where Pozzo saw it in June 1626.[46] The "Ulysses and Achilles" has been identified as the *Ulysses Discovers Achilles among the Daughters of Lycomedes* (fig. 26), Pozzo's piece "with five or six figures drawn from life by Rubens" (A1) that the 1636 inventory describes more fully (C15).[47] Actually it is a painting by Van Dyck that Rubens retouched. The Crown must have acquired it after May 12, 1618, the date of

Prado," *AEAA* 9 (1933), 113-16. See also Azcárate, "Noticias sobre Velázquez," 360 n. 10; and Wethey, *Paintings of Titian*, 2:132.

[44] Robert W. Berger, "Rubens's 'Queen Tomyris with the Head of Cyrus,'" *Bulletin of the Museum of Fine Arts, Boston* 77 (1979), 20.

[45] Salazar was paid on January 19 and July 25, 1625, and Semini on May 5 and August 12, 1625. APM, Libro de pagos, fols. 281, 288, and 289bis; AGS, CM3, leg.

784, Destajos, 1625, fols. 2-2ᵛ and 18bis-18bisᵛ; *id.*, Pintores, 1625, fols. 2-2ᵛ and 8-8ᵛ. Similarly in AGS: Azcárate, "Noticias sobre Velázquez," 362.

[46] Volk, "The King's Summer Apartments," 520 and 525-26; and Matías Díaz Padrón, *Museo del Prado, catálogo de pinturas. 1: Escuela flamenca, siglo XVII*, 2 vols. (Madrid, 1975), 1:226-29.

[47] Bottineau, "L'Inventaire de 1686," 42; and Harris, "Cassiano dal Pozzo," 372.

the second of two letters in which Rubens attempted to sell it to the English collector Sir Dudley Carleton.[48]

As for the two remaining pictures, the "King Cyrus" was the lost *Queen Tomyris* after the Master of Flémalle, and the picture "of the arches" must have been the *Entry of Philip III into Lisbon* described by Pozzo (A13). The arches were the temporary triumphal arches that various guilds, institutions, and colonies of foreigners erected for Philip III's entry into the city in 1619.[49] This lost picture evidently hung as a companion to a lost *Portrait of Philip III* by the *pintor del rey* Bartolomé González, who on June 8, 1626, received final payment "for a portrait which he has made by order of His Majesty of the manner that His Majesty entered the Cortes of Lisbon, on a life-size scale, with the showy costume that has been turned over to the *guardajoyas*. At present it has been hung in his gallery in the Alcázar of this town [Madrid]. It appears thus from the contract that the *maestro mayor* Juan Gómez de Mora made with the aforesaid [González] on October 25, 1620."[50] The New Room must have been the "gallery" in question because this *Philip III* appears to be the same picture as a painting of Philip III's entry into Lisbon for which, when it was put in the New Room, Salazar constructed a frame that Saiz (*not* Semini) was paid for gilding in 1624.[51]

Pozzo describes another picture illustrating an event from Philip III's reign, the *Exchange of Princesses* (A12), which occurred on November 9, 1615. On that day Isabella of Bourbon, the French bride of the future Philip IV, crossed into Spain while his sister, Anne of Austria, entered France as the bride of Louis XIII. This exchange took place on an island pavilion in the Bidasoa River on the Franco-Spanish border near Hendaye and Irún. A small boat pulled along cables conveyed each princess from her native land to the island. The two women arrived at the pavilion and continued on to their new homes simultaneously so that neither lady (nor her nation) took precedence over the other. The painting that Pozzo describes has not survived, and Giovanni de'

[48] Rubens, *Letters*, 59-63.

[49] Harris, "Cassiano dal Pozzo," 373; for Philip III's entry into Lisbon and further bibliography, see George Kubler, *Portuguese Plain Architecture: Between Spices and Diamonds* (Middletown, Conn., 1972), 106-27.

[50] APM, Libro de pagos, fol. 331bis[v]; Azcárate, "Noticias sobre Velázquez," 361 n. 12, cites similar documentation in AGS.

[51] Salazar was paid on April 16, and Saiz on September 11; see APM, Libro de pagos, fols. 237bis[v] and 253[v].

Medici, to whom he attributes it, is not known as a painter.[52] By 1636 the *Exchange of Princesses* had been moved to another setting.[53]

The initial selection of works drawn from the king's holdings for the New Room was soon joined by pictures that had been created especially for its walls. The honor of being the first artist to paint such a work fell to Velázquez, then a rising star at the court. In 1625 he carried out the *Equestrian Portrait of Philip IV*, since lost, that Pozzo remarked upon the following year (A6). Like Titian's *Charles V at Mühlberg*, which it faced, it represented its subject "in armor on horseback, as large as life" against "a beautiful landscape and sky." Although the cavalier did not know who had painted it, Velázquez is generally accepted to have been the artist. There are several early references to his having painted one or more equestrian portraits of the king during his first years at the court.[54]

Moreover, the *Philip IV* that was in the New Room is well documented. Several entries in the court accounts describe it as having been painted in the Gallery of the North Wind, where Velázquez's studio was located. On June 16, 1625, Christóbal Gómez, a *maestro de obras*, was paid for making "a wooden horse 7½ [Castilian] feet tall and 10 [Castilian] feet long [2.1 × 2.8 meters] for the portrait that was painted in the Gallery of the North Wind."[55] Evidently Velázquez used it as a model. On August 20, 1625, and April 6, 1626, Salazar received partial payments for constructing a frame for the portrait, which Semini was paid for gilding on August 22, 1625, and on March 22 and April 24, 1626.[56] The August 22 payment to Semini clinches the authorship of the *Philip IV*, for it explicitly identifies the work as "the portrait of His Majesty, whom God protect, that the painter Diego Velázquez has made." Some of these payments specify that the frame was the same size as that for Titian's *Charles V at Mühlberg*, and one entry records its stretcher dimensions as 13¼ × 11¾ Castilian feet (3.71 × 3.29 meters). The *Philip IV* was on view by December 5, 1625, when the king's locksmith, Miguel Hernández, received

---

[52] Harris, "Cassiano dal Pozzo," 373.

[53] To wit, a staircase linking the *cuarto bajo del verano* to the *bóvedas del verano* (Inventory of 1636, fol. 50bisᵛ).

[54] The various references to early equestrian portraits by Velázquez are reviewed in Harris, "Cassiano dal Pozzo," 368-71.

[55] AGS, CM3, leg. 784, Destajos, 1625, fols. 16-16ᵛ·

(cited by Volk, "The Salón Nuevo," 175).

[56] Azcárate, "Noticias sobre Velázquez," 360-62, cites documents in AGS. See also AGS, CM3, leg. 784, Pintores, 1625, fol. 9ᵛ; AGS, CM3, leg. 723, Carta de pago for March 9, 1626; and APM, Libro de pagos, fols. 292, 311, 316, and 322ᵛ.

a partial payment for tasks that included "making two large hooks and six long angle-ties [*escuadras*] for hanging the large portrait of His Majesty that was hung in the hall."[57]

That accounts for all the paintings Pozzo recalled seeing in the New Room when he wrote his journal entry for May 29, 1626. Had he visited there at the end of the year, he would have seen three recently installed pictures that were the same size as the *Philip IV* and that were painted by three artists who, like Velázquez, held the title *pintor del rey*: Carducho, Eugenio Cajés, and González. All three paintings are lost, but they are documented in the financial accounts of the Alcázar.[58] On April 6, September 4, and October 15, 1626, Salazar received payments totalling 1,020 *reales* for constructing "three pine-wood frames the size of the portrait of His Majesty on horseback in the new hall of the Alcázar of this aforesaid town [Madrid] which are for three paintings that of late are being made for the service of His Majesty and which are in the charge of the painters Vicencio Carducho, Eugenio Cajés, and Bartolomé González."

Salazar's frames were not appraised until October 15, so the pictures could not have been on view while Pozzo was in Madrid. In fact, it was not until December 31, 1626 (on the basis of an appraisal and a memorandum dated December 24), that Salazar was reimbursed 126 *reales* that he had paid twelve workers who had assisted him over twelve days "in arranging and hanging the paintings that Eugenio Cajés, Vicencio Carducho, and Bartolomé González, painters of His Majesty, made, and in changing all the pictures of the new hall."[59] By late 1626 so many paintings graced the New Room that introducing three more large ones necessitated an extensive rearrangement of the ensemble.

Cajés cited his lost painting in a petition dated September 4, 1628, that gave his "making a picture for the hall" as one reason why he should be rewarded with an appointment as usher to the bedchamber in the king's household.[60] (Because Cajés mentioned no other painting of his in the room,

---

[57] APM, Libro de pagos, fol. 305bis.

[58] The following account draws upon *ibid.*, fols. 316, 345, and 352ᵛ; Azcárate, "Noticias sobre Velázquez," 361-62, cites similar records in AGS. See also Diego Angulo Iñiguez and Alfonso E. Pérez Sánchez, *Historia de la pintura española: escuela madrileña del primer tercio del siglo XVII* (Madrid, 1969), 178 and 252; and Mary C. Volk, *Vicencio Carducho and Seventeenth Century Castilian Painting* (New York-London, 1977), 279-80.

[59] AGS, CM3, leg. 723, Carta de pago of December 31, 1626; similarly, APM, Libro de pagos, fol. 364ᵛ.

[60] Sánchez Cantón, *Los pintores de cámara*, 72-73.

the one canvas must have been the only work by him that Carducho had in mind when he described the New Room [B10].) Cajés's argument carried weight because in 1628 he still had not been paid for the picture. It was appraised at 1,000 ducats on November 3, 1631, but not until March 9, 1633, was Cajés paid for "a large picture that he painted at full cost, that is placed in the large new hall of the Alcázar of this town [Madrid] and that is the story of Agamemnon."[61]

The reference to Agamemnon and the description of the painting in the 1636 inventory (C10) make it possible to identify its subject—*Agamemnon and Chryses*, an episode from the *Iliad* (I.8-52 and 364-85). The Greek commander Agamemnon became enamored of a woman prisoner named Chryseis and refused to exchange her for a ransom offered by her father, Chryses, a priest of Apollo. The god avenged the affront to his priest by slaying Greeks until Agamemnon relented. Cajés's painting, to judge from the inventory, showed Chryses kneeling before Agamemnon while Apollo flew overhead, ominously foreshadowing the outcome of Agamemnon's selfishness.[62]

Carducho's painting (B14, C7) depicted *Scipio Africanus Addressing the Romans*, and he faced even greater difficulty in collecting payment for his work. At his death in 1638 he had received nothing for it. On August 14, 1640, the executor of his estate, his nephew Joseph Carducho, petitioned the king either to pay for or to return the picture, which (as if to add insult to injury) was no longer hanging in the New Room.[63] In 1641 the *Scipio* was finally appraised by Félix Castelo (representing Carducho's heirs) and Velázquez (representing the king), but the sum that Philip ultimately paid for it has yet to be discovered.[64]

The subject of González's picture is unknown, and it cannot have remained in the New Room very long. Neither Carducho nor the 1636 inventory men-

[61] APM, Libro de pagos, fol. 613. Similarly in AGS: Azcárate, "Algunas noticias," 49; and *id.*, "Noticias sobre Velázquez," 362 n. 15.

[62] Véronique Gérard, "Philip IV's Early Italian Commissions," *Oxford Art Journal* 5:1 (1982), 10, likewise identifies the subject as Agamemnon, Chryses, and Chryseis. Volk, "The Salón Nuevo," 176, proposes the story of Agamemnon, Achilles, and Briseis (*Iliad*, I.318-56 and XIX.238-308), but the details of that episode do not match the inventory description as closely.

[63] See AGS, CSR, leg. 310, fols. 195-95ᵛ (transcribed in Volk, *Vicencio Carducho*, 279); AGS, CSR, leg. 341, 1640, fol. 58; and Juan J. Martín González, "Sobre las relaciones entre Nardi, Carducho y Velázquez," *AEA* 31 (1958), 63.

[64] Martín González, "Sobre las relaciones," 64; and "Documentos relativos a Velázquez," in *VV*, 2: 250-51.

tions any painting by him there, and it is unlikely that he fared any better than Cajés and Carducho in being paid promptly for his effort. As late as 1689 his heirs were still being paid for pictures that he had painted for Philip III.[65]

The timing of these three simultaneous commissions may reflect a surge of professional jealousy among the king's leading artists. Carducho, Cajés, and González had been appointed *pintores del rey* by Philip III only after years of service.[66] Velázquez, on the other hand, was a full generation younger and a discovery of Philip IV, who named him a *pintor del rey* within weeks of his coming to royal attention in 1623.[67] The speed of his advancement resulted not only from his ability but also from the support of the Count-Duke of Olivares, who actively encouraged his fellow Sevillians with talent to serve at court.[68] The very location of Velázquez's studio in the Gallery of the North Wind, virtually at the point where Olivares's apartments adjoined the king's, would have struck cynical observers as proof that the artist was benefiting from favoritism.

If the older painters regarded Velázquez as a well-connected upstart, it must have infuriated them to see him win the commission for the equestrian portrait of the king for the new picture gallery. There is significant circumstantial evidence for this: His father-in-law, the painter Francisco Pacheco, recorded that an equestrian portrait of the king that Velázquez had painted had been publicly displayed in Madrid and that it had been greeted "with admiration from all the court and with envy from those who practice the art." Although Pacheco did not date the painting, he stated that one of the artist's rewards for creating it was an annuity requiring a papal dispensation that Urban VIII granted in 1626. In fact, in a letter dated October 14, 1626, Velázquez requested Cardinal Francesco Barberini to grant the dispensation.[69] Thus, the portrait could have been the one that was painted for the New Room. If it aroused the envy of other painters at the court, they might have pressed for the opportunity to submit pictures of comparable size to the en-

[65] APM, SA, leg. 5264, Contabilidad, Cuentas particulares, P-4, Pintores y doradores, 1621.

[66] Respectively in 1609, 1612, and 1617—see Angulo Iñiguez and Pérez Sánchez, *Escuela madrileña*, 105 and 203; and Diego Angulo Iñiguez, *Pintura del siglo XVII*, Ars Hispaniae, vol. 15 (Madrid, 1971), 36.

[67] "Documentos relativos," 222-23.

[68] Brown and Elliott, *Buen Retiro*, 42-44; and Pacheco, *Arte*, 1:156-57.

[69] Pacheco, *Arte*, 1:157; and Enriqueta Harris, "Velázquez and His Ecclesiastical Benefice," *BM* 123 (1981), 95-96.

semble. No artists had a better position from which to argue for such a chance than the three other *pintores del rey*.

If assuaging professional jealousies was Philip's goal in commissioning pictures from Carducho, Cajés, and González, the strategy backfired. Indeed, it would be hard to imagine a better way to aggravate the controversy. Once the three paintings were hanging, it was possible to compare works on the same monumental scale by all four painters to the king side by side. That was not necessarily to Velázquez's advantage, because there is evidence that his *Equestrian Portrait of Philip IV* was flawed. Antonio Palomino, the "Spanish Vasari," recounts that Velázquez painted an equestrian portrait of Philip IV when the king was twenty years old, invited public opinion of it, and effaced much of his work when it was "vituperated." The horse, in particular, was attacked for being "contrary to the rules of art."[70] Philip IV turned twenty on April 8, 1625, which raises the possibility that this ill-received picture was the New Room portrait, although it cannot be proved conclusively.[71] That the horse was attacked in particular is also suggestive because an artist who used a wooden model of a horse to paint the equestrian portrait for the New Room might well have had trouble rendering the king's steed accurately.

In any event, one fact is indisputable: Within a few years of its being painted, Velázquez's *Equestrian Portrait of Philip IV* was removed from the New Room and replaced with one painted by Rubens. (We shall consider the circumstances of this substitution in due course.) Compared to Rubens's treatment of the subject, *something* about Velázquez's portrait was inadequate. Whatever the flaw might have been, it surely fueled the attacks being levelled by Velázquez's critics in 1626.

Thus, the stage was set for the most celebrated artistic confrontation in seventeenth-century Spain, the competition to paint "Philip III and the Expulsion of the Moriscos." Philip IV ordered Velázquez to paint the subject in competition with his rivals in order to answer the abuse being directed against him.[72] The theme chosen by the king was his father's decision to expel from

[70] Palomino, *El museo pictórico*, 908.

[71] Part of the confusion stems from Palomino's having reiterated Pacheco's story of the reception accorded the public exhibition of an equestrian portrait of the king by Velázquez elsewhere in his life of the artist (*Ibid.*, 898).

See also n. 54 above.

[72] See Jusepe Martínez, *Discursos practicables del nobilísimo arte de la pintura*, ed. Valentin Carderera y Solano (Madrid, 1866), 117; Pacheco, *Arte*, 1:157-58; and Palomino, *El museo pictórico*, 898-99.

Spain those persons of Moorish descent who had elected to convert to Christianity after the completion of the Reconquest rather than to leave the country. By assigning a common subject to all the participants, unambiguous comparisons of their talents would be possible. Two of Velázquez's three competitors were Cajés and Carducho, but González, who died sometime in 1627, did not participate. Failing health or death might have prevented him from taking part, or, as the least talented of the *pintores del rey*, he might not have been invited to compete. Whatever the case, the fourth competitor was Angelo Nardi, who was younger than González, older than Velázquez, and evidently considered a promising contender.

As is well known, Velázquez triumphed, and as one reward for his success, his *Expulsion of the Moriscos* was installed in the New Room. Pacheco asserts that as another prize, his son-in-law was named an usher to the bedchamber, a post to which Velázquez was, in fact, appointed on March 7, 1627. Assuming that Pacheco's stated reason for the appointment was correct, that establishes a *terminus ante quem* for the competition.[73]

The short interval between the hanging of the three pictures for the New Room by Velázquez's rivals and his victory in the subsequent contest lends weight to the suggestion that the competition was decided not on the basis of full-scale works, but rather on the basis of *bocetos*—i.e., preparatory sketches in oil paint.[74] That would explain why no large-scale "Expulsion" by any of the three losers has survived—they would have had no reason to paint finished versions of their unsuccessful sketches. As for Velázquez's full-scale version of his winning composition, it was destroyed in the 1734 fire. Although one or more of the *bocetos* may yet come to light, the only known artistic testimony to the competition to have survived is a preparatory drawing by Carducho.[75]

Fortunately Palomino provides a firsthand description of Velázquez's finished picture:

[73] Pacheco, *Arte*, 1:158; and "Documentos relativos," 226. Martínez, *Discursos*, 117, says that Velázquez was named to the post after painting unspecified portraits and by virtue of being superior to earlier artists; this precedes his account of the events leading up to the competition. Palomino, *El museo pictórico*, 899, states immediately after his account of the competition that Velázquez was named to the post in 1627, but he does not explicitly assert that the victory led to the appointment. I am inclined to accept Pacheco's claim because as Velázquez's father-in-law, he was in the best position of the three to know the details of the competition.

[74] Julián Gállego, *Diego Velázquez*, Palabra Plástica, no. 2 (Madrid, 1983), 61.

[75] Madrid, Museo del Prado, cat. F.A. 716.

In the center of this picture is the lord King Philip III in armor, pointing with the baton in his hand to a host of tearful men, women, and children, who are being led by some soldiers, and in the distance several carts and a piece of seashore, with some ships for their transportation. . . .

At the right hand of the King is Spain, represented as a majestic matron, in Roman armor, seated at the foot of a building, holding a shield and darts in her right hand, and in her left, some ears of grain, and at her feet there is the following inscription in the socle:

PHILIPPO III

HISPAN. REGI CATHOL. REGUM PIENTISSIMO,

BELGICO, GERM. AFRIC. PAZIS, & IUSTITIÆ

CULTORI; PUBLICÆ QUIETIS ASSERTORI; OB

ELIMINATOS FŒLICITER MAUROS, PHILI-

PUS IV. IN MAGNIS MAXIMUS, ANIMO AD MAIORA NATO, PROPTER

ANTIQ. TANTI PARENTIS, &

PIETATIS, OBSERVANTIÆ-

QUE, ERGO TROPHŒUM

HOC ERIGIT ANNO

1627.

Velázquez finished it in the said year, as attested by his signature, which he placed on a piece of parchment that he represented on the lowest step, which reads as follows:

DIDACUS VELAZQUEZ HISPALENSIS.

PHILIP IV REGIS HISPAN.

PICTOR IPSIUSQUE IUSU, FECIT,

ANNO 1627.[76]

This accords with the briefer description of the painting in the 1636 inventory (C9). As a more impressive portrayal of the late king, Velázquez's picture may have prompted the removal from the New Room of the *Entry of Philip III into Lisbon* and González's *Portrait of Philip III*, which would explain their absence

[76] Palomino, *El museo pictórico*, 898-99; the translation is adapted with minor changes from José López-Rey, *Velázquez: A Catalogue Raisonné of His Oeuvre* (London, 1963), 150.

from Carducho's description of the room and the later inventory. Perhaps a desire to replace them prompted Philip IV's choice of subject for the artistic competition in the first place.

The king's desire to obtain new pictures for the New Room was by no means restricted to canvases by artists in residence at the court, for he also commissioned pictures from painters who were working in Italy.[77] During the period 1627-1628 his ambassador in Rome, the Count of Oñate, ordered four such paintings on his behalf. From Domenichino, Oñate commissioned a *Solomon and the Queen of Sheba* and a *Sacrifice of Isaac*. Carducho recognized Domenichino's hand when he saw the finished works in Madrid (B13), but in 1636 they were misattributed to Guido Reni (C12, 19). Only the *Sacrifice of Isaac* (fig. 27) has survived, but some sense of what the *Solomon and the Queen of Sheba* looked like is preserved in one of the artist's preparatory sketches (fig. 28), which accords with the 1636 description of the finished work.[78] Oñate also commissioned a *Hercules and Omphale* from Artemisia Gentileschi. It, too, has been lost, and its description in the 1636 inventory (C16) must suffice as a guide to its appearance. These three works were shipped to Madrid before Oñate completed his embassy to Rome in 1628. His fourth commission, for an *Abduction of Helen*, went to Guido Reni, who delayed finishing the work until after Oñate had left Rome. It was never shipped to Spain.[79]

Sometime between June 1626 and August 1629 (probably 1627) Philip ordered two more pictures through the agency of the Governor of Milan, don Gonzálo de Córdoba, who delegated the task in turn to his grand chancellor, don Antonio Ferrar. The instructions from Madrid were to "have painted in Milan by the best artists who are there, two paintings, one representing the sacrifice of Abel and his death, the other, the victory of Samson over the Philistines, with the water flowing from the ass's jawbone." It has been argued persuasively that Camillo Procaccini began these pictures and that an unknown artist completed them after Procaccini died in August 1629.[80] They were not dispatched to Madrid until July 1634, and when they were inventoried in the

[77] The following remarks on Philip's Roman and Milanese commissions are based upon Gérard, "Early Italian Commissions," 11-14.

[78] See also Richard Spear, *Domenichino*, 2 vols. (New Haven-London, 1982) 1:221-22 and 226-27.

[79] See also Carlo C. Malvasia, *The Life of Guido Reni*, tr. Catherine Enggass and Robert Enggass (University Park, Pa.-London, 1980), 81-84. The picture is now in the Louvre.

[80] The assertion by Volk, "The Salón Nuevo," 176 n. 49, that these pictures were by Rubens is groundless.

New Room in 1636 (C20, 21), they still had not been framed. Both are lost, but a drawing by Procaccini has survived that could be a preparatory study for the *Cain Slaying Abel* (fig. 29).[81]

Contemporary Flemish painting assumed a significant role in the New Room late in the 1620s when Rubens arrived at the Spanish court. Over the course of his international travels and his dealings with foreign collectors, Rubens had established useful diplomatic contacts that could be employed in negotiating an end to the ongoing war between Spain and England. At the prodding of the Infanta Isabella Clara Eugenia, Philip's aunt and the Governor of the Spanish Netherlands, the king summoned Rubens to Madrid in 1628 for consultations.[82] Pacheco records that when Rubens arrived there, he presented the king with "eight pictures of different things and sizes that are arranged in the New Room among other famous paintings."[83] That is partly confirmed by records of payments totalling 515 *reales* to Nardi on March 6, March 10, and June 26, 1629, for gilding five picture frames for paintings by Rubens. By the time of the final payment, they were on view in the New Room.[84]

The paintings that Rubens brought to Madrid have been identified convincingly with eight of the pictures that are attributed to him in the 1636 inventory:[85]

    —The *Reconciliation of Jacob and Esau* has survived (fig. 30; C8).

    —The *Gaius Mucius Scaevola before Porsenna* (C14) is lost, but the inventory description of it closely matches another version of the subject (fig. 31) that can be taken as a guide to its appearance.[86]

    —The "Boar Hunt" (C23) and the "Deer Hunt" (C24) were based upon a pair of oil sketches by Rubens (figs. 32 and 33) that appear to represent the *Hunt of Meleager and Atalanta* and a *Hunt of Diana*,

[81] See also Nancy W. Neilson, *Camillo Procaccini: Paintings and Drawings* (New York-London, 1979), 169, no. 913.

[82] On this visit and its resulting diplomatic mission, see Jonathan Brown, *Images and Ideas in Seventeenth-Century Spanish Painting*, Princeton Essays on the Arts, no. 6 (Princeton, 1978), 105-106; Gregorio Cruzada Villaamil, *Rubens diplomático español* (Madrid, 1874), 97-274; Rubens, *Letters*, 283-354; and C. V. Wedgwood, *The Political Career of Peter Paul Rubens* (London, 1975),

passim.

[83] Pacheco, *Arte*, 1:153.

[84] APM, Libro de pagos, fols. 472, 472bis, and 494bis. Azcárate, "Algunas noticias," 53, cites similar documents in AGS that corrupt "Rubens" to "Rivera," which he was rightly hesitant to accept.

[85] Harris, "Cassiano dal Pozzo," 372 n. 37.

[86] Julius S. Held, *The Oil Sketches of Peter Paul Rubens: A Critical Catalogue*, 2 vols. (Princeton, 1980), 1:384.

respectively. The available evidence suggests that Rubens collaborated with Frans Snyders on the full-scale versions of these compositions, and that a painting in Mexico City (fig. 34) may be the *Hunt of Diana* that hung in the New Room.[87]

—The *Samson Breaking the Jaws of a Lion* has survived (fig. 35; C25).[88] Its pendant, the *David Killing a Bear* (C26), is lost, but an engraving by Willem Panneels (fig. 36) preserves something of its appearance.[89] Like others of his copies after Rubens, Panneels's engraving reverses the original design. (Thus, David's left arm is the more prominent, which is uncharacteristic of the Western—and Rubens's—preference for right-handed heroes.) Were David to the left and the bear to the right, the composition would make a more balanced pendant to the *Samson*.

—The *Satyr Squeezing Grapes* (C27) is lost, but another version of it (fig. 37) preserves its appearance.[90] Its surviving pendant, the "Ceres and Two Nymphs," which more likely is meant to depict *Three Nymphs Filling the Horn of Plenty* (fig. 38; C28), is the collaborative work of Rubens and Snyders.[91]

Rubens remained in Madrid until April 1629 and won the confidence of Philip IV, who visited him almost daily in the rooms that had been given in

[87] For the oil sketches, see *ibid.*, 1:324-25 and 340-41. Their close match to the 1636 inventory descriptions should put to rest attempts to identify C23 with a Rubens *Hunt of Meleager and Atalanta* in the Prado (cat. 1662) that features none of the life-size figures or dead hunting dogs specified by the inventory. Held dates the two sketches ca. 1635, some seven years after Rubens apparently brought the full-scale pictures to Madrid; however, he noted that unlike other sketches of hunts from the 1630s, Rubens executed the pair "almost to the extent of approaching small finished paintings" (p. 325). It would appear the degree of finish has confounded the stylistic evidence for dating them. (Held's bibliography does not list Harris, "Cassiano dal Pozzo," in which it is recognized that the two hunts were among the eight pictures that Rubens brought to Madrid.)

Matías Díaz Padrón, "La Cacería de venados de Rubens para el Ochavo del Alcázar en Méjico," *AEA* 43 (1970), 131-50, identified the Mexico City picture as a "Deer Hunt" measuring an estimated 2 × 5 *varas* that was first recorded in the Octagonal Room in 1666. As I shall discuss in Chapter IV, that was the New Room *Hunt of Diana*, which was shifted to the Octagonal Room in the late 1640s. Díaz Padrón did not identify this picture with the "Deer Hunt" in the New Room in 1636 because he believed the New Room picture measured only 2 × 3 *varas*. The source for those dimensions was Cruzada Villaamil, *Rubens diplomático español*, 325-27, who had attempted to trace the "Deer Hunt" through successive inventories of the royal collection. On inspection, however, some of the links in Cruzada Villaamil's chain of citations prove too vague to support his argument.

[88] Matías Díaz Padrón, *Pedro Pablo Rubens (1577-1640): exposición homenaje* (Madrid, 1977), 92-93.

[89] Justus Müller Hofstede, "Beiträge zum zeichnerischen Werk von Rubens," *Wallraf-Richartz-Jahrbuch* 27 (1965), 353; and K. G. Boon and J. Verbeer, *Dutch and Flemish Etchings, Engravings and Woodcuts ca. 1450-1700*, vol. 15 (Amsterdam, n.d.), 109.

[90] Held, *Oil Sketches*, 1:353-54.  [91] *Ibid.*, 344-45.

the Alcázar.[92] Among the works that he painted during his stay was an *Equestrian Portrait of Philip IV*. He had undertaken it by October 19, 1628, when orders were given to provide him with any objects from the royal stables and armory that he might require for making the portrait.[93] It was successfully completed by December 2, 1628, when Rubens wrote two letters to friends reporting that the finished work had pleased the king.[94] It was installed in the New Room (C11), and there is no reason to doubt that it replaced Velázquez's *Equestrian Portrait of Philip IV* as soon as it was framed. The Rubens was lost when the Alcázar burned, but a copy of it showing Philip some years older has survived (fig. 39). Most of the latter is studio work, but some scholars have held that Velázquez painted the king's face.[95] What became of Velázquez's portrait is uncertain,[96] but this setback to his artistic standing at the court does not seem to have affected his relations with Rubens. The two became good friends, and Velázquez found in the older artist a model for his own aspirations as a courtier-artist.[97]

In the years following Rubens's visit, Philip continued to acquire pictures for the New Room. From his studio at the court of Charles I of England, Orazio Gentileschi shipped a *Finding of Moses* (fig. 40; C13) to Madrid in the care of his son, Francesco. It must have arrived there between May 8, 1633, when Francesco was provided with a letter of introduction to the English ambassador in Madrid, Sir Arthur Hopton, and October 16, 1633, when Hopton reported home, "I haue seen the peece since in a Roome of yᵉ Pallace where most of the selected peeces are."[98] By that time the king had also acquired the pendant pair of *Jael and Sisera* (C17) and *Samson and Delilah* (C18)

92 Rubens, *Letters*, 292-93.

93 Frances Huemer, *Portraits*, CRLB, pt. 19:1 (Brussels, 1977), 151 and 154 n. 2.

94 Rubens, *Letters*, 291-92. See also Pacheco, *Arte*, 1:153; and Palomino, *El museo pictórico*, 858.

95 E.g., José López-Rey, "A Head of Philip IV by Velázquez in a Rubens Allegorical Composition," *GBA*, 6th ser., 53 (1959), 35-44, asserts Velázquez's participation in the copy; but Huemer, *Portraits*, 1:154, demurs.

96 In 1686 an unframed equestrian portrait of Philip IV in armor that was estimated to measure 5 × 3½ varas (4.2 × 2.9 meters) was recorded in the apartment of the *aposentador de palacio* in the Casa del Tesoro (Bottineau, "L'Inventaire de 1686," 474). Perhaps it was the picture from the New Room.

97 Brown, *Images and Ideas*, 104-106.

98 On November 18, 1633, Philip authorized a payment of 900 ducats to Gentileschi for the picture. See R. Ward Bissell, *Orazio Gentileschi and the Poetic Tradition in Caravaggesque Painting* (University Park, Pa.-London, 1981), 189; Bottineau, "L'Inventaire de 1686," 43-44; Enriqueta Harris, "Orazio Gentileschi's 'Finding of Moses' in Madrid," *BM* 109 (1967), 86-89; and Alfonso E. Pérez Sánchez, *Pintura italiana del s. XVII en España* (Madrid, 1965), 501-502.

by Jusepe de Ribera. Because Carducho lists Ribera among the artists represented in the New Room (B12), the pendants had to have been what Carducho had in mind when he published the *Diálogos de la pintura* in 1633.[99] Neither has survived, but a drawing of *Samson and Delilah* (fig. 41) by Ribera is probably a preparatory study for the painting.[100]

From Flanders the Marquis of Leganés brought two more pictures that entered the New Room sometime after his return to Madrid on January 29, 1635.[101] One, a *Cardinal-Infante Ferdinand* by Van Dyck, has survived (fig. 42; C29). It depicts the king's brother as he dressed for his entry into Brussels on November 4, 1634.[102] The other, now lost, was an anonymous *Battle of Nördlingen* (C30) that illustrated one of Ferdinand's greatest military victories.

Compared to the acquisition of paintings for the New Room, much less is known of the manner in which other furnishings were obtained for it during these years. Most of the available information comes from the 1636 inventory, which lists two unmatched mirrors (C31, 32) and six different marble tables (C33-38). Two of the tables (C34, 35) were acquired from the Calderón estate, and another (C33) was the gift of the nuncio Massimi that Pozzo had described at length in 1626 (A14). As the only table to be specifically identified in 1636 as Florentine, the latter was most likely the one that Philip stood beside when he received the Duke of Modena in 1638. The fate of the Japanese screen that Pozzo remarked upon (A15) is not recorded.

By 1636 the Crown had gathered a formidable ensemble of paintings augmented by handsome furnishings in the New Room. What had begun as an improvised grouping of pictures drawn from the royal holdings and dominated by the work of Titian had grown into an impressive showroom where

[99] For that reason I am reluctant to accept the suggestion in Volk, "The Salón Nuevo," 176 n. 50, that the two pictures might have been among twelve cartloads of paintings that the Count of Monterrey, Viceroy of Naples, sent to Madrid late in 1633. Moreover, those pictures were likely intended for the Buen Retiro; see Brown and Elliott, *Buen Retiro*, 123. Another possibility is that one of the king's agents in Naples (perhaps the viceroy) commissioned the pictures from Ribera around 1627, when the king was also ordering pictures from Rome and Milan.

[100] Priscilla E. Muller, "Contributions to the Study of Spanish Drawings," *AB* 58 (1976), 609, identifies the drawing as a study for the *Jael and Sisera*, but its action more closely accords with Samson's story (Judges 16:17-21) than Jael's (Judges 4:17-22). Furthermore, the composition is consistent with the pictorial tradition for the Samson theme; see Madlyn Kahr, "Delilah," *AB* 54 (1972), 282-99.

[101] Brown and Elliott, *Buen Retiro*, 174.

[102] Bottineau, "L'Inventaire de 1686," 35 and 307-308; and John R. Martin, *The Decorations for the Pompa Introitus Ferdinandi*, CRLB, pt. 16 (London-New York, 1972), 22.

the Venetian master was joined by leading Flemish (Rubens, Van Dyck, and Snyders), Italian (Domenichino, and Artemisia and Orazio Gentileschi), and Spanish (Velázquez, Ribera, Cajés, and Carducho) painters of the day. Hopton recognized its level of quality in 1633 when he called it the room "where most of the selected peeces are." Philip had devised a brilliant setting for receiving extraordinary visitors whom he wanted to dazzle with royal magnificence, and he inaugurated its use for that purpose in 1638. Having gathered an ensemble, his next concern would be to refine it.

### REFINING THE ENSEMBLE: 1637-1659

During the 1630s the predominant artistic enterprise of the court was the construction and decoration of the Palace of the Buen Retiro and its gardens. By the end of the decade, that project had been largely completed.[103] The Crown was then free to turn its attention once again to the Alcázar, which suffered by comparison to the lavish interiors of its new counterpart across town.[104] As a result, beginning in the later 1630s another campaign of renovations was undertaken in the king's chambers. The royal accounts for the years 1640 and 1641, in particular, are filled with references to work in the New Room, the Great Hall, the Room of the *Furias*, the Dark Room, and the South and West Galleries—all part of the King's Quarter.[105] Artisans paved floors with thousands of colored stone tiles, refaced walls with veneers of San Pablo marble, and gilded the *artesonado* ceilings in the Great Hall and the Room of the *Furias*. In addition, new paintings and furnishings were commissioned for some of the king's chambers. Because the New Room was not inventoried in 1666, the changes there must be considered with the aid of the 1686 inventory (Appendix D), keeping in mind that there was little change in the decoration of the palace during the intervening two decades.

Philip entrusted one of the first of these commissions for the New Room to the man whose work already dominated its walls. Sometime in 1639 Rubens agreed to paint four more canvases for the hall: two large pictures of *The*

---

[103] Brown and Elliott, *Buen Retiro*, 87-96 and 105-40.
[104] *Ibid.*, 105.
[105] E.g., in AGS, CM3, leg. 1461: Cargos, fols. 2-7ᵛ

passim; Destajos, fols. 3-72bis passim; Personas, fols. 1-40bis passim; and Compras, fols. 3-19bisᵛ passim and 24ᵛ-28 passim.

*Abduction of the Sabine Women* (D8) and *The Reconciliation of the Romans and the Sabines* (D9), and two smaller ones of *Perseus and Andromeda* (D12) and *Hercules and Antaeus* (D15).[106] This is one of the best documented projects for the New Room because the Cardinal-Infante Ferdinand, then Governor of the Spanish Netherlands, sent reports on Rubens's progress from Flanders to his brother, who was eager to obtain the paintings. None of Philip's letters to Ferdinand is known, but the cardinal-infante's reports attest to the keen personal interest that the king took in acquiring these and other works that he had ordered from Rubens and his associates.

The earliest reference to the commission appears in a letter that the cardinal-infante wrote September 25, 1639: "As for the four paintings that Your Majesty has ordered, Rubens is already working with great spirit at making them very handsome. As for the goal of finishing them, he has not wanted to bind himself to doing more than he is able, judging it very difficult to have it ready for when Your Majesty has ordered. And also he says that those that he and Snyders were making [another, unrelated commission for eighteen small pictures] will be somewhat late, but Your Majesty may feel secure that he will not be wanting for speed and care."[107]

Rubens's progress was delayed by attacks of the "gout" that afflicted him in his later years. On January 10, 1640, Ferdinand wrote that the disease prevented Rubens from painting, and on April 5, 1640, he advised that the artist's hands had been paralyzed for more than a month. "Nevertheless," he reported, "he is trying to recover, and with the warmer weather he may be better, for if not, it would be a great pity for these three paintings to remain so."[108] Evidently the fourth of the pictures was far advanced by then.

Warmer weather brought the desired improvement in Rubens's health, which the cardinal-infante reported on May 2, 1640: "Rubens is better from his attacks and has promised me that the large pictures and the ten small ones that are wanting will be finished by Christmas. I shall urge him as strongly

---

[106] For the following account of this commission, I have benefited greatly from discussions with John R. Martin, who first brought the rediscovery of the *Hercules and Antaeus* to my attention. For a summary of his thoughts on the commission, see his "Rubens's Last Mythological Paintings for Philip IV," *Gentse Bijdragen*

24 (1976-1978), 113-18.

[107] *Correspondance de Rubens et documents épistolaires*, tr. and ed. Max Rooses and Charles Reulens, 6 vols. (Antwerp, 1887-1909), 6:238.

[108] *Ibid.*, 247-48 and 261.

as possible now that he is in a state to work, and I shall try to shorten the deadlines, because with the work in the New Room finished already, these paintings will be greatly missed."[109]

That "work in the New Room" must have been the refacing of its walls because the royal accounts show that payments for tiles for its new floor continued for several months.[110] Between June 3 and 5, 1640, a carpenter and six laborers spent two days hanging pictures there, for which they received 52 *reales*.[111] On September 15, 1640, Semini received the second payment for, among other tasks, "making, at full cost, four canvases painted white [*dados de blancos*] to be put where the veneer is missing" in the New Room.[112] Those blank canvases may have held the places reserved for the eagerly awaited works by Rubens.

Rubens's death on May 30, 1640, dashed the optimism that Ferdinand had expressed in his letter of May 2. On June 10, 1640, he advised the king, "Rubens died ten days ago, which I assure Your Majesty has pained me very much, owing to the state that the paintings are in—one of the two large ones is almost finished, the other sketched, and the two smaller ones very advanced." Ferdinand went on to consider the need to find someone to complete the pictures, and he raised Gaspar de Crayer and an unnamed "chief assistant" [*primer oficial*] of Rubens as possibilities.[113] For a time it seemed that Van Dyck might finish the commission, but nothing came of that.[114] The cardinal-infante made other arrangements, and by February 2, 1641, he could report that three of the four pictures were in his possession.[115] They were dispatched to Madrid on March 10, 1641.[116]

Two entries in the accounts of Rubens's estate clarify how much work he had completed on each of the works. One records the receipt of 4,200 guilders that the king's agent paid on June 24, 1641, for four paintings, "which were *the peace of the Sabines*, a piece of *Andromeda*, a *Hercules*, and another sketched

---

[109] *Ibid.*, 280. The cardinal-infante gives Rubens's deadline as *Pascua*, which I have translated as "Christmas" (i.e., *Pascua de Navidad*) rather than as "Easter" because at the date of the letter (May 2), the Easter season would have been past. Given the king's urgent demands for the paintings, I think it unlikely that Ferdinand would have accepted almost a full year's additional delay. As for the ten small paintings, the other eight of the eighteen had been reported ready to ship on January 10, 1640 (*ibid.*,

247-48).

[110] See n. 105.

[111] AGS, CM3, leg. 1461, Personas, fols. 12bis^v-13, no. 31.

[112] *Ibid.*, Destajos, fols. 13^v-13bis, no. 62.

[113] *Correspondance de Rubens*, 6:304-305; Rooses speculates that the "chief assistant" was Erasmus Quellinus.

[114] *Ibid.*, 310-12.     [115] *Ibid.*, 314.

[116] *Ibid.*, 315-16.

piece."[117] (The last, of course, was the *Abduction of the Sabine Women*.) The other pertinent entry lists a 240-guilder payment by the estate to Jacob Jordaens for finishing a *Hercules* and an *Andromeda*—that is, the two smaller pictures that were "very advanced" at Rubens's death.[118] By the process of elimination, the *Reconciliation of the Romans and the Sabines* must have been the large picture that Rubens had essentially completed. There is a poignant appropriateness to that. A diplomat as well as an artist, Rubens had devoted much of his life to the pursuit of peace. "Reconciliation" was a theme to which he would have responded instinctively.

The cardinal-infante submitted his last known report on the commission on July 20, 1641, when he advised the king on the status of the *Abduction of the Sabine Women*: "The picture is very advanced, but nevertheless it cannot be finished by the end of August, for all the urging that one gives the painter, but I expect it to be very good, because as a new one, he is trying to make a reputation, and more so for having works of Rubens there [to study] [*y mas habiendo de estar allá de las de Rubens*]. Your Majesty can feel secure that I shall not fail to send it as soon as I can."[119] The artist who completed the *Abduction* has never been identified, but Ferdinand's remark that he was trying to make a reputation suggests that he was a young, unestablished painter rather than Jordaens. The cardinal-infante might have found him among those who had worked in Rubens's shop, for those were the artists best trained to complete a picture in the master's style.

Of the four paintings, the *Perseus and Andromeda* (fig. 43) and the *Hercules and Antaeus* (fig. 44) are known. Jordaens's hand is more evident in the latter, which suggests that, as with the larger pictures, Rubens had been more attracted to painting a scene that emphasized love than to painting one that emphasized violence. Both "Romans and Sabines" subjects are lost, but two oil sketches on which they probably were based have survived (figs. 45 and 46).[120]

The cardinal-infante's reports to Madrid reveal the depth of Philip's concern for the decoration of the Alcázar. To adorn the New Room to his satisfaction,

[117] "De Nalatenschap van P. P. Rubens," *Antwerpsch Archivenblad*, n.s. 2 (1900), 80-81.

[118] *Ibid.*, 136.  [119] *Correspondance de Rubens*, 6:317.

[120] Held, *Oil Sketches*, 1:380-81 n. 5. Held notes that the proportions of the sketches differ from those of the finished paintings as given in the royal inventories. I shall account for this seeming discrepancy below.

the king was prepared to order paintings from the most celebrated artist in Europe and to have them shipped to Spain from Antwerp. The cardinal-infante, who as Governor of the Spanish Netherlands was fighting a war with the United Provinces, had to take the time to monitor Rubens's progress and repeatedly to assure his impatient brother that the work was proceeding with all possible speed. It is telling that when Rubens died, Ferdinand wrote that it disturbed him greatly because of the state in which the pictures had been left.

Another enterprise in Philip's campaign to refine the New Room was to regularize the furniture there. In 1636 the hall had contained two unmatched mirrors and six tables, each built to a different design. These were replaced in the early 1640s by new sets of furnishings whose uniformity enhanced the overall harmony of the ensemble. In May 1640 work began on tables for the New Room with tops of San Pablo marble and legs of San Pablo jasper inlaid with Tortosa jasper. Juan Rodríguez designed models for the table legs, and like the table tops, they were executed by the marble workers Bartolomé Zumbigo and Juan Francisco Hermano. Although the royal accounts are ambiguous, there seem to have been six tables in all. Payments for the work continued through the end of 1641, with a few later ones not issued until 1644. The project must have been nearing completion by June 19, 1641, when a payment was authorized to compensate Francisco de Mena, a *maestro de obras*, for removing tables from the New Room—presumably the old ones that had been inventoried there in 1636.[121]

Another product of the early 1640s was the set of eight eagle-frame mirrors (D44-51) that gave the New Room its later name, the Hall of Mirrors. Antonio de Herrera, the king's *escultor de cámara* (sculptor to the bedchamber), made the model for the bronze eagles, for which he was paid in October 1640. The founder and bell-maker Pedro de la Sota carried out the actual casting of the eagles, for which he received an initial payment in August 1641. The ebony-worker Juan Emberg made the ebony frames for the mirrors, for which he was paid in 1643, and the task of assembling the mirrors fell to the master joiner Juan de Chapestua, who collected payments in 1643 and 1644. It appears that

---

[121] For financial records of this project, see the following in AGS, CM3, leg. 1461: Destajos, fols. 2bis-58 passim, 99bis-99bis$^v$, no. 447, and 111bis-11bis$^v$, no. 500; Personas, fols. 12bis-21bis$^v$ passim; and, less certainly, Compras, fols. 59bis-59bis$^v$.

the mirrors were ready to install in the New Room by the mid-1640s.[122] None of them has survived, but many of Carreño's state portraits (e.g., figs. 14 and 15) document their appearance.

It was also during the 1640s that Velázquez emerged as an increasingly influential figure in arranging the decoration of the Alcázar. On June 9, 1643, Philip appointed him *superintendente de las obras particulares* (superintendent of special projects), to work under the Marquis of Malpica, the *superintendente de las obras del palacio* (superintendent of the palace works).[123] On January 10, 1644, Velázquez was issued 1,500 *reales* that he was to distribute to pay for a wooden door for one of the king's bedrooms and for some picture frames to be used at the Pardo Palace.[124] Early in 1647 he was appointed first *veedor* and then *veedor y contador* (overseer and accountant) of the works in the Octagonal Room, which was then under construction.[125] Also that year he became involved in negotiating a settlement between the Crown and Sota for moneys that were due the founder for such projects as the eagle-frame mirrors.[126] Velázquez's advancement continued on March 8, 1652, when he became the *aposentador de palacio*—the official who supervised the *furriera*, the bureau that maintained the Alcázar's furnishings.[127] Apparently as an adjunct to that post he assumed the responsibility for the king's art collection as well. Five marginal notations on the inventory of 1636 (three of them dated June 10, 12, and 22, 1652) indicate that some paintings as well as some furnishings were handed over to him for unspecified purposes.[128] On June 20, 1652, he prepared a memorandum listing the quantities of fabric that were needed to make curtains for several chambers, among them the Hall of Mirrors, the Octagonal Room, and the South Gallery.[129] Thus, by 1652 he was intimately involved in the decoration of the King's Quarter.

[122] Azcárate, "Noticias sobre Velázquez," 379-80, first cited some of the documentation for this project in AGS. See AGS, CM3, leg. 1461, Destajos, fols. 54bis-54bis^v, no. 247; 72bis-72bis^v, no. 320; 73^v, no. 323; 78bis^v-79, no. 346; 92, no. 412; and 105bis, no. 474. Also AGS, CM3, leg. 756, Extraordinario, fols. 25bis-25bis^v, no. 83, and 28, no. 91; AGS, CM3, leg. 1373, Alcázar de Madrid, fols. 60-60^v; AGS, CM3, leg. 2825(1), Receta de Pagaduría, fols. 9bis-10bis; and APM, SA, Inmuebles, leg. 710, 1645, 1646, 1648, and 1649.

[123] For related documents see Azcárate, "Noticias sobre Velázquez," 366-67; "Documentos relativos," 253-54;

and Iñiguez Almech, "La Casa del Tesoro," 662.

[124] AGS, CM3, leg. 1461, Destajos, fols. 96bis-96bis^v, no. 435.

[125] For related documents, see Azcárate, "Noticias sobre Velázquez," 368-70; "Documentos relativos," 259-60; and Iñiguez Almech, "La Casa del Tesoro," 662.

[126] APM, SA, Inmuebles, leg. 710, 1648 and 1649.

[127] "Documentos relativos," 279-80.

[128] Inventory of 1636, fols. 1, 11^v, 16bis, 22bis^v, and 23bis^v.

[129] Iñiguez Almech, "La Casa del Tesoro," 677.

Prior to his appointment as *aposentador* Velázquez had made his second trip to Italy (1649-1651), in part to acquire paintings and sculptures with which to decorate the Alcázar.[130] Among the objects that he commissioned in Rome were twelve gilded bronze lions to be used as supports for six porphyry tables in the Hall of Mirrors (D32-37). Eleven of the twelve have survived (e.g., fig. 47).[131] They are believed to have been designed by Giuliano Finelli in consultation with Velázquez, and to have been cast by Matteo Bonarelli de Lucca, an assistant of Bernini whose name appears on one lion's tail in an inscription dated 1651. The lions were shipped to Spain and reached Madrid by July 17, 1652, when Velázquez, in his new capacity as *aposentador*, authorized an expenditure of six *reales* to provide "a refreshment to the sweepers [*barrenderos*] who helped move the stone table tops in order to install the lions." Two symmetrically disposed lions carried each table, and each lion rested a forepaw on a marble ball.[132]

The apparent inspiration for the table supports was another set of twelve lions that had been destroyed a few years before. On November 30, 1634, Jerónimo de Villanueva, the prothonotary of the Crown of Aragon, had commissioned twelve large silver lions to decorate the Hall of Realms, an important ceremonial chamber in the Palace of the Buen Retiro. Each was a lion rampant that held a torch in its right forepaw and the arms of Aragon in its left. All twelve were melted along with the rest of the silver in the Buen Retiro in 1643 in order to finance the continuing war with France.[133] The memory of that set may have prompted Philip and Velázquez to order a new ensemble of lions made of less costly materials. Moreover, the use of these lions to support porphyry tables suggests that the marble and jasper tables constructed in the early 1640s had failed to satisfy the king.

[130] The best study of his acquisitions, on which much of the following account is based, is Harris, "La misión de Velázquez."

[131] Four are in the Throne Room of the Palacio Real, Madrid; the other seven and a copy made in 1837 are in the Prado (*Ibid.*, 116-17 n. 23).

[132] *Ibid.*, 135-36, quotes a letter of June 29, 1651, in which Philip instructs his ambassador in Rome "that Giuliano Finelli [should] perfect the cornucopias that are to serve as candlesticks [*hacheros*] for the lions, and the form [of them should be] in conformity with the way Diego Velázquez left them when they were begun." Nothing more is known of these candlesticks, which do not appear in any of Carreño's state portraits set in the Hall of Mirrors. AGS, CM3, leg. 1362, Alcázar de Madrid, 1674-75, fols. 13ᵛ-13bis, seems to record a payment on February 15, 1675, for socles of San Pablo marble for the lions (cf. fig. 14).

[133] Brown and Elliott, *Buen Retiro*, 110-11; see also María L. Caturla, *Pinturas, frondas y fuentes del Buen Retiro* (Madrid, 1947), 32.

The lion-supported tables and the eagle-frame mirrors were among the furnishings in the Alcázar that a contemporary witness cited in the late 1650s when he praised Velázquez's accomplishments as a decorator:

> And at present, owing to his painstaking vigilance, solicitude, excellent aptitude, and work, the Palace is so ennobled and aggrandized that it augments the number of wonders of the world. No one doubts that there is no Prince in all the earth who has his Alcázar adorned with such precious and admirable paintings and statues of bronze and of marble, nor such rare [*curiosas*], showy, and lavish furnishings [*margin*: Such as porphyry tables on bronze, fire-gilded lions, and opulent mirrors adorned with bronze imperial eagles likewise gilded] that can compete with those of this one . . .[134]

Velázquez even played a role in acquiring the six porphyry urns (D38-43) that stood atop the tables. When Juan de Córdova, an agent in Rome of the Count of Oñate, then Viceroy of Naples, wrote to the court to describe four different pairs of large porphyry vases that were available for purchase, he sent four drawings of them to Velázquez. The *aposentador* must have recommended them to the king because on December 23, 1652, Philip instructed Oñate to acquire them and to ship them to Madrid as soon as possible.[135] Inasmuch as only ten porphyry urns were inventoried in all the king's chambers in 1686, it is likely that six of the eight went to the Hall of Mirrors.[136]

Yet another task that Velázquez undertook during his second Italian trip was to recruit a fresco painter. Until then fresco painting had languished as a technique of palace decoration under Philip IV. The one notable venture in mural decoration within the Alcázar earlier in his reign had resulted in a fiasco. In 1641 and 1642 Francisco Camilo had painted the ceiling of the West Gallery (fig. 6; corridor 10), probably in oil, with more than fourteen scenes from the *Metamorphoses*, but the sweet and pious temper of his work was unsuited

[134] Lázaro Díaz del Valle, "Epílogo y nomenclatura de algunos artífices: Apuntes varios: 1656-1659," in *Fuentes literarias para la historia del arte español*, ed. Francisco J. Sánchez Cantón (Madrid, 1933), 2:348-49.

[135] Pita Andrade, "Noticias," 404-405.

[136] Inventory of 1686, n.fol. (prefatory summary not transcribed in Bottineau, "L'Inventaire de 1686"). Pita Andrade, "Noticias," 404-405, suggests that five porphyry urns in the Prado belonged to the original eight; in fact, one such urn bears a striking resemblance to the urn in Carreño's *Charles II* (fig. 14).

to Ovid's lusty subjects. Camilo's Jupiter, the king complained, looked like Christ, and his Juno resembled the Virgin Mary.[137] Fresco painters like Carducho and his circle worked in an old-fashioned Italianate style, and the king's principal artist, Velázquez, disliked the physical demands and the technical restrictions that the medium imposed on its practitioners.[138] Faced with this deplorable situation at home, Philip had no recourse but to look abroad for a competent, up-to-date master of fresco painting.

The king's first choice, Pietro da Cortona, declined the royal invitation, and Velázquez eventually persuaded a team of Bolognese *quadratura* specialists, Agostino Mitelli and Angelo Michele Colonna, to come to Spain.[139] They delayed their journey until 1658, but once there, they carried out a variety of commissions for the Crown.[140] Most have since been destroyed, but a *boceto* for a ceiling that they painted in a loggia at the Buen Retiro (fig. 48) conveys a sense of their Spanish work.[141] It amply demonstrates their capacity to create the illusion of elaborate, monumental architecture that towers above the spectator and extends the height of a room.

One of Colonna and Mitelli's most important projects was to fresco the ceiling of the Hall of Mirrors with scenes from the myth of Pandora, which they carried out under Velázquez's supervision with the aid of Carreño and Francisco Rizi. Their work was destroyed in the 1734 fire, and no copy of it exists. Palomino, however, describes the creation and appearance of the fresco at length (Appendix E).[142] In brief, beginning about April 1659, the four artists decorated the ceiling in accordance with a general scheme that Velázquez had worked out. Five episodes from Pandora's story were illustrated. The first,

---

[137] See AGS, CM3, leg. 1461, Destajos, fols. 37bis, no. 165; 46bis$^v$, no. 213; 51-51$^v$, no. 232; 56bis, no. 254; 59, no. 264; 60-60$^v$, no. 269; and 66bis, no. 295 (this and other documentation in AGS first cited by Azcárate, "Algunas noticias," 44-45). See also AGS, CSR, leg. 310, fol. 372; Palomino, *El museo pictórico*, 971; Marqués del Saltillo, "Artistas madrileños 1592-1850," *BSEE* 57 (1953), 179-80; and Edward J. Sullivan, "Claudio Coello and Late Baroque Painting in Madrid" (Ph.D. diss., New York University, 1979), 22-23.

[138] For Velázquez's dislike of fresco painting, see Martínez, *Discursos*, 119-20.

[139] See Harris, "La misión de Velázquez," 111-12 and 132, for the following remarks.

[140] For their work in Spain, see *id.*, "Angelo Michele Colonna y la decoración de San Antonio de los Portugueses," *AEA* 34 (1961), 101-105; Ebria Feinblatt, "A 'Boceto' by Colonna-Mitelli in the Prado," *BM* 107 (1965), 349-57; and Sullivan, "Claudio Coello," 8-10.

[141] Feinblatt, "A 'Boceto.' "

[142] A Carreño drawing in the Real Academia de Bellas Artes de San Fernando, Madrid, is sometimes proposed to be a study for one of the scenes that Carreño painted on the ceiling (e.g., Enriqueta Harris, *Velázquez* [Ithaca, N.Y., 1982], 156 and fig. 163). I am reluctant to endorse this suggestion because the presence of Mercury in the drawing is not accounted for by Palomino's description of the fresco.

rendered by Carreño, featured Vulcan showing Jupiter the statue of a beautiful woman that he had created at Jupiter's command and that was to be brought to life as Pandora. Mitelli painted the second scene, which occupied an oval field at the center of the slightly concave ceiling. It depicted the Olympian gods enthroned on clouds as they endowed Pandora with qualities that would enrich and perfect her. Rizi painted the third episode, in which Jupiter presented Pandora with a golden vessel containing her dowry and counseled her to seek Prometheus as a prospective husband. Elsewhere on the ceiling Rizi showed Pandora offering the vessel to Prometheus, who responded prudently by spurning her advances. The fifth scene, which Carreño carried to an advanced stage before he fell ill, leaving Rizi to complete it, depicted Pandora's marriage to Prometheus' younger, less cautious brother, Epimetheus. Carreño repainted this scene in oils some years later when rain damage necessitated repairs to the fresco.[143] Rizi also painted golden shields bearing unspecified stories in the four corners of the ceiling. Mitelli's contribution consisted of an elaborate architectural framework for these scenes ornamented with an abundant display of figures and decorative embellishments.

The narrative that Palomino recounts follows the "modern" version of the Pandora myth that originated with Erasmus of Rotterdam. It has been noted that single representations of Pandora's story were uncommon, that series portraying it were rare, and that the fresco in the Hall of Mirrors was all the more remarkable because it lacked the climactic scene of Pandora opening her vessel and releasing into the world her baleful dowry—namely, all the evils that afflict mankind.[144] Any attempt to discover a program that informed the decoration of the hall will have to explain why the myth of Pandora was chosen for the ceiling and why its crucial episode was omitted.

Palomino reports that the royal family displayed considerable interest in the ceiling as the work proceeded: "The King went up every day, and sometimes the Queen our lady Doña Mariana of Austria and the Infantas went to see how the work was progressing" (Appendix E). When he says that Philip "went up" (*subía*), he probably refers to the ascent to the main floor from the king's

---

[143] The presence of scaffolding in the Hall of Mirrors in 1673, which would have been required for Carreño's repairs (see Appendix E), is documented in AGS, CM3, leg. 1362, Alcázar de Madrid, 1671-1673, fols. 23-23ᵛ.

[144] For all these points, see the indispensable study of Pandora iconography, Dora Panofsky and Erwin Panofsky, *Pandora's Box: The Changing Aspects of a Mythical Symbol*, rev. edn. (Princeton, 1962), 15-17 and 162.

summer apartments. On at least one occasion, however, the king actually mounted a scaffolding to examine a fresco project. In 1658 Colonna and Mitelli painted the ceilings of three successive rooms in the *cuarto bajo del verano* with scenes of *Night*, *Aurora*, and the *Fall of Phaethon*.[145] In the third chamber laborers participated from October 7 to 20, 1658, in "the work on the scaffolds in the Dispatch Room in the *cuarto [bajo] del verano* that faces the [Garden of the] Prioress in order to paint the flat ceiling, and on a staircase that was made so that His Majesty could ascend to see the painting of it."[146] Philip was so keenly interested in the *quadratura* technique that, in the manner of Pope Julius II supervising Michelangelo's work in the Sistine Chapel, he inspected Colonna and Mitelli's efforts at the closest quarters possible.

If Philip also mounted the scaffolding that was erected for the fresco-painting team in the Hall of Mirrors, he did so at no little risk because the ceiling was two stories high. One of Verger's sections of the Alcázar's interior depicts the file of rooms along the south flank of the King's Quarter that overlooked the Plaza de Palacio (fig. 54). At the left end is the Hall of Mirrors (L) with two stories of windows in its south wall.[147] The section indicates the slight concavity of the ceiling and shows a molding surrounding the central picture space that Colonna filled with gods and goddesses bestowing their gifts upon Pandora.

Other changes wrought in the hall after 1636 may be considered with reference to the 1686 inventory. Comparing it to the earlier inventory of the room, one finds that Titian's *Charles V at Mühlberg* (D1) and his *Allegorical Portrait of Philip II* (D7) had remained there, as had the *Furias* (D3-6), all of which were ascribed to the Venetian master. Also on hand were Velázquez's *Philip III and the Expulsion of the Moriscos* (D11) and Ribera's *Jael and Sisera* (D26) and *Samson and Delilah* (D27). Of the ten paintings from 1636 with which Rubens was associated, six were still present: the *Equestrian Portrait of*

---

[145] The 1686 inventory (Bottineau, "L'Inventaire de 1686," 293-96) gives the sequence as *Night*, *Aurora*, and *Apollo*, as does the 1700 inventory (*Inventarios reales*, 1: 42-45). Colonna himself later listed the subjects as *The Fall of Phaethon*, *Aurora*, and *Night* (Feinblatt, "A 'Boceto,' " p. 349). Evidently the inventory-takers mistook Phaethon for his father Apollo. Palomino, *El museo pictórico*, 922, gives the subjects as *Day*, *Night*, and *The Fall*

*of Phaethon*; his "Day" must have been the *Aurora*.

[146] AGS, CM3, leg. 2995(2), Pagador Francisco de Arce, Alcázar de Madrid, 1657-1659, fols. 49bis-49bis^v.

[147] Figure 54 distorts the left end of the Hall of Mirrors because when Verger's section was photographed, it was allowed to curve into the gutter of the album in which it is kept.

*Philip IV* (D2), the *Reconciliation of Jacob and Esau* (D10), the *Gaius Mucius Scaevola before Porsenna* (D13), the *Ulysses Discovers Achilles among the Daughters of Lycomedes* (D14), the *Satyr Squeezing Grapes* (D24), and the *Three Nymphs Filling the Horn of Plenty* (D25). They had been joined by the four paintings from Rubens's last days: the *Abduction of the Sabines* (D8), the *Reconciliation of the Romans and the Sabines* (D9), the *Perseus and Andromeda* (D12), and the *Hercules and Antaeus* (D15).

The status of Orazio Gentileschi's *Finding of Moses* after 1636 is problematic. The 1686 inventory lists a painting of that subject in the hall but attributes it to Paolo Veronese (D22). Scholarly opinion has divided over whether that misidentifies Gentileschi's picture or describes a lost Veronese that replaced it. On the one hand, Gentileschi's painting has an obvious affinity with Veronese's style that could have inspired a misattribution. (In fact, an eighteenth-century reproductive engraving of it ascribes the composition to Veronese.)[148] Moreover, the estimated measurements given in the inventory, 3 × 4 *varas* (2.51 × 3.34 meters), are reasonably close to the actual dimensions of Gentileschi's canvas (2.42 × 2.81 meters).[149] On the other hand, in 1674 and 1700 a *Finding of Moses* attributed to Artemisia Gentileschi was inventoried in the Pardo Palace, and it has been argued that it was really Orazio's painting.[150] The matter admits no definitive resolution. It is quite possible that Orazio's picture remained in the Hall of Mirrors and that the Pardo painting was a different work, since lost; but it is just as plausible that sometime between 1636 and 1674 the Crown acquired a *Finding of Moses* by Veronese, installed it in the Hall of Mirrors, and transferred Orazio's canvas to the Pardo.[151]

Of the eleven paintings listed in 1686 that have yet to be considered, seven

---

[148] Museo del Prado, *Pintura italiana del siglo XVII: exposición conmemorativa del ciento cincuenta aniversario de la fundación del Museo del Prado* [catalogue by Alfonso E. Pérez Sánchez] (Madrid, 1970), 282.

[149] Bottineau, "L'Inventaire de 1686," 307-308, assigns the picture to Gentileschi.

[150] Bissell, *Orazio Gentileschi*, 189; *Inventarios reales*, 2:139; Museo del Prado, *Pintura italiana*, 282; and Pérez Sánchez, *Pintura italiana*, 501-502.

[151] Information concerning the other pictures that had been in the New Room in 1636 is fragmentary. Car-

ducho's *Scipio Africanus* had been removed before August 14, 1640, when his nephew wrote that it no longer hung there (see n. 63). In 1700 it and Cajés's *Agamemnon and Chryses* were in the Pardo Palace (*Inventarios reales*, 2:137). Rubens and Snyders's *Hunt of Meleager and Atalanta* and *Hunt of Diana* were moved to the Octagonal Room, probably in the late 1640s (see Chapter IV). By 1666 Van Dyck's *Cardinal-Infante Ferdinand* was in the *bóvedas del verano* (Bottineau, "L'Inventaire de 1686," 307-308). The dates of transfer and immediate destinations of Domenichino's *Sacrifice of Isaac* and *Solomon and the Queen of Sheba*,

are attributed to Italian artists. Four Tintorettos hung over the mirrors (D16-19), and two of them are known: the *Judith and Holofernes* (fig. 49; D17) and the "Abduction of Helen" that is now identified as a *Battle of Christians and Turks* (fig. 50; D16).[152] The latter was one of the comparatively few paintings in the King's Quarter to be moved between 1666 and 1686. The 1666 inventory lists it in the Gallery of the North Wind ("Another measuring four *varas* in length and two and one-half in width, by the hand of Tintoretto, the abduction of Helen"), and a marginal notation by another hand adds, "It passed to the apartment of His Majesty, and a myth of Venus by Tintoretto was brought in its place."[153] The simplest explanation, although unverifiable, is that the *Myth of Venus* had been in the Hall of Mirrors and that the two pictures were exchanged. An "Abduction of Helen" (or a *Battle of Christians and Turks*) might have better suited the ensemble than the *Myth of Venus*, or the object might have been to reduce the number of Venus subjects in a room that also contained two "Venus and Adonis" scenes (D19, 30). There is no evidence that Tintoretto's *Judith and Holofernes* or his lost *Pyramus and Thisbe* (D18) and *Venus and Adonis* (D19) were moved between 1666 and 1686.

Two of the three remaining Italian works are attributed to Veronese. The *Christ Child among the Doctors* (fig. 51; D20) is rightly assigned to him, but no judgment can be made about the *Jacob Waters Rachel's Flock* (D23), which is lost.[154] The other Italian picture, the *Forge of Vulcan* ascribed simply to "Bassano," is a Bassano workshop piece (fig. 52; D21).[155] The presence of Venus and Cupid at the forge could mean that the precise subject of the painting was intended to be either "Venus Seeks Arms for Aeneas" or "Vulcan and the Cyclopes Forging Cupid's Arrows."

The final four paintings (D28-31) are also mythological subjects, and all

Procaccini's *Cain Slaying Abel* and *Samson*, Rubens' *Samson and David*, the *Queen Tomyris* after the Master of Flémalle, and the anonymous *Battle of Nördlingen* are unknown.

[152] Bottineau, "L'Inventaire de 1686," 43.

[153] Inventory of 1666, fol. 35ᵛ.

[154] Bottineau, "L'Inventaire de 1686," 43. Theodore Crombie, "*Jacob and Rachel at the Well* by Veronese: A Newly Discovered Painting," *Apollo* 96 (1972), 111-15, attributes a painting of the Jacob story in a London private collection to Veronese. Its dimensions (1.55 × 1.75 meters) are too small for it to have been the painting that hung in the Hall of Mirrors, but it is possible that the Alcázar picture was a variant of the London composition. Unfortunately, the 1686 inventory description is so terse that the matter cannot be resolved with certainty.

[155] Bottineau, "L'Inventaire de 1686," 43, correctly identified this picture with a painting in the holdings of the Prado. It is now on deposit in Barcelona—see also Pérez Sánchez, *Pintura italiana*, 552; and Santiago Alcolea et al., *Pinturas de la Universidad de Barcelona: catálogo* (Barcelona, n.d.), 136-37.

are attributed to Velázquez: *Apollo and Marsyas, Mercury and Argus, Venus and Adonis*, and *Cupid and Psyche*. Only the *Mercury and Argus* (fig. 53) survived the 1734 fire.[156] It has generally been dated to 1659 on the grounds of style and the fact that other decorative work in the hall (the ceiling fresco) was carried out that year under Velázquez's direction. One can readily imagine the king and his *aposentador* wanting to have the hall looking its best before the arrival of the Marshal-Duke of Gramont in October of that year.

After 1659 there would have been little impetus for continuing work in the Hall of Mirrors. Velázquez died in 1660, and Philip IV in 1665. His successor, the feeble Charles II, lacked his father's ambitious enthusiasm for the arts, as well as the money to collect on so grand a scale. Only a few subsequent changes in the hall are recorded. Between 1666 and 1686, as already noted, Tintoretto's *Myth of Venus* or some other, unknown painting was replaced by the *Battle of Christians and Turks*. In 1694 Charles sent the *Reconciliation of Jacob and Esau* to his brother-in-law, Johann-Wilhelm of Neuberg, and by 1700 an *Equestrian Portrait of Charles II* by Luca Giordano had taken its place.[157] The portrait has not survived, but it is recorded in the 1700 inventory, along with all the other paintings that were listed in the hall in 1686.[158] The *Hercules and Antaeus* left Spain sometime between 1700 and 1727, when the tenth Earl of Derby acquired it from a Mr. Winstanley, but the exact circumstances of its removal are unknown.[159] No other change in the painted decoration during the reign of Philip V has come to light.

A few furnishings were added to the hall during Charles II's reign. An account of the room in 1687 specifies that an elaborate clock usually stood in the center of the room atop a square table made from ebony, mahogany, and inlaid stones. (It would be removed for events such as ambassadorial receptions.)[160] The clock and table were not there, however, when the 1700 inventory was compiled. Besides the furnishings that had been listed there in 1686, the later inventory records the addition of an ebony case containing a sculpted *Judgment of Solomon*, five clocks and their cases, two tables with inlaid designs, and two ornamental bronze andirons.[161]

[156] Bottineau, "L'Inventaire de 1686," 44-45.

[157] *Ibid.*, 41.    [158] *Inventarios reales*, 1, 18-20.

[159] Ludwig Burchard and R.-A. d'Hulst, *Rubens Drawings*, 2 vols. (Brussels, 1963), 1:296-97.

[160] See Domínguez Ortiz, "Una embajada rusa," 178-79, for a detailed description of the clock and table.

[161] *Inventarios reales*, 1:129-31.

Thus, by 1659 the decoration of the Hall of Mirrors had evolved to what may be considered its definitive installation. Subsequent changes did not alter the fundamental character of the room. Since 1636 Philip IV and Velázquez had been concerned with refining the already impressive ensemble that had been gathered there. The furnishings were made both more elaborate and more uniform, some pictures were culled, and other canvases replaced them. Rubens remained one of the dominant artistic presences, but the impact of his works was balanced by an increase in Venetian Old Masters, the new contributions of Velázquez, and the breathtaking illusionism of the ceiling fresco.

### THE INSTALLATION OF 1659: A RECONSTRUCTION

Because the Hall of Mirrors changed so little during the reign of Charles II, it is possible to reconstruct the definitive arrangement of the decoration seen by the Marshal-Duke of Gramont when he visited the Alcázar in 1659. By carefully examining Carreño's state portraits of Charles and Mariana, the language of the palace inventories, and the valuable accounts of visitors to the room, we can re-create something of its visual splendor in the mind's eye. (Diagrams 1 and 2 show the reconstruction that is advanced in the following pages.)

The furnishings provide a good starting point. An anonymous witness to the reception of three Russian ambassadors in 1687 records that the eight eagle-frame mirrors hung in four pairs on the east and west walls above four of the lion-supported tables, and that the two other tables stood against the south wall between the windows.[162] Carreño's state portraits confirm this. Behind the queen regent in his Prado *Mariana of Austria* (fig. 15) a pair of mirrors hangs above one of the six tables. Another, wider version of this composition in the Real Academia de Bellas Artes de San Fernando, Madrid (fig. 55) shows the left-most wing of a second pair of eagle-frame mirrors above another table in the right background. The breaks in the walls behind Mariana in both portraits correspond to the doorways and niche indicated in the northeast corner of the room as it is charted on the Justi plan (fig. 10).[163] These details are more easily apprehended from an anonymous drawing after Carreño's

---

[162] Dómínguez Ortiz, "Una embajada rusa," 178.          [163] Iñiguez Almech, "La Casa del Tesoro," 679.

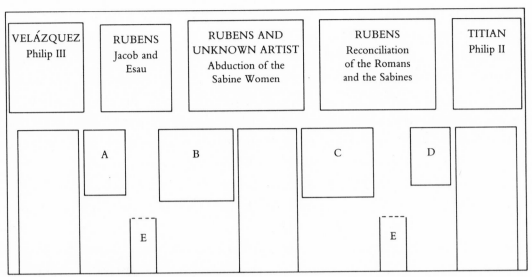

A—RUBENS and JORDAENS, Perseus and Andromeda
B—RUBENS, Gaius Mucius Scaevola before Porsenna
C—RUBENS and VAN DYCK, Ulysses Discovers Achilles
D—RUBENS and JORDAENS, Hercules and Antaeus
E—Fireplace (height unknown)

DIAGRAM 1. *Reconstruction of the north wall of the Hall of Mirrors in 1659*

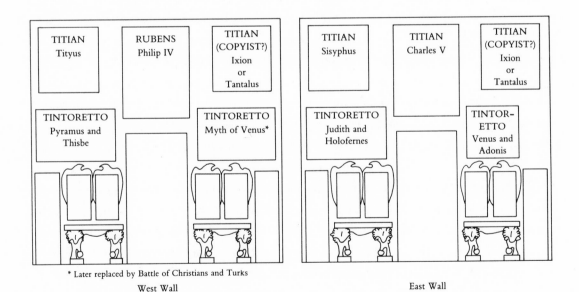

\* Later replaced by Battle of Christians and Turks

West Wall

East Wall

DIAGRAM 2. *Reconstruction of the east and west walls of the Hall of Mirrors in 1659*

composition (fig. 56).[164] At the rear left is the door to the Room of the *Furias* at the east end of the north wall. The detail of the painting above the lintel shows Philip II lifting his infant son in Titian's *Allegorical Portrait of Philip II*. On the adjacent wall Tintoretto's *Judith and Holofernes* spans a niche and a pair of mirrors. Farther to the right is a tall, curtained doorway leading to the queen's apartments. (In reality, no such curtain hung there. It is an invented concession to the conventions of Baroque portraiture.) The second pair of mirrors is mounted to the immediate right of this door.

That second pair of mirrors appears in full in Carreño's version of *Charles II* in Berlin (fig. 14). It cannot be the left-hand pair in the *Mariana* for two reasons. First, the painting above these mirrors is not the *Judith and Holofernes* because the motifs seen in its lower left corner are different and because it spans only the width of the two mirrors. Second, the vertical segment of molding to the left of the painting reaches too high to be part of the corner niche in the *Mariana*, but it could be part of the taller doorway in the center of the east wall. Proof that the *Charles II* does, in fact, show the east wall is found in the reflection that glimmers in the right-hand mirror (fig. 57). It depicts a file of open doorways, and just beyond the first is a sculpture sitting on a table. That is the view through the west door to the Octagonal Room, where a *Spinario* (fig. 86) sat on an octagonal table, and to the other chambers arranged *enfilade* along the south façade of the Alcázar.[165]

Carreño's portraits also confirm that the other two pairs of mirrors hung on the west wall opposite those on the east. In the right-hand mirror in the *Charles II* the dim, golden-brown forms of two bronze eagles surmounting dark, rectangular frames appear to the left of the open door to the Octagonal Room. (The reflection of the king's head overlaps them.) In the Prado *Mariana* the left-hand mirror reflects the pair that hung on the right side of the west wall. In fact, the reflected pair is disproportionately large and, together with the table below them, occupies the entire mirror image (whereas half the west wall is reflected in a single mirror in the *Charles II*). The exaggerated size of the reflected mirrors in the *Mariana* emphasizes the fact that the pairs of mirrors were placed facing each other across the room.

[164] For this drawing, see Margaret R. Lunn and Virginia Espinosa-Carrión, "Los dibujos de Juan Carreño de Miranda," *AEA* 52 (1979), 303.

[165] For the Octagonal Room, see Chapter IV.

Another *Charles II* composition by Carreño that also exists in more than one version (e.g., fig. 59) portrays the king standing in front of one of the two tables that were placed against the south wall between the windows.[166] At the right is an opening onto one of the three balconies—probably the most important of them, the central Great Balcony, the better to glorify the monarch. Thus, Carreño's portraits confirm that the six porphyry tables and the eight mirrors were disposed symmetrically about the north-south axis of the room.[167]

Establishing the positions of the tables and mirrors provides the necessary points of reference for reconstructing the arrangement of the paintings. As remarked above, Carreño's portraits of Mariana record the positions of the *Allegorical Portrait of Philip II* and the *Judith and Holofernes*. Two more paintings can be identified and placed on the basis of their presence in the right-hand mirror reflection in the Berlin *Charles II*: Rubens's *Equestrian Portrait of Philip IV* is mounted over the door to the Octagonal Room, and Titian's *Tityus* hangs to the upper left of it. Neither the *Philip IV* nor the *Tityus* has been reversed, as would occur in a true mirror image. Evidently when Carreño painted the reflection, he did not copy from the small mirror image. Instead, he simply turned his easel around to work directly from the west wall, and that had significant consequences. Had he worked from the mirror, viewing it from the fixed perspective shown in the portrait, not only would he have painted reversed images, but also he would have seen the right half of the west wall, not the left. On the assumption that Carreño did not reverse the details of the north wall either, the mirrors in the *Charles II* must show the right end of the north wall forming an impossible corner with the left end of the west wall. As a result, the beam of light that falls across the reflected *Tityus* and *Philip IV* emanates from no apparent source. In actuality, it came through the upper window on the west end of the south wall (cf. fig. 54).[168] The light in the "real space" of the *Charles II* must also have entered through windows in the

[166] Marzolf, "Juan Carreño de Miranda," 81-82 and 161-62.

[167] This apparent interest in symmetry may have been carried further if the two large porphyry urns without covers (D38, 39) stood on the two tables against the south wall and the four small urns with covers (D40-43) stood on the tables along the end walls. In fact, covered urns

rest atop the end-wall tables in the Berlin *Charles II* and the Real Academia *Mariana of Austria*.

[168] The light within the Uffizi copy of Rubens's *Philip IV* (fig. 39) also falls from the upper left. Rubens undoubtedly took the lighting conditions that prevailed in the New Room into account when he designed the original.

south wall because the king's shadow extends northward, parallel to the east wall.

The 1686 inventory of the room begins with three entries that list the *Charles V at Mühlberg*, the *Equestrian Portrait of Philip IV*, and the four *Furias*. According to the second Duke of Gramont, when his father first entered the Hall of Mirrors in 1659, he saw the *Charles V* hanging above the king's dais. That means the portrait was mounted above the door in the center of the east wall, where the king's throne and dossel were installed at such events. The *Philip IV* hung opposite, over the door to the Octagonal Room in the center of the west wall. Because the *Tityus* was placed to the left of the *Philip IV*, it might be supposed that another of the *Furias* was situated to the right. Furthermore, if the two remaining *Furias* flanked the *Charles V* in like manner, then the set of four would have been distributed evenly about the room. In fact, they were installed that way as early as 1626, when Pozzo recorded that two "Tityuses" flanked the *Charles V* and that two more bracketed the *Philip IV* (at that time, the version by Velázquez) at the opposite end of the room.

Other evidence from the 1636 and 1686 inventories bears out these assumptions. Consider the next five paintings that Ochoa listed after the *Furias* in 1686 (D7-11): the *Allegorical Portrait of Philip II*, the *Abduction of the Sabine Women*, the *Reconciliation of the Romans and the Sabines*, the *Reconciliation of Jacob and Esau*, and the *Philip III and the Expulsion of the Moriscos*. All are estimated to measure five *varas* in height, and the *Philip II* is already known to have hung above the door to the Room of the *Furias*. Two rows of paintings occupy the reflected north wall in the Berlin *Charles II*, and the upper tier consists of large pictures with a common base line. After Ochoa inventoried the upper paintings on the two end walls, he apparently turned to the top row of paintings on the intervening north wall. Beginning with the *Philip II*, he proceeded from right to left down the length of the room. The two "Romans and Sabines" subjects, which he treated in one entry, came next, and convention would have dictated mounting the *Abduction* to the left of the *Reconciliation* in order to facilitate a left-to-right reading of the narrative. Next came the *Jacob and Esau* followed by the *Philip III*, which hung above the door to the Gilded Hall at the west end of the wall. Therefore, all four royal portraits were overdoors that were arranged symmetrically about the north-south axis of the room in

a counterclockwise, chronological sequence of the kings' reigns beginning with the *Charles V*.

To reiterate, Ochoa began with the top row of pictures on the two end walls and then considered the upper level of the north wall. The 1636 inventory follows a comparable pattern with a minor variation. The order of its first entries is:

TITIAN, *Charles V at Mühlberg*
TITIAN (and copyist?), *The Furias*
TITIAN, *Allegorical Portrait of Philip II*
CARDUCHO, *Scipio Africanus Addressing the Romans*
RUBENS, *The Reconciliation of Jacob and Esau*
VELÁZQUEZ, *Philip III and the Expulsion of the Moriscos*
CAJÉS, *Agamemnon and Chryses*
RUBENS, *Equestrian Portrait of Philip IV*

In this case the compiler of the inventory also began with the *Charles V*, and the two *Furias* that flanked it inspired his next entry for the complete set of four. He then worked from right to left along the upper row on the north wall. (The paintings by Carducho and Cajés were the same height as the pictures listed before and after them, so they would have been the correct height for the upper tier.) Upon reaching the end of the north wall (where Cajés's *Agamemnon and Chryses*, not Velázquez's *Philip III*, hung over the door to the Gilded Hall), the compiler turned to the upper row of paintings on the west wall. Because he had already listed its two *Furias* in his entry for the complete set, his next entry was the *Philip IV*. (The similarity of routes followed by the inventory-takers in 1636 and 1686 suggests that Cajés's and Carducho's paintings were removed from the north wall in order to make room for Rubens's "Romans and Sabines" pendants. Perhaps the latter two pictures were commissioned expressly to replace the works by the two lesser masters, whose styles would have seemed *retardataire* by the late 1630s.)

To return to the 1686 inventory, the remaining pictures can be divided into three groups. One consists of four paintings (D12-15) listed individually after the *Philip III*. Ochoa attributes them all to Rubens and estimates each to measure three *varas* in height. Next come the four Tintorettos (D16-19)

that were mounted above the mirrors. Following them are twelve paintings (D20-31) that are listed in six entries as pairs of equal-sized pictures. The Tintorettos, of course, were distributed on the two end walls where the mirrors hung. Because two of the last six entries (for D26-29) explicitly relate the paintings to the windows, the group of twelve must have hung on the south wall, the only one with fenestration. By a process of elimination, the four remaining pictures (D12-15) must have composed the lower row on the north wall.

Common sense suggests that after listing the *Philip III*, Ochoa simply worked his way back across the north wall along the lower tier of pictures. As a result, the left-to-right sequence in which they were arranged matched the order in which he recorded them: *Perseus and Andromeda, Gaius Mucius Scaevola before Porsenna, Ulysses Discovers Achilles among the Daughters of Lycomedes,* and *Hercules and Antaeus.* The compositions of the three surviving works buttress this conclusion. The massive rock to which Andromeda is bound framed the left end of the series, and the turn of her body and the diagonals of Perseus' limbs directed the spectator's attention toward the other pictures to the right (fig. 43). In a similar way the mountain in the *Hercules and Antaeus* bracketed the right end of the series, and the arc of Antaeus' body led the viewer to the left (fig. 44). Achilles' diagonal lunge in the adjacent picture (fig. 26) continued this movement toward the center of the wall.

Determining the spacing among the pictures in the lower row is complicated by the number of breaks in its surface. It was pierced by three symmetrically disposed doorways where there had been windows before Gómez de Mora erected the screen façade that created the New Room in the first place (cf. figs. 1 and 2). In addition, the hall is known to have had two fireplaces, and with tables set against the lower spaces along the east, west, and south walls, the most likely place for the fireplaces was the north wall.[169] The presence of these doors and fireplaces accounts for the lack of agreement among the plans of the Alcázar insofar as the north wall is concerned. Gómez de Mora's *planta alta* (fig. 13) shows the three doors and the two fireplaces, whereas the Ardemans plan (fig. 8) indicates only the doors. Evidently the central door

---

[169] AGS, CM3, leg. 1362, Alcázar de Madrid, 1674-75, fols. 13ᵛ-13bis, documents a payment issued February 15, 1675, for marble trimmings for two fireplaces in the hall; and as previously noted, two ornamental bronze andirons were recorded there in 1700 (*Inventario reales*, 1:131).

was filled in between the date of the Ardemans plan and that of the Justi plan, for the latter (fig. 10) shows only two doors and the fireplaces. On Verger's plan (fig. 11) the central door has become a niche only slightly wider than the two fireplaces. The parquet plan (detail, fig. 58) shows the two doors that remained open and the hollow where the central door had been sealed. It omits the fireplaces because measuring them for parquet flooring would have been pointless.

Another complication in reconstructing the layout of the north wall is the degree of error in Ochoa's estimates of the sizes of the paintings. The table below lists each picture in the hall in 1686, its estimated dimensions in *varas* and meters, and its actual measurements when they are known. Although in some instances the estimates are reasonably accurate, in others there are significant discrepancies. The *Charles V*, *Philip II*, and *Jacob and Esau* illustrate the problem. Although they are close in size (as the 1636 inventory indicates), Ochoa estimates the first to measure 5 × 4 *varas* and the other two to measure 5 × 3. What is more, the estimated height for all three is wrong by about 0.8 meter—almost a full *vara*. Even allowing for the widths of picture frames, the error is significant.

Because Ochoa's accuracy varies, fitting the lost paintings into the reconstruction of the ensemble becomes more difficult. Presumably Velázquez's *Philip III* and Rubens's *Philip IV* measured the same size as Titian's royal portraits (e.g., see the 1636 inventory), rather than the dimensions given by Ochoa. In the case of the two "Romans and Sabines" subjects, however, there is no means to assess his accuracy in estimating their widths. (Their heights would have matched the other pictures in their row.) That is unfortunate because the proportions of the oil sketches on which the pictures seem to have been based (figs. 45-46) do not match those of Ochoa's estimates. Discrepancies of this sort pose obstacles to working out a precise reconstruction of the north wall that duplicates the meeting of four corners that is reflected in the left-hand mirror in the Berlin *Charles II*. (The images are too dim for a frame around a picture to be distinguished from a molding around a doorway or fireplace.) Therefore, the reconstruction illustrated in Diagram 1 should be regarded as an approximate guide to the relative positions of the pictures, not as an exact scale drawing.

Besides the *Charles V* and the *Philip IV*, two sets of four paintings were

<div style="text-align: center;">

TABLE

*Measurements of Paintings in the Hall of Mirrors with*
*Reference to the Inventory of 1686*

</div>

| Artist | Subject | Inventory Dimensions (varas) | Inventory Dimensions (meters) | Actual Dimensions (meters) |
|---|---|---|---|---|
| Titian | Charles V | 5 × 4 | 4.18 × 3.34 | 3.32 × 2.79 |
| Rubens | Philip IV | 5 × 4 | 4.18 × 3.34 | lost |
| Titian (and copyist?) | *Furias* | 3 × 2½ | 2.51 × 2.09 | 2.53 × 2.17 (Tityus) 2.37 × 2.16 (Sisyphus) |
| Titian | Philip II | 5 × 3 | 4.18 × 2.51 | 3.35 × 2.74 |
| Rubens and unknown artist | Abduction of the Sabine Women | 5 × 5½ | 4.18 × 4.60 | lost |
| Rubens | Reconciliation of the Romans and Sabines | 5 × 5½ | 4.18 × 4.60 | lost |
| Rubens | Reconciliation of Jacob and Esau | 5 × 3 | 4.18 × 2.51 | 3.20 × 2.83 |
| Velázquez | Philip III | 5 × 3 | 4.18 × 2.51 | lost |
| Rubens and Jordaens | Perseus and Andromeda | 3 × 1½ | 2.51 × 1.24 | 2.65 × 1.60* |
| Rubens | Gaius Mucius Scaevola before Porsenna | 3 × 3 | 2.51 × 2.51 | lost |
| Rubens and Van Dyck | Ulysses Discovers Achilles | 3 × 3 | 2.51 × 2.51 | 2.46 × 2.67 |
| Rubens and Jordaens | Hercules and Antaeus | 3 × 1½ | 2.51 × 1.24 | 2.15 × 1.49* |
| Tintoretto | Judith and Holofernes | 2¼ × 3+ | 1.88 × 2.51+ | 1.98 × 3.25 |
| Tintoretto | Venus and Adonis | 2¼ × 3+ | 1.88 × 2.51+ | lost |
| Tintoretto | Pyramus and Thisbe | 2¼ × 3+ | 1.88 × 2.51+ | lost |
| Tintoretto | "Abduction of Helen" | 2¼ × 3+ | 1.88 × 2.51+ | 1.86 × 3.07 |
| Veronese | Christ Child among the Doctors | 3 × 5½ | 2.51 × 4.60 | 2.36 × 4.30 |

TABLE (*cont.*)

| Artist | Subject | Inventory Dimensions (*varas*) | Inventory Dimensions (*meters*) | Actual Dimensions (*meters*) |
|---|---|---|---|---|
| Bassano shop | Forge of Vulcan | 3 × 5½ | 2.51 × 4.60 | 2.50 × 4.07 |
| Gentileschi or Veronese | Finding of Moses | 3 × 4 | 2.51 × 3.34 | 2.42 × 2.81 or lost |
| Veronese | Jacob Waters Rachel's Flock | 3 × 4 | 2.51 × 3.34 | lost |
| Rubens | Satyr Squeezing Grapes | 2½ × 2 | 2.09 × 1.67 | lost |
| Rubens and Snyders | Three Nymphs with the Horn of Plenty | 2½ × 2 | 2.09 × 1.67 | 2.23 × 1.62 |
| Ribera | Jael and Sisera | 2 × 3 | 1.67 × 2.51 | lost |
| Ribera | Samson and Delilah | 2 × 3 | 1.67 × 2.51 | lost |
| Velázquez | Apollo and Marsyas | 1 × 3 | 0.84 × 2.51 | lost |
| Velázquez | Mercury and Argus | 1 × 3 | 0.84 × 2.51 | 1.27 × 2.48* |
| Velázquez | Venus and Adonis | 1 × 1½ | 0.84 × 1.25 | lost |
| Velázquez | Cupid and Psyche | 1 × 1½ | 0.84 × 1.25 | lost |

NOTE: 1 *vara* = 0.835 meter
* Modern additions to the canvas are evident

each distributed evenly on the end walls, but the precise locations of only the *Tityus* (from the *Furias*) and the *Judith and Holofernes* (from the four Tintorettos) are certain. In the case of the *Furias*, the compositions of the three known images offer a clue. The viewer reads the *Tityus* from left to right, proceeding up the diagonal of the giant's body and down the arc of his right arm. When it occupied the upper left corner of the west wall, it directed the spectator's attention toward the adjacent *Philip IV*. The three other *Furias* may have been installed with the same concern for relating them to the two portraits. Because the *Sisyphus* has a pronounced orientation toward the right, it probably hung in the upper left corner of the east wall, where it would have directed the

viewer toward the *Charles V.* By that reasoning, the lost *Ixion* and *Tantalus* would each have been situated to the right of one of the portraits. Sanuto's engraving after the *Tantalus*, in which the prisoner's body is turned to the left, lends weight to this hypothesis.

Attempting to deduce the arrangement of the four Tintorettos proves even more conjectural. As previously noted, the picture hanging above the mirrors in the Berlin *Charles II* cannot be the *Judith and Holofernes*, and its one visible corner does not match the motifs in the corresponding corner of the *Battle of Christians and Turks* (the "Abduction of Helen") that was brought into the hall sometime after 1666. It is known that the *Myth of Venus* and the *Battle of Christians and Turks* were comparable in length, and that the latter, in turn, is almost identical in size to the *Judith and Holofernes* (see Table). Therefore, because the painting within the *Charles II* is not as wide as the *Judith and Holofernes*, it cannot be the *Myth of Venus* that would have been in the room in 1659. That leaves the *Pyramus and Thisbe* and the *Venus and Adonis* as possibilities. All that is visible of the painting in the *Charles II* is a quiver of arrows and a small child. Arrows and small children play no role in the myth of Pyramus and Thisbe (Ovid, *Metamorphoses*, IV.55-166), but Cupid and his arrows do appear in portrayals of Venus and Adonis.[170] It seems appropriate, therefore, to identify the painting in the *Charles II* tentatively as the *Venus and Adonis*.

Unfortunately, that conclusion only raises another difficulty. Ochoa names the four Tintorettos in the following order: the so-called *Abduction of Helen*, *Judith and Holofernes*, *Pyramus and Thisbe*, and *Venus and Adonis*. The most convenient way for him to have compiled the list would have been in clockwise or counterclockwise order around the room, but he could not have generated the sequence in that fashion if the *Judith and Holofernes* was in the northeast corner and the *Venus and Adonis* was in the southeast. Instead, he must have zigzagged between the two end walls, in which case the least complicated sequence would put the *Myth of Venus* (later replaced by the *Battle of Christians and Turks*) at the northwest corner and the *Pyramus and Thisbe* at the south-

---

[170] E.g., the many versions by Titian and his shop—see Wethey, *Paintings of Titian*, 3:188-94.

west.[171] Diagram 2 illustrates the proposed reconstruction of the end walls accordingly.

Too little is known about the south wall to permit a complete reconstruction of its appearance. The chief obstacle is the lack of precise measurements of the distances that separated its six windows from each other. Verger's section (fig. 54) is not drawn to exact scale, which limits its usefulness.[172] The parquet plan (fig. 58) offers some help by providing the widths of the lower windows and the segments of wall that alternate with them. Starting from the southwest corner of the room, those measurements are as follows:[173]

| | |
|---|---|
| Wall space | 1.88 meters |
| Side window | 2.99 meters |
| Wall space | 3.28 meters |
| Central window | 2.99 meters |
| Wall space | 3.28 meters |
| Side window | 2.99 meters |
| Wall space | 2.06 meters |

The fact that the twelve paintings that decorated the south wall were listed in pairs in 1686 suggests that they were installed symmetrically about its central vertical axis. As a working premise, we may assume that the first picture listed in each entry was mounted on the left half of the wall. The compositions of the surviving pictures do not preclude this, but the weight of the visual evidence is insufficient to consider the idea proven. As for the furnishings, the two strips of wall between the windows were wide enough to

[171] In the event that the lost *Pyramus and Thisbe* is ever discovered, it will provide a check on this hypothesis. The right-hand mirror reflection in the Berlin *Charles II* shows that the Tintoretto in the southwest corner of the room extended over two mirrors and a doorway. Thus, the *Pyramus and Thisbe* would have to be about as long as the *Judith and Holofernes* for my reasoning to be correct.

[172] The limitations of Verger's section become evident when one examines it in the light of Velázquez's 1652 memorandum on the lengths of material needed to make curtains for the room (Iñiguez Almech, "La Casa del

Tesoro," 677). The draperies were to hang 5½ *varas* in the central window onto the Great Balcony and 5¼ *varas* in those at the sides. That implies the windows differed only ¼ *vara* (0.21 meter) in height, whereas Verger's section suggests the difference was much greater.

[173] In working with the plan I have used the conversions for the French system of measurement (*Pied de Roi* or *Pied de Paris*) given in William B. Parsons, *Engineers and Engineering in the Renaissance* (Baltimore, 1939), 627 and 632: 1 *toise* = 1.949 meters, 1 *pied* = 0.3248 meter, 1 *pouce* = 0.0271 meter, and 1 *ligne* = 0.0023 meter.

accommodate the lion-support tables, which were about three *varas* (2.51 meters) long.

It is possible to determine where a few of the pendant pairs were placed. Ochoa's inventory specifies that Ribera's *Jael and Sisera* and *Samson and Delilah* hung "above the windows" (D26, 27). Measuring an estimated 2 × 3 *varas* (1.67 × 2.51 meters) each, they could not have fitted the narrow spaces between the upper windows and the cornice of the room (fig. 54). They must have hung directly above the outer windows on the lower level.

The same inventory states that Velázquez's *Apollo and Marsyas* and *Mercury and Argus* hung "between the windows" (D28, 29). It has generally been assumed that they were placed high on the wall, but assigning them to the spaces between the upper windows fails to take account of the sizes of the other pictures on the wall. Veronese's *Christ Child among the Doctors* and the Bassano shop's *Forge of Vulcan* are large paintings that measure 2.36 × 4.30 meters and 2.50 × 4.07 meters, respectively. Neither could have hung on the lower half of the wall because the widest spaces there measured only 3.28 meters across. These pictures had to occupy the upper zone, and to judge from Verger's section, the only two sufficiently broad spaces were the areas between the upper windows.

This means that the *Apollo and Marsyas* and the *Mercury and Argus* were installed between the lower windows. That is why the *Mercury and Argus* (fig. 53) has such a strikingly low horizon line. It was intended to be seen at eye level, not from more than a full story below. (It is ironic that the low horizon line has often been given as a reason for concluding that the picture hung high on the wall. The straight-on view of such details as Argus' legs proves that this was not the case.) By placing his two short, wide mythologies above the lion-support tables that stood against the south wall, Velázquez echoed the installation of the four Tintorettos that were mounted above the tables set along the end walls.

Velázquez's *Venus and Adonis* and *Cupid and Psyche* (D30, 31), which measured the same height as his two other mythologies but only half as wide, probably hung on a line with them in the narrower spaces between the outer windows and the end walls. The positions of the four other pictures—the *Finding of Moses*, *Jacob Waters Rachel's Flock*, *A Satyr Squeezing Grapes*, and *Three*

*Nymphs Filling the Horn of Plenty*—remain open to speculation. On the basis of Verger's section, more than one arrangement seems possible.

All these conclusions about the south wall conform to a principle that governed the installation of paintings on the three other walls: The larger paintings were placed above the smaller ones. As early as 1633, Carducho had observed that the New Room was arranged so that "below [the large pictures] are others of smaller size" (Appendix B).

## The Program of the Hall in 1659

Any attempt to discover a program that informs this reconstruction of the Hall of Mirrors must account for the bewildering array of subjects that were portrayed there: the extraordinary choice of the myth of Pandora for the ceiling fresco (not to mention the baffling omission of its climactic episode); depictions of royalty, classical themes, and biblical narratives in the oil paintings on the walls; and prominent animal motifs incorporated into the furnishings. Carl Justi made two fundamental observations on the problem—first, that the "character" of the ensemble was indicated by the portraits of the Habsburg monarchs, and second, that the subject-pictures were "selected and handled from the same allegorico-romantic standpoint."[174] He refrained from specifying the nature of the "character" and "allegorico-romantic standpoint," but his instincts were correct. Kurt Gerstenberg, referring principally to the portraits of Charles V, Philip II, and Philip III, subsequently proposed that the hall was devoted to the martial glory of the Habsburgs who had occupied the Spanish throne.[175] The idea has merit, but it is too limited. The classical and religious subjects remain to be explained, and the *Philip III and the Expulsion of the Moriscos* was more a deportation scene than a conventional military triumph.

On the simplest level, the Hall of Mirrors was a splendid picture gallery that constituted an index of Philip IV's taste. Represented there were the Venetian Renaissance masters who had delighted the Habsburgs for generations and a selection of contemporary artists—notably Rubens, Velázquez, and Ri-

[174] Justi, *Velazquez and His Times*, 457-58.
[175] Kurt Gerstenberg, *Diego Velazquez* (n.p., n.d.), 227.

bera—who enjoyed the king's favor. Had the ensemble survived intact, it would be considered one of the great small museums of the world. Venetian art set the stylistic tenor of the room, and not only in the canvases by Titian, Tintoretto, Veronese, and the Bassano shop. The artistic heritage of Venice was a spring from which both Rubens and Velázquez drank deeply, and if the *Finding of Moses* was not by Veronese, it owed enough to his example that it came to be taken for one. The selection of painters reveals a marked preference for artists traditionally associated with *colore* rather than with *disegno*.

Ochoa's count of the attributions to individual artists in his 1686 inventory bears out this assessment of Philip's taste in painting.[176] In general, artists whose works hung in the Hall of Mirrors were well represented throughout the palace. Titian is most frequently cited with seventy-six attributions (to which must be added twenty-eight copies after his work), followed by Rubens with sixty-two originals (and forty-five copies). After them come Tintoretto, forty-three; Velázquez, forty-three; Ribera, thirty-six; and Veronese, twenty-nine. The only other painters in this range are Brueghel (which member of the family is not specified) with thirty-eight and Snyders with twenty-six. Fifteen works are given to the elder Bassano and eleven to the younger. Attributions to artists customarily associated with *disegno* are fewer: Reni, twelve; Raphael, seven; Leonardo da Vinci, seven; Annibale Carracci, four; Michelangelo, three; Poussin, three; and Andrea del Sarto, two. After Velázquez and Ribera there is a marked drop in the numbers of originals by Spanish artists. The next highest figures are: Pantoja de la Cruz, sixteen; Sánchez Coello, twelve; Mazo, twelve; El Greco, eight; and Carreño, six.

This is not to say that Philip was uninterested in painting outside a range defined by the Venetian Renaissance, the Flemish Baroque, and a few select Spaniards. To fit out the Buen Retiro in the 1630s his agents had purchased art widely at home and abroad. As a result, that palace contained a far more anthological collection of contemporary Flemish, Neapolitan, Roman, and Spanish painting than did the Alcázar.[177] But it is significant that Philip was content to leave those paintings at the Retiro. The Alcázar was the residence in which he spent the most time, and it was a home whose decoration he

---

[176] Inventory of 1686, n.fol.; Bottineau, "L'Inventaire de 1686," 437, cites a selection of figures from the list.

[177] Brown and Elliott, *Buen Retiro*, 114-40.

transformed dramatically between 1636 and his death in 1665. If, at the end of his reign, the Alcázar was a treasure house of certain kinds of paintings, it was because they were the paintings that gave him the greatest satisfaction.

The Hall of Mirrors, however, was more than a mere show place for fine pictures by the king's favorite painters. It was also a Hall of Princely Virtue—that is, a ceremonial chamber splendidly decorated to proclaim the noble virtues, superior character, distinguished lineage, and royal mission of the prince whose palace it occupied.[178] By a combination of narrative and analogical imagery, the paintings and furnishings in the Hall of Mirrors expressed a sophisticated program of ideas about the king and his family. When a visitor like the Marshal-Duke of Gramont stepped into the hall, he found himself confronted not only by the reigning monarch, but also by an extensive visual proclamation of the glorious achievements of the Habsburg rulers who had governed the Spanish realms in a manner befitting virtuous Christian princes.

At the heart of this program was the prominence of the four royal portraits within the ensemble, each of which hung above a doorway on a principal sightline. Royal portraiture had been established as a fundamental element in the decoration of the hall from the first years of its existence. Titian's *Charles V at Mühlberg* and his *Allegorical Portrait of Philip II* were brought from the Pardo Palace expressly to hang there. Velázquez's *Equestrian Portrait of Philip IV* was painted for the New Room and was designed to match the dimensions of Titian's *Charles V*, as was the *Equestrian Portrait of Philip IV* by Rubens that replaced the Spaniard's work. Bartolomé González's *Portrait of Philip III* and the *Entry of Philip III into Lisbon* represented that monarch until Velázquez's *Philip III and the Expulsion of the Moriscos* completed the initial set of four equally large royal portraits in 1627. (Thus, Philip IV had two motives for staging the *Moriscos* competition. Not only was it to provide Velázquez with the opportunity to vindicate himself from the criticisms of his rivals, but also it was to provide a necessary component of the New Room's adornment, regardless of who won the contest.)

Within the context of the Hall of Mirrors these portraits presented the Spanish Habsburgs as Christian princes—to be specific, as *Catholic* princes who employed their political power and military might to protect and promote the

[178] *Ibid.*, 147-56, defines the Hall of Princely Virtue as a type.

True Faith. It was a commonplace of seventeenth-century Spanish political theory that a monarch was a "vicar of God."[179] The great portraits in the Hall of Mirrors illustrated Philip IV and his predecessors meeting the fearsome responsibilities of that office. Each likeness stated unambiguously that an enemy of Catholicism, be he a Protestant heretic or a Muslim infidel, was an enemy of Spain who faced defeat at the hands of the Habsburg line.

Titian's *Charles V at Mühlberg* (fig. 16) commemorates a triumphant victory of Catholic forces over heretics, the emperor's overwhelming defeat of the Protestant League of Schmalkalden on April 24, 1547.[180] Astride the same horse and dressed in the same armor that he used at the battle, the emperor rides confidently into the field displaying the rose-colored sash worn by Catholic commanders in the religious wars of the sixteenth and seventeenth centuries. In lieu of the traditional attributes of command (a field marshal's baton or a sword), he carries a spear. That was the chosen weapon of a slayer of dragons (symbols of heresy) and of the *miles Christianus* (the Christian Knight). It also associated the Holy Roman Emperor with his ancient Roman predecessors, who ritually carried a spear when setting out for an important battle.

The *Allegorical Portrait of Philip II after the Battle of Lepanto* (fig. 17) celebrates both a victory of the Holy League (Spain, Venice, and the Papacy) over the Turkish fleet on October 7, 1571, and the birth of Philip's son Ferdinand (who is often misidentified in seventeenth-century references to the picture) in December that year.[181] The triumph of Christians over infidels is signified by a naval battle in the background and by the captive Turk and trophies in the lower left corner. The king lifts his son toward a winged Victory, who descends bearing a laurel garland and who hands the infant a victor's palm branch with a banderole inscribed, "MAIORA TIBI" ("You will do better"). The allegory not only commemorates a Catholic triumph over Islam but also promises even greater deeds by the king's heir apparent.

Prince Ferdinand died when he was seven, and Philip II was eventually succeeded instead by Philip III, whom Velázquez glorified with his *Philip III and the Expulsion of the Moriscos*. That canvas portrayed the event that was widely

---

[179] José Antonio Maravall, *La teoría española del estado en el siglo XVII* (Madrid, 1944), 197-201.

[180] For the following iconographic summary, see Erwin Panofsky, *Problems in Titian: Mostly Iconographic* (New York, 1969), 84-87; and Wethey, *Paintings of Titian*, 2:87.

[181] Panofsky, *Problems in Titian*, 72-73.

regarded as the king's greatest accomplishment. The Moriscos were a racial minority of Moors who, by virtue of having converted to Christianity, had been allowed to remain in Spain after the Reconquest. Among the reasons that Philip III expelled them from Spain by a decree of April 9, 1609, were widespread skepticism of the sincerity of their conversion and mistrust of their loyalty at a time when Turkish attacks on Spain's Mediterranean coast were still feared. Owing to such attitudes the expulsion was perceived by many to have strengthened the security of both Spain and the Catholic Faith.[182]

Although Rubens painted his *Equestrian Portrait of Philip IV* as a pendant to Titian's *Charles V at Mühlberg*, it differed from that and from the other two portraits in that it was a generalized allegory that did not refer to a specific event. Its symbolic content can be deciphered readily with the aid of two contemporary poems that Lope de Vega and Francisco López de Zárate wrote in praise of it, as well as the explanation given by the 1636 inventory (C11).[183] As seen in the Uffizi copy of the lost original (fig. 39), Philip, dressed in armor and carrying a baton, is depicted as a military commander on horseback. Above him the personification of Divine Justice aims a thunderbolt at his enemies. Beside her is Faith, who, with her right hand, holds before the king a laurel garland symbolizing victory, while with her left she plants a cross on a terrestrial globe near the Iberian peninsula—a sly allusion to Spain's role as a bastion of the Faith. Two putti lower the globe onto Philip's shoulder, thereby indicating that he bears the responsibility for protecting Catholicism throughout the world. In effect, Rubens illustrates one of Philip's epithets: "the Spanish Atlas." On the ground an Indian who carries the king's helmet personifies the New World and its wealth, which finances Spain's defense of the Faith. Philip's horse rears up to trample a serpent, symbol of heresy, that is coiled among the thistles in the lower left corner. Thus, the picture represents Philip as a champion of Catholicism and an enemy of heresy.

[182] Elliott, *Imperial Spain*, 299-303. Typical of the later praise for Philip III is Juan de Vargas Machuca, *Informe a la Magestad de Filipo Qvarto, el Grande el Piadoso, Rey de las Españas, y Emperador de las Indias* (Madrid, 1662), fols. 18-18ᵛ. In this panegyric to the Spanish Habsburgs, Philip III is praised at greatest length for the expulsion (in a section devoted to his virtues as a Catholic).

[183] Larry L. Ligo, "Two Seventeenth-Century Poems Which Link Rubens' Equestrian Portrait of Philip IV to Titian's Equestrian Portrait of Charles V," *GBA*, 6th ser., 75 (1970), 345-48. Some of the interpretations in these verses smack of poetic license at the expense of iconographic rigor (e.g., identifying the horse as a symbol of the Spanish people), and the poems should be used with caution accordingly. See also López-Rey, "Head of Philip IV," 36; and Huemer, *Portraits*, 1:152-53.

As a suite, the four royal portraits presented the Spanish Habsburgs as awesome defenders of the Faith. Upon entering the Hall of Mirrors from the ceremonial approach through the Octagonal Room, a visitor would first see Titian's *Charles V* dominating the east wall. (It was so striking that it was the one picture whose subject the second Duke of Gramont saw fit to record in his account of his father's reception in 1659.) Then, turning counterclockwise, he would discover images of the emperor's successors on the Spanish throne in chronological sequence, each one carrying on the mission of bolstering the Catholic faith. So important to the decorative program were these portraits that after the *Reconciliation of Jacob and Esau* was removed in 1694, it was judged desirable to add Charles II's portrait to the ensemble as a replacement.[184]

The eagles and lions that were incorporated into the furnishings of the hall had symbolic meanings that associated them with the portraits. They were both general allusions to royal status and heraldic symbols referring to the Habsburg dynasty. Traditionally the eagle has been considered the king of birds, and to this day the lion is called the king of beasts. Lions also signified the Kingdom of León (*león* means "lion"), and the Crown of Castile and León was the heart of the Monarchy. The eagle was a heraldic symbol of the Habsburgs as well—most notably the double-headed imperial eagles of Charles V. In the Hall of Mirrors the lions and eagles underscored the fact that it was the Habsburg kings of Spain whom the portraits depicted as Christian princes.

The four portraits were meant to be interpreted within the broader context of the classical and biblical paintings that surrounded them. The approach to understanding that context is exemplified by a passage in Carducho's *Diálogos de la pintura* in which the Maestro of the dialogues instructs his pupil to relate the decoration of a structure to its use:

> And whenever one proposes to adorn some building, one must attend to the character of it in general, to the use of each part in particular, and to the person who is to occupy it and who has it [the decoration] made. . . .
> If it is royal galleries [that are being decorated], it is historical

---

[184] If Giordano's lost portrait was like his small version of the subject in the Prado (cat. 197), its composition would have derived from Rubens's *Philip IV*.

subjects that are to be painted—grave, majestic, exemplary, and worthy
of imitation: such [subjects] as prizes that great monarchs have given
to those who are constant in valor and virtue, just punishments of evil
deeds and treachery, exploits of the most celebrated princes and cap-
tains, triumphs, victories, and battles. Scipio against Hannibal, Aeneas
against Turnus, Caesar against Pompey, Xerxes against the Lacedae-
monians, and other similar deeds. And of the many modern subjects
that there are, those of Charlemagne and the Emperor Charles V, whose
victories were excellent, and whose battles were mighty. And if, per-
haps, it is convenient, or to the taste of the donor, to paint the works
of Virgil, Homer, and the myths of Ovid, try to make the virtuous
morality that they contain evident with lively interpretation and nat-
uralness. Withhold the ignorance and do not show the impure and
immodest boorishness [that they contain], attending to the beneficial
and not inviting damage.[185]

Because Carducho sees a relationship between art and royal comportment, he
advocates that a king's gallery be decorated with pictures that inspire the
virtuous behavior that befits great princes. His preferred subjects are exemplary
acts performed by the distinguished rulers and commanders of both ancient
and modern times, but he also permits themes that are drawn from ancient
literature when their moral content is instructive. In other words, he invokes
one of the fundamental tenets of Renaissance art theory—that artistic subject
matter should edify the viewer. (He is also indulging in veiled self-promotion.
Of all the antique heroes that he lists, only one, Scipio, appeared in the New
Room in 1633—in the *Scipio Africanus Addressing the Romans* that he himself
had painted in 1626. In 1633, when the *Diálogos* was published, no other
royal gallery in Madrid rivalled the New Room in the thematic significance
that it had already attained.)[186]

The notion that history could provide instructive models of good kingship
was an idea that Philip IV himself expressed in a different context. As part
of his program of self-education under Olivares's guidance, Philip undertook

[185] Carducho, *Diálogos*, 326-29.
[186] For the program of the room before 1659, see the following section in this chapter.

in 1633 to translate two books from Francesco Guicciardini's *Historia d'Italia*. In an epilogue he explained that studying history was one of the ways that he had trained himself to be a good king:

> Reading histories also seemed to me to be a very essential subject in order to attain the end to which I directed my desires to acquire knowledge, because they [histories] are the true school in which the Prince and King will find models to follow, cases to heed, and means by which to bring the affairs of his Monarchy to good ends. To this purpose I read the histories of Castile of the kings Don Ferdinand the Saint, Don Alonso the Wise, Don Sancho the Brave, D. Ferdinand IV (whom they call "the Summoned One"), the chronicle of Don Alfonso IX, the histories of Don Peter the Just or the Cruel, Don Henry II, and Don John I; the history of the King Don John II, with the *Varones ilustres* of Fernán Pérez de Guzmán; the two manuscript histories of the King Don Henry IV, those of the Catholic Kings, and that of the Emperor Charles V, my great-grandfather; the *Historia general de España* and the *Varones ilustres* by Hernando de Pulgar; those of both Indies, the history and wars of Flanders, and Roman history by the princes of it, Sallust, Livy, Tacitus, and Lucan; the history of France, the history and wars of Germany, the Roman campaign, and the history and schism of England. Aside from this, it also seemed [good] to me to read sundry books in all languages and translations about professions and the arts, which sharpen and stimulate the taste for good letters, and some [books] of examples which, although apocryphal, are very profitable.[187]

Carducho's ideas on the nature of palace decoration would have found a receptive, sympathetic reader in the man who wrote those lines. Philip was seeking from the printed page what Carducho thought should be provided in paint: models of good kingship to teach and inspire the monarch.

Carducho's approach to palace decoration reflects a prevailing attitude that informed the selection of many of the classical and biblical subjects that adorned

---

[187] Philip IV of Spain, "Autosemblanza de Felipe IV," in "Cartas de Sor María de Agreda y de Felipe IV," ed. Carlos Seco Serrano, *Biblioteca de Autores Españoles*, 109 (1958), 232-33. See also Brown and Elliott, *Buen Retiro*, 41.

the Hall of Mirrors. Some were to be understood as demonstrations of behavior worthy of emulation—in effect, a catalogue of royal virtues. Others, more admonitory in tone, portrayed ignoble behavior to be avoided and the just punishment of villains. The implication was that the Spanish Habsburgs comported themselves in accordance with the lessons taught by these paintings. Moreover, the emphasis in the royal portraits on the struggle between Catholicism and its opponents colored the interpretation of several classical subjects with Christian overtones. The actions of the Olympic deities who rewarded mortals who respected them and who punished those who defied them signified, by analogy, the heavenly favor reserved to the Catholic faithful and the eternal damnation that awaited heretics, Jews, and infidels. In the Hall of Mirrors, Catholic piety was the supreme virtue.

It should be acknowledged, however, that Carducho's precepts do not account for all the subjects that were presented in the Hall of Mirrors. Considerations other than programmatic ones came into play: the availability of pictures in the royal stockpile, the evolution of the ensemble over several decades, the unplanned manner in which many of the pictures were acquired, and the character of the chamber as a showroom for fine paintings that were not necessarily chosen for their content. As a result, the program never attained the ironclad consistency of such contemporary ensembles as the great cycles designed by Rubens or Cortona's Planetary Rooms in the Pitti Palace; rather, it was a looser assemblage.[188]

Keeping these circumstances in mind, we can consider the roles that the various subject-pictures played within the overall context of the Hall of Mirrors. The four *Furias* provided the most straightforward examples of the "just punishments of evil deeds and treachery" that Carducho thought should be represented. All four villains had committed crimes against the gods. The giant Tityus had attempted to rape Latona, and Ixion had tried to seduce Juno. Ancient writers accused Tantalus of many crimes, the worst of which had been murdering his son Pelops and serving him to the gods. His other crimes had

---

[188] Rubens's projects for the Luxembourg Palace and the Whitehall Banqueting House are the most appropriate of his cycles for comparison; see Held, *Oil Sketches*, 1:87-136 and 187-218, for summaries of their programs and further bibliography. For Whitehall, see also Roy C. Strong, *Britannia Triumphans: Inigo Jones, Rubens and Whitehall Palace* (London, 1981). For Cortona's work, see Malcolm Campbell, *Pietro da Cortona at the Pitti Palace: A Study of the Planetary Rooms and Related Projects* (Princeton, 1977), 63-157.

included betraying Jupiter's secrets and stealing the gods' divine food to share with his mortal friends. Sisyphus had betrayed one of Jupiter's secrets and had lived by robbery and murder; he was also said to have deceived the gods on several occasions.

Titian based his *Furias* suite upon a passage from Ovid's *Metamorphoses* (IV.456-61) in which Juno observes the four villains suffering eternal torments in Hades for their crimes.[189] Tityus had been staked to the ground so that a vulture could tear at his internal organs (fig. 22); Ixion was bound to the rim of a wheel that ceaselessly tumbled him head over heels; Tantalus was placed between food and water that receded from him whenever he sought to slake his hunger and thirst (cf. fig. 23); and Sisyphus was condemned to roll a great rock to the top of a hill, whence it always rolled back down (fig. 21). In the Hall of Mirrors these scenes of Hades illustrated the inevitable downfall of the wicked and suggested that an analogous damnation in Hell would befall those who defied the Catholic faith. The juxtaposition of these tormented villains with the triumphant portraits of Charles V and Philip IV that they flanked was striking. It was no accident that Rubens designed his *Equestrian Portrait of Philip IV* so that Divine Justice seemed to aim her thunderbolts at the adjacent *Tityus* (diagram 2 and fig. 57).

Between the portraits of Philip II and Philip III on the north wall hung an expanse of paintings designed by Rubens (diagram 1). Those in the upper row portrayed instances of behavior that exemplified the virtue and benefits of reconciliation. The *Abduction of the Sabine Women* and its companion, the *Reconciliation of the Romans and the Sabines*, should be interpreted together (cf. figs. 45 and 46). As Plutarch (*Lives*, "Romulus," XIV) describes the abduction, it was a carefully considered action that the Romans, who had no women with whom they could continue their line, committed with the welfare of both tribes in mind: ". . . they did not commit the rape out of wantonness, nor even with a desire to do mischief, but with the fixed purpose of uniting and blending the two peoples in the strongest bonds."[190] To that end the Romans carried off only unmarried women—with the exception of one, Hersilia, who was seized by mistake—and allowed the Sabine men to escape unharmed.

[189] Panofsky, *Problems in Titian*, 148.
[190] Plutarch, *Lives*, tr. Bernadette Perrin, Loeb Classical Library (Cambridge, Mass.-London, 1946), 1:131.

The reconciliation of the two tribes was effected by the Sabine women, who intervened on the battlefield when the Sabine men launched an attack to recapture their women. Led by Hersilia, the women pleaded that they desired neither the deaths of their Roman husbands, whom they had come to love, nor the deaths of their Sabine fathers and kinsmen. It was, writes Plutarch ("Romulus," XIX), "a sight that was wonderful to behold and a spectacle that passes description. . . . So then both armies were moved to compassion, and drew apart to give the women place between the lines of battle; sorrow ran through all the ranks, and abundant pity was stirred by the sight of the women, and still more by their words, which began with argument and reproach, and ended with supplication and entreaty."[191]

This moved the warriors to resolve their dispute peacefully, whereafter all lived in Rome under the joint rule of Romulus and Tatius, respectively the Roman and Sabine kings. Livy (*From the Founding of the City*, I.9-13) gives a comparable account of the episode. Together the two paintings celebrated a triumph of compassion and peaceful reconciliation in which two kings participated. What is more, Hersilia is sometimes said to have become the wife of Romulus, which would elevate her courageous intervention to a display of queenly virtue.

Rubens's *Reconciliation of Jacob and Esau* (fig. 30) portrays Jacob's return to Canaan with his family, servants, and possessions after having lived for many years with his uncle and father-in-law Laban. Jacob had originally fled Canaan to escape the hatred of his brother Esau, whose birthright he had stolen. On his return journey he feared the reception that awaited him, but when Esau came to meet him, it was with tears of joy at their reunion (Genesis 33:1-16). Rubens underscored this moment of peaceful reconciliation by basing Jacob and Esau's poses on an emblem of *concordia* that had been devised by Andrea Alciati.[192] Owing to Jacob's status as a patriarch of Israel, he and his brother would have stood as suitable models for the comportment of princes.

Reconciliation was not just an abstraction to Philip IV, but a goal that he pursued throughout his reign. The reunification of the rebellious United Provinces with the Spanish Netherlands had been an objective of the Monarchy

---

[191] *Ibid.*, 147-49.
[192] Jonathan Brown, "On the Origins of 'Las Lanzas' by Velázquez," *ZfK* 27 (1964), 240-45.

for decades, and Spain, like the rest of Europe, had become embroiled in the bitter division between Protestants and Catholics across the continent. Moreover, from 1635 until 1659, Spain was at war with France. Reconciliation even became a goal at home because there was constant tension between the Spanish realms and the central authority in Madrid. In 1640, the year after Philip had commissioned the "Romans and Sabines" paintings from Rubens, both Catalonia and Portugal revolted.

Ten years later, with those two realms still in open defiance of the Crown, the king's chief chronicler, don José de Pellicer Ossau de Salas y Tovar, published his *Alma de la gloria de España*. In part it was an epithalamium on Philip's marriage to Mariana of Austria, of whom Pellicer wrote that "it is hoped that, like another Hersilia set between the armies of her spouse and his vassals, she will conquer unarmed; and with sweet and eloquent language she will sheathe the sword of her great husband and lower those of his two kingdoms that have revolted."[193] The Catalans were eventually subdued by more conventional measures, but Philip never regained his sovereignty over the Portuguese. As the wars that sapped the Monarchy's resources dragged on, the virtues of peaceful reconciliation must have struck Philip as an essential goal of kingship worthy of illustration in the New Room.

In the lower row of paintings on the north wall four ancient warriors performed valorous acts of heroic virtue. Each exemplified qualities worthy of emulation by a king. In the *Perseus and Andromeda* (fig. 43) the hero Perseus releases the princess Andromeda from her bonds after having slain the sea monster that had threatened to devour her. Cupid, god of love, and Hymen, god of marriage, flutter overhead to signify that Perseus has won Andromeda as his bride. His winged steed Pegasus—an attribute of virtue[194]—stands near the dead monster on the shore in the background. Moreover, the hero wears the same armor that Rubens customarily uses for portrayals of Christian knights like Saint George, rather than the antique armor that is found in his other depictions of Perseus. Within the context of the Hall of Mirrors, Perseus might

[193] Joseph Pellicer de Tovar, *Alma de la gloria de España: eternidad, magestad, felicidad, y esperanza suya en las reales bodas: Epitalamio* (Madrid, 1650), fol. 10.

[194] Cesare Ripa, *Iconologia, o vero descrittione d'imagini delle Virtv', Vitij, Affetti, Passioni humane, Corpi celesti, Mvndo e sue parti* (1609; rpt. New York-London, 1976), 539-40.

therefore be understood as a Christian champion rescuing Spain or the Faith from evil.[195]

The *Gaius Mucius Scaevola before Porsenna* (cf. fig. 31) illustrated an ancient display of wartime heroism that is recounted by Plutarch (*Lives*, "Publicola," XVII) and Livy (*From the Founding of the City*, II.12-13), among others. Gaius Mucius was a Roman who, intending to kill the enemy king Porsenna, slew one of Porsenna's men instead and was taken prisoner. In order to prove his fearlessness to his captors, he held his right arm in the flames of an altar without showing any pain. This display of valor so impressed Porsenna that he spared the Roman's life, a decision that led, in turn, to a negotiated settlement between the Romans and Porsenna's forces. In commemoration of his ordeal Gaius Mucius won the epithet *Scaevola*—"left-handed." Courage was a fundamental royal virtue, the more so when it led to peace.

The *Ulysses Discovers Achilles among the Daughters of Lycomedes* (fig. 26) illustrates another characteristic of heroic virtue. At the behest of his mother, the sea nymph Thetis, Achilles had disguised himself as a woman among the daughters of Lycomedes instead of joining the Greek army that was mobilizing against the city of Troy. The Greek general Ulysses penetrated the ruse by placing an array of trinkets and arms before the women and by having one of his men sound an alarm. Caught off guard, Achilles revealed himself by instinctively seizing the weapons in order to ward off the feigned attack (Hyginus, *Myths*, 96). So great was his heroic virtue that it could not be suppressed—a trait worthy of royal emulation.

The last of the four pictures in that row, the *Hercules and Antaeus* (fig. 44), portrays another hero's victory over a justly punished villain. Antaeus, the king of Libya, was a giant who challenged strangers to wrestle and who killed them when they became exhausted. Hercules defeated him by holding him off the Earth (his mother and the source of his strength) and crushing him to death (Apollodorus, *The Library*, II.5.11; and Diodorus Siculus, *The Library of History*, IV.17). Like its pendant, the *Perseus and Andromeda*, the picture celebrates the triumph of virtue. Indeed, Hercules was considered the paragon of heroic virtue.[196] This subject would have had added significance for Philip

---

[195] Martin, "Rubens's Last Mythological Paintings," 117-18.

[196] E.g., Ripa, *Iconologia*, 537-38.

IV because the kings of Spain traditionally claimed descent from Hercules and because Libya was ruled by the infidels whom the Spanish monarchy had historically opposed.[197]

To the extent that the struggle between good and evil depicted throughout the hall carried religious connotations, it was significant that three of the protagonists in the four preceding paintings each had an immortal parent. Jupiter fathered Perseus and Hercules (yet another of the parallels between Rubens's pendants), and the sea nymph Thetis was Achilles' mother. These circumstances lent the pictures overtones of divinities (demigods) triumphant over their enemies, implying an analogous victory of Catholicism over its foes.

It is when we turn to Tintoretto's paintings above the mirrors that we begin to find departures from Carducho's precepts for palace decoration. The *Judith and Holofernes* (fig. 49) illustrates the story of the virtuous Jewish heroine who beheaded the enemy commander who had menaced her people (Judith 13:1-10). Once again courage was presented as a virtue, and a wicked villain was done away with. Too little is known of the *Myth of Venus* to determine what import, if any, it had for the meaning of the ensemble. The *Battle of Christians and Turks* (fig. 50) that later replaced the *Myth of Venus* cannot be evaluated with certainty until the seventeenth-century perception of its subject is confirmed. If it was regarded as a *Battle of Christians and Turks* (that is, if the royal inventories erred by calling it an "Abduction of Helen"), then its pertinence to the program is obvious. On the other hand, if it was consistently understood as an *Abduction of Helen*, then its contribution to the program is not as easily defined. It might have referred to the many displays of valor that marked the Trojan War, which Helen's abduction precipitated; it might have been admonitory, implying that Paris' intemperate love for Helen brought on years of conflict and destruction; or it might have had some more obscure significance. Another possibility is that it was transferred to the room without regard for the program.

It is not known which episode Tintoretto portrayed from the myth of *Venus and Adonis*, but it was probably either a "Parting of Venus and Adonis" or a "Venus Mourning the Dead Adonis," the two events that artists represented

[197] On the Spanish use of Hercules imagery, see Diego Angulo Iñiguez, "La mitología y el arte español del Re-       nacimiento," *BRAH* 130 (1952), 121-90; and Brown and Elliott, *Buen Retiro*, 156-61.

most frequently.[198] According to Ovid (*Metamorphoses*, X.519-59 and 708-39) Venus loved the mortal hunter Adonis and warned him against the dangers of pursuing wild beasts. Nevertheless, he was fatally wounded in the thigh by a wild boar shortly thereafter. Stricken with grief, Venus transformed his blood into an anemone so that its annual blooming would commemorate her sorrow. In effect, this conferred a kind of immortality upon him. The hunter's bravery was a trait worthy of emulation, especially at a court where hunting was a favorite royal pastime.[199] Furthermore, in narrower, more theological terms, the goddess' conferral of immortality on a mortal whom she loved signified the analogous Christian reward of resurrection that awaited the Catholic faithful.[200]

Tintoretto's remaining subject, *Pyramus and Thisbe*, resists incorporation into a program devoted to royal comportment. Perhaps this tale of ill-starred lovers whose double suicide resulted from a misunderstanding (Ovid, *Metamorphoses*, IV.55-166) was intended to warn against the consequences of unrestrained passions. Otherwise, its presence must have resulted from other considerations, such as the need for four Tintorettos of comparable size to place above the mirrors or the use of the hall as a showroom for the king's favorite painters. There is nothing to prove or disprove that the four original Tintorettos were conceived as a set. It is quite possible that they were assembled as a group in Madrid, not Venice.

The pictures that adorned the south wall may be conveniently considered in pairs, just as they are listed in the 1686 inventory. Veronese's *Christ Child among the Doctors* (fig. 51), which depicts the Saviour's display of wisdom and understanding at an early age (Luke 2:42-52), pertained to the program as a reference to the Faith and its superiority over Judaism (represented by the rabbis), and as a reference to the intellectual qualities that were desirable in princes. Its pendant, the Bassano shop's *Forge of Vulcan* (fig. 52), cannot be related to the overall themes of the room as easily. If its precise subject is

---

[198] E.g., see the lists of examples compiled in Andor Pigler, *Barockthemen: Eine Auswahl von Verzeichnissen zur Ikonographie des 17. und 18. Jahrhunderts*, 3 vols., rev. edn. (Budapest, 1974), 2:254-64.

[199] For the significance of hunting, see the discussion of the Octagonal Room in Chapter IV.

[200] Jeanne Chenault, "Ribera, Ovid and Marino: 'Death of Adonis,'" *Paragone* 22 (1971), 74-75, demonstrates that a moralizing tradition associating Adonis' death with Christ's was still active in the seventeenth century.

"Venus Seeks Arms for Aeneas," then it may refer to the virtuous prince's need to arm himself—spiritually as well as physically—against his enemies. On the other hand, if the picture is meant to represent "Vulcan and the Cyclopes Forging Cupid's Arrows," then the pairing with the Veronese may have been based on nothing more consequential than the motif of a youth among adults that is common to both. Aside from that, they might have been paired on such nonprogrammatic grounds as their comparable size and Venetian origins.

With the *Finding of Moses*, whether the known version by Gentileschi (fig. 40) or a lost work by Veronese, and with Veronese's *Jacob Waters Rachel's Flock*, we return to surer ground: the display of qualities worthy of royal emulation. In the *Finding of Moses* those qualities were courage and compassion. The Pharoah of Egypt had ordered that all male Hebrew infants be cast into the Nile, but when his daughter found the baby Moses adrift in a reed basket, she took pity and rescued him (Exodus 2:3-10). In Gentileschi's version her knowledge of the risk that she is taking is made apparent by her pointing out that the infant has been circumcised. The *Jacob Waters Rachel's Flock* represented a less dramatic act of kindness. Jacob first met Rachel when she brought her father's flock of sheep to a well, where Jacob had already encountered some shepherds. It was the shepherds' custom to roll back a stone that covered the well when all their flocks were gathered there. Because Rachel had come at the wrong time, they refused to open the well, whereupon Jacob moved the rock himself and watered the sheep for her (Genesis 29:1-12). In these two Old Testament stories the models of virtuous behavior are not commoners. One was the pharoah's daughter, a princess, and the other, Jacob, was a future patriarch of Israel. Both were fitting exemplars of royal behavior.

The *Satyr Squeezing Grapes* (cf. fig. 37) and the *Three Nymphs Filling the Horn of Plenty* (fig. 38) both referred to earthly abundance. In the former, now lost, a satyr introduced two little fauns to the joys of the grape, and a tigress nursed her cubs. In the latter a cornucopia is filled to overflowing with fruits and vegetables. The pair conveyed no profound moral meaning, but within the context of the Hall of Mirrors they might have been taken to illustrate the prosperity and well-being that resulted from good kingship. Otherwise the pictures were on view solely for their beauty.

Ribera's *Jael and Sisera* and *Samson and Delilah* (cf. fig. 41) were originally conceived as pendants because their subjects were complementary. Jael was a virtuous heroine who slew Sisera, an enemy of her people (Judges 4:17-22), whereas Delilah was a villainous harlot whose treachery brought about Samson's downfall ( Judges 16:17-21). These themes of the conflict between good and evil lent themselves naturally to the program. Like Tintoretto's *Judith and Holofernes*, the *Jael and Sisera* illustrated a woman's heroic valor. The *Samson and Delilah* served as a moral admonition in which the ruin that consorting with a harlot brought upon Samson became a warning against abandoning the virtuous life in order to appease baser instincts.

Velázquez's *Apollo and Marsyas* and *Mercury and Argus* (fig. 53) illustrated two myths of gods who triumphed over lesser, bestial creatures. The satyr Marsyas rashly challenged Apollo to a contest of musical skill and lost. As retribution for the temerity of the challenge, Apollo skinned him alive (Ovid, *Metamorphoses*, VI.382-400). That punishment was the subject of Velázquez's lost painting. The surviving *Mercury and Argus* depicts Mercury's rescue of Io, who had been transformed into a cow, from Argus, a watchman with one hundred eyes who had been set to guard her. The god lulled his victim to sleep with a flute and then beheaded him with a sword (Ovid, *Metamorphoses*, I.668-721). The pairing of these two subjects was appropriate because each featured a god who overcame an inferior being with music and then took a blade to him.

Velázquez's two other mythologies differed by depicting tales of gods who loved mortals and who rewarded them with forms of immortality. It is not known which specific episode of their story his *Venus and Adonis* portrayed, but he probably selected one different from Tintoretto's picture for the sake of variety. The episode represented in the *Cupid and Psyche* is not known either. In essence, that tale (Apuleius, *The Golden Ass*, IV-VI) is another story of virtue triumphant in which the mortal woman Psyche performs seemingly impossible tasks set by Venus and thereby wins permission to marry Cupid, who loves her. He, in turn, persuades Jupiter to admit Psyche to the immortal company of the Olympian gods.

All four of Velázquez's mythologies lent themselves to the general sense of the program—the virtuous were rewarded and the ignoble were punished.

Because the four subjects entailed the relations between divinities and mortals, they also alluded to the religious spirit of the program. A god's conferral of immortality signified the Christian promise of resurrection to the Catholic faithful. The punishments inflicted upon Argus and Marsyas, on the other hand, symbolized the divine retribution awaiting nonbelievers.[201]

To sum up, the subject-pictures that accompanied the royal portraits on the walls in 1659 constituted a compendium of virtues that the Spanish Habsburgs embraced and vices that they shunned. The paintings reminded the spectator that the virtuous would inevitably triumph and that the wicked were doomed to destruction. Piety, in particular, was presented as a necessary virtue, and the royal portraits made it perfectly clear which faith merited the viewer's devotion. The program was most coherently presented on the north wall, where the applicability of the paintings' subjects to the overall theme was readily apparent. The canvases on the end walls accorded well with the program, except for a few of the Tintorettos. It was the south wall on which the role of the hall as a gallery of beautiful paintings was most in conflict with its role as a statement of the royal character and mission. To different degrees the *Forge of Vulcan*, the *Satyr Squeezing Grapes*, and the *Three Nymphs Filling the Horn of Plenty* pose difficulties for those trying to accommodate all the works in an overall program. On the other hand, it is telling that the program readily accommodates all the subject-pictures that were expressly commissioned for the hall—the four works ordered from Rubens in 1639 and the four mythologies that Velázquez painted in 1659.

That leaves the ceiling fresco devoted to Pandora to be accounted for. It, too, enhanced the presentation of the Spanish Habsburgs as heroic proponents of Catholicism. According to her myth it was Pandora who released into the world all the evils that afflict mankind when she opened the vessel that Jupiter had given her as a dowry. The patristic tradition that equated her with Eve, who brought about the Fall of Man, had been revived in the sixteenth century.[202] Because one of the subsidiary scenes in the fresco showed Prometheus

[201] An established interpretive tradition regarded Apollo's harsh punishment of Marsyas as just—e.g., Pedro Sánchez de Viana, *Anotaciones sobre los quinze libros de las Trāsformaciones de Ouidio: Con la Mithologia de la fabulas y otras cosas* (Valladolid, 1589), fol. 131ᵛ, interprets the myth as a warning against temerity, "in the same manner that God is accustomed to punish the folly of the conceited and the haughty."

[202] Panofsky and Panofsky, *Pandora's Box*, 64 and 154-56.

rejecting Pandora's advances, it is certain that she was meant to be seen in a negative light. The implication of the fresco for the overall program was that the evils that Pandora had released into the world were opposed by the Spanish Habsburgs, Christian princes all.

That was the long-term significance of the fresco. In an extraordinary case of dual meaning, however, it also communicated a contradictory, short-term message, one that explains the surprising omission of Pandora opening her vessel from the ceiling. This second meaning was rooted in the events of 1659, the year that the Marshal-Duke of Gramont visited Madrid in order to solicit María Teresa's hand on behalf of Louis XIV. The marriage had been desired by the French for several years in spite of the fact that Spain and France had been at war since 1635. An early manifestation of that interest occurred in 1653, when Anne of Austria (Philip IV's sister and Louis XIV's mother) sought to obtain a portrait of María Teresa through the agency of the Venetian ambassadors in Paris and Madrid. In March 1654 the ambassadors transmitted another request to the Spanish court for fifteen portraits of members of the House of Austria, and in September 1654 Philip asked in turn for ten portraits of the French royal family. On October 9, 1655, Giacomo Querini, the Venetian ambassador to Spain, advised the Venetian Senate that the French portraits had reached Madrid. One depicted Louis XIV, and Querini reported a week later that María Teresa took advantage of every pretext to visit the gallery where it hung, explaining to her maids of honor, *"Saludo a mi novio"*—"I salute my suitor."[203]

The French raised the possibility of a royal match during peace negotiations in the summer of 1656, but the Spanish rejected the suggestion.[204] Because Philip had no legitimate son at the time, María Teresa was the heir apparent under the fundamental law of Spain. Her countrymen feared that if she married Louis and later inherited the Spanish throne, the couple's first son would

[203] Jeannine Baticle, "Notes sur les portraits de la Maison de Bourbon envoyés en Espagne au XVIIᵉ siècle," *Revue des Arts* 10 (1960), 197-98; and *id.*, "Recherches sur la connaissance de Velázquez en France de 1650 à 1830," in *VV*, 1:534-35. Bertaut, "Journal du voyage," 38, recounts a similar tale of María Teresa's attentions to Louis XIV's portrait.

[204] Jules J. Valfrey, *La diplomatie française au XVIIᵉ*

*siècle: Hugues de Lionne. Ses ambassades en Espagne et en Allemagne. La Paix de Pyrénées, d'après sa correspondance . . .* (Paris, 1881), 56-60; Antonio Cánovas del Castillo, *Historia de la decadencia de España desde el advenimiento de Felipe III al trono hasta la muerte de Carlos II*, 2nd edn. (Madrid, 1910), 510-11; and Reginald T. Davies, *Spain in Decline, 1621-1700* (London-New York, 1957), 68-69.

eventually inherit the crowns of both nations, thereby putting Spain under
the dominion of a king of France. That prospect was as repellant to the Spanish
as it was appealing to the French. The resulting stalemate was not broken
until November 27, 1657, when the birth of Philip's son Felipe Próspero
altered the situation dramatically. (Another son, Fernando Tomás, was born
December 21, 1658, but he died the following year.) With a male heir to the
throne at hand, the marriage became acceptable to the Spanish, and it was
successfully negotiated as part of the Peace of the Pyrenees in 1659. Later that
year Gramont made his embassy to Madrid, and María Teresa married her
French cousin in 1660.

The marriage must have been anticipated at the Spanish court by early
1659 when the ceiling fresco for the Hall of Mirrors was being planned. In
fact, because the hall had become established by then as the chamber in which
the king received distinguished visitors, the decision to paint the ceiling in
the first place may have been inspired by a wish to dress up the room in
anticipation of the French embassy. That expectation prompted Velázquez to
omit the final episode of the Pandora myth when he determined the subject
for the fresco. The disastrous outcome of Epimetheus and Pandora's marriage
would have been an unsuitable image beneath which to propose a royal union.
Instead, the dominant image overhead at the ceremony was the central oval
in which the Olympian gods bestowed their gifts of beauty, grace, and re-
finement upon Pandora. On that day the scene alluded to the many virtues of
the bride-to-be, María Teresa, while the negative aspects of the myth were
discreetly ignored.

Using Pandora to celebrate all that was good about a woman may seem a
jarring application of her story, but the literary conventions of the day per-
mitted striking transformations of ancient mythology. For example, the con-
temporary playwright Pedro Calderón de la Barca wrote a drama entitled *La
estatua de Prometeo* in which Pandora is a statue of the goddess Minerva that is
brought to life. The villainess in the play is not Pandora but Minerva's alter
ego, Pallas.[205] When classical mythology could be transformed so freely, new
interpretations of traditional subjects were readily admissible.

In addition, we should recall the interest with which the king, queen, and

[205] The play is considered in Panofsky and Panofsky, *Pandora's Box*, 118-19 and 129.

infantas followed the progress of work on the ceiling. What could have been more natural than for the royal family, especially María Teresa, to have studied intently the fresco that was meant to glorify her impending engagement and marriage? The content of the fresco was as important to the court as the spectacular style in which it was painted, for on the singular occasion of Gramont's reception it was intended to proclaim the merits of a Spanish Habsburg princess. After the conclusion of his embassy, the perceived significance of the fresco reverted to its more conventional meaning.

Thus, from the fresco on the ceiling to the furnishings on the floor, the Hall of Mirrors became an elaborate declaration of the Habsburgs' commitment to defend and to promote Catholicism, a mission that was founded on the conviction that their superior virtues as Christian princes would inevitably prevail. What is more, this bold proclamation was conveyed by a stunning ensemble of fine art that was itself compelling proof of the splendor and refinement of the royal dynasty.

### THE INVENTION OF THE PROGRAM

By 1659, the year when the definitive installation of the Hall of Mirrors was completed, Velázquez's place as the king's principal artistic advisor was secure. But should he be credited with inventing the program of the hall or only with refining it? The essentials of its meaning had been worked out decades earlier. In fact, the same program is more easily discerned from the pictures that were displayed in the New Room in 1636 than from those that were on view in 1659. The apparent sacrifice of some programmatic clarity resulted from the desire to incorporate fine works by the king's preferred artists regardless of their applicability to the overall meaning of the ensemble.

As in 1659, the four great royal portraits were in place in 1636, and their significance was the same. Moreover, two other pictures amplified their meaning—Van Dyck's *Cardinal-Infante Ferdinand* (fig. 42) and the anonymous *Battle of Nördlingen*. Although he was not a king, Ferdinand was a member of the royal family, and he had earned a place in the New Room by commanding his troops to a crushing victory over Swedish forces at the Battle of Nördlingen on September 6, 1634. Because it was a major triumph over Protestants for

the Catholic forces of the Thirty Years' War, the victory was in keeping with the themes expressed by the royal portraits. The battle was especially rich in dynastic associations because the cardinal-infante's ally and fellow commander at Nördlingen was a German Habsburg, King Ferdinand of Hungary (later the Emperor Ferdinand III). Informed courtiers visiting the New Room also might have known that the sword worn by the cardinal-infante in Van Dyck's portrait was the same one that his great-grandfather Charles V had carried into the Battle of Mühlberg, another Habsburg victory commemorated elsewhere in the room.[206] It was the affinity of Van Dyck's portrait and the *Battle of Nördlingen* with the themes of the New Room ensemble that accounted for their being placed there, rather than in the Buen Retiro, which the Crown was fitting out at the time that the two pictures were acquired.

Most of the subject-pictures that were recorded in the New Room in 1636 and that were removed by 1659 were easily accommodated within its program of dynastic glorification. Several provided further illustrations of virtuous or wicked leaders. Carducho's *Scipio Africanus Addressing the Romans* portrayed an ancient Roman commander who won important victories against the Carthaginians in both Spain and Africa, and who thereby became a forerunner of the later generations of Spaniards who fought the Reconquest and sought to contain the Muslim forces in northern Africa. Cajés's *Agamemnon and Chryses* demonstrated that a king's impious and intemperate behavior would bring divine wrath upon himself and his people. Domenichino's *Solomon and the Queen of Sheba* (3 Kings 10:1-13 and 2 Chronicles 9:1-12; cf. fig. 28) depicted the wise and devout monarch who ruled Israel during its era of greatest glory and who proved his sagacity by solving the problems that the queen propounded. A favorable comparison to the Habsburgs was obviously intended. The same artist's *Sacrifice of Isaac* (Genesis 22:1-12; fig. 27) reiterated the desirability of piety in rulers, for the Hebrew patriarch Abraham's obedience to God was so unwavering that he was prepared to sacrifice his son at the Lord's command. The anonymous *Queen Tomyris with the Head of Cyrus* (Herodotus I.204-15; fig. 24) alluded to both good and evil kingship by representing the queen's just vengeance for the bloodthirsty military tactics that the Persian king Cyrus had employed against her people.[207]

[206] Díaz Padrón, *Escuela flamenca*, 1:103.
[207] Berger, "Rubens's 'Queen Tomyris,' " 15-25, ex-amines the use of Tomyris imagery at several seventeenth-century courts.

Four other pictures conformed to the general interest that the ensemble showed in the struggle between courageous, virtuous heroes and evil villains or beasts: Rubens's *Samson Breaking the Jaws of a Lion* ( Judges 14:5-6; fig. 35) and *David Killing a Bear* (1 Kings 17:34-37; cf. fig. 36); and the *Samson Drinking from the Jawbone* (after slaying the Philistines; Judges 15:15-19) and *Cain Slaying Abel* (Genesis 4:3-8; cf. fig. 29) begun by Camillo Procaccini. In the first three a hero prevailed, whereas the fourth provided an admonition against intemperate behavior (the murderous consequences of Cain's jealousy). The *David Killing a Bear* was more than a story of a shepherd defending his flock because David cited his killing a bear and a lion as proof that the Lord was with him and that he was the champion best suited to oppose the evil Philistine giant, Goliath. The net of the program can even be stretched to encompass the *Hunt of Meleager and Atalanta* (Homer, *Iliad*, IX.430-605, and Ovid, *Metamorphoses*, VIII.270-547; cf. fig. 32) and the *Hunt of Diana* (fig. 34) by Rubens and Snyders. In the seventeenth century hunting was regarded as a suitable activity for princes that afforded them a peacetime opportunity to display heroism and to train for war.[208] Had Reni's *Abduction of Helen* reached Madrid and joined this ensemble, it could have been interpreted in the same moralizing light as is suggested above for the so-called *Abduction of Helen* by Tintoretto that later hung in the room.

Artemisia Gentileschi's *Hercules and Omphale* was strikingly out of place in such company. Evidently it was commissioned to hang as a pendant to the *Ulysses Discovers Achilles* by Van Dyck and Rubens. They were the same size, they were hung together in 1636 (C15, 16), and they both portrayed valorous warriors who, for a time, assumed what were traditionally women's roles.[209] Yet Gentileschi's picture posed a problem: Whereas the point of the *Ulysses Discovers Achilles* was that Achilles' heroic nature could not be repressed, the *Hercules and Omphale* depicted an unheroic Hercules overcome by love for Omphale and reduced to spinning thread meekly among women. However effective a contrast to Achilles that might have made for didactic purposes, it was hardly the image of his presumed ancestor that the king of Spain wanted to promote. When Philip set about refining the New Room in the late 1630s,

[208] See the discussion of the Octagonal Room in Chapter IV.

[209] Gérard, "Early Italian Commissions," 12.

he may have commissioned the *Hercules and Antaeus* from Rubens with an eye
to removing Gentileschi's objectionable painting from the ensemble and in-
troducing an image of his ancestor that better suited the propagandistic intent
of the program.

By 1636, then, the program had evolved to the point that it accounted
satisfactorily for all but one painting in the room. In fact, the tenets of the
program had been laid down even earlier, in the 1620s, albeit in an improvised
manner. From the beginning royal portraiture had played a role in the dec-
oration, and paintings such as the *Exchange of Princesses* and the *Entry of Philip
III into Lisbon* had also glorified the royal family. Titian's *Religion Aided by
Spain* (fig. 18) announced the Habsburg mission in allegorical terms. Although
precise explanations of its meaning vary, it is generally regarded as showing
a strong and confident personification of Spain coming to the assistance of the
naked personification of Faith.[210]

Titian's *Furias*, with their moralizing warnings against impiety; Rubens
and Van Dyck's *Ulysses Discovers Achilles*, with its lesson that true virtue could
not be suppressed; and the anonymous *Queen Tomyris with the Head of Cyrus*,
with its implicit judgment of good and bad kingship—all these were on view
during the first years that the hall was decorated. While Titian's *Adam and
Eve* (fig. 20) hung there, its illustration of the Fall of Man alluded to the
Original Sin from which only the Catholic faith of the Habsburgs could redeem
mankind. Years later that theme would be restated by the Pandora ceiling
fresco.

The program evolved rapidly from that nucleus of works. By 1626, when
Carducho and Cajés were respectively painting *Scipio Africanus Addressing the
Romans* and *Agamemnon and Chryses*, the meaning of the New Room had begun
to take on its distinctive character. Although the *Hercules and Omphale* fitted
the developing scheme awkwardly, the rest of the Italian commissions of 1627-
1628 lent themselves to the purpose. Rubens's gift of eight paintings in 1628
was rich in subject matter that elaborated the overall statement. Thereafter
the king and his artistic advisors were alert to possible acquisitions whose

---

[210] Wethey, *Paintings of Titian*, 1:124, summarizes the literature. See esp. Rudolf Wittkower, "Titian's Allegory of 'Religion Succoured by Spain,'" *JWCI* 3 (1939), 138- 40; Erica Tietze-Conrat, "Titian's Allegory of 'Religion,'" *JWCI* 14 (1951), 127-32; and Panofsky, *Problems in Titian*, 186-90.

aesthetic quality and symbolic content suited them to the ensemble. By 1636 the program had attained remarkable lucidity and beauty.

No document names the advisors who worked out the program of the New Room with the king's approval, but there is a clue to their identities in the similarity of its concerns with those of the program of another royal chamber: the Hall of Realms in the Palace of the Buen Retiro.[211] Itself a majestic statement of Spanish royal propaganda, the Hall of Realms was decorated between late 1633 and early 1635—that is, at about the same time that the program of the New Room had fully blossomed. Like the New Room, the Hall of Realms was at first most appreciated for its view. When fiestas were celebrated in the Principal Court of the Buen Retiro, the Hall of Realms served as the royal box. Later it served as a throne room in which the king presided over court ceremonies and entertainments. In other words, it became an official setting for the monarch, such as the New Room eventually became, and its decoration enhanced that use.

The Hall of Realms took its name from the coats of arms of the Spanish realms that were frescoed on its ceiling, but its decorative glory hung on the walls below. There three sets of paintings celebrated Philip IV, his dynasty, and the triumph of Spanish arms under his wise and courageous leadership. On the two end walls five equestrian portraits by Velázquez and his assistants depicted Philip III; his wife, Margaret of Austria; Philip IV; his first wife, Isabella of Bourbon; and his son, Prince Baltasar Carlos. Like the four great portraits in the New Room, they demonstrated the continuity of the royal line, in this case from the reigning monarch's parents to his heir apparent. Furthermore, the male portraits characterized their subjects as military commanders, thereby asserting, as in the New Room, that the Habsburg kings of Spain stood ready to take to the field of battle in order to accomplish their goals. Twelve large battle pictures that dominated the side walls identified those goals as the preservation of the Monarchy and the defense of Catholicism. Each illustrated a Spanish victory from the years of Philip IV's rule, and all but one (depicting the relief of a Spanish ally, Genoa, from a siege by the French and the Savoyards) glorified successes against Protestant opponents. Eight painters created the battle pictures—Cajés, Carducho, Félix Castelo,

---

[211] The following account of the Hall of Realms draws extensively on Brown and Elliott, *Buen Retiro*, 141-92.

Jusepe Leonardo, Juan Bautista Maino, Antonio Pereda, Velázquez, and Francisco de Zurbarán. All had made their careers in Castile except Zurbarán, the leading painter in Seville, who was summoned to Madrid to participate in the project.

Zurbarán painted the entire third series, ten deeds of Hercules, which alternated with the battle scenes on the lateral walls. These recalled the distinguished ancestry that the kings of Spain claimed and summoned up all the positive traits associated with Hercules as qualities of the Habsburg line: Hercules the paragon of strength and heroic virtue; Hercules the conqueror of discord; and Hercules the mortal of such noble accomplishment that he was apotheosized into the immortal company of the Olympian gods. By analogy the Habsburg kings of Spain were no less valorous, no less determined to bring peace and harmony to their realms, and no less certain to attain a heavenly reward.

It has been persuasively argued that three men formulated the program of the Hall of Realms.[212] Foremost among them was the king's favorite, the Count-Duke of Olivares, who as the governor of the Buen Retiro was instrumental in seeing it built and decorated. The preservation of the Monarchy and the defense of the Faith were the cornerstones of his foreign policy, and by celebrating the victories of Spanish arms, the Hall of Realms defended his conduct of the affairs of state. (Of course, no hint was given of Spain's military setbacks under his regime.) Two of Olivares's Sevillian protégés probably assisted him in working out the details of the ensemble—the poet Francisco de Rioja and the painter Velázquez. Rioja, a classical scholar and Olivares's personal librarian, was also the chronicler of Castile (i.e., an official historian to the Crown). With such a background he was ideally suited to assemble the historical details to be represented in the battle paintings and to select appropriate deeds of Hercules for Zurbarán to paint. As a practicing artist, Velázquez was well equipped to coordinate the mechanical aspects of the job such as working out the dimensions of the paintings, assigning the subjects to different artists, and supervising the execution of the pictures. Together these three men oversaw the transformation of the bare walls of the Hall of Realms into an extraordinary panegyric to Philip IV and his rule.

[212] *Ibid.*, esp. 190-91.

Likewise, Olivares and his circle are the most likely candidates to have imposed a program on the New Room as its early decoration evolved. By 1636 the New Room, like the Hall of Realms, was informed by an unwavering belief that the Habsburg kings of Spain, a royal line unmatched in virtue, had a sacred mission to defend the Monarchy and its faith against all opponents. Turning the court into a glorious setting for Philip IV was one of Olivares's preoccupations, and as he lived in apartments on the main floor of the Alcázar, the decoration of the King's Quarter could not have escaped his attention. The splendor of the New Room was perfectly in keeping with the ideas of a minister who embraced the traditional notion that a king's greatness was expressed by the dignity and splendor of his dwellings.[213]

One telling clue to Olivares's interest in the New Room is that the two judges in the 1627 competition to paint "Philip III and the Expulsion of the Moriscos," the architect Giovanni Battista Crescenzi and the painter Maino, both belonged to the Olivares circle.[214] It is also significant that the programmatic meaning of the hall was most clearly expressed while Olivares was in power. If, as has been suggested, the *Hercules and Antaeus* was commissioned from Rubens in order to replace Artemisia Gentileschi's *Hercules and Antaeus*, then after Rubens and Jordaens's picture was installed in 1641, the overall program would have satisfactorily accounted for every painting in the room. After Philip dismissed Olivares in 1643, the consistency of the program suffered as a few pictures were admitted to the renamed Hall of Mirrors for their beauty rather than for the appropriateness of their meaning. That resulted from the shift of influence over the decoration from Olivares, first and foremost a politician, to Velázquez, first and foremost an artist.

The contemporary decoration of the Hall of Mirrors and the Hall of Realms in the two great palaces of Madrid inevitably begs a comparison. Although both ensembles were directed toward similar ends, they differed in the means by which those ends were achieved. Because the Hall of Realms was conceived and decorated in a single campaign, it was the more coherently organized. Restricting the subjects of the wall paintings to three narrowly defined sets—equestrian royal portraits, Spanish military victories, and deeds of Hercules—rendered the meaning of the room more accessible. The fact that the sets of

[213] *Ibid.*, 233-35.                    [214] *Ibid.*, 44-45.

battle pictures and Hercules myths were each of consistent sizes imposed a sense of order and regularity on the ensemble, as did the fact that Velázquez was responsible for all the portraits and Zurbarán for all the Hercules scenes. Owing to the speed with which all these pictures were completed, they were entirely the work of contemporary Spanish painters.

The Hall of Mirrors, on the other hand, evolved slowly, sometimes by happy accident, and it continued to change well after the decoration of the Hall of Realms had been fixed permanently. It presented a far more varied blend of subject matter, of sixteenth- and seventeenth-century painting, and of Flemish, Italian, and Spanish styles. Even the dimensions of its pictures were more diverse. As a result, its program may not have been discerned as readily by the casual spectator. One measure of this is that the Hall of Realms is the better remembered of the two chambers.

In other ways, however, these differences worked to the advantage of the Hall of Mirrors. The protracted manner in which its paintings were assembled allowed for greater selectivity. As a result, the room ultimately contained an ensemble of higher quality. Titian, Rubens, and Velázquez—later joined by Tintoretto and Veronese—were masters of the highest order, whereas most of the painters represented in the Hall of Realms were less accomplished. Velázquez's equestrian portraits make a handsome set, and his one battle picture, the *Surrender of Breda*, is a masterpiece, as is Maino's sole contribution, *The Recapture of Bahía*. Leonardo and Pereda rendered battle scenes that are pleasing for their color, but the surviving contributions by Cajés, Carducho, Castelo, and Zurbarán are disappointing, routine efforts. By 1640 Carducho's *Scipio Africanus Addressing the Romans* had been banished from the New Room, but he still had three battles on view in the Hall of Realms. Zurbarán's Hercules series is a mixed performance. Although he brought off a few pictures forcefully (most notably the *Death of Hercules*), the suite as a whole invites the conclusion that his limited training had left him inadequately prepared to render a heroic, male nude engaged in violent action. Even the best of these works pale beside the mythologies designed by Rubens and Titian that adorned the Hall of Mirrors. Nor can there have been any comparison between the uninspired coats of arms on the ceiling of the Hall of Realms and the myth of Pandora that eventually crowned the Hall of Mirrors. Each ensemble was more than the

sum of its parts, but in the Hall of Mirrors each part was more likely to be of interest in its own right.

Another, more ironic difference between the two rooms was that although the paintings in the Hall of Realms were all by contemporary artists, the ensemble as a whole was the more old-fashioned.[215] The greater part of its imagery—the royal portraits and the battle pictures—was literal and narrative in character. Aside from the emblematic coats of arms on the ceiling, only the Hercules paintings depended on the more evocative technique of symbolic analogy to convey their point about the character of the Habsburg regime. This ran counter to the tendency of seventeenth-century Halls of Princely Virtue to play down literal, narrative images in favor of allegory and other forms of analogical symbolism.

In that sense the decorative program in the Hall of Mirrors was more modern. Whereas the portraits in the Hall of Realms avoided allegory and depended entirely upon the persons of the royal family to convey the greatness of the Habsburg line, three of the four great portraits in the Hall of Mirrors embellished their subjects with allegorical personifications. Victory swooped toward Titian's Philip II, Spain sat enthroned beside Velázquez's Philip III, and both Catholic Faith and Divine Justice accompanied Rubens's Philip IV onto the battlefield. Although some pictures represented the royal family in essentially literal or narrative terms in the early years of the New Room— Titian's *Charles V at Mühlberg*, Van Dyck's *Cardinal-Infante Ferdinand*, González's *Portrait of Philip III*, the *Entry of Philip III into Lisbon*, the *Exchange of Princesses*, and the *Battle of Nördlingen*—in the end, only the *Charles V* remained in the hall.[216] The numerous subject-pictures had to be interpreted as analogies of virtuous and wicked behavior if they were to contribute to the program.

An advantage of the analogical mode of decoration over the literal-narrative was that it was less likely to pass out of date. In the definitive arrangement of the Hall of Mirrors in 1659 neither the *Equestrian Portrait of Philip IV* nor

[215] *Ibid.*, 155-56, first noted this distinction.

[216] This is not to say that the *Charles V* was devoid of symbolic content; e.g., as previously remarked, the spear carried by the emperor summoned up associations with ancient Roman emperors, Christian knights, and opponents of heresy. What is significant here is that Titian refrained from using overt allegorical devices like personifications in the portrait; indeed, he rejected the advice of his friend Pietro Aretino that he include personfications of Religion and Fame in it (Panofsky, *Problems in Titian*, 86-87).

any of the subject-pictures alluded to specific events. Only the three other royal portraits did so, and by good fortune none of them had become an embarrassment. Charles V's victory at Mühlberg had occurred so long before that it could be appreciated as a triumph even though the Habsburgs had failed to stamp out German Protestantism. Because the Turkish Empire was much less an immediate threat than it had been in 1571, Titian's *Allegorical Portrait of Philip II after the Battle of Lepanto* could still be displayed proudly. It made no matter that Prince Ferdinand had not succeeded his father, for by the seventeenth century many observers had lost track of who the baby in the picture was (A10, C6, and D7; Carducho, B7, named him correctly). As for Philip III, because the Moriscos whom he had expelled in 1609 had not returned, Velázquez's portrait of him remained attuned to everyday reality. The prevailing emphasis within the program upon general statements about royal virtue rather than upon specific incidents had preserved the forcefulness of the argument.

The same could not be said for the Hall of Realms. Baltasar Carlos's death in 1646 undermined the message implicit in the royal portraits that the king would be succeeded by a worthy heir. Philip's next legitimate son, Felipe Próspero, was not born until 1657, and in the end, the king's successor was the sickly Charles II, born in 1661. Several of the military victories commemorated in the battle pictures were reversed within a few years of the completion of the paintings. As it happened, the outcome of one battle had been overturned even before the initial victory had been painted.[217] By 1659 the too-literal imagery of the battle pictures would have inspired cynicism rather than pride. On every front, the might of Spanish arms was being thwarted. The Treaty of Münster had confirmed Dutch independence, the Portuguese rebels had secured de facto independence, and the Peace of the Pyrenees had just been concluded to the advantage of France. The self-congratulatory attitude of the battle pictures simply did not accord with reality.

Because the Hall of Mirrors presented a generalized statement about the *ideals* of the regime, it retained credibility. Because the Hall of Realms boasted of the *accomplishments* of the regime, its program increasingly sounded a hollow note as events at home and abroad denied the greatness asserted by the paint-

[217] Brown and Elliott, *Buen Retiro*, 164-68.

ings. By 1659 the program of the Hall of Realms was a message whose time had passed.

History has since been kinder to the Hall of Realms—more so than to the Hall of Mirrors. Today both should be appreciated not for the accuracy of their statements, but for the eloquence with which they made them. A profound sensitivity to the ways in which beautiful images could be joined to create complicated meanings underlay the decoration of both chambers. By 1636 the thematic character of both ensembles had been determined, and although the contents of the Hall of Mirrors were later changed, its meaning was not substantially altered. Taken together, these two impressive state chambers epitomized the fundamental convictions that the Spanish Habsburgs held about themselves and their place in the world.

# The Gilded Hall and Conventions of Spanish Habsburg Decoration

O NE OF THE recurrent needs of the Spanish Habsburg court was a vast indoor space in which large audiences could assemble to witness majestic state ceremonies and lavish royal entertainments. In the Alcázar of Madrid that need was met by the *salón grande* (Great Hall), which took its name from its colossal size (fig. 13; no. 23). It rose two stories in height, and before it was subdivided in the seventeenth and early eighteenth centuries, it measured 36 × 166 Castilian feet (about 10 × 46.5 meters) in plan.[1] During Philip IV's reign it was also called the *salón de las comedias* (Hall of Comedies or Hall of Plays) for its use as a theater, and the *salón dorado* (Gilded Hall) for its redecoration around 1640. As in the Hall of Mirrors, its various decorative schemes throughout these years promoted the glory of the Spanish Habsburgs. These schemes culminated in an exceptional combination of paintings and tapestries that, like the earlier ensembles in the hall, incorporated themes found repeatedly in other decorative programs at the court. It is against this background—the conventions of Spanish Habsburg decoration—that the Great Hall should be considered.[2]

## A ROYAL ASSEMBLY HALL

Gómez de Mora's *relación* identifies this immense space as the "Great Hall in which celebrations with plays and balls are held and in which the King and Queen dine in public on the wedding day of ladies who marry in the Palace."[3] It is best remembered today as the setting for court entertainments that included dances, masques, and, above all, theatrical performances. Such festiv-

---

[1] Martín González, "El Alcázar de Madrid," 6.

[2] This chapter builds upon the considerable foundation of material assembled by Varey and Shergold, *Los celos,*

esp. lv-lxxi and 143-68.

[3] Gómez de Mora, "Relaçion de las cassas," fol. 1ᵛ.

ities often were held to celebrate events of special significance to the royal family, among them births, baptisms, birthdays, engagements, and marriages. When plays were presented, the seating of the audience was governed by a strictly defined protocol that was set down in the *etiquetas* of 1647-1651.[4] In brief, the actors performed at the west end of the hall, the king and members of the royal family sat toward the east end, and the remaining spectators were ranged along the walls in the intervening space. After a performance ended, the ladies of the court would file out in pairs, stopping to curtsy before the king. Thus, the king and his family were the focus of attention by virtue of their location and the courtesies paid to them. The other use that Gómez de Mora cites refers to a custom whereby a lady of the court was privileged on her wedding day to dine in public with the king and queen. The meal was served on a dais at the head of the room (its east end) in accordance with another ceremony that was included in the *etiquetas* of 1647-1651.[5]

The king also used the Great Hall for receptions of extraordinary visitors to the court before such events were assigned to the Hall of Mirrors. It was there that Philip III twice received the Duke of Mayenne in 1612 when he made his embassy in order to sign the marriage contract between Anne of Austria and Louis XIII. There, too, the Crown received Princess Margarita of Savoy, Dowager Duchess of Mantua, in 1634. When the princess entered Madrid, Philip IV escorted her through the city to the Alcázar, whereupon "They entered by the secret staircase in the Small Vestibule, the work of his grandfather; they arrived at the Great Hall; and the Queen came out from her quarter with her ladies to the New Room and to the [Great] Hall by a door that is located before [the place where] one begins to descend the staircase, where the Queen was waiting and had just arrived."[6] (The Small Vestibule was an entrance to the Alcázar in the base of the old Homage Tower.) As the Princess of Carignano was welcomed with comparable honors in 1636, she too, must have been received in the Great Hall.

Such receptions were carefully planned events. On at least one occasion, however, the Great Hall became the setting for a spontaneous gathering owing

[4] Varey, "L'Auditoire du Salón Dorado"; and "Etiquetas," 565-68.

[5] "Etiquetas," 455-59.

[6] Novoa, *Historia*, 3:22; see also *Cartas de algunos PP.*, 1:107.

to its capacity to hold a crowd. When word of the Spanish victory at Fuen-
terrabía reached the court on September 10, 1638, Philip brought the news
to the queen in her quarters. Then, in an astonishing breach of royal decorum,
"he came out to the Great Hall of the Palace because the crowd, which consisted
of men of every class, was such that the halberdiers could not contain it,
because they began to throw stones. The King commanded that they allow
them free passage, and thus the hall was filled with titled nobility, knights,
and some commoners. All kissed the King's hand, and His Majesty embraced
most of them and walked among them, passing through the hall as if they
were equals."[7]

The *etiquetas* of 1647-1651 also assign to the Great Hall the *juramento de
pazes*, a diplomatic ceremony at which the king would swear to uphold a peace
treaty with another nation in the presence of its ambassador.[8] On such occasions
the king's chief major-domo or a grandee would meet the ambassador at the
door to the Antechamber and escort him to the hall along the reception route
through the King's Quarter. Such events took place on December 17, 1630,
when Philip IV swore to uphold a newly negotiated peace with England in
the presence of Sir Francis Cottington, and on August 31, 1679, when Charles
II swore to uphold the Treaty of Nijmegen with France in the presence of the
Marquis of Villars.[9]

The Great Hall was put to its most solemn use when a deceased king,
queen, or heir apparent lay in state before the body was conveyed to El Escorial
for interment.[10] The forms to be observed were codified in the *etiquetas* of
1647-1651.[11] The deceased would be displayed on a platform erected at the
east end of the hall, and an altar for Pontifical Masses would be placed in front
of it. While the body lay on view, clerics from the Royal Chapel and delegations
from all the monastic communities in Madrid would celebrate Low Masses at
six more altars arranged along the side walls. During the years of Philip IV's

[7] *Cartas de algunas PP.*, 3:22.

[8] "Etiquetas," 385-89.

[9] "Clausulas," fol. 89; Pierre, Marquis de Villars, *Mé-
moires de la cour d'Espagne de 1679 à 1681*, ed. M. A.
Morel-Fatio (Paris, 1893), 70; and *Relaciones breves*, 396.

[10] In the case of an heir apparent, he was only entitled
to such a lying in state if he were a *príncipe jurado* ("sworn

prince")—i.e., an heir apparent to the Crown of Castile
and León whom the nobility of the Crown and the *pro-
curadores* of its great cities had legally recognized with an
oath of allegience. "Etiquetas," 307-50, describes the
ceremony at which the oath was given.

[11] *Ibid.*, 578-81.

reign, this ceremony was observed following the deaths of Philip III (1621), Isabella of Bourbon (1644), and Philip IV himself (1665).[12]

The Great Hall, then, was the setting for diverse social and state functions at which the king—and, at times, other members of the royal family—was the center of attention. It was a public chamber where the monarch was meant to be seen. Accordingly, its decoration had a "public" function—to promote the Habsburg dynasty in the eyes of the spectators who gathered there.

## THE EARLY DECORATION OF THE HALL

The earliest account of the decoration of the Great Hall appears in the "Thesoro choragraphico de las Espannas," a journal kept by Jacob Cuelvis, a German who traveled throughout Spain in 1599 (Appendix F).[13] When he saw it, the room was adorned primarily with views of territories, cities, and towns (F1-13, 16-21, and 25), and secondarily with military and political triumphs of Charles V (F14-15 and 26). Three curiosities rounded out the selection: two pictures from the "island of China" (F22, 23) and a "portrait of the Cook and Cupbearer" (F24) that seems to have combined the figures from Giuseppe Arcimboldo's *Cook* and *Cellarman*.[14]

A later visitor to the Great Hall, Gil González de Avila, noted the emphasis on topographical views in the decoration when he described it briefly in 1623: "In this room there are many things to see in the way of paintings, maps of many cities of Spain, Italy, and Flanders, by the hand of Jorge de las Viñas, who is foremost in this."[15] "Jorge de las Viñas" was the Flemish painter Anton van den Wyngaerde, whom Philip II had summoned to the court around 1561 and had commissioned to paint views of Spanish cities. These probably made up the greater part of the topographical paintings in the Great Hall.[16]

[12] Philip III's lying in state is cited in *Relaciones breves*, 124. For Isabella, see *Pompa Fvneral Honras y Exequias en la muerte de la muy Alta y Catolica Señora Doña Isabel de Borbon . . .* (Madrid, 1645), fols. 9-11v; and José Pellicer Ossau de Salas y Tovar, *Avisos históricos* (Madrid, 1965), 252-53. For Philip IV, see Pedro Rodríguez de Monforte, *Descripcion de las honras que se hicieron a la Catholica Mag.d de D. Phelippe quarto . . .* (Madrid, 1666), fols. 29v-35.

[13] For Cuelvis's visit to the Alcázar, see also Antonio Domínguez Ortiz, "La descripción de Madrid de Diego Cuelbis," *AIEM* 4 (1969), 135-40.

[14] Cf. Benno Geiger, *I dipinti ghiribizzosi di Giuseppe Arcimboldi, pittore illusionista del Cinquecento (1527-1593)* (Florence, 1954), pls. 42 and 43.

[15] Gil González de Avila, *Teatro de las grandezas de la Villa de Madrid, Corte de los Reyes Catolicos de España* (Madrid, 1623), 310.

[16] Egbert Haverkamp-Begemann, "The Spanish Views

To judge from the 1636 inventory, these pictures remained an important element of the painted decoration there during the first fifteen years of Philip IV's reign. At that time sixty-eight pictures were listed in the Great Hall (Appendix G):

Twenty-six tempera paintings showing views of cities in Spain, Italy, and Flanders [many of the cities also appear in Cuelvis's 1599 list]

Six tempera paintings of wars fought by Charles V

An oil painting of Philip II's army entering Lisbon and the battle of the Alcántara bridge

A tempera painting of the Royal Monastery of San Lorenzo at El Escorial by Fabricio Castelo

A tempera painting of a land and sea battle at Malacca

Two old, small tempera paintings of Philip I's entry into La Coruña and of festivals in his honor in Valladolid

Four small, black-and-white oil paintings of personified virtues

A tempera painting of a palace in Brussels

A colored print of the city of *Aynch* [Aix?]

Three oil paintings describing the structure that Philip III had built to bring water from the valley of Daimiel to the Alcázar of Madrid[17]

Eight oil paintings of the Festival of the Popinjay in Flanders staged in honor of the Archduke Albert and the Archduchess Isabella in 1615[18]

Twelve oil paintings of battles fought in Germany by Charles V, which Philip IV had ordered to be copied from tempera originals[19]

Two oil paintings of views of Madrid

of Anton van den Wyngaerde, *Master Drawings* 7 (1969), 377-78 and 384-86; Sánchez Cantón, *Los pintores de cámara*, 38; and Iñiguez Almech, *Casas reales*, 68.

[17] The inventory attributes one of these pictures to Juan de las Roelas (G46). The other two were works by Isaac Guillermo that Velázquez appraised in 1631; see Azcárate, "Noticias sobre Velázquez," 363; and APM, Libro de pagos, fol. 595bis (cited by María A. Mazón de la Torre, *Jusepe Leonardo y su tiempo* [Zaragoza, 1977], 104 and 433).

[18] Three works from this series by Denis van Alsloot are in the Prado; see Díaz Padrón, *Escuela flamenca*, 1:16-

[19]. For documents of 1618 pertaining to the construction, gilding, and painting of frames for these pictures, see AGS, CM3, leg. 784, Destajos, 1618, fols. 1bis[v]-2; *id.*, Pintores, 1618, fol. 1 (Azcárate, "Algunas noticias," 60, first cited sources in this *legajo*); AGS, CM3, leg. 765, Pagador Jacinto Ortiz de Ibarra, Jornales, fols. 3bis-3bis[v]; and APM, SA, Inmuebles, leg. 710, 1618.

[19] Moreover, in the adjacent Dark Room were "Two canvases in tempera, one a little larger than the other, of the wars in Germany in the time of the Emperor Charles V, that used to be with the others of this genre in the Great Hall" (Inventory of 1636, fol. 23).

The list of subjects reveals a preoccupation with the secular power of the Spanish Habsburgs. Almost all the securely identified cities were under the territorial control of the Monarchy, and the striking exceptions of Rome and Genoa were closely tied to Spanish interests, the former as the seat of Catholicism and the latter as a banking center with which Spain's finances were intertwined. The martial scenes illustrated the military prowess of the dynasty, especially that of Philip IV's most illustrious forebear, Charles V, whose example was instrumental in making battle scenes one of the favored elements of Habsburg decoration.[20]

The city views and battle scenes were interrelated because it was generally by military force that a monarchy retained its territories. Philip I's entry into La Coruña, the festivals celebrated in honor of members of the royal family, and the structures built under royal patronage (El Escorial and the water conduit serving the Alcázar) were all subjects that alluded to the Habsburgs' positions as rulers. The personifications of virtues referred to the moral legitimacy of the dynasty that ruled and defended such extensive dominions.[21]

Representations of properties and territories owned and governed by a monarch—be they buildings, cities, or entire kingdoms—were recurrent features of decorative programs at the Spanish court that illustrated the material evidence of Habsburg power and greatness. For example, when the Torre de la Parada was renovated in the 1630s, seventeen paintings of other royal dwellings were installed along its main staircase.[22] A more ambitious assertion of territorial control was incorporated into four temporary arches that the town of Madrid erected for the triumphant entry of Mariana of Austria into the court on November 15, 1649.[23] They were embellished according to an elaborate program that assigned a continent (Europe, Asia, Africa, or America) and an element (air, earth, fire, or water) to each arch. The geographical and elemental imagery was intended to proclaim the might of Spain and her dominion over a worldwide empire.

[20] Brown and Elliott, *Buen Retiro*, 148-50.

[21] The mix of personified virtues and topographical views had a precedent in the Pardo Palace, where in 1590 one room featured a selection of battle pictures and Habsburg portraits rounded out by four images personifying Faith, Hope, Charity, and Fame; see *ibid.*, 151-52.

[22] Alpers, *Torre de la Parada*, 130-33.

[23] The most detailed description of the entry is *Noticia del recibimiento i entrada de la Reyna nuestra Señora Doña Maria-Ana de Austria en la mvy noble i leal Villa de Madrid* (n.p., 1650). J. E. Varey and A. M. Salazar, "Calderón and the Royal Entry of 1649," *Hispanic Review* 34 (1966), 1-26, analyze the iconography of the decorations.

Coats of arms symbolizing the different Spanish realms provided a more restrained means of expressing the territorial extent of the Monarchy. Those on the ceiling of the Hall of Realms were appropriate because the battle pictures on the walls below celebrated the prowess of Philip IV's armies in defending the integrity of the empire. Coats of arms were also common motifs in royal ensembles of occasional art. When Isabella of Bourbon entered Madrid for the first time on December 19, 1615, one of the temporary arches that stood along her route featured "sixteen figures of Kingdoms with their coats of arms and keys in their hands, offering them to Her Highness."[24] Other series of escutcheons were routinely incorporated into the decorations for such events as royal baptisms and funerary exequies.[25]

The descriptions of the Great Hall in 1599, 1623, and 1636 all refer to its painted decoration; yet, during this period there were times when the cavernous room was hung with tapestries. Cassiano dal Pozzo remarked upon this when he described the tapestries that were displayed outside the Alcázar for the Corpus Christi procession of 1626:

> One saw very beautiful tapestries and particularly the following: the deeds of the Emperor Charles V in the Greater Levant around Tunis and La Goletta—the battles, the sieges, the naval enterprises—all with such good design, and so colored that painting yields to it. It is true that as they are continuously hung in the Hall of Plays, they are somewhat faded.[26]

The tapestries that were "continuously hung in the Hall of Plays" were a monumental series illustrating the *Conquest of Tunis and La Goletta* by Charles V. They will be considered in detail below; here it will suffice to note that they were so large that even the Great Hall could not have conveniently accommodated both the tapestries and the sixty-eight paintings that were listed in 1636. The paintings must have been hung during the summer months, when it was the custom to take down the tapestries in the Alcázar.[27] As one

---

[24] León Pinelo, *Anales*, 210.

[25] E.g, the coats of arms displayed prominently for the baptism of Baltasar Carlos—see "Epitome," fol. 98; *Relaciones breves*, 381 and 386; and Soto y Aguilar, "Tratado," fol. 53ᵛ. For coats of arms used at the royal exequies for Isabella of Bourbon and Philip IV, see *Pompa Fvneral*

*Honras*, fol. 36ᵛ; and Rodríguez de Monforte, *Descripcion de las Honras*, fols. 61-61ᵛ, respectively.

[26] Cassiano dal Pozzo, untitled journal of Cardinal Francesco Barberini's legation to Spain in 1626, BAV, Ms. Barb. lat. 5689, unpaged.

[27] Bertaut, "Journal de voyage," 28, notes the practice

observer recorded when Philip IV lay in state in the hall on September 18 and 19, 1665, it was "hung with the tapestry series of the Conquest of Tunis, which is the one that is put in it every winter."[28] Jacob Cuelvis had arrived in Madrid on May 29, 1599, by which time the tapestries must have been taken down because he does not mention them in his account of the Great Hall. On the other hand, the 1636 inventory, which seems to have been compiled late that year, makes no mention of them either.[29] Apparently the procedures that governed whether paintings or tapestries were on view entailed more than a simple change for the summertime.

## A SERIES OF KINGS

Late in the 1630s, when Philip IV and his artistic advisors turned their attention from outfitting the Buen Retiro back to the Alcázar, they selected the Great Hall as one of the chambers to be renovated. In 1639 workers began to gild its *artesonado* ceiling, which caused the room to be called the Gilded Hall. Also at that time other workers embellished the walls with marble and jasper, paved the floor with stone tiles, and enlarged the windows in the upper story of the north wall.[30]

Evidently the windows that had existed before the renovation admitted insufficient light to show the new decoration to advantage. In 1622, when Gómez de Mora's entrance façade was under construction, the Great Hall's southern windows had been filled in because they no longer overlooked the Plaza de Palacio. Instead, five windows had been opened in the north wall and four others had been painted illusionistically.[31] Presumably the real windows alternated with the fictive ones. (Because the windows occupied the upper story, none of them is indicated on the plans of the main floor of the palace.) The indirect light from the King's Courtyard could not have been as bright as the direct lighting from the south that had been sacrificed—hence, the

---

of taking down tapestries in the summer; see also Justi, *Velazquez and His Times*, p. 102.

[28] José María Caparrós, "Enfermedad, muerte y entierro del Rey D. Felipe IV de España," *Revista del Centro de Estudios Históricos de Granada y su Reino* 4 (1914), 186.

[29] See Chapter I, n. 40.

[30] Varey and Shergold, *Los celos*, pp. lix-lxxi; AGS, CM3, leg. 1461, Destajos, fols. 14bis^v-31bis^v passim; *id.*, leg. 1466, Pagador Francisco de Villanueva, Destajos, 1640-1644, fols. 1-1bis; and APM, Cédulas reales, XIII, fol. 287^v.

[31] APM, Libro de pagos, fols. 163^v and 164bis^v-65; APM, SA, Obras, leg. 5208, fols. VII-VIIIbis^v; and APM, SA, Inmuebles, leg. 710, 1622.

enlargement of the windows around 1639.[32] Portions of this renovation are visible in a watercolor painted early in 1673 by Francisco de Herrera the Younger showing the stage and scenery for a play that was performed at the west end of the hall on December 22, 1672 (fig. 60).[33] The gilded *artesonado* ceiling towers above the stage, and a niche containing one of the windows lies below the cornice at the upper right.

Another reason for enlarging the windows was to better illuminate a new series of thirty-two paintings that had been created for the hall. They had been conceived sometime before April 30, 1622, when a payment to Carducho was authorized for works that included "a canvas measuring two *varas* square, more or less, of two Kings of Castile as a model for putting them in the hall of the Alcázar."[34] In 1636, this painting, now lost, was inventoried in the Passage to La Encarnación: "Another canvas, in tempera, portraits of Don Alonso the Warrior and Don Sancho the Brave, that was made by Carducho as a model for those that are to be painted for the Great Hall."[35] Perhaps the delay in carrying out the project may be attributed to the change in regimes in 1621 and to Carducho's declining standing as a court artist under Philip IV. Whatever the case, it was not until the year following Carducho's death in 1638 that a team of artists began work on a series of paintings based upon his prototype.

That series represented more than nine centuries of *Kings of Asturias, Castile, and León* (hereafter cited simply as the *Kings of Castile*).[36] Each of the thirty-two canvases depicted either two kings, or one king and his consort, in a chronological sequence that began with *Pelayo and His Consort* and ended with *Philip III and Philip IV*. Among the artists who participated in the project

---

[32] Enlarging the windows may have caused some structural damage because in 1645 workmen carried out a prolonged campaign of repairs to the windows, the north wall, and the adjacent wing of the upper cloister. See AGS, CM3, leg. 756, Alcázar de Madrid, Extraordinario, fols. 3-17bis[v], nos. 8, 27, 34, 35, 42, 47, 54, 56, 58, and 59; and APM, SA, Inmuebles, leg. 710, 1645.

[33] The watercolor is one of five found in ONV, Cod. Vindob. 13.217. See Varey and Shergold, *Los celos*, xxxvii-xliii and figs. 1-5; and Steven N. Orso, "Francisco de Herrera the Younger: New Documentation," *Source: Notes in the History of Art* 1:2 (Winter 1982), 29-32.

[34] AGS, CM3, leg. 784, Pintores, 1625, fols. 8[v]-9[v]

(see also other AGS documentation cited in Juan J. Martín González, "Arte y artistas del siglo XVII en la corte," *AEA* 31 [1958], 133); and APM, Libro de pagos, fol. 172bis. These documents relate to several tasks Carducho carried out for the Crown, some from as early as 1612 or 1613 (which ones are not specified); thus, it is possible that he painted the model as much as a decade before the April 30, 1622, payment.

[35] Inventory of 1636, fol. 3[v].

[36] This account draws upon the detailed reconstruction of the series advanced by J. E. Varey in Varey and Shergold, *Los celos*, 143-68.

were Antonio Arias Fernández, Francisco Camilo, Alonso Cano, Félix Castelo, Francisco Fernández, Jusepe Leonardo, Pedro Núñez, Diego Polo, and Francisco Rizi. Juan Rizi also may have played a part, but the documentation of his role is less secure. The earliest contracts and receipts for advances on the work were signed in September 1639; receipts for completed pictures date from as late as 1648, but most fall within the period from 1639 to 1642.[37] On March 4, 1641, the joiner Juan Bautista de Miranda received 243 *reales* for thirteen stretchers that he had made for some of the paintings.[38] Once they were ready, the pictures were installed in chronological order along the cornice on the east, south, and west sides of the hall. In Herrera the Younger's watercolor, about half of one painting is seen at the upper left, opposite the window niche.

The thirty-two paintings were subsequently reduced in number. When the east end of the hall was partitioned between 1650 and 1656-1659, the series was divided, and one or two paintings had to be removed.[39] The partitioning created a new chamber that became another bedroom for the king (i.e., fig. 9; no. 18). The 1686 inventory of its contents includes the following entry: "On the cornice of this room and in the Gilded Hall that follows there are twenty-eight equal-sized pictures, fitted and inserted [in place], in which are painted all the kings of Spain and their descent from the King Don Pelayo to the King our lord Don Philip IV. They are two *varas* in width and one and one-half *varas* in height, and by different artists."[40] It is unlikely that the installation of one partition required the removal of four paintings, but the reason so many were taken down by 1686 has yet to be explained satisfactorily.

Only three paintings remain from the series, most of which was lost in the 1734 fire.[41] Two of them, *A King of Castile* (fig. 61) and *Two Kings of*

[37] Much of the documentation for this series is quoted extensively in *ibid.*, 143-49; and María L. Caturla, "Los retratos de reyes del 'Salón dorado' en el antiguo Alcázar de Madrid," *AEA*, 20 (1947), 1-10. The same year that Varey and Shergold published *Los celos*, Azcárate, "Algunas noticias," passim, published notices of additional pertinent documents in AGS, CM3, leg. 1461, Destajos, fols. 40ᵛ-43ᵛ, 59-59bis, and 60-60ᵛ. (See also AGS, CM3, leg. 1373, Alcázar de Madrid, fols. 22bis and 44-44ᵛ.) Unlike AHPM sources known to Caturla and Varey, the AGS documents include records of payments to "Juan Rice" (Juan Rizi?), but they must be handled with caution because some of the AGS documents contain inaccuracies.

(E.g., whereas one of the AHPM documents correctly assigns a *Charles V and Philip II* [fig. 63] to Antonio Arias Fernández, an AGS reference gives it to Pedro Núñez).

[38] AGS, CM3, leg. 1461, Destajos, fols. 25ᵛ-25bis. The payment states that the *Kings* were for both the Great Hall and the Room of the *Furias*, but that is a recurrent error in the AGS documents.

[39] On the date of the partitioning, see Varey and Shergold, *Los celos*, lxiv-lxvi.

[40] Bottineau, "L'Inventaire de 1686," 54.

[41] Varey assembles the documentary references to pictures from the series that were moved to other locations before 1734 and reviews the works that have been pro-

*Castile* (fig. 62), are by Cano.[42] The single *King*, a fragment of a picture that once represented two figures, shows an enthroned, crowned monarch holding a sword and an orb. The *Two Kings* are also crowned and enthroned, and each holds a scepter. All three figures are boldly foreshortened because in their original setting they would have been viewed from below. Cano painted both canvases with a bright palette in order to compensate for the distance separating them from the spectator.

The third surviving picture, Arias Fernández's *Charles V and Philip II* (fig. 63), portrays the two rulers seated and dressed in armor. The former wears the insignia of the Order of the Golden Fleece and grasps a sword and a scepter. His son wears a sword and holds a commander's baton in his left hand, while his right hand rests on an orb sitting beside a helmet on a table. Both figures are foreshortened, and the color scheme includes a vivid red in the draperies at the rear. Like Cano, Arias Fernández attempted to compensate for the separation between the painting and its viewers. Inasmuch as their works were based upon a common model (Carducho's painting), the rest of the series must also have portrayed foreshortened, enthroned monarchs bearing attributes of political and military authority. Such is the case for the seated, crowned monarch in Herrera's watercolor.

Series of kings and other rulers were found repeatedly in decorative ensembles at the Spanish Habsburg court.[43] In the most general sense, a collection of illustrious monarchs signified the glory of the nation, owing to the belief that a great people was ruled by great leaders. Such glory was also transmitted to the reigning monarch, who was perceived to have inherited a dynastic tradition of greatness. More important, he inherited the legitimacy to rule. Most crowns passed by inheritance—the longer the line of royal descent, the more venerable and legitimate the regime. Part of the propaganda campaign that the Habsburg regime waged against the 1640 revolt of Portugal was the publication of the *Svcession de los Reynos de Portugal y el Algarbe* by the king's

---

posed as survivors from the ensemble, in Varey and Shergold, *Los celos*, 148-54.

[42] *Ibid.*, 167, suggests that the *Two Kings* might be *Fruela II and Alfonso IV* and that the single *King* might be half of either *Alfonso III and His Consort* or *García and His Consort*. The suggestion in Caturla, "Los retratos,"

6-8, that these paintings might be by Jusepe Leonardo has not found wide acceptance.

[43] The fundamental study of series of Spanish kings is Elías Tormo, *Las viejas series icónicas de los Reyes de España* (Madrid, 1917); see also Brown and Elliott, *Buen Retiro*, 151-52 and 156.

chief chronicler, José Pellicer.[44] In essence, it mounts a lengthy genealogical argument to defend the legitimacy of Habsburg dominion over the Crown of Portugal.

Serial portrayals of kings enabled the monarchs who commissioned them to promote specific perceptions of the royal line. The portraits in the Hall of Mirrors, for example, depicted the Spanish Habsburgs as militant champions of Catholicism. The series in the Gilded Hall stressed the political authority of the kings of Castile by showing them enthroned and bearing various attributes of rule. The thrones were especially appropriate to the setting because at most of the special events that took place in the Gilded Hall—theatrical performances, bridal meals, the *juramento de pazes*, and the two receptions for the Duke of Mayenne—a chair was provided for the king.[45]

Another of Pellicer's volumes, the *Alma de la gloria de España*, presents a contemporary interpretation of the *Kings of Castile* in this propagandistic vein. The *Alma* is not only an epithalamium to Philip IV and Mariana of Austria's marriage, but also a panegyric to the royal couple and to the House of Austria. As part of an assertion of the secure and direct succession of the Habsburg line in Spain, Pellicer traces the two lines of the rulers of the Crown of Castile and León and the Crown of Aragon from the Middle Ages to Philip IV. His vehicle for doing so is a commentary on the *Kings of Castile* in the Gilded Hall and on another series of the *Kings of Aragon* in the Buen Retiro.[46] At one point the distinguished qualities of Philip's predecessors prompt him to ask, "Wherefore, then, are *Books* necessary for the King and Queen to study how to be *Monarchs*? Wherefore other maxims on governing besides reading the features of those referred to [i.e., the painted kings]? For in each one breathes the best of his great virtues, and if one [virtue] of each effigy is imitated [by the King], a most perfect King will be formed."[47] To Pellicer the *Kings of Castile* and the *Kings of Aragon* not only illustrated the legitimacy of Philip's rule but also provided exemplars of royal comportment. By emulating his great predecessors,

[44] Logroño, 1641.

[45] "Etiquetas," pp. 386, 456, and 565; Cabrera de Córdoba, *Relaciones*, 483; and "Relaçion de las Capitulaçiones," fol. 581ᵛ. Chairs are often symbols of authority in royal portraiture; see Julián Gállego, *Visión y símbolos en la pintura española del Siglo de Oro* (Madrid, 1972),

269-71.

[46] Pellicer, *Alma*, fols. 10ᵛ-16; in fols. 21ᵛ-24 he also traces Mariana's German ancestry.

[47] *Ibid.*, fol. 15; Varey, in Varey and Shergold, *Los celos*, 159, first drew attention to the importance of this passage for understanding the *Kings of Castile*.

Philip would become a perfect king. This is of a piece with Carducho's thoughts on palace decoration and with Philip's comments on his reasons for studying history. The example of the past, whether expressed by word or painted image, inspired virtuous kingship in the present. This fully accorded with the traditional premise of Renaissance art theory that portraiture could inspire a spectator to imitate a sitter's virtues.[48]

Serial portrayals of kings and other rulers enjoyed considerable popularity at the Spanish court during Philip's reign. The Hall of Realms illustrated three successive generations of Habsburgs, the Hall of Mirrors showed four, and the Gilded Hall traced a continuous succession back to Pelayo, who ruled in Asturias from 718 to 737. Four other series in Madrid were also noteworthy: the aforementioned *Kings of Aragon*, an unfinished suite of *Visigothic Kings*, and a set of *Dukes of Milan*, all in the Buen Retiro; and a *Kings of Portugal* series in the Alcázar.

The Aragonese series consisted of forty-two copies after originals that Philip had seen in the Palacio de la Diputación de las Cortes in Zaragoza when he visited there in 1626.[49] On May 16, 1632, the deputies of the Kingdom of Aragon contracted with Pedro and Andrés Urzainqui, Francisco Camilio, and Vicente Tió to copy the paintings for the king, who desired a set of them. The pictures must have been on hand in Madrid before June 16, 1635, when the carpenter Manuel de Torres was paid "for forty-two stretchers for the portraits of the Kings of Aragon and other small things that he did in the Salón of the Buen Retiro."[50] The original series was lost during the siege of Zaragoza in 1808 and 1809, but thirty-nine of the copies were still in existence as late as 1916.[51]

The suite of copies included both the Kings of Aragon and their predecessors, the Counts of Aragon and the Kings of Sobrarbe. It ran from *García Ximénez*, the first King of Sobrarbe, to Philip IV, who governed the Crown of Aragon as *Philip III*. (Philip I of Castile never inherited the Crown of

[48] Marianna Jenkins, *The State Portrait: Its Origins and Evolution*, Monographs on Archaeology and the Fine Arts, no. 3 (n.p., 1947), 4-5.

[49] For this series, see Tormo, *Las viejas series*, 77-82 and 99-116; and Von Barghahn, "Pictorial Decoration," 155-57, 159-60, 162, 182, 293-97, 301-302, 306-307, and 352.

[50] Caturla, "Los retratos," 8.

[51] Tormo, *Las viejas series*, 99-116 passim; he illustrates twenty-eight pictures from the series, which by then had been dispersed.

Aragon.) Each ruler was shown standing full-length, and most wore crowns and carried such attributes of rule as orbs, scepters, staffs, or swords. The majority of pictures incorporated two coats of arms—that of the realm and the personal device of the particular ruler. The *Ferdinand II*, the twenty-fifth King of Aragon, was typical (fig. 66).

Pellicer's comments in his *Alma de la gloria de España* establish that, like the *Kings of Castile*, the *Kings of Aragon* were understood to assert the continuity of the ruling line in the Crown of Aragon and the consequent legitimacy of Philip's reign over it. This was a matter to which the king was especially sensitive. When he succeeded his father in 1621, he had not yet visited the three realms that composed the Crown of Aragon—the Kingdoms of Aragon and Valencia, and the Principality of Catalonia—to swear to uphold their *fueros* (traditional rights). His appearance was required if he were to be considered the legal heir to the Crown. That technicality had provided the regional authorities with a justification for resisting the central government in Madrid during the first years of Philip's reign. It was to overcome that argument that Philip convened the Cortes of the three realms in 1626 and visited Aragon and Catalonia.[52] Thus, he first saw the original series of the *Kings of Aragon* when the legitimacy of his claim to the Crown of Aragon was much on his mind. Moreover, when Pellicer published the *Alma* in 1650, the Catalan revolt against the Monarchy had not yet been quelled. Having a series that included both the past rulers of Catalonia and himself as their successor became a visual assertion of Philip's continued claim to legitimate authority over that troublesome realm.

Only five canvases are known to have existed in the unfinished series of *Visigothic Kings*.[53] They were painted by five artists who were active in Madrid—Carducho, Castelo, Andrés López, Jusepe Leonardo, and Pereda—and all five pictures have survived (e.g., fig. 65). Two are dated 1635, from the period when the Buen Retiro was being decorated. The reason the series was never completed has yet to be explained. Each painting depicts a single, full-length king dressed in armor who holds or stands beside various weapons and attributes

[52] Elliott, *Revolt*, 6-7, 148-60 passim, and 215-47 passim.

[53] For this series, see Tormo, *Las viejas series*, 117-28; and Von Barghahn, "Pictorial Decoration," 148, 168, 200, 277-78, 321, and 392-93.

of rule while a battle rages in the background. The series thus illustrated the military prowess of Philip's medieval predecessors, which, by implication, was characteristic of the reigning monarch as well.

The *Dukes of Milan* consisted of eight or nine paintings of the Sforzas who had held the ducal title before it reverted to Charles V. It has been speculated that either the series was brought to Spain from a Sforza collection after Charles ceded the title to his son Philip II, or that the pictures were seventeenth-century copies of an older set.[54] Three are known to have survived, among them the *Giovanni Galeazo Maria Sforza* (fig. 64), which represents the duke in half-length, wearing armor and gripping a baton. Evidently this series also portrayed its subjects as commanders. Because it did not include any Habsburg dukes of Milan, the ensemble did not assert the legitimacy of Philip IV's rule over the duchy as forcefully as the *Kings of Aragon* and the *Kings of Castile* justified his dominion over those Crowns. Nevertheless, by displaying the portraits of his Milanese predecessors, Philip implied that he was their rightful successor, just as he was the legitimate successor of the Visigothic kings.

Another series that did extend to Philip IV was the *Kings of Portugal*, now lost, which was inventoried in the Passage to La Encarnación in 1636: "Twenty portraits, in oil on panel, narrow and tall, with gilded and black frames. Fifteen of them were shifted from the Gallery of the North Wind, and the other five were recently made in order to be put in this passage. They are the kings of Portugal up to the King our lord Don Philip IV."[55] It has been suggested that the original fifteen portraits were commissioned by John II of Portugal and that they were later brought to Madrid, where Philip IV commissioned the five additions.[56] The latter—which portrayed the kings Henry, Sebastian, Philip II, Philip III, and Philip IV—were painted by Semini, who received his first payment for them in 1626.[57] Bringing the series up to date

[54] For this series, see Tormo, *Las viejas series*, 143-46, and Von Barghahn, "Pictorial Decoration, 127-128 and 219-20.

[55] Inventory of 1636, fol. 3ᵛ. They were in the same room in 1686 (Bottineau, "L'Inventaire de 1686," 456). González de Avila, *Teatro*, 310, confirms that a *Kings of Portugal* series was in the Gallery of the North Wind in 1623.

[56] For this series, see also Tormo, *Las viejas series*, 73-75.

[57] AGS, CM3 leg. 2825(1), Pagaduría, fols. 11-11ᵛ; and APM, Libro de pagos, fols. 345ᵛ and 494ᵛ-94bisᵛ (cited in part by Mazón de la Torre, *Jusepe Leonardo*, 102-103 and 430). Similarly in AGS: Azcárate, "Algunas noticias," 58. On August 20, 1625, and April 6, 1626, Lorenzo de Salazar was paid for making the five panels on which Semini painted; see APM, Libro de pagos, fol. 316 (similarly in AGS: Azcárate, "Noticias sobre Veláz-quez," 361 n. 11).

gave it a significance comparable to that of the *Kings of Aragon* and the *Kings of Castile*. It asserted that the Habsburg accession in Lisbon following the death of Henry was just and that Philip IV was the legitimate successor on the Portuguese throne. It was, of course, a notion that the Portuguese challenged successfully when they rebelled in 1640.

Serial portrayals of monarchs also figured in temporary decorations at the Spanish court. Perhaps the most striking instance of this was seen when Mariana of Austria entered Madrid in 1649. Her route through the town passed a "Genealogy of the Kings of Castile and the Emperors of Germany" that had been erected on the steps of the convent of San Felipe.[58] This took the form of an enormous gallery 180 Castilian feet (50.4 meters) long that incorporated a large central niche flanked by four smaller niches at each side. In the central niche a golden crown rested on a canopied throne. Beside it were statues of Philip and Mariana, shown dressed in the same costumes that they wore that day, placing their hands on the crown as if dividing it between them. The immediate ancestries of the king and queen were traced in the smaller niches. Proceeding outward to the left, one encountered Philip IV's predecessors on the Castilian throne: Philip III, Philip II, Charles V, and Philip I. To the right were Mariana's German forebears: Ferdinand III, Ferdinand II, Archduke Charles of Habsburg, and Ferdinand I. Adjacent to each niche was an emblematic painting ten Castilian feet (2.8 meters) tall with an accompanying *octava* that explained its symbolic testimony to the neighboring figure's achievements. These drew upon the established repertory of Habsburg themes—military prowess, pious devotion to the Faith, and dynastic greatness.

On the king's side Philip III's painting celebrated the capture of the North African ports of Larache (1610) and Mamora (1614), while that of Philip II referred to the victories of St. Quentin (1557) and Lepanto (1571), and to the construction of the Royal Monastery of San Lorenzo at El Escorial, the "eighth wonder of the world." Charles V was honored with a sun shining over a vast landscape that signified his constant travels throughout his realms in order to

---

[58] The most detailed account of the structure appears in *Noticia del recibimiento*, 66-72. See also "Epitome," fols. 357-57ᵛ; Marqués del Saltillo, "Prevenciones artísticas para acontecimientos regios en el Madrid sexcentrista (1646-1680)," *BRAH* 121 (1947), 375-79; Varey and Salazar, "Calderón," 10-12; and Manuel de Villaverde Prado y Salazar, *Relacion escrita a un amigo ausente desta Corte, de la entrada que hizo la Reyna N. S. Dᵃ Mariana de Austria . . .* (Madrid, [1649]), unpaged.

attend to their needs in person. In Philip I's emblem the heraldic lion of the Crown of Castile and León embraced the Habsburg eagle, thereby signifying that it was in his person that the royal blood of Castile and that of the House of Austria first mingled.

Mariana's ancestors were no less proudly saluted. In Ferdinand III's painting the queen's father was shown with the Cardinal-Infante Ferdinand jointly commanding their Catholic forces to victory at the Battle of Nördlingen (1634). Her grandfather Ferdinand II was presented as the hero who had overcome both a declared enemy, the Protestant king Gustavus Adolphus of Sweden, and a traitor, Albert van Wallenstein, Duke of Friedland. The Archduke Charles was praised as a "Catholic Titus" for his piety, gentleness, and benignity. In another painting alluding to ties between Spain and Germany, Ferdinand I, Charles V's brother and his successor as Holy Roman Emperor, was honored for his birth in Alcalá de Henares, his opposition to the Turkish emperor Sulaimān the Magnificent, and his death on the Feast of Saint James Major, the patron saint of Spain.

This royal genealogy by no means stopped after tracing only four generations of the king and queen's ancestors. The ends of the gallery were enclosed by two great trees in which the separate genealogies of the royal couple were illustrated in 120 crowned ovals containing the kings and emperors from whom they had descended. The last of these ovals disappeared into clouds, indicating that the couple's distinguished lines continued even further into the past but that artistic limitations prevented those earlier generations from being portrayed. The gallery, then, was an extended glorification of the House of Austria that traced the lineage of the king and queen in what were literally two family trees.

Serial portrayals of the royal dynasty were found in temporary and permanent ensembles throughout the court of Philip IV. Although their compositional formats varied, they shared a capacity to represent the continuity of the royal line, to assert the concomitant legitimacy of the reigning monarch, to illustrate the distinctive virtues of the dynasty, and to record the achievements of its eminent members. Not only did they promote the royal house in the minds of the viewers, but also they provided the living king and his family with worthy models on whom they could pattern their own lives. In Philip's

ancestry lay both the legal basis of his kingship and the standard by which his accomplishments would be measured. It was within that context that the *Kings of Castile* were meant to be understood.

## A CYCLE OF TAPESTRIES

After the Great Hall was transformed into the Gilded Hall around 1640, the *Conquest of Tunis* tapestries continued to be displayed there during much of the year. This monumental woven ensemble illustrated one of Charles V's most celebrated triumphs, his military campaign in 1535 to recover Tunis from the Turkish forces that had captured the city from Spain's vassals in 1534. The emperor himself commanded the multinational imperial army that invaded North Africa. The conquest succeeded to the extent that first La Goletta and then Tunis were retaken, but some enemy forces were able to retreat to Algiers, which could not be attacked at that time. After it had secured Tunis, the imperial army withdrew from Africa.

Among those whom Charles had selected for his retinue on the expedition was the Flemish painter Jan Vermeyen, who in 1546 was commissioned to prepare cartoons for a tapestry series that would chronicle the campaign.[59] The *editio princeps* of the resulting *Conquest of Tunis* was woven between 1548 and 1554 at the factory of Willem Pannemaker, the most distinguished of the Brussels tapestry-makers. Manufactured from the finest of materials (including a fortune in gold and silver thread), the cycle consists of twelve monumental panels. An introductory *Plan of the Campaign* presents a map of the Mediterranean region in which the war was fought, and eleven narrative scenes illustrate the progress of the expedition from the *Review of the Army in Barcelona* to the *Re-embarkation of the Army* for its return to Europe. The seventh panel, *The Capture of La Goletta* (fig. 67), typifies the series. The battle is a richly detailed panorama of clashing armies. A card in the ornamental right-hand border provides the viewer with a geographic orientation to the battle, while a lengthy

[59] The series is to be studied thoroughly in Hendrik J. Horn, *Charles V's Conquest of Tunis: Cartoons and Tapestries by Jan Cornelisz Vermeyen*, forthcoming. For previous literature, see Albert F. Calvert, *The Spanish Royal Tapestries* (London-New York, 1921), 32-47; Elías Tormo y Monzó and Francisco J. Sánchez Cantón, *Los tapices de la Casa del Rey N. S.: notas para el catálogo y para la historia de la colección y de la fábrica* (Madrid, 1919), 95-100; and Conde Viudo de Valencia de Don Juan, *Tapices de la Corona de España*, 2 vols. (Madrid, 1903), 1:29-30.

Castilian text along the top and a briefer Latin one below explain the action. So that there is no mistaking whose triumph the victory was, the double-headed imperial eagle occupies both upper corners, and the emperor's personal device, the Pillars of Hercules with the inscription PLUS OVLTRE, occupies the left-hand border.

Like other monarchs of the sixteenth and seventeenth centuries, the Spanish Habsburgs esteemed tapestries as an important form of princely decoration to be prized for both the beauty of their designs and the sumptuousness of their materials. To own them was a sign of wealth and cultivation. Moreover, they possessed the advantage of portability—their owner could have them rolled up, transported in his royal train, and unfurled at his destination to create a regal setting worthy of his splendor. To an itinerant ruler like Charles V, this might well have been useful, and as we shall see below, both Philip III and Philip IV took *Conquest of Tunis* tapestries with them on important journeys. By the seventeenth century the Spanish Habsburgs had two sets of the series on hand in the Alcázar: the original one for Charles V and a second one woven for Mary of Hungary immediately upon the completion of the first. Ironically it was Charles's earlier suite that came to be called *la nueva* ("the new one") and Mary's that was referred to as *la vieja* ("the old one") by the seventeenth-century court.[60]

Just as Charles and his successors collected paintings in great numbers, so they amassed a considerable body of tapestries. The inventory of hangings kept in the Alcázar that was compiled for the *Testamentaría* of Charles II incorporates a virtual roll call of distinguished suites from the later Middle Ages and the Renaissance, especially sets woven by Flemish masters.[61] Among the sets listed were the *Conquest of Tunis and La Goletta*, the *Acts of the Apostles*, the *Apocalypse*, the *Story of Noah*, the *History of Cyrus*, the *Seven Deadly Sins*, the *Story of Vertumnus and Pomona*, and the *History of Scipio Africanus*.

The Spanish Crown displayed these tapestries to great effect on solemn and celebratory occasions. A contemporary account of the ceremony at which the Duke of Mayenne signed the wedding contract between Louis XIII and Anne of Austria on August 22, 1612, demonstrates the use of tapestries as

[60] I am grateful to Hendrik J. Horn for clarifying this for me. The two series can be distinguished by the measurements given for them in the 1700 inventory (*Inventarios reales*, 1:244-45 and 252-53), in which their nicknames are also given.

[61] *Ibid.*, 1:241-358, lists the holdings of the Office of Tapestries at the Alcázar; most of the tapestry sets appear at the head of the list, 243-73.

expressions of royal splendor. (In the following excerpt the numbers from Gómez de Mora's *planta alta* [fig. 6] that correspond to the rooms described have been inserted in brackets.)

In the Great Hall [23] . . . which was where His Majesty the King our lord was with the Most Serene Infanta, Queen of France, and His Highness the Prince for the kissing of hands after the aforesaid marriage articles had been signed (as will be told of in its place), the rich, new tapestry set of Tunis was hung. That is the history of the enterprise and wars that the Emperor Charles V undertook in the journey that he made to Tunis and La Goletta. This tapestry set is very rich, being made of colored silks, gold, and silver. . . . The hall where His Majesty carries out his business [12] was hung with a tapestry series of silk, silver, and gold, of the history of Noah with the Ark of the Flood. In the said hall was put a table covered with black velvet.

The Bedchamber [8] was hung with a tapestry set that is called [the story of ] Pomona. It is very pleasing, rich with silk, silver, and gold, and filled with many gardens and galleries with nymphs in them. The border of this tapestry consists of very rich leaf ornament and grotesqueries. In this room there is a ceremonial bed, and on this day it was covered with black damask with velvet valances. Next to it was a table and a chair also of black velvet.

Farther out in the Hall of *Consultas* [6] was hung another tapestry series of things from history that is called [the set of ] the Honors, also of silk, silver, and gold. Farther out in the Small Hall [5] was hung the tapestry set of the Seven Deadly Sins, also of silk, silver, and gold. The large room that is for the corps of guards [4], being the passage from the room where the marriage contract was signed [81] to the King's Quarter, and the room farther within, which is called the Room of the *Cortes* [evidently the unnumbered room to the immediate east of room 4], were hung with the old tapestry set of Tunis, which also is of silk, silver, and gold. The hall within which is where the marriage contract was signed [81] was hung with the rich tapestry series of the Seven Deadly Sins that they call "the good one."[62]

---

[62] "Relaçion de las Capitulaçiones," fols. 581-82.

From the repeated references to the richness of the tapestries and the luxurious materials from which they were made, it is evident that they were displayed in order to impress Mayenne and his party with the wealth and splendor of the royal household. With luck the tapestries made a better impression on the duke than they had on his first reception in the Alcázar on July 12. On that occasion the French party had arrived at the palace at dusk, and there was insufficient light for them to appreciate the hangings.[63]

The sets that were selected for the duke's second reception were chosen more for their visual appeal than for apposite subject matter. Had thematic content been the primary consideration, the king's servants surely would have adorned the room where the marriage contract was signed with something more appropriate than the *Seven Deadly Sins*. This attitude persisted under Philip IV in other circumstances when a visitor was escorted through the King's Quarter. On the occasion of a *juramento de pazes*, for example, the *etiquetas* of 1647-1651 prescribed, "The *juramento de pazes* is celebrated in the Gilded Hall of His Majesty's Alcázar. The rooms of the entry [of the ambassador who is to witness the king's oath] and the hall are hung with rich tapestries."[64] Opulence, not content, was emphasized.

One of the striking features of contemporary accounts of special events at the Spanish court is the frequency with which the *Conquest of Tunis* tapestries were displayed in ensembles of temporary decorations. From the turn of the seventeenth century to the first days of Charles II's reign, they are recorded as having been on view for the following occasions (which took place in Madrid unless otherwise noted): (1) Margaret of Austria's reception of the royal councils in the Chapter Room of the royal monastery of San Jerónimo prior to her first entry into the capital as wife of Philip III on November 6, 1599;[65] (2) a *juramento de pazes* on June 4, 1601, at which Philip III swore to uphold the Treaty of Vervins with France in the cathedral of Valladolid;[66] (3 and 4) the baptisms of Anne of Austria and her younger brother, the future Philip IV,

---

[63] Cabrera de Córdoba, *Relaciones*, 483.

[64] "Etiquetas," 385-86.

[65] Cabrera de Córdoba, *Relaciones*, 46.

[66] *Ibid.*, 102. The *etiquetas* of 1647-1651 do not specify which tapestries were to hang in the Gilded Hall for a *juramento de pazes*, but from the Valladolid precedent of

1601 (which is cited in the 1647-1651 *etiquetas*), it might reasonably be concluded that the *Conquest of Tunis* series was considered most appropriate. (The accounts of *juramentos de pazes* in the Gilded Hall in 1630 and 1679 cited in n. 9 do not specify which tapestries were displayed.)

at the church of San Pablo in Valladolid, respectively on October 7, 1601,[67] and June 22, 1605;[68] (5) the oath-taking ceremony at the church of San Jerónimo on January 13, 1608, whereby the future Philip IV became the heir apparent to the Crown of Castile and León;[69] (6) the two receptions of the Duke of Mayenne in the Gilded Hall in 1612 (as described above);[70] (7) the formal occupancy by Augustinian nuns of the newly constructed royal convent of La Encarnación, which had been established by Philip III in fulfillment of a vow made by his wife Margaret, on July 2, 1616;[71] (8) the belated coronation of Philip III as king of Portugal and the legal confirmation of the future Philip IV as heir to the Crown of Portugal, which were performed in the Royal Hall of the palace in Lisbon in 1619;[72] (9 and 10) the baptisms of two of Philip IV's daughters, the Infantas Margarita María Catalina and María Eugenia, respectively on December 8, 1623,[73] and June 7, 1626;[74] (11) the Corpus Christi procession of 1626, in which the visiting papal legate, Cardinal Francesco Barberini, participated;[75] (12) the baptism of the Infanta María Teresa on October 7, 1638;[76] (13) the installation of the Holy Sacrament in the Royal Chapel of the Alcázar on a permanent basis, thereby raising the chapel to the status of a parish church, on March 10, 1639;[77] (14) the lying-in-state of Isabella of Bourbon in the Gilded Hall on October 7, 1644;[78] (15) the confirmation of Baltasar Carlos as heir apparent to the Kingdom of Aragon when he swore to uphold its *fueros* in the cathedral of Zaragoza on August 20, 1645;[79]

[67] Jehan L'Hermite, *Le Passetemps de J. Lhermite*, vol. 2, ed. É. Ouverleaux and J. Petit (Antwerp, 1896), 336.

[68] *Relacion verdadera, hecha y verificada por vn testigo de vista . . . del Bautismo del Serenissimo Principe de España . . .* [Valladolid, 1605], unpaged; and Cabrera de Córdoba, *Relaciones*, 246.

[69] Cabrera de Córdoba, *Relaciones*, 325; *Relacion verdadera, en qve se contiene todas las ceremonias y demas actos que passaron en la jura que se hizo al Serenissimo Principe nuestro señor Don Phelipe Quarto . . .* (Alcalá, 1608), unpaged; and *Relaciones breves*, 56.

[70] See nn. 62 and 63.

[71] Gerónimo de Quintana, *A la mvy antigua, noble y coronada Villa de Madrid: Historia de sv antigvedad, nobleza y grandeza* (Madrid, 1629), fols. 437-38; and *Relaciones breves*, 101.

[72] *Coronacion de la Magestad del Rey don Felipe Tercero nuestro Señor; Ivramento del serenissimo Principe de España su hijo . . .* (Seville, 1619), unpaged

[73] *Relacion verdadera del acompañamiento y Baptismo, de la serenissima Princesa, Margarita, Maria, Catalina* (Madrid, 1623), unpaged; and *Relaciones breves*, 271.

[74] *Relaciones breves*, 356-57.

[75] *Ibid.*, 354; and Pozzo, untitled journal, unpaged.

[76] *Copiosa relacion de las costosissimas galas, vistosas libreas, y preciosissimas joyas, que el dia del Bautismo de la señora Infanta, luzieron en la Corte de España . . .* (Seville, 1638), unpaged.

[77] *Cartas de algunos PP.*, 3:195; and *Relaciones breves*, 462.

[78] Pellicer, *Aviso*, 252.

[79] Pedro Lanaja y Lamarca, *Relacion del ivramento de los fueros de Aragon, qve hizo el Serenis^{mo} Principe Don Balthasar Carlos . . .* (Zaragoza, 1645), 3; and *Relacion del Jvramento de los Fueros de Aragon, que hizo el Serenissimo Principe D. Baltasar Carlos . . .* (Seville, 1645), fol. 1.

(16) the lying-in-state of Philip IV in the Gilded Hall on September 18 and 19, 1665 (as described above);[80] and (17) the induction of Charles II into the Order of the Golden Fleece in the Antechamber of the King's Quarter on November 8, 1665.[81]

Doubtless there were other occasions at which the *Conquest of Tunis* tapestries were displayed.[82] It should be noted that at many of these events, several tapestry series were put on display; however, it is clear from contemporary accounts that the *Conquest of Tunis* panels set the standard for quality. In describing the baptism of Margarita María Catalina, one contemporary witness reports that a temporary passage linking the Alcázar to the parish church of San Juan (where the baptism was performed) "was adorned and made most beautiful by the rich tapestries of Tunis and La Goletta, all of gold and silk, with consummate figures and such that here nature confesses itself surpassed by art. . . . Further within [the Alcázar] were seen the antechamber and other rooms of the said Most Serene Princess, all richly adorned with the history of the Apocalypse and the Acts of the Apostles, not inferior in their quality, to that of Tunis."[83] In a similar vein, a witness to the ceremony in the cathedral of Zaragoza at which Baltasar Carlos became the legal heir to the Kingdom of Aragon reports, "The presbytery and columns near the platform [on which the ceremony took place] were adorned with the precious Tunis tapestry set, which for its artfulness and richness, is assigned to great festivities because its art surpasses its material, [it] being of silver and gold. And all that it contains are trophies of the invincible Emperor Charles V."[84]

As the preceding survey of uses attests, the *Conquest of Tunis* tapestries were considered appropriate for all manner of events. Frequently they were the series chosen when only one suite of hangings was displayed for a special occasion. Particularly telling is that on two royal excursions from Madrid for political ceremonies of great consequence for the Monarchy—Philip III's jour-

---

[80] See n. 28.          [81] "Etiquetas," 888-89.

[82] The *Conquest of Tunis* was not *always* used for special events; e.g., the set did not hang at San Jerónimo in Madrid for the oath-taking ceremony at which Baltasar Carlos became the legal heir to the Crown of Castile and León in 1632. See Juan Gómez de Mora, *Relacion del Ivramento qve Hizieron los Reinos de Castilla i León al Ser.ᵐᵒ*

*don Baltasar Carlos . . .* (Madrid, 1632), fols. 4ᵛ-5; and Antonio Hurtado de Mendoza, *Convocacion de las Cortes de Castilla, y ivramento del Principe nuestro Señor D. Baltasar Carlos Primero deste nombre* (Madrid, 1632), fol. 11.

[83] *Relacion verdadera del acompañamiento*, unpaged.

[84] Lanaja y Lamarca, *Relacion del ivramento*, 3.

ney to Portugal in 1619 and Baltasar Carlos's visit to Zaragoza in 1645—it was deemed necessary to bring a set of the *Conquest of Tunis*. The series enjoyed such preferential status because it incorporated the fundamental themes of Spanish Habsburg decoration. The panels promoted the dynasty by glorifying its most illustrious representative, the victorious commander Charles V. The outcome of his expedition—the restoration of Spanish control over foreign territory—demonstrated Habsburg might, military prowess, and determination to defend all corners of the Monarchy. Because the campaign pitted Catholic forces against an infidel Turkish army, the series necessarily alluded to the Habsburgs' mission to defend the Faith against its enemies. This combination of themes constituted a powerful expression of the political and religious ideals of the dynasty that was analogous to the programs that informed the Hall of Mirrors and the Hall of Realms.

The monumental portrayal of Charles V's exploits in Africa, brilliantly rendered in tapestries of the highest artistic quality, presented his successors with a paradigm of the achievements expected of a Habsburg monarch. When viewed in this light, the suitability of the *Conquest of Tunis* for the Gilded Hall is immediately apparent. The spectators who assembled there to attend state ceremonies or court entertainments saw one or more members of the royal family surrounded by an archetypal statement of the glory and the purpose of their line.

After the Great Hall became the Gilded Hall, the *Conquest of Tunis* assumed further significance. The first painting in the *Kings of Castile* series represented *Pelayo and His Consort*. Pelayo was the king who in 718 defeated a small Muslim force at Covadonga—a minor encounter in Asturias that was regarded as the beginning of the Reconquest. From that date commenced the slow recovery of Iberia from Muslim domination that was finally completed in 1492 by the Catholic Kings, Ferdinand and Isabella. In other words, the *Kings of Castile* consisted of those monarchs who had ruled during the Reconquest and their Habsburg successors up to Philip IV. As a result, the lengthy series of paintings implied that the Habsburgs had inherited not only the territories of the Crown of Castile but also the ideals of the Reconquest. This reference to the Christian recovery of Iberia harmonized thematically with the recapture of Tunis and La Goletta illustrated in the tapestries on the walls below. During the sixteenth

century Spanish policy toward North Africa had been, in effect, a continuation of the final stage of the Reconquest, the campaign against Granada.[85] Might not that perception of the African expedition have lingered in the seventeenth century, even after Spain's primary concerns in foreign affairs had shifted to the European theater? In any event, both the paintings and the tapestries represented the monarchs of Castile who had valiantly opposed the infidels.

Another reason that the *Conquest of Tunis* assumed greater significance was that the paintings that had been inventoried in the Great Hall in 1636 were later removed permanently, probably during the renovations of 1639 to 1642. The removal can be deduced from the 1686 inventory, to which we must refer because the Gilded Hall is one of the rooms missing from the incomplete 1666 inventory. Bernabé Ochoa signed and dated the later inventory on August 11, 1686.[86] At that time of year—the hottest month of summer—the *Conquest of Tunis* would not have been hanging. By then, too, the Gilded Hall had been partitioned to create the new bedroom at its east end, and Ochoa inventoried the *Kings of Castile* in both rooms under the heading of the bedroom. Whereas eighteen other pictures are listed in that bedroom, no others are recorded in the Gilded Hall.[87] That means the walls below the cornice had been left bare during the summer.[88] Inasmuch as the installation of the king's collection in 1686 remained virtually unchanged from that of 1666, the *Kings of Castile* must have been the only paintings to have adorned the Gilded Hall during the later years of Philip IV's reign.

This shift in the role of painted decoration in the Gilded Hall accords with other changes that were effected in the Alcázar between 1636 and 1666. Of the sixty-eight paintings inventoried in the Great Hall in 1636, thirty-seven were executed in tempera (*al temple*), including the twenty-six city views and the six wars of Charles V at the head of the list (G1-32). By the time the renovations of 1639-1642 had begun, these works might have deteriorated. Philip II had commissioned the city views more than seventy years before, and Philip IV had already commissioned oil copies after another set of battle scenes

---

[85] Elliott, *Imperial Spain*, 43-44.
[86] Inventory of 1686, fol. 94ᵛ.
[87] Bottineau, "L'Inventaire de 1686," 53-54.
[88] Herrera the Younger painted his watercolor view of the hall (fig. 60) in the winter of 1672-1673, when the *Conquest of Tunis* would have been hanging. The tapestries he shows do not match any of the *Conquest of Tunis* panels, but the latter are such detailed compositions that Herrera understandably had to use simpler images to meet the constraints of his medium.

in tempera (G55-66). However, even if the tempera paintings were still well preserved, they might have looked old-fashioned. A comparison of the 1636 inventory with those of 1666 and 1686 suggests that tempera paintings and city views were not to Philip IV's taste. After 1636 there is a pronounced decrease in the numbers of both kinds of works found in the King's Quarter. Oil painting, already predominant in 1636, increased markedly. By 1686 a considerable number of topographical views and maps—at least one of which can be identified with a picture that had been in the Great Hall[89]—were located in the Passage to La Encarnación, the storage area for works that were out of favor or in poor condition. Cityscapes and other topographical views did not disappear from Spanish court art, but they were deemphasized in the Alcázar.

At least in part, the transformation of the Great Hall into the Gilded Hall was prompted by a desire to upgrade the quality of its painted decoration. The impetus for this might have come from one of the king's advisors, or from the king himself, who, at the least, had to approve and pay for the changes. The new program differed from the old one by shifting emphasis from the territories that the kings of Spain governed to the qualities and achievements of the kings themselves. Ironically, by the time the *Kings of Castile* went on view, the age of the great monarchs who had raised Spain to her most glorious heights had passed. It was the fate of Philip IV and his son Charles II to preside over Spain's decline.

[89] Bottineau, "L'Inventaire de 1686," 459: "A description of the conveyance of water from Daimiel to the palace in the time of King Philip III made by Alonso Carbonel (who was *aparejador* of the royal works), in a picture five *varas* in length and one and one-quarter in height, in a black frame"; cf. Appendix G, no. 44.

## CHAPTER IV

# Further Observations on the King's Quarter

ALTHOUGH they differed in degree of complexity, the decorative ensembles in the Hall of Mirrors and the Gilded Hall were alike in that both proclaimed the legitimacy, mission, and glory of the Habsburg dynasty in Spain. Such decoration befitted public rooms in which the king performed ceremonial duties of state. Other ensembles in the King's Quarter were based upon different, less complicated ideas, such as grouping pictures by national school or by genre. If more sophisticated themes were present at all, they were subordinated to the simpler unifying trait. Among such chambers three stand out as noteworthy examples of this approach to decoration: the South Gallery, the Octagonal Room, and the Room of the *Furias*.

## THE SOUTH GALLERY

Like the Hall of Mirrors, the *galería del mediodía* (South Gallery) was created by the construction of the new façade that Gómez de Mora designed (fig. 13; no. 13). It was rectangular in plan, seven bays in length, and two stories in height. Two of Verger's sections include views of its south wall (fig. 54; room I) and its west end (fig. 68; room I). Gómez de Mora's *relación* identifies it as the "main gallery where the king is usually present,"[1] and that is all that is known of its use during the seventeenth century, aside from the fact that it lay along the formal approach to the Hall of Mirrors.

Philip III had intended the gallery to be decorated with frescoes and stuccoes according to a plan worked out by Carducho. Under the supervision of Gómez de Mora, Carducho and Cajés were to paint frescoes of figures and historical

[1] Gómez de Mora, "Relaçion de las cassas," fol. 1ᵛ.

subjects, Fabricio Castelo was to paint grotesques, and all three were to work on accompanying half-relief stuccoes and gilding.[2] The king's death in 1621 halted this project, which Philip IV evidently chose not to carry out. In the *Diálogos de la pintura* Carducho, in the guise of the Maestro of the dialogues, discusses with his Discípulo what he had intended to portray:

> DISCIPLE: . . . I am thinking of that drawn plan that, if I remember rightly, is the one that you made to carry out in the South Gallery of this Alcázar of Madrid, the execution of which was stopped by God's having carried off His Majesty for Himself.
>
> MASTER: It was a concept suitable for that place, all of it being an epilogue of the events in the ages of the world from the Creation to these our times with the most celebrated and best known persons in each age. It made allusion to the ages of mankind. Shown in each one of them was an heroic deed of that age by famous persons, and it was all accommodated with much moral history and with much erudition and example.[3]

This intended display of distinguished heroes and their feats from every age of human history, selected in part for their moral lessons, conformed to Carducho's belief that palace decoration should provide models of behavior worthy of royal emulation. In fact, this passage introduces his discourse on relating the adornment of a structure to its use. The abandonment of his project was an early sign of his waning fortunes as a court artist under Philip IV. Perhaps he included this account of his plan in the *Diálogos* as an implicit defense of its merits.

After Carducho's scheme was abandoned, the South Gallery was decorated with easel paintings. Sixty-five pictures were inventoried there in 1636 (see Appendix H), forty-six of which comprised sets of four or more works. The subjects and attributions of the sets were as follows:

Six portraits by Rodrigo de Villandrando of Philip III, Margarita of Austria, Philip IV with the dwarf Soplillo, Isabella of Bourbon,

---

[2] The plan was one of four that had been submitted to the king; see Gérard, "La fachada del Alcázar," 94, citing documentation in AVM.

[3] Carducho, *Diálogos*, 326.

the Infanta María, and the Cardinal-Infante Ferdinand (H1-6)

Twelve paintings of the months of the year, with the fruits, flowers, and birds of the appropriate seasons (H7-18)

Eight paintings of the four elements and the four seasons (H19-26)

Four paintings by Fabricio Castelo of the royal residences of Balsain, San Lorenzo el Real, the Pardo, and Aranjuez (H27-30)

Four landscapes with figures (H39-42)

Twelve subject-pictures by Juan de la Corte (H45-56)

Fifteen other works were listed singly or in pairs, including portraits (among them two by Rubens and two copied after Titian), religious subjects (two of them attributed to Bosch), landscapes, and genre scenes. Two Florentine polished stone mosaics and two hand-colored works on paper (a map of Flanders by Pedro de Teixeira and a genealogy of the House of Austria by Juan Bautista Labaña) completed the list of pictures. The furnishings consisted of two mirrors and four serpentine marble tables.

No single idea united all those works, but visitors to the gallery would have seen that many pictures shared significant characteristics. The sets, of course, were one kind of grouping, and the installation of the suites of six and twelve pictures might well have been related to the division of the south wall into seven bays of windows with six intervening wall spaces (fig. 54). Another category was the Habsburg dynasty, which was represented in twelve portraits and the royal genealogy. No doubt it was these pictures that inspired another name for the room, the *galería de los retratos* (Gallery of Portraits).[4] Landscapes comprised another group, and the eight paintings of the seasons and the elements thematically overlapped the twelve months of the year. Nevertheless, even though these subordinate groups are evident from the inventory alone, it is the lack of unity to the ensemble as a whole that is most readily apparent. No overall theme links the bewildering array of genres, and the attributed works have Flemish, Italian, and Spanish origins.

The South Gallery was another of the chambers that were transformed

---

[4] Although Bottineau, "L'Inventaire de 1686," 149, asserts that this name was inspired by a series of *Roman Emperors* that entered the gallery in 1652, the name was already in use by 1636. That year's inventory refers to a "Passage that runs from the Great Hall to His Majesty's Gallery of Portraits" (fol. 17bis). From the organization of the King's Quarter and the inventory, the latter room must have been the South Gallery.

between 1636 and 1666. Of the seventy-two pictures that García de Medrano listed there in 1666, twenty-six were grouped in three sets: twelve *Roman Emperors* attributed to Titian, six half-length portraits also assigned to Titian, and eight portraits of Venetian women attributed to Tintoretto. Apart from two more portraits by Tintoretto, the remaining works were listed individually. Moreover, in the three decades since 1636, sculpture and furnishings had assumed greater significance. The new selection included two marbles that each depicted a *Triumph of an Emperor*, two porphyry heads, a relief of the *Nativity*, four porphyry tables with gilded legs, two mirrors, four marble heads on jasper bases, and two sets of bronze andirons with figures.[5]

That ensemble became virtually permanent—especially the paintings. Between 1666 and 1686 the only changes in the pictures were the removal of two genre subjects attributed to the Bassani and the replacement of a *Beheading of Saint John the Baptist* by Rubens with a *Virgin and Child with Saints* by Veronese.[6] Between 1686 and 1700 no pictures were changed.[7] As for the sculpture, by 1686 the *Nativity* had been removed, and a bronze *Bacchanal* in half-relief on a lapis lazuli field, a porphyry *Bacchanal of Infants* also in half-relief, and bronze groups of *Hercules Killing a Centaur with His Club* and *Laocoön and His Sons* on ebony bases had been added to the ensemble. The 1686 inventory also specifies that the two figures in each pair of andirons were Hercules and a nymph with serpents.[8] By 1700 the *Hercules Killing a Centaur*, the *Laocoön and His Sons*, and the andirons had been removed, and two Neapolitan clocks had been put on display there.[9]

By and large, the arrangement that had been reached by the end of Philip IV's reign was left undisturbed. It was a more unified ensemble than that of 1636 and one in which Venetian painting predominated. On the evidence of the 1666 and 1686 inventories, at least sixty-three of the seventy-two pictures hanging in 1666 were painted by Venetian artists. Attributions to Titian were the most numerous (thirty-five), followed by attributions to Tintoretto (nineteen), Veronese (six), and the Bassani (three).[10] Fifty-eight pictures can be

[5] Inventory of 1666, fols. 46-51. I have not appended this text because its wording closely corresponds to that in the 1686 inventory, which Bottineau, "L'Inventaire de 1686," 150-59, has published with consistent references to the earlier text.

[6] Bottineau, "L'Inventaire de 1686," 150-59.

[7] *Inventarios reales*, 1:23-27.

[8] Bottineau, "L'Inventaire de 1686," 159.

[9] *Inventarios reales*, 1:134-35.

[10] Not all the attributions in the inventories are correct

classified as "portraits" in the broadest sense—that is, as paintings of real or imagined figures. By that standard the South Gallery was far more the Gallery of Portraits in 1666 than it had been in 1636. Yet another feature that enhanced the visual harmony of the decoration was the apparent uniformity of the picture frames. The 1636 inventory describes nine kinds of frames for all but three of the pictures, whereas the 1666 inventory mentions the frames of twenty-seven pictures, and all are listed simply as black ones. Their use must have been standard by then, because the first entry in the 1686 inventory of the gallery states that "these and the other paintings in this room have black frames."[11]

In sum, the 1666 ensemble derived its coherence from the dominance of one school (Venetian painting), the emphasis on one genre (portraiture), and the consistent use of black frames. These unifying traits were far less complicated than the programs underlying the Hall of Mirrors and the Gilded Hall. That was in large part attributable to the differences in function assigned to each room. The latter two were public rooms, and their decoration was intended to be seen by spectators who gathered to watch the king perform ceremonial duties of state. The South Gallery, on the other hand, belonged to Philip's more private apartments—"where the King is usually present," as Gómez de Mora put it. Propagandistic considerations were not nearly as significant in planning its decoration, and simpler ideas for its organization sufficed.

These two approaches to palace decoration were not mutually exclusive, however. In many instances they overlapped, as in the case of the Gilded Hall. All the artists known to have painted the *Kings of Castile* were contemporary Spanish masters, and their pictures conformed to the standard composition that Carducho had devised. Because the series was conceived as a whole, the pictures were framed consistently. In a similar way, the *Conquest of Tunis* tapestries were visually consistent because they were based upon one artist's unified design and were woven in a single shop. Even among the complexities of the Hall of Mirrors there was one simple unifying trait: All the pictures had black frames (D1).

---

(Bottineau, "L'Inventaire de 1686," 150-59, assembles the possible identifications of works that have survived), but what is at issue here is what seventeenth-century visitors to the gallery perceived its paintings to be.

[11] *Ibid.*, 151.

Although the South Gallery did not possess a unified program that informed all its pictures, it did incorporate a subsidiary theme of imperial imagery that related it to two neighboring areas of the palace and its grounds, the Garden of the Emperors and the Gilded Hall. In large part this theme was vested in the twelve *Roman Emperors* attributed to Titian. The set initially consisted of eleven *Emperors* that Titian had painted for Federico II Gonzaga during the period 1536-1539, to which the painter Bernardino Campi added a twelfth, *Domitian*, in 1562.[12] They were among the Mantuan treasures that were later purchased by Charles I of England. After his execution in 1649 and the sale of his possessions by the Commonwealth, the *Roman Emperors* were acquired through intermediaries by Philip IV. There is inconclusive evidence that while the series was in Charles's collection, Titian's *Vitellius* was replaced with a copy by Van Dyck, and when the Florentine ambassador reported the arrival of the pictures at Madrid in September 1652, he, too, described one of them as a copy by Van Dyck.[13]

All twelve paintings were destroyed by the 1734 fire, but their compositions are known from numerous copies, among them twelve engravings by Aegidius Sadeler (e.g., fig. 69). The suite represented the first twelve emperors of Rome: *Julius Caesar, Augustus, Tiberius, Caligula, Claudius, Nero, Galba, Otho, Vitellius, Vespasian, Titus,* and *Domitian.* Each was portrayed in half-length, striking a commanding posture and displaying prominent attributes of authority. Imperial garlands, batons, armor, and swords were recurrent, and *Augustus* rested one hand on a globe.

These *Roman Emperors* were installed on one level along the top of the walls of the South Gallery. A memorandum that the painter Jean Ranc prepared immediately after the 1734 fire in order to report which paintings had been lost or saved states that in the gallery "only the portraits of the twelve Emperors that were up high near the ceiling and those that were on the same line were lost." All those that were hung lower were saved.[14] It has been suggested that

[12] For the discussion that follows, see Wethey, *Paintings of Titian,* 3:43-47 and 235-40. Wethey cites a journal of Cosimo III de' Medici's 1668 trip to Spain (*Viaje de Cosme de Médicis,* 123) as indicating that the grand-duke saw eleven *Roman Emperors* by Titian in the "*sala dorata,*" but the set never hung in the Gilded Hall. The journal makes an abrupt transition from a description of the Gilded Hall to a list of some of the best pictures in the Alcázar, and that sudden shift produced the misunderstanding.

[13] Wethey, *Paintings of Titian,* 3:235; and Justi, *Velazquez und sein Jahrhundert,* 617.

[14] Bottineau, *L'Art de cour,* 624.

six of the *Roman Emperors* were installed between the upper windows on the south wall (fig. 54) and that the other six were placed opposite them on the north wall in the intervals between matching sham windows.[15] This seems likely; even if there were no sham windows (such as had been painted in the Great Hall in 1622), the disposition of the *Roman Emperors* on the north wall still would have corresponded to their counterparts across the room. The other works that Ranc said had been "on the same line" probably occupied the end walls.

The South Gallery was deliberately chosen as the setting for the *Roman Emperors* not only because their style and subject harmonized with the rest of the ensemble and because their number fitted the design of the room, but also because the gallery overlooked the Garden of the Emperors, where twenty-four busts of Roman emperors and a full-length statue of the Holy Roman Emperor Charles V were displayed. The busts had been gifts to Philip II. Twelve were copies after antique works that Cardinal Giovanni Ricci di Montepulciano gave him in 1561, and the other twelve were the present of Pope Pius V.[16] Both sets portrayed the same sequence of emperors as the painted series, from Julius Caesar to Domitian.[17] The full-length *Charles V* can be identified from its description in the 1636 inventory: "A full-length statue that is a portrait of the lord Emperor Charles V in armor, with a mantle, a sword in his right hand whose point touches one base, and an eagle. Beneath his right foot is an English morion. The said statue is placed on another base of black and white marble. On the first base—which with all the statue is of white marble—there is an inscription that says who it is."[18] That can only have been the marble *Charles V* by Leone and Pompeo Leoni in the Museo del Prado (fig. 70).[19]

The presence of the statue amidst the two dozen busts was appropriate because Charles V had been a Holy Roman Emperor, which title asserted that

---

[15] *Id.*, "Philip V and the Alcázar," 70.

[16] Varey and Shergold, *Los celos*, lviii-lix.

[17] Inventory of 1636, fols. 51ᵛ-53.

[18] *Ibid.*, fol. 52ᵛ.

[19] See Eugène Plon, *Leone Leoni, sculpteur de Charles-Quint, et Pompeo Leoni, sculpteur de Philippe II: les maîtres italiens au service de la Maison d'Autriche* (Paris, 1887),

284-85, for this statue. However, Plon incorrectly asserts that it was kept in the basement of the Alcázar until being moved to the garden of the Hermitage of San Pablo at the Buen Retiro sometime during Philip IV's reign. González de Avila, *Teatro de las grandezas*, 310, records the presence of a *Charles V* and of *Roman Emperors* in the Garden of the Emperors in 1623.

he was the successor of the ancient caesars whose likenesses surrounded his own. Indeed, one of Charles's considerable political accomplishments had been to revive the use of ancient imperial imagery to glorify his own regime and to proclaim his link with his antique predecessors.[20] None of the later Spanish Habsburgs became a Holy Roman Emperor (the title remained a prerogative of the German branch of the family), but their descent from Charles associated them with the Roman imperial tradition.

Owing to this association the sculptures can be regarded as another variation on the "series of rulers" theme in Habsburg decoration. Setting the *Charles V* among the busts implied that he shared in the glory of the caesars, and by extension so did his descendants. The combination also recalls Carducho's prescription for the decoration of royal galleries, in which he treats Charles as a modern analogue of the princes and commanders of antiquity. Accordingly, the subjects of the garden sculptures could be interpreted as models of princely behavior and accomplishment as well as distinguished forerunners of the Habsburg line. (Courtly discretion, of course, would have led viewers to overlook the more unsavory activities of personages such as Caligula and Nero.)[21]

Thus, a visitor to the South Gallery encountered multiple allusions to the Roman imperial tradition. High above his head, the painted *Roman Emperors* lined the length of the gallery. Dispersed elsewhere on the walls among the many other portraits were two likenesses of Charles V, and one each of his wife (the Empress Isabella), his son (Philip II), and his brother (the Emperor Ferdinand I)—all attributed to Titian. Seen in the company of the *Roman Emperors*, the five portraits reminded the astute viewer of the ties between the Habsburgs and the imperial tradition. So, too, did the two marbles that each represented a *Triumph of an Emperor*.[22] What is more, from the lower windows

[20] For Charles V and the imperial theme, see Jean Jacquot, ed., *Les Fêtes de la Renaissance, II: Fêtes et cérémonies au temps de Charles Quint* (Paris, 1960); Roy Strong, *Art and Power: Renaissance Festivals 1450-1650* (Berkeley, 1984), 75-97; Hugh Trevor-Roper, *Princes and Artists: Patronage and Ideology at Four Habsburg Courts 1517-1633* (New York, 1976), 11-45; and Frances A. Yates, *Astraea: The Imperial Theme in the Sixteenth Century* (London and Boston, 1975), 1-28.

[21] Another notable imperial series in the royal holdings consisted of 141 heads of emperors that Philip III commissioned from Carducho and that were inventoried in the Casa de la Ribera at Valladolid in 1607; see Angulo Íñiguez and Pérez Sánchez, *Escuela madrileña*, 143.

[22] Possibly the two porphyry heads and the four marble heads in medallions that were inventoried in the gallery in 1666, 1686, and 1700 depicted emperors as well. In particular, the porphyry heads were displayed above the marble reliefs of imperial triumphs.

in the south wall the visitor could look down into the Garden of the Emperors, where twenty-five sculpted portraits reiterated the Habsburg connection with imperial greatness.

The person with the greatest access to the gallery was Philip IV, who went there often according to Gómez de Mora. It is telling that although the Alcázar had a *jardín de la reina*, or Queen's Garden, lying to the east below the queen's apartments (figs. 5 and 7), it did not have a King's Garden per se. Instead, the king's apartments overlooked the Garden of the Emperors, as if its very name were meant to suggest the royal association with the imperial tradition. Some justification for the imperial imagery could have been found in the fact that although Philip was not a Holy Roman Emperor, his titles did include that of "Emperor of the Indies."

The installation of the painted *Roman Emperors* also invited a comparison of the South Gallery to the Gilded Hall—another long, rectangular room to which it was literally parallel. Just below the ceiling in each ran a series of paintings that depicted celebrated rulers—*Roman Emperors* in one, *Kings of Castile* in the other. Although the two series differed markedly in number and compositional format, both portrayed their subjects displaying prominent attributes of authority. The similarity between the two ensembles might have been fortuitous, but at the least it reflected a consistent attitude toward subject matter that was considered appropriate for palace decoration.

Too little is known of the history of the South Gallery to date its transformation precisely or to identify who conceived the new arrangement with certainty, but there are grounds for a few conjectures about both. Some paintings that were inventoried there in 1666 did not enter the royal collection before the 1650s. One of the few subject-pictures, a *Venus and Adonis* by Veronese, has been identified with a painting that Palomino says Velázquez purchased for the king in Venice during his second trip to Italy: "He also bought an Adonis and Venus embracing with a little Cupid at their feet, by the hand of Paolo Veronese, and some portraits."[23] On June 23, 1651, Philip wrote to his ambassador in Rome that Velázquez had returned to Madrid and that part of the goods that he had brought with him were in cases aboard

---

[23] Palomino, *El museo pictórico*, 911; and Bottineau, "L'Inventaire de 1686," 156. The picture is Prado no. 482.

Neapolitan ships that had landed on the Spanish coast.[24] If the Veronese was among them, it would have reached Madrid later that year. Perhaps some of the portraits that Palomino mentions also entered the South Gallery at that time. As we have seen, the *Roman Emperors* arrived at the court in September 1652. Another portrait, inventoried in 1666 as "the Duke of Ferrara with a dog," has been recognized to be Titian's *Federico II Gonzaga, Duke of Mantua*, which the king could not have acquired before February 21, 1655, when it was listed in the estate of the Marquis of Leganés.[25]

All this suggests that at least part of the redecoration of the South Gallery took place in the 1650s, but whether the transformation had begun before then remains to be determined. The four-year gap between the arrival of the *Venus and Adonis* (1651) and the *terminus post quem* for the acquisition of the *Federico II Gonzaga* (1655) probably means that, as in the Hall of Mirrors, the change was effected gradually as suitable works became available. During the 1650s Velázquez must have been responsible for maintaining the gallery, which was among the rooms considered in his memorandum of June 20, 1652, concerning the lengths of fabric needed to make window curtains.[26] But the ultimate responsibility for the gallery lay with Philip IV, in whose quarter it was located. A fondness for Venetian painting was characteristic of his taste and that of his Habsburg predecessors, and the undercurrent of imperial imagery within the ensemble could only have pleased him.

## THE OCTAGONAL ROOM

The creation of the *pieza ochavada* (Octagonal Room) was one of the most ambitious of the renovations of the King's Quarter undertaken during Philip IV's reign because it entailed the reconstruction of the room itself as well as the installation of works of art. Its site on the main floor in the Homage Tower (fig. 13; nos. 86 and 87) had been part of the Cardinal-Infante Ferdinand's apartments until he left Madrid to become Viceroy of Catalonia in 1632. For some time thereafter it was called the *galería de los trucos* (*Trucos* Gallery).

[24] Harris, "La misión de Velázquez," 135.

[25] Pedro Beroqui, *Tiziano en el Museo del Prado* ([Madrid], 1946), 41-42; and Bottineau, "L'Inventaire

de 1686," 152.

[26] Iñiguez Almech, "La Casa del Tesoro," 677.

Evidently the tables for playing that form of billiards had been transferred there from the Gallery of the North Wind.[27]

The new Octagonal Room was designed, constructed, and decorated between 1646 and 1648.[28] To judge from the results, it was built with three goals in mind: to create a splendid new space for the display of works of art, to rebuild the staircase in the tower that descended to the vestibule where the king would board his coach, and to open a grand, unbroken approach from the South Gallery to the Hall of Mirrors. The disposition of rooms *enfilade* had been introduced into Spanish palace design at the Buen Retiro in the 1630s by the Italian architect Giovanni Battista Crescenzi.[29] In this instance, however, it was Crescenzi's rival, Gómez de Mora, who incorporated the feature in the project, which he directed as *maestro mayor* of the royal works. He was assisted by Velázquez, who was appointed overseer and accountant of the project in 1647.[30] The completed chamber appears on the Ardemans, Justi, and Verger plans (figs. 9-11); one of Verger's sections shows an elevation of it (fig. 54; room K); and the background in a portrait of *Mariana of Austria* by Mazo provides a tantalizing glimpse of it as seen from the Hall of Mirrors (fig. 71).[31]

The octagonal floor plan that gave the room its name was set within a square cut from the thick walls of the old tower. It was not an equilateral octagon; rather, its four sides parallel to the axes of the palace were wider than the "oblique walls" that connected them. As Yves Bottineau has concisely analyzed Verger's plan and elevation of the room, "On either side of the central section—consisting of two tiers, each with two windows, separated by a long rectangular panel—wall surfaces at oblique angles to the central sections are symmetrically disposed (within an architectural framework of high Corinthian

[27] For the location of the *Trucos* Gallery, see AGS, CM3, leg. 756, Extraordinario, fols. 39ᵛ-39bis, 40ᵛ-40bis, and 96-96ᵛ.

[28] For documentation of this and related works, see *ibid.*, fols. 33ᵛ-122 passim; *id.*, Nominas, fols. 10bis-64ᵛ passim; and AGS, CM3, leg. 1373, Salón Ochavado, passim. Azcárate, "Noticias sobre Velázquez," 367-73, first cited much of this documentation. See also APM, SA, Inmuebles, leg. 710, 1646.

[29] Brown and Elliott, *Buen Retiro*, 84.

[30] Velázquez's celebrated dispute with Gómez de Mora is generally held to have involved this project. See An-

tonio Bonet Correa, "Velázquez, arquitecto y decorador," *AEA* 33 (1960), 225-27; Iñiguez Almech, "La Casa del Tesoro," 672-73; and René Taylor, "Juan Bautista Crescencio y la arquitectura cortesana española," *Academia: Boletín de la Real Academia de San Fernando* 48 (1979), 86-89.

[31] These views of the room are discussed in Bonet Correa, "Velázquez," 233-35; Yves Bottineau, "A Portrait of Queen Mariana in the National Gallery," *BM* 97 (1955), 114-16; and Neil MacLaren, *National Gallery Catalogues: The Spanish School*, 2nd edn., rev. by Allen Braham (London, 1970), 52-54.

pilasters) showing doors with arched pediments, and above them rectangular and semi-circular panels; ten niches, shown on the plan between the windows and, cantwise, on either side of the doors, are more or less legible on the elevation where they are shown to contain statues."[32]

One detail of Verger's elevation is problematical—it depicts seven full-length statues in niches in half the room, which, if we assume the design was symmetrical, implies that there were fourteen such figures altogether. Verger's plan only shows ten niches, symmetrically disposed, and, as we shall see below, the inventories of the room's decoration consistently list only ten such sculptures in the room. The error in the elevation apparently resides in the two statues at the edge of the south (i.e., the central) wall, for which no corresponding niches appear on Verger's plan. It is possible that the number of full-length statues was increased between 1700, when the room was inventoried for the last time, and 1711, when Verger drew his plan and elevation, but for a correct understanding of its appearance under the Habsburgs the two questionable figures should be disregarded.

The elevation indicates that the doors in the east and west walls were taller than those in the oblique panels. The west door stands to the left in the background of Mazo's *Mariana of Austria* and has a flat entablature, whereas a curved pediment surmounts the lower, northwest door at the right. Like the Hall of Mirrors and the South Gallery, the Octagonal Room was two stories tall, and according to Verger's section, its height equalled its width. Above its cornice rose an octagonal ceiling defined by eight ribs that sprang from the Corinthian pilasters below. None of the views adequately conveys the rich coloring of the stonework in the chamber. The niches, pilasters, and ceiling ribs were jasper, the revetments were marble, and the floor was paved with stone tiles.[33] The paintings and sculptures that were displayed there further heightened the brilliant coloration of the room. It was surely its polychromy, as well as its octagonal plan and its use to show works of art, that in 1651 prompted the Florentine ambassador to compare the Octagonal Room to the Tribune in the Uffizi.[34]

---

[32] Bottineau, "A Portrait," 115.

[33] See the AGS documentation in n. 28.

[34] Justi, *Velazquez und sein Jahrhundert*, 545 n. 1.

As work progressed on the Octagonal Room, plans were made to decorate it with paintings. In 1647 stretchers and frames were constructed for twenty paintings that were to hang there, and in 1647 and 1648 Mazo was paid 1,480 *reales* for "six paintings that he made for the Octagonal Room and other repairs [*aderezos*] in some of the others."[35] When Medrano inventoried the room in 1666 (Appendix I), twenty paintings were on view, but none was by Mazo. Either he had painted pictures that were removed from there before 1666, or, what is more likely, all his efforts had consisted of restorations of existing pictures. (Perhaps the six that he had been cited for making had required more extensive repairs than the rest.) Inasmuch as Mazo was the expert consultant who assisted Medrano in appraising the paintings, Medrano could not have misidentified originals by Mazo as the work of other artists.

All twenty pictures had been painted by Flemish artists. A *Bacchus and Nymphs* (I1), *Mercury* (I2), and *Saturn* (I3) were assigned to Van Dyck in 1666, but in 1686 they were reattributed to Rubens.[36] The latter was represented extensively in the room with three pictures of hunting and war (I5-7), later described in 1686 as "[two] hunts and a war"; a set of eight small paintings (I8-15) later identified in 1686 as "the Labors of Hercules and myths"; and a pair representing *Hercules* (I17) and *Diana* (I18). He was also credited for the *Hunt of Meleager and Atalanta* (I20) that in 1636 had been hanging in the New Room with the *Hunt of Diana* (I16), for which he shared credit with Snyders.[37] Also attributed to Rubens and Snyders was a *Diana and Nymphs Hunting* (I4). The lone work to go unattributed in 1666, a *Hercules Wrestling with a Lion* (I19), was given to Rubens in 1686. All twenty paintings remained in place after 1666, and the only picture to be added during the reign of Charles II was a ceiling painting described in 1686 and 1700 as "three nymphs with musical instruments and a little cupid" by Tintoretto.[38] As in the Hall of Mirrors and the South Gallery during their later years, all had black frames.

Ranc's memorandum concerning the survival of paintings after the 1734 fire states that "from the Octagonal Room, which was of the School of Rubens,

[35] AGS, CM3, leg. 756, Extraordinario, fols. 45v-45bis and 52-52bisv; *id.*, Nominas, fols. 47-47v and 48bisv-49v; and AGS, CM3, leg. 1373, Salón Ochavado, fols. 1bis and 5bis-5bisv. Azcárate, "Noticias sobre Velázquez," 372, first cited these documents.

[36] For the 1686 inventory citations in the following remarks, see Bottineau, "L'Inventaire de 1686," 57-59.
[37] See Chapter II, n. 87.
[38] Bottineau, "L'Inventaire de 1686," 59; and *Inventarios reales*, 1:21.

only three or four small pictures were saved."[39] However, these small pieces are unknown, and the only picture that has been identified as a survivor is the *Hunt of Diana* (fig. 34), one of the two largest paintings in the room. The appearance of its pendant, the *Hunt of Meleager and Atalanta*, is known from Rubens's preparatory sketch (fig. 32). It has also been plausibly suggested that a *Diana and Nymphs Hunting* by Mazo (fig. 72) is a copy after the lost original by Rubens and Snyders (I4).[40] The *Hercules Wrestling with a Lion* might have been based on either of two designs by Rubens for which his oil sketches have survived.[41] Tintoretto's ceiling painting apparently resembled another, surviving version of the subject—its actual theme is an *Allegory of Music*—that matches the inventory descriptions and that has also been attributed to Tintoretto.[42]

From the beginning sculpture played a significant role in the Octagonal Room. On May 28, 1647, a payment of 745 *reales* to the master gilders Francisco de Córdoba and Juan Cerrano was authorized "for cleaning ten bronze statues that were brought from the royal household of the Buen Retiro. Seven of them were seven planetary deities [ *planetas*], and of the other three, one was the portrait of Philip II, another of the Emperor, and another of the Queen of Hungary. These were to be put in the new Octagonal Room that was made in the Alcázar of Madrid."[43] The Cardinal-Infante Ferdinand had acquired the *Seven Planetary Deities* for the Buen Retiro in 1637 from an Antwerp merchant. The work of Jacques Jonghelinck, all seven survived the 1734 fire (figs. 73-78).[44] Two of the bronze portraits can be identified as the *Philip II* (fig. 79) and the *Mary, Queen of Hungary* (fig. 80) that Mary had commissioned from Leone Leoni in 1549.[45]

[39] Bottineau, *L'Art de cour*, 624.

[40] Alpers, *Torre de la Parada*, 40.

[41] See Held, *Oil Sketches*, 1:311-12 and 330-31.

[42] For the extant version of the composition, see Rodolfo Pallucchini and Paola Rossi, *Tintoretto: le opere sacre e profane*, 2 vols. (Milan, 1982), 1:221, and 2:434 and pl. 287. It is unlikely that this is the same picture as the one that adorned the Octagonal Room because the inaccessible location of the latter—at the center of a two-story ceiling—would have prevented its rescue during the 1734 fire.

[43] AGS, CM3, leg. 756, Extraordinario, fols. 58ᵛ-58bis (cited in Azcárate, "Noticias sobre Velázquez," 371-72).

[44] See L. Smolderen, "Bacchus et les sept Planètes par Jacques Jonghelinck," *Revue des Archéologues et des Historiens d'Art de Louvain* 10 (1977), 102-43; Brown and Elliott, *Buen Retiro*, 109-10; Bottineau, "A Portrait," 115; and MacLaren, *The Spanish School*, rev. Braham, 54 n. 10. Unfortunately, repeated efforts to obtain a photograph of one of these statues, *The Sun (Apollo)*, for reproduction here have proved unavailing.

[45] See Michael P. Mezzatesta, "Imperial Themes in the Sculpture of Leone Leoni" (Ph.D. diss., New York University, 1980), 108-71, for these works with further bibliography.

As for the portrait of the emperor, that can be narrowed to two possibilities, both by Leone Leoni—either his group of *Charles V and Fury Restrained* (fig. 82) or his half-length *Bust of Charles V* (fig. 81).[46] The first of these depicts its subjects as full-length figures. It had been displayed in the Emperor's Courtyard of the Buen Retiro in the 1630s, where it appears in a painting of that palace from ca. 1636-1637 that has been attributed to Jusepe Leonardo. It does not appear there, however, in the elaborate *Map of Madrid* that Teixeira published in 1656, which does show another sculpture, Pietro Tacca's *Equestrian Portrait of Philip IV*, in the Queen's Garden of the same palace.[47] On the other hand, the record of payment to the gilders for cleaning the ten bronzes makes no mention of the figure of Fury, and the *Bust of Charles V*, like the other nine bronzes, portrays a single figure, albeit not in full length. A case can be made for assigning either piece to the Octagonal Room, but because it is known that the *Charles V and Fury Restrained* had been in the Buen Retiro and because there is some evidence that it was removed from there by 1656, it seems the more likely candidate.

When Medrano inventoried the Octagonal Room in 1666, the *Seven Planetary Deities* were the first sculptures that he listed (I21-27). His next entry cites three bronze, life-sized figures (I28-30), but by that time the three portrait statues had been removed from the ensemble. In their place stood three figures that Velázquez had commissioned for the room during his second trip to Italy. They have been convincingly identified as an *Athlete with a Discus* (fig. 83), an *Orator* (fig. 84), and a *Satyr at Rest* (fig. 85), which had been cast in Rome in 1650 and 1651 from molds taken from antique statues.[48] Other *adornos* present in 1666 included twelve marble medallions on jasper pedestals (I31-42), four bronze heads (I43-46), and a bronze *Spinario* (fig. 86) on an octagonal table (I47).[49] The *Spinario* was another of Velázquez's acquisitions from his second Italian trip.[50] The same sculptures were present in 1686, but by 1700 the *Spinario* and its table had been removed, and an elaborate clock, its case,

[46] See *ibid.*, 1-107, for these works with further bibliography.

[47] See Brown and Elliott, *Buen Retiro*, 109 and 111-14, and figs. 30 and 39.

[48] Harris, "La misión de Velázquez," 119-20.

[49] Wooden models were made for casting bronze legs for the octagonal table, but evidently that was never carried out (I47); other tables were also constructed for the Octagonal Room, but as they are not listed in any of the inventories, they may never have been placed there. See AGS, CM3, leg. 756, Extraordinario, fols. 45bis^v-71bis^v passim (cited in Azcárate, "Noticias sobre Velázquez," 372-73).

[50] Harris, "La misión de Velázquez," 120-21.

and a *trucos* table had been added to the ensemble.[51] The 1700 inventory also specifies that the twelve marble medallions were "white marble heads of emperors in half-length."[52]

Although there is insufficient evidence on which to base a complete reconstruction of the Octagonal Room, Mazo's *Mariana of Austria* (fig. 71) and Verger's section (fig. 54) convey hints of its arrangement. In the *Mariana* parts of two paintings are visible above the west doorway, and the bronze *Venus* from the *Seven Planetary Deities* stands in a niche to the right.[53] One of the four bronze heads sits atop the curved pediment of the northwest doorway; presumably its three counterparts were symmetrically disposed above the doors in the other oblique walls. Although Verger's section omits the paintings, it does suggest where a few of them were installed. One of the two largest scenes—the *Hunt of Diana* (fig. 34) or the *Hunt of Meleager and Atalanta* (cf. fig. 32)—must have occupied the wide rectangular panel on the south wall, and the other would have hung opposite it in a similar panel on the north wall. During Charles II's reign Tintoretto's *Allegory of Music* would have been installed at the center of the ceiling, where the jasper ribs of the walls converged. Mazo omitted the *Spinario* and its table from his painting (probably for compositional reasons), and by the time that Verger drew his section, they had been removed from the room. As the right-hand mirror reflection in Carreño's Berlin *Charles II* (fig. 57) shows, they stood in the center of the room. None of the views indicates how the twelve marble emperors were displayed.

As in the South Gallery, the painted decoration of the Octagonal Room was unified by the choice of subject matter and an emphasis on one regional school of painting. Whereas portraiture by the Venetian school, especially Titian, was featured in the gallery, Flemish painting prevailed in the Octagonal Room, where Rubens was the presiding genius and mythological subjects predominated. Only the late addition of Tintoretto's *Allegory of Music* departed from the Flemish basis for the ensemble. That probably reflected the relative availability of ceiling paintings, which were a genre that Venetian Renaissance

[51] Bottineau, "L'Inventaire de 1686," 59-61; and *Inventarios reales*, 1:132-34.

[52] *Ibid.*, 132.

[53] MacLaren, *The Spanish School*, rev. Braham, 53, confirms the identification of the *Venus* on the basis of a radiograph that shows the upper part of the statue beneath the curtain painted over it. *Ibid.*, 52, identifies the object blocking the northwest door as a toy coach.

masters had practiced more frequently than their Flemish Baroque counterparts.

Also as in the South Gallery, there was a readily discernible subtheme in many of the paintings: hunting. It is telling that an account of Cosimo III de' Medici's visit to Madrid in 1668 records that in the Alcázar "one entered an octagonal room, on each of the faces of which there is a large picture by Rubens representing various hunts of Diana."[54] The hunts of Diana were not the only painted subjects in the room, but that is the impression that the ensemble left in the writer's mind. Hercules, the individual represented most frequently in the paintings, was likewise one of the greatest hunters in antiquity.

Hunting was a favorite pastime of generations of Habsburgs, who relished its thrills and esteemed it a sport worthy of princes, and Philip IV was no exception.[55] The chase was held to provide an opportunity for a prince to display his valor, and it was widely regarded as an ideal training ground in the arts of war. Juan Mateos, the king's hunting master, epitomizes this attitude in the prologue to a treatise on hunting that he published in 1634.[56] Hunting, Mateos argues, is a noble activity befitting princes because it trains them for warfare. From hunting they learn to endure the elements, master their horses and fears, accustom themselves to the sight of blood, acquire proficiency with arms, and familiarize themselves with the tactics and stratagems that they must know to survive. Its nobility, he continues, is proved by the distinguished history of great men who were great hunters. Among those whom he cites are David, Hercules, Achilles, Alexander the Great, and the long line of kings of Spain, including one who himself had written a treatise on hunting (an allusion to Alfonso XI of Castile, author of the *Libro de la montería*).[57] His list of illustrious hunters concludes with none other than Philip IV:

From a tender age he speared wild boars with such dexterity that it was the wonder of those who saw it; and His Majesty has improved at

---

[54] *Viaje de Cosme de Médicis*, 124 n. 3.

[55] See Alpers, *Torre de la Parada*, 101-104; Luis Calandre, *El Palacio del Pardo (Enrique III-Carlos III): estudio preliminar* (Madrid, 1953), 3-108 passim, esp. 3-20; and Gállego, *Visión y símbolos*, 271-72.

[56] Juan Mateos, *Origen y Dignidad de la Caça* (Madrid,

[57] On Alfonso XI's authorship, see Matilde López Serrano, *Libro de la Montería del Rey de Castilla Alfonso XI: estudio preliminar*, 2nd edn. (Madrid, 1974), 8 and 17-18.

1634), unpaged.

it in such a manner that he has commanded that when he fights them, no dogs that seize them by the legs may be loosed, but only hunting dogs that track them. For this reason, just as his glorious ancestors made him the monarch of so many dominions, so his skill with the lance and with gunpowder makes him the monarch of the populations of the air and of the populace of the forests. All these actions are well attested marks of warfare, if any war were to merit so sovereign a presence.

Mateos employs a circular logic of merit by association: Hunting is noble because great kings practice it, and kings are great because they excel in the noble art of hunting.

That attitude accounted in part for the presence, in an urban palace, of an ensemble that emphasized the rural sport of hunting. On the face of it, such a subject was better suited to a country house like the Pardo Palace or a hunting lodge like the Torre de la Parada, both of which were adorned with hunting pictures among other decorations.[58] Because the chase was regarded as a suitable—indeed, essential—activity for princes, paintings of fearless hunters provided another expression of the inspirational palace decoration that Carducho advocates in his *Diálogos de la pintura*: exemplary models for virtuous rulers. The inclusion of Hercules in both Mateos's prologue and the Octagonal Room was especially apt, for he was considered not only the greatest hunter and warrior of antiquity but also one of the earliest kings of Spain.

The Octagonal Room differed from most of Philip's chambers in that its sculpture played a role equal to its paintings.[59] Initially the sculptural decoration had honored his forebears by displaying portraits of his grandfather (Philip II), great-grandfather (Charles V), and great-great-aunt (Mary of Hungary) in the company of the *Seven Planetary Deities*. This associated the king's ancestors with the ancient practice of apotheosizing members of the Roman imperial family into the company of the gods, a practice that the twelve marble heads of Roman emperors may also have prompted visitors to the room to recall. It was another expression of the Habsburgs' association with the imperial

[58] For the Torre, see Alpers, *Torre de la Parada*, 107-28 and 143-45. Calandre, *El Palacio del Pardo*, is the best introduction to the Pardo, but a more thorough study is needed.

[59] Sculpture likewise played a lesser role in the Buen Retiro; see Brown and Elliott, *Buen Retiro*, 114.

tradition that the nearby South Gallery and the Garden of the Emperors evoked as well.

By replacing the portrait statues with the *Athlete with a Discus, Orator*, and *Satyr at Rest*, Velázquez (who by the 1650s had charge of such matters as *aposentador*)[60] altered the significance of the ten bronzes. What had been a glorification of the royal dynasty became an illustration of characters from ancient life and literature that was but part of a greater ensemble of sculpture and painting. Gods and heroes, nymphs and emperors, hunters and warriors— all surrounded the visitor to the chamber. The *Spinario*, a copy of one of the most famous antiquities known to the seventeenth century, sat at the center of it all. To the spectator with a vivid imagination, the Octagonal Room presented a microcosm of the ancient world.

## THE ROOM OF THE *FURIAS*

The Room of the *Furias* (fig. 13; no. 24) was a royal bedroom. In 1626 Gómez de Mora called it the "apartment in which His Majesty ordinarily sleeps, next to the Queen's apartment,"[61] and almost eighty years later Ardemans identified it as the "bedroom of Their Majesties" (fig. 9; no. 23).[62] The chamber took its name from the *Furias* by Titian (and a copyist?), which had hung there before they were moved to the New Room. Jacob Cuelvis saw the room in 1599 (Appendix J) and recorded the presence of the *Furias* there (J9-12), although he mistook Sisyphus carrying his rock (fig. 21) for Atlas bearing a mountain, and Ixion whirling on his wheel for Icarus falling from the sky. He also observed eight paintings of the *Four Elements* (J1-4) and the *Four Seasons* (J5-8) that were versions of the eight *grilli*—fantastic bust-length figures composed of animals, plants, or inanimate objects that pertained to the elements or seasons that the figures represented—that Arcimboldo had invented and

[60] The Octagonal Room was another room considered in Velázquez's June 20, 1652, memorandum concerning fabric needed for curtains; see Iñiguez Almech, "La Casa del Tesoro," 677.

[61] Gómez de Mora, "Relaçion de las cassas," fol. 1ᵛ.

[62] I have found only one recorded ceremonial use for the room. On March 25, 1612, Philip III received the ordinary French ambassador there, less than a month before the Duke of Mayenne's arrival at the court. As in Mayenne's receptions, the ordinary ambassador was escorted through the King's Quarter, but his route continued through the Great Hall to the Room of the *Furias*. Apparently the king preferred a less public, more intimate setting on that occasion. See Cabrera de Córdoba, *Relaciones*, 467-68; and "Relation d'un voyage en Espagne," ed. C. Claverie, *RH* 59 (1923), 493.

presented to the Holy Roman Emperor Maximilian II in 1569.[63] Most likely either Maximilian or his successor, Rudolf II, had sent the eight to Philip II as a gift.

The number four governed this ensemble: four *Seasons*, four *Elements*, and four *Furias*. Yet, as in the South Gallery and the Octagonal Room, more sophisticated ideas supplemented the simplicity of this unifying numerical trait. The original eight *grilli* for Maximilian II were imperial allegories filled with symbolic allusions to the emperor's power, the harmony of the world under his reign, his opposition to the Turkish empire, Habsburg marriages, and the continued dominion of the Habsburg dynasty. This symbolism made the copies of Arcimboldo's inventions an appropriate gift from one Habsburg to another. The *Furias* did not lend themselves directly to such interpretations, but they were related to the *grilli* in a less complicated way. Whereas the *Elements* and the *Seasons* referred to the natural world of man's daily life, the *Furias* illustrated eternal torments in Hades, a realm of the afterlife. The opportunity to contrast the underworld with the natural world may have prompted the original decision to assemble these paintings in one room.

By 1636 all twelve pictures had been removed from the room, and a new ensemble had taken their place.[64] The inventory taken that year (Appendix K) lists thirty-four paintings, twenty-one of them portraits. All but four of the sitters—Pope Hadrian (K2), a Francisco Tomás (K7), Louis XIII of France (K10), and Henrietta Maria of England (K11)—were Habsburgs by birth or by marriage, spanning four generations from Charles V to the children of Philip III.

Fundamentally the ensemble was a portrait gallery that glorified the Habsburg line. Two paintings of the Exchange of Princesses between Spain and France in 1615 (K21-22) expanded that theme, as did seven views of Spanish territories—Gibraltar (K25-28), Málaga (K34), Mallorca (K19), and Menorca

---

[63] For the following remarks on the invention of the *grilli*, their variants, and their meaning, see Thomas DaC. Kaufmann, *Variations on the Imperial Theme in the Age of Maximilian II and Rudolf II* (New York-London, 1978), ii and 76-102; similarly, *id.*, "Arcimboldo's Imperial Allegories," *ZfK* 29 (1976), 275-96. A painting of *Spring* in the Real Academia de Bellas Artes de San Fernando, Madrid, might have belonged to the *Four Seasons*.

[64] The *Elements* and the *Seasons* might have been the eight pictures that were recorded in the South Gallery in 1636 (H19-26). Four of these pictures may have been the "four portraits made of various trinkets [*baratijas*]" that were in the Gallery of the North Wind in 1666 and that were subsequently moved to the king's summer apartments (Inventory of 1666, fol. 36).

(K20)—and a picture of unspecified (military?) undertakings of Charles V (K23). Three miscellaneous subjects completed the suite—a *Hunt* (K32) and two paintings attributed to Bosch (K24 and 33), the only artist specified by name. One of these was a "wagon of many things" (a version of the *Hay Wain*?), and the other a *Temptation of Saint Anthony*. But the three miscellaneous pieces were exceptions to the chief concerns of the ensemble. When Philip IV retired in the evening and awoke in the morning there, he found himself surrounded by images that, for the most part, recalled the greatness of his family line. Like the more formally organized *Kings of Castile* in the adjacent Gilded Hall, the Habsburg portraits asserted the merit of his lineage and spurred him to emulate his distinguished predecessors.

The later inventories ignore the Room of the *Furias*, which may mean that it came to be considered part of the neighboring Queen's Quarter. The 1700 inventory mistakenly applies its name to the king's new bedroom that had been partitioned from the east end of the Gilded Hall (fig. 9; no. 18), but a reference to the *Kings of Castile* along its cornice betrays the error.[65] The mistake is telling. Whereas the South Gallery and the Octagonal Room lay on the dramatic approach to the Hall of Mirrors, the Room of the *Furias* played a negligible role in the public life of the king. Its lack of a ceremonial function, in turn, accounts for the uninspired impression that the 1636 listing of its contents makes. There simply was no great need to dress it up to impress visitors. Indeed, its decoration in 1599 seems to have been more interesting than the ensemble that replaced it. The very name of the chamber is the best proof of this, for it continued to be called the Room of the *Furias* years after the *Furias* had been removed from its confines.

[65] *Inventarios reales*, 1:120.

# CHAPTER V

# *The Role of the Setting in* Las Meninas

L AS MENINAS (fig. 87) is one of the undisputed masterpieces of Western art. For more than three centuries Velázquez's portrait of himself painting amidst members of the royal family and their household has earned him praise for his subtlety of psychological observation, his convincing spatial illusionism, and his masterly handling of paint. Yet the importance of this remarkable picture lies not only in its beauty, for it is also one of the few surviving interior views of the Alcázar of Madrid. By reconstructing the decorative scheme of the room that it portrays, we can resolve the longstanding problem of the significance of the paintings hanging on the rear wall for the meaning of *Las Meninas*.[1]

The two large pictures in the background have long been recognized as Mazo's lost *Minerva and Arachne* (at the left) and his *Contest of Pan and Apollo* (right; fig. 88). Both were copies after paintings in the Torre de la Parada that were based in turn upon oil sketches by Rubens.[2] The first of these, the oil sketch for which has survived (fig. 89), illustrated Ovid's account of the tapestry-weaving contest between the goddess Minerva and the mortal woman Arachne, which ended in a draw (*Metamorphoses*, VI.50-145). Rubens's composition depicts the aftermath of the competition, when Minerva strikes Arachne with a shuttle from a loom to punish her for her arrogance in challenging a deity. The *Contest of Pan and Apollo* (often misidentified as the "Contest of Apollo and Marsyas") represents the outcome of another competition recounted by Ovid (*Metamorphoses*, XI.146-79). The mountain god Tmolus, having judged Apollo's artistry with the lyre superior to Pan's musicianship with the syrinx, extends a victor's garland to the winner. Meanwhile Apollo, angered

---

[1] Some of the conclusions reached in this chapter first appeared in Steven N. Orso, "A Lesson Learned: *Las Meninas* and the State Portraits of Juan Carreño de Miranda," *Record of The Art Museum, Princeton University* 41:2

(1982), 24-34.

[2] In general, my identifications of Mazo's copies after paintings from the Torre de la Parada in this chapter have followed Alpers, *Torre de la Parada*, passim.

by the mortal Midas's preference for Pan's music, punishes Midas by trans-
forming his ears into those of an ass.

   In addition to those two works, two other paintings also decorate the rear
wall in *Las Meninas*. One hangs to the right of the open door, and the other
appears to the left of Velázquez's head. Both are partly concealed from view,
and neither subject can be recognized from the painting. Nevertheless, these
small pictures must be identified before it can be determined what significance,
if any, they and the two large pictures have for the meaning of *Las Meninas*.

## THE MAIN ROOM OF THE PRINCE'S QUARTER

In his biography of Velázquez, Palomino provides a brief description of the
setting as it appears in *Las Meninas*: "In this gallery, which is the one in the
Prince's Quarter where he painted, various paintings are seen with difficulty
on the walls. They are known to be by Rubens and depict stories from the
*Metamorphoses* of Ovid."[3] This was not the Gallery of the North Wind, where
Velázquez was recorded working in 1632. Rather, it was a room first inven-
toried in 1686 as the *pieza principal* (Main Room) of the *cuarto bajo que llaman
del príncipe que cae a la plazuela de palacio* (Prince's Quarter below the Main
Floor that Overlooks the Plaza de Palacio). It lay directly below the South
Gallery in the space occupied by rooms 12 and 25 on Gómez de Mora's plan
of the second floor of the palace (fig. 7).[4] In 1626, when he drew the plan,
these were respectively the Cardinal-Infante Ferdinand's dining room and a
gallery in the quarters of his sister María.[5]

   When the partition separating these chambers was later removed, they
became the Main Room, a rectangular gallery seven bays in length.[6] That
probably occurred in 1643, when Baltasar Carlos, whose title gave the Prince's

[3] Palomino, *El museo pictórico*, 921.
[4] Francisco J. Sánchez Cantón, *Las Meninas y sus per-
sonajes* (Barcelona, 1943), 14, first identified the setting
as the Main Room on the basis of the 1686 inventory.
Bottineau, "L'Inventaire de 1686," 450-51, located it
precisely with the aid of the Ardemans plan, which iden-
tified the South Gallery (fig. 9; no. 13) as the "Gallery
of Grandees, and below the Prince's Quarter."
[5] Gómez de Mora, "Relaçion de las cassas," fols.
3ᵛ-4.
[6] The partition can be identified with a "wooden par-

tition wall that was made in the lower gallery of His
Majesty in order to place a dossel for the Infanta María"
that Semini was paid for painting on July 23, 1621
(APM, Libro de pagos, fol. 145). In fact, a platform for
her throne is shown against the partition wall in Gómez
de Mora's plan. Apparently this wooden wall was later
replaced, for a thick plaster partition was constructed in
February 1628 "to divide the windows of the aforesaid
quarter of the Queen of Hungary [María's title in 1628]
from those in the quarter of the lord Cardinal-Infante"
(APM, SA, Obras, leg. 5208, fol. 26bis).

Quarter its name, took up occupancy in the *cuarto*.[7] Because the windows that faced south line the right-hand wall in *Las Meninas*, the rear wall in the painting must have been the east end of the room. Only its left-hand door is indicated on the 1626 plan. Its counterpart to the right, which opens onto stairs and a landing, most likely was cut into the wall when the Octagonal Room was constructed and the staircase in the Homage Tower was renovated in the late 1640s.

The 1686 inventory lists the forty paintings then in the Main Room as by Mazo, almost all of them copies after works designed by Rubens (see Appendix L). Many were based upon paintings in the Torre de la Parada; others, upon pictures elsewhere in the Alcázar; and the remainder, upon originals that have yet to be identified. Comparing *Las Meninas* to the inventory establishes that the painting portrays the Main Room accurately. This is most evident from the way that the distribution of paintings on the four visible bays of the window wall conforms to the inventory text. The last two entries each describe a row of six *entreventanas* (pictures between windows), which implies that there were seven windows, as Gómez de Mora's plan shows. In *Las Meninas* there are two tiers of *entreventanas*, the smaller ones (L29-34) situated above the taller, narrower ones (L35-40). Above them hangs a row of *sobreventanas* (pictures above windows) in which wide paintings (L17-23) alternate with narrow ones (L24-28) as the inventory requires.[8]

Moreover, one of the six lower *entreventanas* is recognizable in *Las Meninas*, and it hangs precisely where the inventory would lead one to expect to find it. Ochoa listed the six in order as *Heraclitus*, *Democritus*, *Hercules and the Hydra*, *Mercury*, *Saturn*, and *Diana*—all copies after Rubens by Mazo (L35-40). Mazo based the first five upon pictures in the Torre de la Parada; the original upon which the *Diana* is based has yet to be identified with certainty.[9] Mazo's

[7] Baltasar Carlos's occupancy of the Prince's Quarter probably dates from June 21, 1643, when Philip IV appointed his son's household (León Pinelo, *Anales*, 328; and Novoa, *Historia*, 4:124). For documentation of renovations in the Prince's Quarter at that time, see AGS, CM3, leg. 1461, Destajos, fols. 84bis-121ᵛ passim; *id.*, Compras, fols. 45bis and 52ᵛ; *id.*, Conventos y Iglesias, fols. 4-4bisᵛ; and APM, SH, Reinados, Felipe IV, I, leg. 2915, 1636-1647.

[8] One would expect there to have been six rather than

five narrow *sobreventanas* for a consistent alternation. Either there was a break in regularity or the pictures were miscounted in 1686. The 1700 inventory (*Inventarios reales*, 1:71) also specifies five pictures, but because its text follows that of 1686 so closely, any earlier error might have been transcribed unthinkingly.

[9] Díaz Padrón, *Escuela flamenca*, 1:333-34, suggests a picture in the Passage to La Encarnación in 1686 might have been the original *Diana*: "A painting of Diana going to the hunt, measuring one *vara* in height and one-half

*Democritus*, *Hercules and the Hydra*, *Mercury*, and *Diana* have survived.[10] His *Heraclitus* and *Saturn* are lost, but Rubens's full-scale originals for the Torre have been preserved.[11] Thus, the compositions of all six *entreventanas* can be matched against the patches of color in the picture from that row that is closest to the viewer in *Las Meninas*. It has to be the *Mercury* (fig. 95). The silver glint of the wings on his cap, the warm red of the mantle drawn across his body, and the dark gap between his upper right arm and his torso are all discernible. Counting from the back of the room, the *Mercury* is the fourth picture in its row. It is also the fourth subject to be named in its inventory entry. Because the logical way for Bernabé Ochoa to have compiled that entry would have been to list the paintings in left-to-right sequence, this confirms that Velázquez took pains to record the Main Room ensemble accurately in *Las Meninas*.

None of the remaining pictures on the south wall is recognizable. The six *Labors of Hercules* (L29-34) in the upper row of *entreventanas*, also copied by Mazo after Rubens, call to mind the eight lost paintings by Rubens from the Octagonal Room (I8-15) that Ochoa identified in 1686 as "the Labors of Hercules and myths."[12] Because none of these works is known, no certain relationship between the two sets can be confirmed; however, there does not appear to have been any other set of Hercules paintings by Rubens that Mazo could have copied.[13]

As for the large *sobreventanas* of animals and landscapes (L17-23), Mazo might have copied them from pictures in the Torre de la Parada, but if so, they were based upon compositions by Frans Snyders, not by Rubens as the inventory states.[14] The fifty animal and hunting scenes that Philip IV had ordered for the Torre were mostly displayed over doors and windows, so many of the compositions would have been suitable for adaptation as *sobreventanas* in

---

in width, by the hand of Rubens" (Bottineau, "L'Inventaire de 1686," 476). However, see also n. 13 below.

[10] Prado nos. 1706 (*Democritus*), 1708 (*Mercury*), 1710 (*Hercules*), and 1725 (*Diana*).

[11] Prado nos. 1678 (*Saturn*) and 1680 (*Heraclitus*).

[12] Bottineau, "L'Inventaire de 1686," 58; for the Octagonal Room, see Chapter IV.

[13] Alpers, *Torre de la Parada*, 274-79, reviews the Hercules subjects painted by or after Rubens that were cited

in the 1686 inventory. Another possible link between the Octagonal Room and the Main Room is that four of the subjects in the other row of *entreventanas*—Mercury, Saturn, Hercules, and Diana—were also shown in four pictures, now lost, in the Octagonal Room (I2-3 and I17-18). However, see also n. 9 above.

[14] Alpers, *Torre de la Parada*, 116-22 and 143-45; on the identification of Snyders as the artist responsible for the originals, see Held, *Oil Sketches*, 1:251-53.

the Main Room. The smaller *sobreventanas* of dogs and a wild boar (L24-28) depicted comparable subjects, but they are the only paintings that Ochoa did not call copies by Mazo. Such was the preponderance of copies by him, however, that it is tempting to speculate whether Ochoa accidentally omitted the phrase "copies of Rubens" from the pertinent entry.[15]

The distribution of paintings on the three remaining walls can be deduced by a process of elimination. *Las Meninas* attests that the *Minerva and Arachne* (L1) and the *Contest of Pan and Apollo* (L2) hung on the east wall. The word *enfrente* in the next entry for an *Abduction of the Sabine Women* (L3) of the same size implies that it and a subsequent *Abduction of Proserpina* (L4), also the same size, hung on the west wall opposite the first two pictures. A later entry for four small pictures (L13-16) states that they were disposed "in the facing spaces on the end walls" (*en las frentes de las remates*). Because all the paintings on the window wall have already been accounted for, the walls in question must have been those at the east and west ends of the room. In other words, two of these four pictures were the small ones that hang on the rear wall in *Las Meninas*. In conformance with the inventory, their height exceeds their width.

That leaves eight paintings (L5-12) to assign to the north wall. No view of it exists, but to judge from Gómez de Mora's plan (fig. 7), its niches and doorways were placed symmetrically. Because the paintings are described in entries for four "equal-sized" pairs, they, too, were probably distributed symmetrically about the central vertical axis of the wall. Too little is known about the wall to reconstruct their arrangement, but as in the case of the south wall in the Hall of Mirrors, we might reasonably suppose that the first picture in each entry occupied the left half of the wall. Mazo copied five of the eight paintings on that wall from works in the Torre de la Parada: *Mercury and Argus* (L5), *Deucalion and Pyrrha* (L7), *The Banquet of Tereus* (L8), *Orpheus Leads Eurydice from Hades* (L9), and *The Apotheosis of Hercules* (L10; misidentified as Phaethon).[16] The three other pictures copied originals in the King's Quarter of the Alcázar. An *Alexander the Great on a Lion Hunt* (L6) and a *Dido and Aeneas* (L12) were

---

[15] The 1700 inventory also calls the pictures originals by Mazo (*Inventarios reales*, 1:71).

[16] Four of Mazo's copies have survived: Prado nos. 1369 (*Apotheosis of Hercules*), 1643-P (*Mercury and Argus*), 1708-P (*Deucalion and Pyrrha*), and 2226-P (*Banquet of Tereus*). For the *Orpheus Leads Eurydice from Hades*, see Rubens's full-scale work, Prado no. 1667.

derived from works that were recorded in the Dark Room in 1666, 1686, and 1700.[17] A "Diana on a Hunt" (L11) has been identified as the *Diana and Nymphs Hunting* (fig. 72) that Mazo apparently copied from an original by Rubens and Snyders in the Octagonal Room.[18]

Unlike the north wall, the east and west end walls lend themselves to detailed reconstructions. (Diagram 3 shows the reconstruction that is advanced in the following remarks.) The language of the 1686 inventory suggests that they were arranged so that each work on one wall faced another of the same size and shape across the room. Furthermore, Gómez de Mora's plan shows two doorways at the west end of what became the Main Room. They are located in positions similar to those of the doors in the east wall as it is portrayed in *Las Meninas* (i.e., after the renovation of the Homage Tower in the late 1640s). Thus, on each end wall two large canvases hung above doorways, and a small one hung between each doorway and the adjacent corner of the room. However, this symmetry does not mean that a mirror hung at the middle of the west wall, opposite the mirror in *Las Meninas* that reflects the blurred likenesses of Philip IV and Mariana of Austria. The 1686 inventory lists no *adornos* of any kind in the Main Room, which means that there were no mirrors in it. Velázquez invented the looking glass in *Las Meninas* in order to introduce the king and queen discreetly into his composition. It is the one inaccuracy in his portrayal of the chamber.

On the east wall the installation of the *Minerva and Arachne* to the left of the *Contest of Pan and Apollo* suited their compositions. The diagonals of the principals' bodies in the *Minerva and Arachne* (fig. 89) imparted a motion to the right in the composition that directed the spectator's attention toward the adjacent *Pan and Apollo* (fig. 88). In the latter the continued movement to the right along Apollo's outstretched arm is countered by the orientation of the three other figures to the left and by the mountainside that occupies the right third of the composition.

This sensitivity in relating the compositions of the pictures to their installation is a clue to reconstructing the west wall. One of its larger canvases,

[17] Inventory of 1666, fol. 45; Bottineau, "L'Inventaire de 1686," 164-65; and *Inventarios reales*, 1:30. A fragment of Mazo's *Dido and Aeneas* has survived; see Prado no. 1744-P. For surviving versions of this subject by Rubens and his shop, see Held, *Oil Sketches*, 1:316.

[18] Alpers, *Torre de la Parada*, 40.

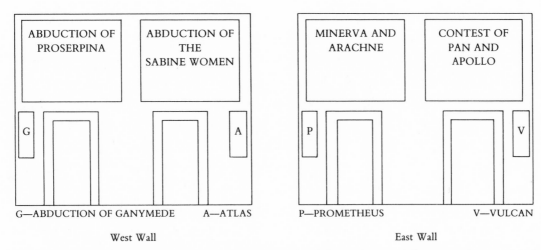

G—ABDUCTION OF GANYMEDE          A—ATLAS          P—PROMETHEUS          V—VULCAN

West Wall                    East Wall

DIAGRAM 3. *Reconstruction of the east and west walls of the Main Room of the Prince's Quarter*

Mazo's *Abduction of Proserpina* (L4; fig. 90), was based upon another of Rubens's paintings for the Torre de la Parada. As in the *Minerva and Arachne*, its composition sweeps the viewer's attention toward the right as Pluto makes off with his victim. Its pendant was Mazo's *Abduction of the Sabine Women* (L3), now lost, for which the most readily available model was the picture that Rubens had designed for the New Room. To judge from Rubens's oil sketch (fig. 45), its composition was more balanced, with the rising mass of struggling figures at the right providing a barrier to movement as did the mountain in the *Contest of Pan and Apollo*. This invites the conclusion that the *Abduction of Proserpina* hung to the left of the *Abduction of the Sabine Women*.

Mazo's four remaining pictures on the end walls (L13-16) were more copies of mythological subjects from the Torre de la Parada: *Vulcan Forging Thunderbolts*, *The Abduction of Ganymede*, *Atlas Bearing the Heavens*, and *Prometheus Stealing Fire* (misidentified by the inventory as Hercules). Only the *Vulcan* has survived (fig. 92); the other three can be represented here by Rubens's oil sketch for the *Atlas* (fig. 94), his full-scale *Ganymede* (fig. 93), and the full-scale *Prometheus* by one of his assistants (fig. 91).[19] Determining the arrangement

[19] A misinterpretation of the pertinent inventory entry (L13-16) leads Moffitt, "Velázquez in the Alcázar," 274-75 and 297 n. 10, to dispute this placement of the four pictures. The 1686 inventory specifies their measurements as "*dos tercias de alto y vna de ancho*," which Moffitt interprets as two-thirds of a *vara* in height and one *vara*

of Mazo's four pictures must take into account the directional orientations of
their compositions, the order in which the single inventory entry lists their
subjects, and the thematic affinities, if any, that they shared with the large
pictures on the same walls. These criteria are best met by assigning the
*Prometheus* and *Vulcan* respectively to the left and right sides of the east wall,
and the *Ganymede* and *Atlas* to the left and right sides of the west. With that
arrangement Ochoa would have produced the order of subjects that appears in
the inventory simply by starting at the *Vulcan* and listing the four in clockwise
sequence around the room.[20]

   This reconstruction makes thematic sense. Assembled on the east wall were
four paintings of immortals who practiced different arts. Three pictures referred
directly to their talents—Minerva defended her reputation as a tapestry-weaver,
Apollo proved his musical virtuosity, and Vulcan forged his most awesome
weapons, the thunderbolts of Jupiter. The titan Prometheus, who was shown
stealing fire from the gods, was also a sculptor who molded human beings
and whose theft was intended to benefit his creations. Thus, four arts were
alluded to: tapestry, music, metalwork or smithery, and sculpture. Across the
room three of the four paintings shared the theme of "abduction": the *Abduction
of Proserpina*, the *Abduction of the Sabine Women*, and the *Abduction of Ganymede*.
The fourth subject, *Atlas Bearing the Heavens*, had to be included because there
was no other abduction scene for Mazo to copy among the suitably proportioned
canvases in the Torre de la Parada and the rest of the royal collection. Of the
available subjects designed by Rubens, the *Atlas* had the merits of a composi-
tional orientation toward the left and a minor thematic link with the *Pro-
metheus* that faced it across the room—the two titans were brothers.

---

in width. This has a certain plausibility; in fact, the
compilers of the 1700 inventory miscopied the phrase as
"*dos tercias de altto y Uara de ancho*" (*Inventarios reales*,
1:71). However, in the 1686 inventory, a *tercia* is itself
a unit of measurement; the correct interpretation of the
1686 estimate is "two *tercias* in height and one *tercia* in
width." To confirm this, one has only to look at Mazo's
surviving *Vulcan* (fig. 92). Its height is greater than its
width, which flatly contradicts Moffitt's reading. (Its ac-
tual measurements, 65 × 34 cms., are fairly close to my
reading of 2 × 1 *tercias*, or 56 × 28 cms.) Although
Mazo's *Atlas*, *Ganymede*, and *Prometheus* are lost, it is clear
from the surviving versions of their compositions (figs.
94, 93, 91) that their heights, too, would have exceeded

their widths.

   Having needlessly banished the four pictures from the
end walls, Moffitt suggests that the pictures occupied
some of the window-embrasures along the south wall;
indeed, he even identifies the strip of wood seen in the
embrasure closest to the viewer as one of the pictures'
frames. That would have been an unlikely place to hang
a picture, and the strip of wood is brown, whereas the
1686 inventory specifies that all the pictures in the room
had black frames. The strip of wood in question is more
likely the edge of a shutter that has been opened to admit
light into the room.

[20] In inventorying the room, Ochoa followed a similar
procedure to that which he had used in the Hall of Mir-

Compared to the two end walls, the two lateral walls lacked thematic coherence. On the window wall each row of pictures had a measure of internal consistency—animal scenes (L17-28); the Labors of Hercules (L29-34); and a gallery of two philosophers, Hercules, and three deities (L35-40)—but there was little to relate one tier to another. The north wall featured a miscellaneous selection of antique subjects (L5-12) in which even the pendant pairs were matched on the basis of size rather than of content.

The complete ensemble, then, was a loose array of classical (mostly Ovidian) subjects in the style of Rubens that was accompanied by a selection of animal scenes. But why was this ensemble created in the first place? It cannot have been to make accessible in Madrid the compositions by Rubens that were kept at the Torre de la Parada because some of the copied originals were elsewhere within the Alcázar. And when did Mazo carry out the work? His involvement may have stemmed from his tenure as Baltasar Carlos's drawing master, in which case he may have executed the paintings during the few years (1643-1646) that the prince lived in the Prince's Quarter. It is even conceivable that Mazo's father-in-law, Velázquez, who was appointed a superintendent of special projects in 1643, directed the project.[21] Whatever the case, the ensemble must have been in place by the time that Velázquez painted *Las Meninas* around 1656. In the absence of any convincing explanation, we must conclude that no detailed program underlay the choice of paintings by Rubens that Mazo copied for the Main Room. Whoever devised the project had the copies installed in as orderly a fashion as possible, arriving at a solution that was more coherent on the end walls than on the lateral ones.

## IN DEFENSE OF PAINTING

If, as Palomino asserted, the Main Room had been the studio where Velázquez worked, then his having set *Las Meninas* there would have been unremarkable.

---

rors. He began with the upper pictures on the east and west end walls, next considered the entire north wall, returned to the end walls for their lower pictures, and concluded with a top-to-bottom review of the south wall, the only one with windows.

[21] AGS, CM3, leg. 1461, Destajos, fol. 94ᵛ, no. 423, cites authorization of a payment of 404 *reales* on November 27, 1643, to the carpenter Bernabé García "for fifteen

pine-wood frames painted black for the paintings of different kinds [*géneros*] for the Prince's Quarter." *Ibid.*, fol. 120bis, no. 538, records authorization of a payment of 2,000 *reales* on June 21, 1644, to the ebony-worker Juan Emberg for "the frames that he made and is making for the Prince's Quarter." Perhaps some of these frames were for pictures that were later recorded in the Main Room.

However, Palomino erred, for the Main Room was not the painter's customary workplace. Four days after Velázquez died in 1660, his son-in-law Mazo and his successor as *aposentador de palacio*, Francisco de Rojas, compiled an inventory of the *alhajas* belonging to the king that had been left in the Prince's Quarter at the artist's death. None of these furnishings, which included paintings, corresponded to the pictures in the Main Room.[22] Although the precise site of his studio cannot be determined, it must have been better located for use by a painter than the Main Room, which, owing to its southern exposure, would have subjected Velázquez to constantly changing lighting. (In his old studio in the Gallery of the North Wind he had enjoyed a consistent, northern light.) Because *Las Meninas* nevertheless portrays Velázquez at work in the Main Room, he must have had a conscious reason for setting the composition there rather than in the studio where others would have expected to see him paint. That reason is intimately bound up with the meaning of his picture.

It has been convincingly demonstrated that Velázquez intended *Las Meninas* to assert the rightful status of painting as a liberal art.[23] It was a pictorial argument that supported his longstanding ambition to overcome Spanish social prejudices against painters and become a knight in the noble Order of Santiago. The picture advanced his case in several ways. For one thing, by representing himself painting in the presence of Philip IV (whom he discreetly introduced into the Main Room in the reflection of the mirror that he invented for that purpose), Velázquez called to mind the special relationship between the Greek painter Apelles and his patron, Alexander the Great. The latter often visited Apelles in his studio and promised that he would allow no other artist to paint

---

[22] "Documentos relativos," 388-89. Wherever Velázquez's studio was located, it should not be identified with the *obrador de los pintores de cámara* (Workshop of the Painters to the Bedchamber) in the Prince's Quarter that was inventoried in 1686 (Bottineau, "L'Inventaire de 1686," 454), in 1694 ("Documentos inéditos para la historia de las Bellas Artes en España," ed. M. R. Zarco del Valle, CDIHE, 55 [Madrid, 1870], 439-43), and in 1700 (*Inventarios reales*, 1:73 and 154). The latter workshop was evidently converted to use as a painter's studio in 1677 and 1678. See AGS, CM3, leg. 1306, Pagador Melchor de Arce, 1677-1684, Obras del Alcázar, fols. 2bis-5bis^v passim, 14bis^v-15^v, and 24bis; and *id.*, Rezeta del Veedor y Contador de Obras Reales, fols. 5bis-5bis^v.

[23] The most important exposition of this argument is Brown, *Images and Ideas*, 87-110, upon which the following discussion draws extensively. Madlyn Kahr, "Velázquez and *Las Meninas*," AB 57 (1975), 225-46, reaches similar conclusions with less satisfactory arguments; these are expanded slightly in her *Velázquez: The Art of Painting* (New York, 1976), 128-202. For the broader context of the debate over the status of painting as a liberal art, see Julián Gállego, *El pintor, de artesano a artista* (Granada, 1976); and Mary C. Volk, "On Velázquez and the Liberal Arts," AB 58 (1978), 69-86.

his likeness. For Velázquez that tradition was especially meaningful because Philip often visited his studio, and he, too, had promised that he would permit no other artist to paint his portrait.[24]

The story of Alexander and Apelles was crucial to a defense of painting as a liberal art that had originated in Renaissance Italy. Painting, it was argued, must be a noble activity because it was patronized by great kings, who would only grant their favor to enterprises worthy of their station. (This argument of merit by association was the same kind of reasoning that Juan Mateos used in 1634 to defend the nobility of hunting.) Alexander was frequently held up as an exemplar of the magnificent ruler who rightly appreciated the merits of painting and who generously rewarded its most distinguished practitioners. By illustrating a modern renewal of the Alexander and Apelles tradition, Velázquez declared that painting remained a noble endeavor.

To underscore his point, Velázquez incorporated other references to his closeness to the king in *Las Meninas*. As a sign of the royal favor that he enjoyed, he represented himself wearing a golden key in his belt that signified his office as *aposentador de palacio*, a post to which Philip had appointed him (passing over more highly recommended candidates to do so) and one which guaranteed him regular access to the king. The key was not just an ornament, but a passkey that gave the artist entry to the entire Alcázar. To emphasize that point, Velázquez showed the queen's *aposentador*, José de Nieto, opening the right-hand door at the rear of the chamber. Lest there be any doubt that it was the Alcázar—the permanent dwelling of the king—in which he served, the artist set *Las Meninas* in a recognizable chamber within the royal household.[25]

But why choose a gallery in the Prince's Quarter? The king, after all, lived in the King's Quarter on the floor above, where there were splendid settings like the Hall of Mirrors and the Gilded Hall that were well known to the aristocratic courtiers whose prejudices Velázquez sought to overcome. The explanation is that the Main Room contained something that would strengthen

---

[24] Pacheco, *Arte*, 1:157 and 161; and Palomino, *El museo pictórico*, 904.

[25] Because Kahr ("Velázquez," 229-40; and *Velázquez*, 141-63) does not recognize that *Las Meninas* portrays a real chamber, she lays undue emphasis on the significance of Flemish gallery-pictures as visual precedents for the composition. Their role in Velázquez's formulation of the composition, if any, was of secondary importance.

Velázquez's case—the paintings on the walls. It is generally recognized that pictures within pictures in seventeenth-century paintings often convey symbolic clues to the overall meanings of the works in which they appear. Various proposals have been advanced to account for the presence of the *Minerva and Arachne* and the *Contest of Pan and Apollo* in the background of *Las Meninas*, of which the most convincing is that Velázquez was referring to Rubens, the artist who had originally designed their compositions.[26] Philip had knighted Rubens in 1631, and Velázquez found in that honor an apt precedent for the knighthood that he sought in the 1650s.

When the subjects of the two smaller paintings on the rear wall—*Prometheus* and *Vulcan*—are considered as well, Velázquez's argument gains in force. Out of all the possible settings in the Alcázar that he could have used for his defense of painting, Velázquez settled on the one that provided a backdrop of four immortals who practiced tapestry-weaving, music, sculpture, and smithery. The favorable associations of these arts and their exalted masters surely appealed to his sensibilities. To this august company he added painting, represented by himself.

Not content merely to copy the east wall and to lend its thematic associations to his argument, Velázquez refined his case with judicious censorship. *Las Meninas* would have required only slight compositional changes for the *Prometheus* and *Vulcan* to have been fully visible; yet, Velázquez elected to obscure them with shadow and to block them from view. He had good reason to do so. At the heart of the aristocratic prejudice against the status of painting as a liberal art rested the conviction that because painters earned their livings by working with their hands, they were no better than ordinary craftsmen. This objection manifested itself in 1630 when the Council of State advised Philip not to name Rubens his *residente* (a diplomatic envoy) at the English court until a full-fledged ambassador could be sent from Madrid. The council argued that "Peter Paul Rubens would have been very appropriate for the post because of the fame and acquaintance that he enjoys in that court. But because he practices a craft that in the end is base and done by hand, it would seem to present difficulties if Your Majesty were to give him the title of one of your

---

[26] Brown, *Images and Ideas*, 104; I concur with his objections to earlier interpretations of the meaning of the pictures.

ministers."[27] It was this resistance to men who worked with their hands that Velázquez had to overcome.

A coarse, half-naked figure laboring at an anvil was hardly the image of an artist that Velázquez needed to promote at the court, and for that reason he obscured Mazo's *Vulcan* from view when he painted his masterpiece. The *Prometheus* was likewise objectionable because sculpture required strenuous manual effort. The Italian Renaissance *paragone* disputing the comparative stature of painting and sculpture had been debated in the Sevillian intellectual circle in which Velázquez had trained, and sculpture had emerged the loser. Among the arguments levelled against sculpture was the claim that it could not be a liberal art because the manual labor that it entailed was too base an activity.[28]

Velázquez left visible Mazo's *Minerva and Arachne* and his *Contest of Pan and Apollo* because they conveyed more favorable images of the creative artist. Minerva and Apollo were the two deities who presided over the arts and whose own artistic achievements demonstrated the greatest beauty, refinement, and skill. Music, at which Apollo excelled, was already regarded as a liberal art, and it surely suited Velázquez's purposes that Minerva was not shown performing the manual labor of weaving at a loom. Mindful of the social prejudices of the day, Velázquez emphasized the two compositions that enhanced his argument while playing down the pair with less helpful connotations.

To recapitulate, once Velázquez had decided to portray himself painting in his sovereign's presence, he consciously chose to locate the action in the Main Room of the Prince's Quarter. The paintings on its east wall, which he selected for the background, served him in three ways. As pictures in the royal collection, they identified the site as a specific chamber in the Alcázar. As compositions designed by Rubens, they alluded to another courtier-artist whom Philip had knighted some years before. As representations of immortal beings who practiced different arts, they supported Velázquez's claim on behalf of the nobility of painting. Together with the other references to his standing that he incorporated in the painting, these pictures within the picture made *Las Meninas* a compelling argument for the dignity of Velázquez's profession.

[27] *Correspondance de Rubens*, 5:351; tr. in Brown, *Images and Ideas*, 105.

[28] Brown, *Images and Ideas*, 49-50.

Ultimately the argument proved successful, for with the assistance of his royal patron Velázquez finally gained admittance to the Order of Santiago in 1659.

## *LAS MENINAS* AND ROYAL PORTRAITURE

In *Las Meninas* Velázquez introduced two innovations into the iconographic vocabulary of royal portraiture at the Spanish court. One advance, using pictures within the picture to help convey his meaning, was an established technique in other genres, but it had not played a role in Spanish royal portraiture during the first half of the century. His other innovation was using an identifiable chamber as his setting. Alone among all of Velázquez's portraits of the royal family, *Las Meninas* presents its subjects in a recognizable interior.[29] All the others, whether they feature the most spartan or the most luxurious of furnishings, cannot be identified with any specific chamber in any royal dwelling. By using the Main Room in the Prince's Quarter for *Las Meninas*, Velázquez buttressed his defense of painting as a liberal art. At the same time, using that setting implicitly praised the kingship of Philip IV. Throughout seventeenth-century Europe generous patronage of the arts was regarded as a distinguishing characteristic of great princes. By showing Philip visiting him while he painted in a room of the king's palace that was filled with the king's pictures, Velázquez depicted his sovereign as an art lover and collector. If the "Alexander and Apelles" imagery that *Las Meninas* evokes flatters Velázquez by comparing him to the greatest painter in antiquity, it is no less complimentary in comparing Philip to the Macedonian conqueror and patron of the arts.

At least two, and possibly three, of Velázquez's immediate successors as *pintor de cámara* appreciated these innovations with varying degrees of subtlety and understanding. Each, in turn, incorporated them into state portraits of Mariana of Austria or Charles II. After Philip died in 1665, Mariana became

---

[29] One outdoor portrait by Velázquez, the *Riding Lesson of Baltasar Carlos* (collection of the Duke of Westminster), features identifiable surroundings, the Prince's Quarters of the Buen Retiro. See Brown and Elliott, *Buen Retiro*, 255; Enriqueta Harris, "Velázquez's Portrait of Prince Baltasar Carlos in the Riding School," *BM* 118 (1976), pp. 266-75; and Michael Levey, *Painting at Court* (London, 1971), 142.

the regent of Spain, administering the Monarchy on behalf of her son, who had yet to reach the age of majority. It was a task for which she was ill prepared, and her decisions as queen governor often put her at odds with the aristocratic elite who sat on the councils of government. Moreover, her son's feeble health and limited faculties did not bode well for the future.[30] In such circumstances, it was all the more desirable that the painters to the bedchamber should present the regent and the boy-king in ways that assured the viewer that they were capable of governing well. One way to accomplish this was to draw upon the lessons of *Las Meninas*.

Mazo, who immediately succeeded his father-in-law as *pintor de cámara*, adapted the device of the recognizable setting for his portrait of *Mariana of Austria* (fig. 71), in which the viewer can see beyond the Hall of Mirrors, where the queen governor sits, to the Octagonal Room, where governesses and servants tend to her son's needs. Mazo's concern is to present the basis for Mariana's authority as regent. Her nun's habit, the customary dress of high-born Spanish widows, calls to mind her late husband, whose will had named her regent on behalf of their son Charles, who stands in the background. She sits in the Hall of Mirrors, the state chamber that she used for her office as she carried out her responsibilities. Thus, by showing both mother and child in two state chambers of the Alcázar, Mazo proclaims the rightfulness of Mariana's place as regent.

This said, it must be conceded that Mazo squanders the potential of his setting to glorify Mariana and Charles as splendid personages and lovers of fine art. Ignoring the brilliant decoration of the Hall of Mirrors, he strips it of its paintings and furnishings, and covers the bare walls with a curtain, a stock device for filling space in Baroque portraits. All he represents of the room's splendor is its tiled floor. The glimpse of the Octagonal Room that he permits us is almost as limited. The viewer can make out the bronze *Venus*, a sculpted head, some architectural trimmings, and a few illegible details of paintings—meager hints of the chamber's beauty.

A different approach is taken in an anonymous portrait of *Charles II* (fig. 96) that is sometimes attributed to Sebastián de Herrera Barnuevo, who suc-

[30] See Henry Kamen, *Spain in the Later Seventeenth Century, 1665-1700* (London-New York, 1980), 20-27.

ceeded Mazo as *pintor de cámara*.[31] In this instance the artist seized upon the
use of pictures within a picture, but both the setting that he presents and the
pictures within it are fanciful inventions. A portrait of Mariana, again dressed
as a widow, hangs on the wall behind the young king, and a simplification
of Rubens's *Equestrian Portrait of Philip IV* dominates the room beyond. It was
owing to his descent from these two parents that Charles was king, a point
that is underscored by the cherub bearing his crown and scepter. The theme
is reiterated by the book propped up beside Charles, which is illustrated with
portraits of three more of his royal predecessors: Philip III, Philip II, and
Philip I.[32] Furthermore, a sculpted bust of his most glorious ancestor, Charles
V, borne by an imperial eagle stands on a pedestal behind the book. Its design
may have been inspired by both Leone Leoni's *Bust of Charles V* (fig. 81) and
the eagle-frame mirrors in the Hall of Mirrors. Certainly the bronze lions
supporting the porphyry tables below those mirrors inspired the lion clasping
an enormous sphere in the lower left corner of the painting. Nevertheless, no
one familiar with the Alcázar would mistake this muddled setting for the
stately magnificence of the Hall of Mirrors.

It was Carreño, Herrera Barnuevo's successor as *pintor de cámara*, who best
understood the implications of Velázquez's innovations in *Las Meninas*, which
he incorporated into such state portraits as his Berlin *Charles II* (fig. 14) and
his Real Academia *Mariana of Austria* (fig. 55; cf. fig. 56). The subject of each
portrait benefits not only from being represented conducting affairs of state
but also from being shown to live in a splendidly decorated palace that befits
his or her royal magnificence. Furthermore, just as Velázquez selected a back-
ground for *Las Meninas* that would contribute to his glorification of painting,
so Carreño posed each of his subjects in the hall so that the surrounding
decoration would comment on his character and authority.

[31] José Camón Aznar, *La pintura española del siglo XVII*, 2nd edn., Summa Artis, vol. 25 (Madrid, 1978), 451, attributes the portrait to Herrera Barnuevo; but José M. Moran Turina, "El retrato cortesano y la tradición española en el reinado de Felipe V," *Goya*, no. 159 (November-December 1980), 157, regards it as an anonymous work. The matter cannot be resolved with certainty until Herrera Barnuevo's activity as a painter is studied thoroughly.

[32] There are also two pairs of pendant portraits, each of a man and a woman, within the picture. One pair hangs below the equestrian portrait of Philip IV in rectangular frames, and the other pair leans against the illustrated book in oval frames. The identities of these

In the *Charles II* two pictures on the west wall are discernible in the right-hand mirror reflection (fig. 57)—Rubens's *Equestrian Portrait of Philip IV* (cf. fig. 39) and Titian's *Tityus* (fig. 22). Courtiers already familiar with the Hall of Mirrors and its program would have understood that by including Rubens's portrait, Carreño had alluded to the legitimacy of Charles's kingship, which he had rightly inherited from his father. Just as Philip defended Catholicism in Rubens's painting, so Charles would carry on the royal mission and vanquish the enemies of his faith, as surely as the gods had punished Tityus for his crime. Carreño's portrait proclaims the continuity of the Habsburg line and its purpose.

For his portrait of Mariana, Carreño selected a background that contained the lower right section of Titian's *Allegorical Portrait of Philip II after the Battle of Lepanto* (fig. 17) and Tintoretto's *Judith and Holofernes* (fig. 49). In the first Philip II holds up the newborn son who, it is promised, will follow in his father's steps and win even greater victories for Spain and Catholicism. Carreño's point was that as regent, Mariana would raise her son to pursue the same goals avidly. Lest there be any doubt about the queen governor's character and determination, Carreño compared her as well to Judith, whose courage and dedication to the well-being of her people were unwavering.

By his adept choice of backgrounds for these portraits, Carreño revealed a profound and sensitive understanding of Velázquez's achievements as the painter of *Las Meninas* and as a decorator of the Hall of Mirrors. From *Las Meninas* he learned that he could use the king's art collection as a symbol of royal splendor and that carefully selected pieces from that collection could enhance the meanings of state portraits in which they appeared. By choosing as his setting the Hall of Mirrors—the program of which he surely learned while frescoing its ceiling under Velázquez's direction—he revealed his awareness of the unique role that the room played in the life of the court. As the king's reception chamber for extraordinary visitors and as the queen governor's office, it was a focal point for the affairs of state. As the most brilliantly decorated chamber of the Alcázar, it epitomized the notion that a monarch's

figures are not certain, but they might be Charles II's two sisters and their husbands, which would round out the allusions in the painting to the king's family.

greatness should be demonstrated by the magnificence of his surroundings. And as a programmatic statement of the Habsburg mission, it summarized the ideals to which the royal dynasty aspired. Owing to these associations, the use of the Hall of Mirrors enriched the meanings of Carreño's portraits. In a sense, the portraits have repaid the favor. Today they are precious evidence for reconstituting the Hall of Mirrors and its program for the edification of the modern audience.

# AFTERWORD

ON FEBRUARY 5, 1658, Philip IV caught a feverish cold while watching the installation of some paintings in his summer apartments in the Alcázar of Madrid.[1] Although we should not exaggerate the significance of this incident, the king's apparent willingness to risk exposure to a chill in order to supervise the hanging of his pictures attests to the keen personal interest that he took in his collection. It was but one of many actions by which the king demonstrated his enthusiasm for art. His childhood training in painting and drawing; the similar training that he ordered for his son Baltasar Carlos; his frequent visits to the studios of Rubens and Velázquez to watch them paint; the knighthoods that he conferred upon them both; his frequent demands for reports from Flanders on Rubens's progress on pictures that he had ordered; his dispatching of Velázquez to Italy to acquire paintings and sculptures for the Alcázar; his fascination with the fresco-painting techniques of Colonna and Mitelli, which he pursued to point of mounting their scaffolding to examine their work more closely—all these episodes testify to the pleasure that he derived from artists and their works.

Philip was sensitive to the way that his collection was displayed as well as to the individual pieces of which it was composed. It was he who authorized the expense and inconvenience of renovating and redecorating large sections of the King's Quarter of the Alcázar over the course of his reign. As the head of state with the last word on court etiquette, he approved the lengthy route that distinguished visitors followed through the King's Quarter, notwithstanding the inconveniences in the west wing that eventually prompted Charles II to change the itinerary. In Philip's time a Hamete Aga Mustafarac or a Marshal-Duke of Gramont made his way through halls adorned with tapestries on the north side of the King's Quarter, next passed into the gilded and frescoed chambers of the west wing, and then emerged into the succession of rooms along the south flank that were hung with easel paintings. Only after traversing this gantlet of art was the visitor shown into the climactic presence of the king himself.

The royal collection impressed its audience not only by the sheer quantity

[1] Enriqueta Harris, "A Letter from Velázquez to Camillo Massimi," *BM* 102 (1960), 166 n. 12.

of its works, but also for their quality. Philip had a discerning eye. His early preference for Velázquez over lesser talents like Carducho, the torrent of commissions that he granted to Rubens, and the affinity that he shared with Rubens and Velázquez for Venetian sixteenth-century painting, especially that of Titian, were hallmarks of his taste. In Rubens and Velázquez themselves he enjoyed the services of the foremost Flemish and Spanish painters of the day, and had he succeeded in luring Pietro da Cortona to Madrid, he would have employed one of Italy's leading talents in like fashion. Ensembles like those in the Gilded Hall, the South Gallery, and the Octagonal Room reflected his appreciation of Spanish, Venetian, and Flemish painting.

What transformed the collection from a passive to an active expression of royal splendor was the king's awareness that he could have his possessions arranged in ensembles that proclaimed the ideals and the accomplishments of the Habsburg dynasty. Series of rulers expressed the legitimacy of Habsburg rule over the Spanish realms and implicitly praised the merit of the living king and his family. Battle pictures and views of royal possessions (from palaces to entire kingdoms) illustrated Habsburg might and wealth. Those assets were means to an end, the propagation and defense of Catholicism, which the programs of the Hall of Mirrors and the Gilded Hall declared to be the mission of the royal line. Underlying the appreciation of those ensembles was the widespread belief—explicitly stated by Carducho—that palace decoration should demonstrate and foster the virtuous behavior that befitted great princes. When informed by that attitude, even hunting scenes assumed kingly significance. Thus, by its beauty and its content, the art collection in the Alcázar of Madrid, whether considered as a whole or one room at a time, provided Philip with a regal setting that never failed to inspire awe among those who found themselves in the presence of the Planet King.

# APPENDICES

# Cassiano dal Pozzo on the New Room (1626)

While the Signore Cardinal conferred with His Highness, we went to see some pictures in the room, among which, upon entering the door, there was immediately above this [door] [1] one with five or six large figures drawn from life by Rubens. There followed [2] a picture in which was portrayed Religion or Faith in the form of a beautiful, mostly nude, and sad woman on a beach, as if shipwrecked. She is gathered up [raccolta] and aided by Spain. This is by Titian. Above these is [3] a Tityus said to be by Titian also, larger than life-size by half. There follows by the same artist [4] a great life-size portrait of Charles V in armor on horseback in the act of thrusting at full gallop, with a beautiful landscape. There follows [5] another Tityus, corresponding to the other one, by the hand of the Spaniard "Mudo." Opposite the portrait of Charles V on the other end wall of the room is [6] a portrait of the present king in armor on horseback, shown from life. There is a beautiful landscape and sky, and it is also by the hand of a Spanish painter. It is situated in the middle of [7-8] two other Tityuses. There follows [9] an Adam and Eve, somewhat larger than life-size, by Titian. And then [10] a stupendous, great, and extraordinary picture in which is the king [lacuna] lifting a nude child who appears newborn in his arms, so as to enable him [the child] to take a palm from the hand of an angel coming from heaven. Here one sees a colonnade, beautifully rendered [in perspective?], a building, sky, landscape, and seascape, and in the latter a naval battle. From the angel flies a motto that says Restant maiora tibi. There was also [11] a picture in the German manner that was made

most diligently of a man who is cured of a small stone in his head and who expresses the intensity of pain in his face marvelously. There were also two paintings, [12] one of the arrival of the two present Queens of France and Spain when they arrived at Irún. There one sees a triumphal arch constructed on each river bank. In the middle of the same [picture] in the axis of the two arches is a small island reduced to the form of a small temple. A way is made from one arch to the other via the same small temple with duplicate canopies on either side, and all the river banks were covered by the nobility of the two nations, French and Spanish. Both their majesties were seen to arrive at the same time at the small temple without the work of oarsmen. The exchange being made, they were seen to pass, the one from one border, and the other from the other. It [the painting] was the invention and work of Signore Giovanni de' Medici, son of Raphael, brother of the archbishop of Pisa, and ambassador of the Grand Duke in Spain. One saw very great strangeness of clothing on the women of these countries not unlike those of the women of Turkey, especially in their adornment of the head. [13] The other picture was the entry of Philip III into Lisbon, which gives a beautiful view of the port full of both huge and small ships that are [decorated] in the grand manner. And through the wooden bridge for the disembarkation the order of the [participants in the] entry and the arches of the nations which were seen there, all of which was portrayed in one picture. In the same room there was [14] the small table that Monsignore Massimi sent to His Majesty by the galley on which we arrived, this being two braccia on

each side. It is of the highest standard [*mora-tissimo paragone*], inlaid with semiprecious stones—that is, jasper, agate, carnelian, chalcedony, lapis lazuli, and others—inlaid with life-size sprigs of flowers; that is, orange [blossoms], jasmine, roses, and violets of Aquileia, with each flower by itself. The greens of the leaves or the lifelike colors of these flowers are set against the most brilliant black that, for comparison, no better can be found, not only in painting, but in nature itself. This [table] has a most beautiful gilded base which is all carved. It was made in the Galleria of the Grand Duke, from which have emerged this style of *tarsia* and the true skill to work whatever kind of semiprecious stones that one might want. In the same room, before arriving there, there was [15] one of those paintings from Japan that is folded one [panel] against the other in the manner of their books, which, standing on their feet, serve to divide rooms and to screen doors. They are called *biombos*. They are made with long panels, one attached to the other, and unfold together. It was constructed from the aforesaid standing paintings [and made] a small room, which takes up little space, which is its use. They can be carried conveniently, they make a very charming show of painting, and they can quickly form a room in whatever shape is desired.

SOURCE: Cassiano dal Pozzo, untitled journal of Cardinal Francesco Barberini's legation to Spain in 1626, Biblioteca Apostolica Vaticana, Ms. Barb. lat. 5689, unpaged; as transcribed in Enriqueta Harris, "Cassiano dal Pozzo on Diego Velázquez," *Burlington Magazine* 112 (1970), 372-73.

## APPENDIX B

# *Vicente Carducho on the New Room ( 1633 )*

[*In the eighth dialogue of Carducho's* Diálogos de la pintura *the Maestro (Carducho) is reminded of the New Room when he lists the paintings by Titian in the Alcázar.*]

[The paintings by Titian include] [1-4] the four *Furias* on four large canvases—Sisyphus, Tityus, Tantalus, and Ixion. The last two are originals and the other two, copies by Alonso Sánchez [Coello], the famous Portuguese, although they are regarded as originals by Titian. . . . There is [5] another of Faith, who is transported to the barbarous idolatry of India by the armed might of Spain . . . [6] an Adam and Eve that is original . . . And there is [7] a large picture of King Philip II standing, holding out Prince Ferdinand, who was born in the year 1571, the same year as the great naval victory of Lepanto that was won from the great Selīm II and Euldj 'Alī. This allegory was painted for its having been thought Spain had been given a needed successor in that year, and for such a glorious victory over such a powerful enemy. Thus the Turks are cast down at their feet and an angel descends from Heaven with a palm branch and utters the motto, *Maiora tibi*. And in the distance is the battle itself, daubed in excellently.

Of the same size is [8] another canvas with the Emperor, his father, in armor on horseback. These two pictures adorn the newly constructed great room that has balconies facing the plaza. These are all the pictures by Titian. In the same room there are other pictures of similar size by the hand of [9] Peter Paul Rubens, [10] Eugenio Cajés, [11] Diego Velázquez, [12] Jusepe de Ribera (who is called the Little Spaniard), [13] Domenichino, and [14] Vicencio Carducho, and below them are others of smaller size. Above all these are the four *furias* that, as we said, are by Titian.

These are the ones that I can remember having seen, although I know there are many others that I have forgotten because they were less singular.

SOURCE: Vicente Carducho, *Diálogos de la pintura: su defensa, origen, esencia, definición, modos y diferencias*, ed. Francisco Calvo Serraller (Madrid, 1979), 433-35; the translation is adapted in part from Robert Enggass and Jonathan Brown, *Italy and Spain 1600-1750: Sources and Documents* (Englewood Cliffs, N.J., 1970), 212-14.

## APPENDIX C

# The 1636 Inventory of the New Room

### THE NEW ROOM OVER THE VESTIBULE AND MAIN ENTRANCE OF THE PALACE

[1] A large oil painting on canvas, with a black, gilded frame, of a portrait of the Emperor Charles V in armor on horseback with a lance in his hand and with a sash and red feathers. The horse is chestnut-colored with scarlet trappings. This portrait was brought from the Pardo to be put in this room and is by the hand of Titian.

[2-5] Four large, square canvases with gilded frames, on which the four *furias* are painted in oil. Two of them are by the hand of Titian and the other two by Alonso Sánchez [Coello]. The ones by Titian are of Sisyphus and Tantalus, and those of Tityus and Ixion are by the aforesaid Alonso Sánchez.

[6] Another large canvas with a gilded and black frame, on which Titian has painted in oil King Philip II standing in armor. He is

holding out Prince Diego. An angel above gives him [the prince] a palm with an inscription that says *mayore tibi*. There is a naval battle in the distance and a Turkish captive with symbols of submission.

[7] Another large oil painting on canvas, of the same size as the previous one and with a gilded and black frame, of Scipio entreating the Romans. It is by the hand of Vicencio Carducho. In it Scipio is dressed in the Roman manner in armor. In his right hand is a raised sword, and his left hand entreats. Tullio Cicero is below with a laurel crown, and there are many soldiers on the other side.

[8] Another, slightly smaller canvas by the hand of Rubens, a Flemish painter, of the reconciliation of Jacob and Saul [*sic*], in which there are three camels, a horse, a lamb, and other animals and figures. It has a gilded and black frame.

[9] Another oil painting on canvas, of the

size of the two preceding ones [*crossed out*: and by the hand of the aforesaid painter], of the expulsion of the Moriscos. In it is King Philip III wearing armor and dressed in white. To his right is a seated figure of Spain with spoils of war. A multitude of Morisco men and women are leaving, and there is a Latin inscription below. It has a gilded and black frame. This canvas is by the hand of Diego Velázquez.

[10] Another oil painting on canvas, of the same size and with the same frame, which is the story of Chryseis [*Greseida*], by the hand of Eugenio Cajés. In it the king of the Greeks is seated, and her father is petitioning for her. In the background there is a battlefield, and in the sky there is a figure with a bow in his hand in a golden chariot drawn by four white horses.

[11] Another oil painting on canvas, of the same size and with the same frame, in which there is a portrait of our lord Philip IV, whom God protect, by the hand of Rubens. He is in armor and is mounted on a chestnut horse. He has a scarlet sash, a baton in his hand, and a black hat with white feathers. Above is a terrestrial sphere supported by two angels, and Faith, who holds a cross above it. They offer a laurel crown to His Majesty. At her [Faith's] side is Divine Justice, who hurls thunderbolts against the enemies. On the other side of the ground there is an Indian who carries his [the king's] helmet.

[12] Another oil painting on canvas, of the same size and with the same frame, by the hand of Guido of Bologna, a Roman painter, in which Queen Sheba [*Saba*] is offering her treasures to King Solomon, who is seated beneath a canopy. There are other figures who accompany the king and queen.

[13] Another canvas, smaller than those preceding and without a frame, of the story of the finding of Moses in the river. There are eight women and the child in a small basket. It is by the hand of a painter of the King of England, from whom it was bought.

[14] Another square canvas, larger than those of the *furias*, with a gilded and black frame; it is by the hand of Rubens. It is the story of Mucius Scaevola burning his arm over a pyre on which is a fire. There are a seated king, a dead man on the ground with a dagger, and other standing figures.

[15] Another canvas, of the same size and with the same frame as the preceding; it is the story of when Ulysses found Achilles dressed as a woman among the daughters and wife of Darius [*sic*]. Achilles is dressed as a woman with a dagger in his right hand and the scabbard in the other. Ulysses grips him by the arm, and there are other women with jewels and mirrors in their hands.

[16] Another of the same size and with the same frame, of a story of Hercules, who is shown spinning among some women. There is a cupid who indicates what Hercules is doing. It is by Gentileschi, a female Roman painter.

[17-18] Two other, horizontally extended canvases, middling in size, that are oil paintings by the Little Spaniard, Jusepe de Ribera, a Valencian. One is the story of Jael putting a nail through Sisera's ear. He is dressed in blue and in armor, and she is above him with a hammer in her right hand. There is a helmet on a bright red cloth. The other is of Delilah when she cut the sleeping Samson's locks. There is a soldier with a halberd in his hand.

[19] Another square canvas, with a gilded and black frame, that is smaller than the aforesaid ones. It is a Sacrifice of Abraham by the hand of Guido of Bologna.

[20] An oil painting on canvas, on which is painted the story of Samson when he killed

the Philistines with the jawbone. He kneels on the ground among them. In his right hand is a jawbone from which water falls, and he is drinking. It is five [Castilian] feet in width, and five [Castilian] feet and four fingers in height. It has no frame.

[21] Another oil-on-canvas on which is painted Cain killing his brother Abel with a cudgel in his right hand. He holds him down and is beating him with it.[1] There are two small lambs in the corner of the canvas, and behind Cain are two tulips and two narcissus. It is the same size and by the same hand as the preceding picture.

[22] Another, very old canvas that is painted in oil, with a gilded and black frame, in which a woman who has cut off the head of a king is putting it in a jar that a woman holds in her hands. There are two male figures, one of whom is putting the sword in its scabbard, and there is a small dog that is lapping up the blood that escapes from the dead body. There are three female figures in all.

[23-24] Two other long and narrow canvases by the hand of Rubens with gilded and black frames and with life-size figures. One is a wild boar hunt with a nymph with a bow in her hand, with which she has speared the boar with an arrow. There are some dead dogs and other living ones, and other hunters with spears in their hands. The other is a hunt in which there are many dogs killing a deer, nymphs dressed as hunters who are pursuing it with spears, another nymph who has shot an arrow that has lodged in a tree, and another who holds a dog.

[25-26] Other middling-sized canvases with the same hand and frame. One is of Samson breaking the jaws of a lion. The other is

of David killing a bear. It has a dead lion, and on the other side are a dead ewe and other living ones.

[27-28] Two other canvases of equal size, of the same size as and narrower than the preceding ones, with the same hand and frames. One is a satyr who is squeezing out a bunch of grapes to two small children. There is a tiger just delivered of three small cubs. The other is the goddess Ceres with two nymphs who hold a cornucopia of fruits. There is a monkey at their feet that is eating other fruits.

[29] A half-length portrait, which the Marquis of Leganés brought back, of the Infante Ferdinand in the dress and manner in which His Highness entered Brussels. He has a baton in his right hand. He wears a bright red velvet coat with gold trim, and a scarlet sash embroidered with gold, in which there is a broadsword. There is a brocade curtain. It is by the hand of Van Dyck, a Flemish painter, with a gilded and burnished frame.

[30] An oil painting on canvas of the Battle of Nördlingen, in which are the camps of the aforesaid Infante-Cardinal, of the King of Hungary, and of the enemy. At one side is a [written] description on a yellow ground. It has no frame. The aforesaid marquis brought it.

[31-32] Two mirrors: the large one with a glass plate one *vara* in height, with a smooth ebony frame; and the other with a smaller glass plate, embellished with ornament consisting of pilasters and modillions with their ends [*remates*] inlaid with stones of different colors.

[33] A stone table of black marble inlaid with many flowers, and in the middle a multicolored parrot that is pecking a mazzard cherry. The nuncio Massimo sent this when he was Bishop of Catania. It was made in Florence and has been polished. It measures more than five [Castilian] feet in length and four in width, and the legs are of gilded wood.

[1] "He holds him down": In the original inventory, "*y le al debajo*"; in the contemporary copy (see Chapter I, n. 40), "*y le tiene debajo.*"

[34] Another table of white marble, four and one-half [Castilian] feet square, that is inlaid with four jars with different flowers. In the middle is an octagon outlined in lapis lazuli and whites. It was brought from the auction [of the estate] of don Rodrigo Calderón. It has walnut legs with boxwood and ebony embellishments [*perfiles*].

[35] Another table with a black marble field, nine [Castilian] feet in length, and in it different grotesques and spoils of war in different colors. The outside molding [is] of white marble inlaid with different colors. The supports are of Toledo marble, and in the middle is a large marble oval that appears to be agate. It was bought from the aforesaid auction.

[36] Another table of black marble with white veins, a little more than five [Castilian] feet in length. It is broken in two places by one corner, and two fragments are missing. It has walnut legs engraved with some gilded things.

[37] Another table more than five [Castilian] feet in length of different colored jaspers that has a border of white marble for a trimming and an ebony molding that serves it as a guard, with some legs [in the shape] of four terms [*de quatro términos*] carved in walnut with some gilded embellishments [*perfiles*].

[38] Another table that measures five [Castilian] feet in length and four in width. On black marble it has different foliate patterns [*follajes*] in the Roman style made of various jaspers, and it has a border half a [Castilian] foot wide with different shields inlaid over veined marble. It is finished with a black marble molding and has gilded, burnished [*alistos*], and engraved legs of walnut.

SOURCE: Madrid, Archivo del Palacio Real, Sección Administrativa, Inventarios, leg. 768, 1636, fols. 14ᵛ-17.

## APPENDIX D

# *The 1686 Inventory of the Hall of Mirrors*

[1] A portrait of the Emperor Charles V on horseback, in armor, with a lance in his hand; an original by Titian measuring five *varas* in height and four in width. This canvas and all those of this room have black frames.

[2] Another portrait, of the King our lord Philip IV on horseback with a baton in his right hand and with some symbolic figures [*empresas*] and children; an original by Rubens of the same height and width as the preceding one.

[3-6] Four equal-sized paintings of the *furias* measuring three *varas* in height and two and one-half in width; originals by the hand of Titian.

[7] A picture with the portrait of the King Philip II offering to Our Lord his son King Philip III at his birth, with an angel who descends with a palm and a victory against the Ottoman house that appears to be that of the naval battle; an original by the hand of Titian

measuring five *varas* in height and three in width.

[8-9] Two equal-sized pictures measuring five and one-half *varas* in width and five in height; the one of the abduction of the Sabine women, and the other of the battle of the Romans and the Sabines; originals by the hand of Rubens.

[10] Another picture, of the meeting of the brothers Jacob and Esau, with different figures and animals, measuring three *varas* in width and five in height; an original by the hand of Rubens.

[11] Another picture, of the same size, of the expulsion of the Moriscos by King Philip III; an original by the hand of Diego Velázquez.

[12] Another picture, of the myth of Andromeda and Perseus, an original by Rubens measuring three *varas* in height and one and one-half *varas* in width.

[13] Another painting, of the story of Mucius Scaevola of Rome, measuring three *varas* square; an original by Rubens.

[14] Another painting, of the same size, of the myth of Achilles and Deidamia; an original by Rubens.

[15] Another painting, measuring three *varas* in height and one and one-half *varas* in width, of the myth of Hercules killing the son of the Earth; an original by Rubens.

[16-19] Four equal-sized pictures over the mirrors, all originals by the hand of Tintoretto; the one of the abduction of Helen, another of Judith and Holofernes, another of Pyramus and Thisbe, and another of Venus and Adonis; measuring two and one-quarter *varas* in height and more than three in width.

[20-21] Two equal-sized paintings measuring five and one-half *varas* in width and three in height; the one of the disputation of the lost Christ Child with the rabbis, an original

by the hand of Paolo Veronese; and the other the forge of Vulcan, an original by Bassano.

[22-23] Two equal-sized pictures measuring three *varas* in height and four in width; the one of when they took Moses from the River Nile, and the other of Jacob watering Rachel's flock; originals by the hand of Paolo Veronese.

[24-25] Another two equal-sized pictures, measuring two and one-half *varas* in height and two *varas* in width; the one of a satyr squeezing out a bunch of grapes and a lioness; and the other of some nymphs with a cornucopia of flowers and fruits; both by the hand of Rubens.

[26-27] Another two equal-sized pictures, above the windows, measuring three *varas* in width and two in height; the one of the story of Jael and Sisera; and the other of Samson and Delilah; originals by the hand of Jusepe de Ribera.

[28-29] Another two equal-sized pictures, between the windows, measuring three *varas* in width and one *vara* in height, of two myths; the one of Apollo flaying a satyr, and the other of Mercury and Argus with a cow; both originals by the hand of Velázquez.

[30-31] Another two equal-sized pictures, measuring one *vara* in height and one and one-half *varas* in width; the one of Adonis and Venus, and the other of Psyche and Cupid; originals by the hand of Velázquez.[2]

[32-37] Six equal-sized porphyry tables measuring three *varas* in length and one and one-half *varas* in width, with gilded bronze moldings. Each table has for legs two life-size lions of the same gilded bronze, with a marble

---

[2] Bottineau, "L'Inventaire de 1686," 44, misstates the width of these pictures as "*vna media*" instead of "*Vara y media.*" The inventory of 1700 also specifies one and one-half *varas* (*Inventarios reales*, 1:20).

ball upon which each lion rests a paw. All are on socles of San Pablo marble.

[38-43] Six urns made of the same porphyry as the tables, one on each table; the two largest in the manner of equal-sized pitchers and the other four in the style of cups with their covers [*a manera de tazas como cubiertas*].[3]

[3] In 1700, "*a manera de tazas Con Sus Cubiertas*" (*Inventarios reales*, 1:129).

[44-51] Eight mirrors with glass plates measuring one *vara* in height and three *quartas* in width, with *lignum vitae* frames and gilded bronze devices—each mirror has a gilded bronze eagle that supports and clasps it.

SOURCE: Madrid, Archivo del Palacio Real, Sección Administrativa, Bellas Artes, leg. 38, 1686, fols. 7-8 [paintings] and 85-85ᵛ [*adornos*].

## APPENDIX E

# *Antonio Palomino on the Pandora Ceiling for the Hall of Mirrors*

[*In his life of Velázquez, Palomino recounts how Colonna and Mitelli, the Bolognese fresco painters whom Velázquez had recruited in Italy to work for Philip IV, decorated several rooms in the Alcázar of Madrid, among them the Hall of Mirrors.*]

At this time they deliberated about what was to be painted in the *Salón grande*, which has windows above the principal entrance to the palace, and, having chosen the Fable of Pandora, Diego Velázquez made a plan of the ceiling with the distribution and design of the paintings, and in each section was written the story to be represented.

They began this work in the year 1659, about the month of April. It fell to Don Juan Carreño to paint in fresco the god Jupiter and Vulcan, his blacksmith and chief engineer, showing him that statue of a woman which Jupiter had ordered him to fashion with the utmost perfection that his talent permitted and which he had done to the best of his abil-

ity. Thus he produced a marvelous statue, of singular beauty. In the background was painted the forge and workshop of Vulcan, with its anvils and vices and other blacksmith's tools, and in it the Cyclopes, whom he had as workmen, who were called Brontes, Steropes, and Pynacmon.

It fell to Michelangelo Colonna to paint the scene where Jupiter commanded the gods that each should bestow on Pandora a gift whereby she would be made more perfect: Apollo, music; Mercury, discretion and eloquence; in short, each of them enriched her with what came from his own store. Because she had acquired so many gifts from the gods, they called her Pandora in Greek: from *Pan*, which means 'all'; and from the word *Doron* which signifies 'endowment'; and the two names together mean 'endowed with all'. The gods and goddesses are seen beautifully placed on thrones of clouds, with their own attributes to identify them; presiding over them all is

Jupiter on an eagle, with Pandora and Vulcan below. This is the principal theme and is in the middle of the ceiling: its form is somewhat oval, and the whole ceiling somewhat concave.

It fell to Francisco Rizi to paint Jupiter handing to Pandora an exquisite gold vessel, saying that in it was the dowry for her support, and that she should look for Prometheus who was a person worthy to be endowed with what she had.

In another part of the ceiling Rizi painted Pandora offering that vessel of gold to Prometheus, who with a very lively gesture and movement rejects her and takes his leave, without wishing to listen to her any longer. For he was so cautious and wise that he knew that her composure and fine bearing and the clever way she persuaded him were somewhat deceptive. In the background are Hymen, god of marriage, and a little cupid going out through a door, considering his arms to be useless there.

Prometheus, aware that Pandora was going to meet his brother Epimetheus, warned him; and advised him, since he was younger and not very clever, that if that woman chanced to arrive at his door he should on no account allow her to enter, as she was a deceiver. Pandora went to Epimetheus' house at a time when she knew that Prometheus was absent, and managed to charm him with the flattery of her sweet words and she convinced him so effectively that he married her, without heeding his brother's advice or considering the consequence that could arise from the afflictions, disturbances, and other trials that matrimony brings with it. The painting of the marriage of Epimetheus and Pandora was begun by Carreño; and when it was far advanced he was interrupted by a very serious illness so that it was necessary for Rizi to finish it. Rizi also painted the scenes on the imitation gold shields in the four corners of the room. But after some years, when the opportunity arose to erect scaffolding in order to repair the damage done to the painting by rain, Carreño repainted almost the whole composition in oils.

To Mitelli fell the decoration, which he executed in the grand manner, enriching it with such fine architecture, ground work, and massive ornament, that it seems to add strength to the building. What is particularly worth noticing is the great facility and skill with which it is carried out. Colonna painted certain still-life motifs, garlands of leaves, fruit, flowers, shields, trophies, as well as fauns, nymphs, and beautiful children standing on the raised cornice of imitation jasper, and he also painted a garland of gilded laurel which encircles the whole room. The room was made so beautiful that it rejoices the eye, refreshes the memory, enlivens the understanding, instructs the mind, raises the spirit, and lastly expresses all majesty, talent, and grandeur. The King went up every day, and sometimes the Queen our Lady Doña Mariana of Austria and the Infantas went to see how the work was progressing. His Majesty asked the artists many questions which showed the love and affability with which he always treated members of this profession.

For all these subjects excellent drawings or cartoons were made, actual size and on tinted paper, which served as half-tone for the white highlights. This kind of drawing is very famous and is practiced by great artists; therefore, Vasari wrote: *Questo modo è molto alla pittoresca, e mostra più l'ordine del colorito.* And those drawings that Colonna made were extremely pleasant, for they looked as if they were colored; the reason being that since the paper was pure blue, he heightened with white, and blended with red earth, following the same process as in painting.

There are many artists who refuse to make their cartoons actual size for work in oils, but for work in fresco this is essential, so as to make sure that the work is divided accurately and to scale and in order to see the effect that the selection and judgment of the painter will have on the whole.

SOURCE: Antonio Palomino de Castro y Velasco, *El museo pictórico y escala óptica* (1715-1724; rpt. Madrid, 1947), 923-25. The translation is reprinted from Enriqueta Harris, *Velázquez* (Ithaca, N.Y., 1982), 215-16, with minor orthographic changes. (© 1982 by Enriqueta Harris. Used by permission of Cornell University Press and Phaidon Press Limited.)

## APPENDIX F

# *Jacob Cuelvis on the Great Hall (1599)*

### THE GREAT HALL

*On the left-hand {wall}*

[1] The city of Rome.

[2] The port of Malacca in the Indies. A very great city and fortress for the King of Spain. It seems to be invincible because it has only one entrance.

[3-13] Seville. Córdoba. Granada. Toledo. Jerez de la Frontera. Antequera. Burgos. Genoa. Segovia to the right and its bridge or aqueduct. The Escorial of San Lorenzo. Milan.

[14] The entry of the Castilian army into the Kingdom of Portugal, the general being D. Antonio de Toledo, Duke of Alba, the famous captain of the Emperor Charles V; and the battle and capture of that kingdom.

[15] Here again is the portrayal of the battles and victories that the Emperor Charles V won in Germany, with the names of the most important captains in the field and the leaders of both parties.

*On the right-hand {wall}*

[16-20] Valencia. Zaragoza. Lérida. Barcelona. Segovia with its bridge of Hercules.

[21] Mexico City in the Indies.

[22] A picture that was made on the island of China itself. The island is portrayed with the walls that it has. The foundation is gilded. A *tabula* of different parts, a portrait of all the kinds of birds that are seen here.

[23] Opposite there is another one. They are portraits of the men of this same island. They all have bald heads, small eyes and mouths, and they drink from their wine sacks. They are very great drunkards.

[24] *The portrait of the Cook and the Cupbearer*

The Cook has a pot for a hat and his cordon is a trivet. His hands a small box of spoons [*indecipherable*] were such that they appeared to be the fingers of the

hand. The Cupbearer has a cask for a
body and a golden cup for a nose.

[25] The island of St. Helena *ubi se rescuma* [?]
ships coming from India.

[26] In the great hall is painted the triumph
of the Emperor Charles V when he was
crowned in Rome. He is riding on
horseback and bearing a branch of lau-
rel in his right hand.[4]

---

[4] Following his account of the Great Hall, Cuelvis
describes the Room of the *Furias* (see my Appendix J)

SOURCE: Diego Cuelbis [Jacob Cuelvis],
"Thesoro choragraphico de las Espan-
nas," London, British Library, Ms.
Harley 3822, fols. 103ᵛ-106.

and then proceeds to treat *La Sella [Silla?] de Isla China*
(fols. 107ᵛ-108). Domínguez Ortiz, "Descripción de
Madrid," 140, interprets this as a return to the Great
Hall. I am hesitant to follow, but if it is so, that would
add six jasper tables to the ensemble. One is described
in detail for its precious stones and for the fact that it
was a cardinal's gift. The tables would not have affected
the meaning of the painted decoration in the Great Hall.

## APPENDIX G

# The 1636 Inventory of the Great Hall

[1-26] Twenty-four [*sic*] canvases, in tem-
pera, in which are painted some cities of Spain,
Italy, and Flanders; some of which have the
arms of His Majesty in the upper part, with
some colored banderoles below them, and in
them the names of each of the cities, which
are the ones that follow:

The city of Granada with some Morisco
women in their costumes.

The city of Naples seen from the direc-
tion of the sea, which besides having the
arms of His Majesty has those of the Em-
peror and the aforesaid city at the corners.

The city of Burgos seen from the direc-
tion of the river, in which is a peasant lean-
ing on a shepherd's crook next to a
hermitage.

The city of Zaragoza, seen from the di-
rection of the river and the entry from
Barcelona.

The city of Lérida seen from the direction
of the river and the entry from Barcelona.

The aforesaid Barcelona seen from the di-
rection of the sea facing the port.

That of Valencia seen from the entry from
Castile and the Portal de Cuarte.

The city of Málaga seen from the direc-
tion of the sea.

The city of Toledo seen from the Puerta
del Cambrón entrance.

The city of Gibraltar viewed from the
direction of Algeciras, in which its bay,
mountain, and city are shown.

The city of Cádiz seen from the direction
of the sea, its bay and Puente de Suazo lying
to the left.

The port of Santa María viewed from the
salt mines and the river, where the old
bridge was.

The palace of Brussels and its park, where

they [*sic*] are tilting on horseback.

The city of Seville viewed from the direction of Triana, in which the river and bridge are shown.

The city of Córdoba viewed from the river and bridge.

The city of Jaén seen from the direction where there is a column that appears to be a round pillar [*rollo*], and next to it are two men, one of whom is writing.

The city of Segovia viewed from the direction of the river, in which the bridge is shown to the right.

The city of Jerez de los Caballeros, in which there are two figures, one of whom is writing.

The city of Antequera viewed from the direction of the meadow, in which is a seated shepherd playing a flute and next to him a dog.

Guadalupe, which to the right shows an old building and two men, one of whom is writing.

The city of Cuenca, which is shown from the direction of the Jucár River and the entry from Madrid.

Another canvas of the city of Toledo viewed from the direction of the river and the Castle of San Cervantes, in which there are three figures on the left side, one of whom is playing [an instrument].

The city of Genoa viewed from the direction of the sea and port, and in the upper part a shield on a blue field with gold letters that names it, and two coats of arms at the sides.

The city of Malines, and at its sides there are the arms of His Majesty, those of the country, and [those of] the aforesaid city.

The city of Rome, in oil paint, and in the upper part it has an angel with a placard that names it.

The city of Utrecht in Flanders, and besides the arms of His Majesty it has two others at the sides and a windmill in the right-hand part.

[27-32] Six canvases, in tempera painting, measuring five and one-half [Castilian] feet in length and four in height, more or less, in which are the wars of our lord Emperor Charles V.

[33] A canvas in oil measuring four *varas* in length, more or less, with a gilded and black frame, of the entry that the army of the lord King Philip II made into Lisbon, in which is shown the battle that took place on the Alcántara bridge and on land and sea.

[34] Another canvas, in tempera painting, with a gilded and black frame, in which is the Monastery of San Lorenzo el Real, seen from the direction of the main entrance; all the building is in perspective, and it is by the hand of Fabricio Castelo.

[35] Another canvas in tempera, in which is the city of Malacca and a battle that has two Portuguese galleons and a great land army.

[36-37] Two small canvases in tempera, greater in length than in height [*prolongados*] and old; the one, the entry of the lord King Philip I into La Coruña, and the other, the fiestas that they staged for him in Valladolid.

[38-41] Four small, square, black-and-white canvases, in oil, in which are the virtues, which are some seated figures.

[42] A painted canvas, in tempera, of a palace in Brussels, and in the upper part at one side is a shield, with three angels that hold it and a canvas; it measures five and one-half [Castilian] feet in length, more or less.

[43] An illuminated print on paper of the city of *Aynch* [Aix?]; it measures one *vara* in length and has a gold and silk trimming for a frame.

[44] A canvas in oil, measuring sixteen [Castilian] feet in length, with a black frame, which is the description of the structure that was made at the command of the lord King Philip III in order to convey the water from the valley of Daimiel to the palace of Madrid; in it there is an extended, ovoid shield with a label that names it.

[45] Another canvas in oil, measuring four [Castilian] feet in length, with a black frame, which follows the aforesaid description of the water conveyance; and the palace and a shield in which the conveying of the water is explained [está puesto] are painted [also].

[46] Another canvas in oil, measuring eight [Castilian] feet in length, with a gilded frame, in which is the structure for conveying the aforesaid water from the valley of Daimiel to the palace, with a section of the structure that was made for the execution of this work, by the hand of Roelas, a painter and cleric.

[47-54] Eight canvases in oil painting, with gilded and black frames, in which are painted the fiestas that they celebrated in 1615 for the archduke and archduchess in Flanders with the festival that they call "of the Popinjay."

The first measures fourteen and one-half [Castilian] feet in length and four and one-half in height, in which are painted the guilds [oficios] with their insignias as they are going to shoot at the popinjay.

The second, which measures the same length and height, is how the militia companies went.

The third, measuring twenty [Castilian] feet in length and the same height, is of how the companies passed before the archduke and archduchess, Their Highnesses being in the town hall; the companies were newly dressed for the Infanta.

The fourth, measuring twelve [Castilian] feet in length and the same height, in which are the four giant figures and the four giant heads that they brought out for this fiesta. There is a figure of a very great horse caparisoned in black, and atop it four men in armor with naked swords. There are three coats of arms in the aforesaid caparison.

The fifth, measuring fourteen [Castilian] feet in length, in which there is a procession of all the orders. It ends with Our Lady, whom four men dressed in white and barefoot carry on a litter, and four figures dressed in color with their blue garments, who are the major-domos of this fiesta.

The seventh, a canvas measuring nine and one-half [Castilian] feet in length and six and one-half in height, in which is painted the day that the popinjay was shot at; in which it is shown how Their Highnesses were at the fiesta, when the Infanta fired, and when she showed herself afterwards to the people in a balcony and they gave her their congratulations.

The eighth, another canvas measuring twelve and one-half [Castilian] feet in length and four and one-half in height, in which are the fiestas that Their Highnesses celebrated at Our Lady of the Forest. Their Highnesses are shown in a bower overlooking a lagoon.

[55-66] Twelve canvases in oil, measuring seven [Castilian] feet in length and five and three-quarters in height, more or less, with gilded and black frames, that are battles that the lord Emperor Charles V fought in Germany. They each have in the upper part a quadrilateral [quadrada] tablet, greater in length than in height [prolongada], in which is the exposition of each one. Those of three are blank in the aforesaid tablets. These paintings were ordered copied by His Majesty, in

the time of the Marquis of Malpica, from the tempera canvases that he had of these battles.

[67-68] Two canvases, in oil painting, measuring six and one-half [Castilian] feet in length, pictures of the Town of Madrid, the one viewed from the Hermitage of San Isidro, with the saint ploughing next to the said her-mitage; and the other is viewed from the upper Prado and one sees the Carrera de San Jerónimo and the Calle de Alcalá.

SOURCE: Madrid, Archivo del Palacio Real, Sección Administrativa, Inventarios, leg. 768, 1636, fols. 19bis^v-22^v.

# APPENDIX H

## The 1636 Inventory of the South Gallery

### GALLERY THAT FACES SOUTH ABOVE THE GARDEN OF THE EMPERORS

[1-6] Six portraits, with gilded and burnished frames, life-sized. One is the lord King Philip III, in armor, with foils [armas negras] and with a baton in his hand resting on a globe. Another is the Queen Doña Margarita dressed in white with a book of hours in her right hand, which is on a table, and a handkerchief in the other. Another one is the King our lord as a prince with his right hand on Soplillo, His Majesty's dwarf, dressed in white embroidered with gold. Another is the Queen our lady as a princess, dressed in white and in black glass ornaments [vidrios] outlined in gold, which was her costume when Her Majesty entered Lisbon. Another is the Infanta María dressed in colors, with one hand on a table and a fan in the other. Another of the lord Cardinal-Infante with one hand on a chair and a book of hours in the other. These portraits are the ones that Villandrando made.

[7-18] Twelve small canvases, with gilded and black frames, in which are painted in oil the twelve months of the year, with the fruits, flowers, and birds of the season.

[19-26] Eight paintings on panel, measuring one vara in height, with carved walnut frames, in which are the four elements and the four seasons of the year, each in its own [picture].

[27-30] Four canvases in oil, with gilded and black frames, in which are the residences of Balsain, San Lorenzo el Real, the Pardo, and Aranjuez. They are by the hand of Fabricio Castelo.

[31-32] Two half-length portraits, life-sized. The one is the lord Emperor Charles V, in armor, with a baton in one hand and with his helmet on a table. The other is the Empress, his wife, dressed in mulberry, with a string of pearls on her neck that ends in a jewel. She has a book of hours in her left hand. They are copies of Titian, and they have gilded and black frames.

[33-34] Two other canvases in oil, measuring seven [Castilian] feet in length, more or less; in one is the portrait of the lord Archduke Albert, in half-length, dressed in black, with his left hand on his gloves, and with a country house in the background. The other is the Infanta Doña Isabella, his wife, the same size, dressed in black and seated in a chair, opening

a fan with both hands. In the background is another country house. They are by the hand of Rubens.

[35] A portrait of the lord King Philip II when he was old. He is dressed in black, in half-length, with one hand on his sword and some gloves in the other. It has a gilded and black frame.

[36] Another portrait, somewhat smaller, in half-length, of the Queen Doña Ana, dressed in black with a wimple on her head [*con toca en punta*], with her gloves on, and with one hand on a chair. It has a black frame with a gilded outline.

[37-38] Two Flemish paintings on panel; the one is of events of war on land and sea, of armed troops marching, of a Franciscan friar with a small dog under his arm, and of different places that have caught fire. The other is a landscape in which is a bit of sea and a farmer on the land sowing. They have gilded and variegated [*jaspeadas*] frames.

[39-42] Four Flemish paintings on panel, of various landscapes and figures. They have gilded and black frames, and gilded foliage on a black field in their friezes.

[43-44] Another two paintings on panel; the one is a tempest on the sea. The other is the martyrdom of Saint Catherine. There is an angel that descends with a sword. They have gilded and variegated [*jaspeadas*] frames, and measure a little less than a *vara* in length.

[45-56] Twelve small canvases in oil, with small, gilded and black frames, measuring half a *vara* in length, more or less, by the hand of Juan de la Corte. They are the ones that were removed from the room where His Majesty reads in the *cuarto bajo*. They are of different subjects.

[57-58] Two small pieces of painting on panel, measuring two *tercias* in length, with curved [*ondeados*] ebony frames. In the one is

a quarrel of soldiers over a game, a deck of cards scattered on the ground, and a rout. In the other are some soldiers playing dice on a drum.

[59-60] Two mosaic landscapes of different polished stones made in Florence, with ebony frames, the one with greater work than the other.

[61-62] Two panels, in oil, by the hand of Hieronymus Bosch, with gilded and black frames. The one is of Saint Christopher, who is crossing a river, with various figural inventions [*invenciones de figuras*] and two fires. The other is the temptation of Saint Anthony Abbot, represented at night, with a lamp in the trunk of a tree.

[63] A small landscape in oil, on panel, with a gilded and black frame, in which are some soldiers who are next to a fountain and who want to cross a bridge. It measures two [Castilian] feet in length, more or less.

[64] A hand-map [*mapa de mano*], hand-colored, that Don Pedro de Teixeira made of the states of Flanders. It measures five [Castilian] feet in length, more or less. In the upper part are the arms of His Majesty with a shield on a red field, and in the upper part some letters of gold.

[65] A tree of the descent of the House of Austria with the other realms united with her that Juan Bautista Labaña made on hand-colored paper, with a gilded frame and some inscriptions. In the four *medios* it will measure two *varas* in width more or less.

[66-67] Two mirrors, the one measuring three *quartas* in width with an ebony frame; and the other measuring two *tercias* in width with an ebony frame and a frieze of *lignum vitae*.

[68-71] Four long and narrow tables of serpentine marble with drawers and legs of wal-

nut embellished [*perfilados*] with ebony and boxwood. Two of them are broken in the middle [*por medio*].

SOURCE: Madrid, Archivo del Palacio Real, Sección Administrativa, Inventarios, leg. 768, 1636, fols. 17bis^v-19bis.

## APPENDIX I

# *The 1666 Inventory of the Octagonal Room*

[1] A painting measuring two *varas* in height and one and one-half in width of a Bacchus with some nymphs, by the hand of Van Dyck, valued at 200 silver ducats.

[2-3] Another two paintings measuring the same height and one-half *vara* in width of two planetary deities [*planetas*]—one of Mercury and the other of Saturn [*insert*: by Van Dyck], valued at 50 ducats each.

[4] A painting measuring three and one-half *varas* in length and one and one-half *varas* in height of Diana hunting with her nymphs, by the hand of Rubens and Snyders, valued at 150 ducats.

[5-7] Another three measuring the same size of hunting and war, all by Rubens, 50 ducats each.

[8-15] Another measuring one *vara* in height and one-half *vara* in width; altogether there are eight at 50 ducats each, by Rubens; that amounts to 4,400 *reales*.

[16] Another measuring five *varas* in length and two in height, nymphs hunting deer, by the hands of Rubens and Snyders, valued at 300 ducats.

[17-18] Another two paintings measuring one and one-half *varas* in size [*largo*] of Her-

cules and Diana, valued at 60 ducats each, by the hand of Rubens.

[19] Another measuring two *varas* in length and one and one-half in height of Hercules wrestling with a lion, valued at 100 silver ducats.

[20] Another measuring five *varas* in length and two in height of a hunt of dogs and boars of dogs and figures [*sic*], by Rubens, valued at 300 silver ducats.

[21-27] The seven planetary deities [*planetas*], in bronze with pedestals of the same, full-length [*cuerpos naturales*], at 800 silver ducats each, which amounts to 61,600 *reales*; at which the aforesaid Don Sebastián de Herrera appraised them.

[28-30] Another three bronze figures, the same size; at 900 ducats each, they amount to 2,700 silver ducats; at which the aforesaid Don Sebastián appraised them.

[31-42] Twelve marble medallions [*medallas*][5] with their pedestals of different colored

---

[5] The 1686 inventory also calls these twelve objects *medallas* (Bottineau, "L'Inventaire de 1686," 60); however, that of 1700 (*Inventarios reales*, 1:132) calls them *cabezas*. Even though they stood on pedestals, the use of *medallas* in 1666 and 1686 indicates that these marbles were portrait medallions, not busts.

jasper, at 300 silver ducats each. They amount to 3,600 silver ducats, at which the aforesaid Don Sebastián de Herrera appraised them.

[43-46] Four bronze heads at 250 ducats each, at which the aforesaid Don Sebastián de Herrera appraised them.

[47] A bronze statue of the one who cuts the thorn with its wooden pedestal of feigned jasper, on an octagonal jasper table that rests on a wooden leg. The statue is valued at 600 silver ducats and the table at 400 silver ducats; at which the aforesaid Don Sebastián de Herrera appraised them.

SOURCE: Madrid, Archivo del Palacio Real, Sección Administrativa, Bellas Artes, leg. 38, 1666, fols. 55-56ᵛ.

## APPENDIX J

### *Jacob Cuelvis on the Room of the* Furias (1599)

FOURTH ROOM, NOT SO LARGE, NEAR THAT ONE [THE GREAT HALL]

Near the window on the right-hand side: Eight very ingenious inventions and paintings of the four elements and the four seasons of the year as men.

[1] I.  Fire, which has burning or plain [*rasos*] coals in his head. The nose [*illegible*], the face is entirely silica, the eyes a piece of a candle, the forehead [*illegible*] and the beard [*illegible*].

[2] II.  Air. The head was made of every kind of bird. The body a peacock. The nose an Indian cock, and the mouth a cock and a hen above it.

[3] III.  Water. The head is *pesces* or fish. The nose [*illegible*]. The beard [*illegible*].

[4] IV.  Earth. Many beasts, and serpents around the head like a crown. The body is a lion. The nose a lamb. The head a deer and rabbits.

[5] Winter. Much firewood.

[6] Summer [*sic*]. Many different flowers.

[7] Summer. Many fruits.

[8] Autumn. Some apples and pears.

[9-12] Up high in the room there are four very handsome pictures of Virgilian Torment. 1. Tityus and a vulture. 2. Atlas *portar montem*. 3. Tantalus *qui poner fugacia captat*. 4. *Sitiens Icarus*.

SOURCE: Diego Cuelbis [Jacob Cuelvis], "Thesoro choragraphico de las Espannas," London, British Library, Ms. Harley 3822, fols. 106-107.

APPENDIX K

# The 1636 Inventory of the Room
# of the Furias

ROOM THAT THEY CALL "OF THE *FURIAS*"
WHICH IS BEHIND THE *CANCEL*
[AND IS] WHERE THE
KING SLEEPS

[1] A full-length portrait, in oil, of the Infanta Doña Isabella, dressed in a scarlet costume, dress skirt, and white jacket [*jubón*].

[2] A knee-length portrait of Pope Hadrian seated with a book of hours in his hand. It has a green curtain.

[3] Another portrait of Leopold William as a five-year-old child, dressed in white and a red sash.

[4-6] Three pictures in oil in which are all the children of King Philip III our lord dressed in white, in which there are seven persons.

[7] Another half-length portrait of Francisco Tomás as a boy, dressed in brown, his left hand on a small dog.

[8] Another portrait, full-length, of King Philip III our lord, dressed in black.

[9] Another of the same size, of the Queen our lady Doña Margarita, dressed in black with a black headdress.

[10] A full-length portrait of the King of France, [who] recently inherited [his crown], dressed in mulberry.

[11] A portrait of the Queen of England, his sister, dressed in mourning.

[12] Another portrait of the Queen of France, sister of the lord King Philip III, dressed in the French manner in embroidered mulberry, with a small dog on a table.

[13] Another portrait of the Queen our lady dressed in white embroidered with gold and black.

[14-15] Two portraits of sisters of the lord Emperor, the one with a fan and the other with a small dog on a table.

[16] A portrait, that appears to be the lord Emperor Charles V dressed in black, with a low neckpiece [*cuello bajo*] and wearing the insignia of the Golden Fleece. It is full-length and badly painted.

[17] Another portrait, full-length, that appears to be King Philip II our lord, in armor with colored breeches. It is badly painted, and in the upper part is his coat of arms.

[18] Another portrait, of Prince Don Carlos, dressed in yellow with a mulberry-colored short cloak lined with ermine. It is a full-length portrait.

[19] A large canvas in oil, in which is painted the island of Mallorca with the arms of His Majesty and of the island in the upper part. It has a gilded frame and measures eight [Castilian] feet in size more or less.

[20] Another canvas of the same size and shape, of the island of Menorca. Both canvases were in the Gallery of the North Wind.

[21-22] Another two canvases, of the same size and frame, of the handing over [*entregas*] of Spain and France [i.e., the Exchange of Princesses in 1615].

[23] Another canvas in tempera, measuring two *varas* in size, with three groups of undertakings [*tres ordenes de empresas*] of the Em-

peror Charles V signified by the eagle. It was in the Gallery of the North Wind.

[24] A canvas in tempera, by Hieronymus Bosch, measuring one *vara* in size, more or less, of a wagon of many things.

[25-28] Four canvases in oil, measuring seven [Castilian] feet in size, more or less, that are of Gibraltar viewed from four directions, with gilded frames.

[29] A full-length portrait of the Infanta Doña Ana, who today is Queen of France, with a white costume embroidered with gold and spring colors.

[30] Another portrait of Prince Don Carlos as a youth, in armor with white breeches, and with his left hand on his sword.

[31] Another portrait of the lord King Philip II as a youth, dressed in black, with white breeches and an old-fashioned hat with a white feather, and with his hand on his sword.

[32] A canvas in oil, of a hunt, with a gilded frame, that was brought from the Gallery of the North Wind.

[33] A painting in oil on panel, of the Temptation of Saint Anthony, in which there are various figures by the hand of Hieronymus Bosch. It has a gilded frame.

[34] A large canvas in oil, with a gilded frame, in which is the city of Málaga viewed from the sea from the sea [*sic*] and a patch of land [*pedazo*] in the area of the castle of Fuengirola. It measures eight [Castilian] feet in size, more or less.

SOURCE: Madrid, Archivo del Palacio Real, Sección Administrativa, Inventarios, leg. 768, 1636, fols. 13ᵛ-14ᵛ.

# APPENDIX L

# The 1686 *Inventory of the Main Room of the Prince's Quarter*

### MAIN ROOM

[1] A painting measuring two and one-half *varas*, almost square, of the myth of Arachne and Pallas, who wove the story of the rape of Europa, with a black frame, copy after Rubens by the hand of Juan Bautista del Mazo, who was *pintor de cámara*.

[2] Another painting measuring the same size and in a black frame, of the myth of the god Pan and Apollo, [who has] made a satyr, copy of Rubens by the hand of the aforesaid Juan Bautista del Mazo.

[3] Another painting on the opposite wall [*enfrente*] measuring the same size and in a black frame, of the rape of the Sabines, copy of Rubens by the hand of the aforesaid Juan Bautista del Mazo.

[4] Another measuring the same size of the rape of Proserpina with some small cupids and

a chariot that four horses draw, in a black frame, copy of Rubens by the hand of the aforesaid Juan Bautista.

[5-6] Two equal-sized paintings measuring four and one-half *varas* square, with black frames, the one of a myth of Mercury beheading Argus, in which there is a cow—and the other of Alexander the Great on a lion hunt, both copies of Rubens by the hand of Juan Bautista del Mazo.

[7-8] Another two equal-sized paintings measuring two *varas* in length and a *vara* in height, in black frames, the one of the myth of Deucalion and Pyrrha, who throw stones, and the other of Procne and Philomena, who present a head, copies of Rubens by the hand of the same Juan Bautista del Mazo.

[9-10] Another two equal-sized paintings measuring one *vara* square, the one of the myth of Orpheus and Eurydice when he brought her out of Hades with music—and the other of Phaethon with a chariot of four white horses and some small cupids, in black frames, copies of Rubens by the hand of Juan Bautista del Mazo.

[11-12] Another two equal-sized paintings measuring one *vara* in width and one and one-half in height, the one of Diana on a hunt, and the other of the story of Dido and Aeneas, who receives her dismounting from a horse, in black frames, copies of Rubens by the hand of the aforesaid Juan Bautista del Mazo.

[13-16] Four equal-sized small pictures in the facing spaces on the end walls [*en las frentes de las remates*] of this room, measuring two *tercias* in height and one in width, in black frames—one of Vulcan—another of Ganymede, whom an eagle carries off—another of Atlas with a globe on his shoulder—and another that looks like Hercules with a kindled torch in his hand, copies of Rubens by the hand of the aforesaid Juan Bautista del Mazo.

[17-23] Seven paintings over the windows measuring three *varas* in width and three *quartas* in height of different birds, animals, and landscapes, copies of Rubens by the hand of Mazo, in black frames.

[24-28] Five small, equal-sized pictures measuring one-half *vara* in width and three *quartas* in height in the spaces between the pictures over the windows, in black frames, portraying a wild boar and some dogs, by the hand of the same Juan Bautista del Mazo.

[29-34] Six small pictures measuring one-half *vara* in width and two *tercias* in height, between the windows, of the Labors of Hercules, by the same hand and copies of Rubens, in black frames.

[35-40] Another six pictures measuring one and one-half *varas* in height and two *tercias* in width, also between the windows, in black frames, two of the philosophers Democritus and Heraclitus, one of Hercules killing the seven-headed Hydra, and the three remaining ones of Mercury, Saturn, and Diana, copies of Rubens by the hand of the aforesaid Juan Bautista del Mazo.

SOURCE: Madrid, Archivo del Palacio Real, Sección Administrativa, Bellas Artes, leg. 38, 1686, fols. 43-44ᵛ.

# BIBLIOGRAPHY

*Aclamacion Real y Publica de la Coronada Villa, y Corte de Madrid; en cuyo nombre leuantó el Pendon de Castilla el Excelentissimo senor Duque de San Lucar y de Medina de las Torres, Conde de Oñate y Villa-Mediana, Correo mayor general de España, por su Augusto, y Catolico Rey Carlos II. que Dios guarde.* Madrid, 1665.

Alcolea, Santiago, with Joaquim Garriga Riera and Isabel Coll Mirabent. *Pinturas de la Universidad de Barcelona: catálogo.* Barcelona, n.d.

Alekséev, Mijail. *Rusia y España: una respuesta cultural.* Translated by José Fernández Sánchez. Madrid, 1975.

Alpers, Svetlana. *The Decoration of the Torre de la Parada.* Corpus Rubenianum Ludwig Burchard, pt. 9. London-New York, 1971.

Angulo Iñiguez, Diego. "La mitología y el arte español del Renacimiento." *Boletín de la Real Academia de la Historia* 130 (1952), 63-212.

——. *Pintura del siglo XVII.* Ars Hispaniae, vol. 15. Madrid, 1971.

——, and Pérez Sánchez, Alfonso E. *Historia de la pintura española: escuela madrileña del primer tercio del siglo XVII.* Madrid, 1969.

Azcárate, José María de. "Algunas noticias sobre pintores cortesanos del siglo XVII." *Anales del Instituto de Estudios Madrileños* 6 (1970), 43-61.

——. "Datos para las biografías de los arquitectos de la corte de Felipe IV." *Revista de la Universidad de Madrid* 11 (1962), 517-46.

——. "Noticias sobre Velázquez en la corte." *Archivo Español de Arte* 33 (1960), 357-85.

Barrionuevo, Jerónimo de. *Avisos.* Edited by A. Paz y Mélia. 4 vols. Colección de Escritores Castellanos, vols. 94, 96, 99, and 103. Madrid, 1892-1893.

Baticle, Jeannine. "Notes sur les portraits de la Maison de Bourbon envoyés en Espagne au XVIIᵉ siècle." *La Revue des Arts* 10 (1960), 195-200.

——. "Recherches sur la connaissance de Velázquez en France de 1650 à 1830." In *Varia velázqueña: homenaje á Velázquez en el III centenario de su muerte 1660-1960,* 1:532-52. Madrid, 1960.

Berger, Robert W. "Rubens's 'Queen Tomyris with the Head of Cyrus.'" *Bulletin of the Museum of Fine Arts, Boston* 77 (1979), 4-35.

Beroqui, Pedro. *Tiziano en el Museo del Prado.* [Madrid], 1946.

Bertaut, François. "Journal du voyage d'Espagne (1659)." Edited by F. Cassan. *Revue Hispanique* 47 (1919), 1-317.

Bissell, R. Ward. *Orazio Gentileschi and the Poetic Tradition in Caravaggesque Painting.* University Park, Pa.-London, 1981.

Bonet Correa, Antonio. "Velázquez, arquitecto y decorador." *Archivo Español de Arte* 33 (1960), 215-49.

Boon, K. G., and Verbeer, J. *Dutch and Flemish Etchings, Engravings, and Woodcuts ca. 1450-1700.* Vol. 15. Amsterdam, n.d.

Bottineau, Yves. "L' Alcázar de Madrid et l'inventaire de 1686." *Bulletin Hispanique* 58 (1956), 421-52; and 60 (1958), 30-61, 145-79, 289-326, and 450-83.

——. "Antoine du Verger et l'Alcázar de Madrid en 1711." *Gazette des Beaux-Arts,* 6th ser., 77 (1976), 178-80.

——. *L'Art de cour dans l'Espagne de Philippe V 1700-1746.* Bordeaux, [1960].

——. "Aspects de la cour d'Espagne au XVIIᵉ siècle: l'étiquette de la chambre du roi." *Bulletin Hispanique* 74 (1972), 138-57.

Bottineau, Yves. "Philip V and the Alcázar at Madrid." *Burlington Magazine* 98 (1956), 68-75.

——. "A Portrait of Queen Mariana in the National Gallery." *Burlington Magazine* 97 (1955), 114-16.

Brown, Jonathan. *Images and Ideas in Seventeenth-Century Spanish Painting*. Princeton Essays in the Arts, no. 6. Princeton, 1978.

——. "On the Origins of 'Las Lanzas' by Velázquez." *Zeitschrift für Kunstgeschichte* 27 (1964), 240-45.

——, and Elliott, John H. *A Palace for a King: The Buen Retiro and the Court of Philip IV*. New Haven-London, 1980.

Burchard, Ludwig, and d'Hulst, R.-A. *Rubens Drawings*. 2 vols. Brussels, 1963.

Cabrera de Córdoba, Luis. *Relaciones de las cosas sucedidas en la córte de España, desde 1599 hasta 1614*. Madrid, 1857.

Calandre, Luis. *El Palacio del Pardo (Enrique III-Carlos III): estudio preliminar*. Madrid, 1953.

Calvert, Albert F. *The Spanish Royal Tapestries*. London-New York, 1921.

Camón Aznar, José. *La pintura española del siglo XVII*. 2nd edn. Summa Artis, vol. 25. Madrid, 1978.

Campbell, Malcolm. *Pietro da Cortona at the Pitti Palace: A Study of the Planetary Rooms and Related Projects*. Princeton, 1977.

Cánovas del Castillo, Antonio. *Historia de la decadencia de España desde el advenimiento de Felipe III al trono hasta la muerte de Carlos II*. 2nd edn. Madrid, 1910.

Caparrós, José María. "Enfermedad, muerte y entierro del Rey D. Felipe IV de España," *Revista del Centro de Estudios Históricos de Granada y su Reino* 4 (1914), 171-89.

Carducho, Vicente. *Diálogos de la pintura: su defensa, origen, esencia, definición, modos y diferencias*. Edited by Francisco Calvo Serraller. Madrid, 1979.

*Cartas de algunos PP. de la Compañía de Jesus sobre los sucesos de la monarquía entre los años de 1634 y 1648*. 7 vols. Memorial Histórico Español, vols. 13-19. Madrid, 1861-1865.

*Catálogo de la exposición del antiguo Madrid*. Madrid, 1926.

Caturla, María L. *Pinturas, frondas y fuentes del Buen Retiro*. Madrid, 1947.

——. "Los retratos de reyes del 'Salón dorado' en el antiguo Alcázar de Madrid." *Archivo Español de Arte* 20 (1947), 1-10.

Ceán Bermúdez, Juan A. *Diccionario histórico de los mas ilustres profesores de las bellas artes en España*. 6 vols. 1800. Reprint. Madrid, 1965.

Chenault, Jeanne. "Ribera, Ovid, and Marino: 'Death of Adonis.' " *Paragone* 22 (1971), 68-77.

"Clausulas del Testtamento del Senor Phelipe Quartto el Grande Rey de las Españas, y de las demas cossas contenidas en este Papel y noticias de la Corte de Madrid desde el año 1669 hasta 1684." Madrid, Biblioteca Nacional, Mss. 2024.

*Copiosa relacion de las costosissimas galas, vistosas libreas, y preciosissimas joyas, que el dia del Bautismo de la señora Infanta, luzieron en la Corte de España: que fue jueues siete de este presente mes de Octubre de 1638. años*. Seville, 1638.

*Coronacion de la Magestad del Rey don Felipe Tercero nuestro Señor; Ivramento del serenissimo Principe de España su hijo; Celebrado todo en el Real Salon de Palacio, en la ciudad de Lisboa, Domingo catorce de Iulio*. Seville, 1619.

*Correspondance de Rubens et documents épistolaires*. Translated and edited by Max Rooses and Charles Reulens. 6 vols. Antwerp, 1887-1909.

Crombie, Theodore. "*Jacob and Rachel at the Well* by Veronese: A Newly Discovered Painting." *Apollo* 96 (1972), 111-15.

Cruzada Villaamil, Gregorio. *Rubens diplomático español*. Madrid, 1874.

Cubillo de Aragon, Alvaro. *Relacion breve, de la solemnissima entrada que hizo en la Villa de Madrid, Corte, y Silla de los Catolicos Reyes de España, el Excelentissimo Señor Duque de Agramont, Embaxador Extraordinario del Christianissimo Rey de Francia, Luis Dezimo Quarto, cerca de los felizes casamientos de aquella Magestad, con la Serenissima Infanta Doña Maria Teresa de Austria, y Borbon, hija del Catolico Rey, y de la Esclarecida, y Serenissima Reyna Doña Isabel de Borbon, digna de inmortal memoria Señores nuestros, y a las pazes de las dos Coronas, grandeza de su recibimiento, y acompanamiento*. Madrid, 1659.

Cuelbis, Diego [Jacob Cuelvis]. "Thesoro choragraphico de las Espannas." London, British Library, Ms. Harley 3822.

Davies, Reginald T. *Spain in Decline, 1621-1700*. London-New York, 1957.

Deleito y Piñuela, José. *El rey se divierte (Recuerdos de hace tres siglos)*. Madrid, 1935.

Derjavin, Const. "La primera Embajada rusa en España." *Boletín de la Real Academia de la Historia* 96 (1930), 877-96.

Díaz del Valle, Lázaro. "Epílogo y nomenclatura de algunos artífices: Apuntes varios: 1656-1659." In *Fuentes literarias para la historia del arte español*, ed. Francisco J. Sánchez Cantón, 2:323-93. Madrid, 1933.

Díaz Padrón, Matías. "La Cacería de venados de Rubens para el Ochavo del Alcázar en Méjico." *Archivo Español de Arte* 43 (1970), 131-50.

———. *Museo del Prado, catálogo de pinturas. I: Escuela flamenca, siglo XVII*. 2 vols. Madrid, 1975.

———. *Pedro Pablo Rubens (1577-1640): exposición homenaje*. Madrid, 1977.

"Diferentes sucesos y noticias desde el año de 1629 hasta el año de 1636." Madrid, Biblioteca Nacional, Mss. 9404.

"Documentos inéditos para la historia de las Bellas Artes en España." Edited by M. R. Zarco del Valle. In *Colección de documentos inéditos para la historia de España*, 55:201-640. Madrid, 1870.

"Documentos relativos a Velázquez." In *Varia velázqueña: homenaje á Velázquez en el III centenario de su muerte 1660-1960*, 2:209-413. Madrid, 1960.

Domínguez Ortiz, Antonio. "La descripción de Madrid de Diego Cuelbis." *Anales del Instituto de Estudios Madrileños* 4 (1969), 135-44.

———. "Una embajada rusa en la corte de Carlos II." *Anales del Instituto de Estudios Madrileños* 15 (1978), 171-85.

———. *The Golden Age of Spain 1516-1659*. Translated by James Casey. New York, 1971.

Elliott, John H. *El Conde-Duque de Olivares y la herencia de Felipe II*. Colección Síntesis, no. 2. Valladolid, 1977.

———. *Imperial Spain 1469-1716*. London, 1963.

———. *The Revolt of the Catalans: A Study in the Decline of Spain (1598-1640)*. Cambridge, 1963.

———, and Peña, José F. de la. *Memoriales y cartas del Conde Duque de Olivares*. 2 vols. Madrid, 1978-1980.

Enggass, Robert, and Brown, Jonathan. *Italy and Spain 1600-1750: Sources and Documents*. Englewood Cliffs, N.J., 1970.

"Epitome de todas las cosas suzedidas en Tiempo del señor Rei don ph̃e quartto." Madrid, Real Academia de la Historia, Ms. 9-3-5-G-32bis.

"Etiquetas generales de la Casa R̃l del Rey nr̃o S̃r para el Uso y exerzicio de los oficios de

sus Criados." Madrid, Biblioteca Nacional, Mss. 10.666.

Feinblatt, Ebria. "A 'Boceto' by Colonna-Mitelli in the Prado." *Burlington Magazine* 107 (1965), 349-57.

Fradejas Lebrero, José. "Diario madrileño de 1636 (24 de mayo a 27 de diciembre)." *Anales del Instituto de Estudios Madrileños* 16 (1979), 97-161.

Galitzin, Emmanuel. *La Russie du XVIIᵉ siècle dans ses rapports avec l'Europe occidentale: récit du voyage de Pierre Potemkin envoyé en ambassade par le tsar Alexis Mikhailovitch à Philippe IV d'Espagne et à Louis XIV en 1668.* Paris, 1855.

Gállego, Julián. *Diego Velázquez.* Palabra Plástica, no. 2. Madrid, 1983.

———. *El pintor, de artesano a artista.* Granada, 1976.

———. *Visión y símbolos en la pintura española del Siglo de Oro.* Madrid, 1972.

Geiger, Benno. *I dipinti ghiribizzosi di Giuseppe Arcimboldi, pittore illusionista del Cinquecento (1527-1593).* Florence, 1954.

Gérard, Véronique. *De Alcázar a Palacio: el renacimiento en el Alcázar de Madrid.* Madrid, forthcoming.

———. "L'Alcázar de Madrid et son quartier au XVIᵉ siècle." *Colóquio,* 2nd ser., 39 (December 1978), 36-45.

———. "La fachada del Alcázar de Madrid (1608-1630)." *Cuadernos de Investigación Histórica* 2 (1978), 237-57.

———. "Philip IV's Early Italian Commissions." *Oxford Art Journal* 5:1 (1982), 9-14.

———. "Les Problèmes artistiques de l'Alcázar de Madrid (1537-1700)." *Mélanges de la Casa de Velázquez* 12 (1976), 307-22.

———. "Los sitios de devoción en el Alcázar de Madrid: capilla y oratorios." *Archivo Español de Arte* 56 (1983), 275-84.

Gerstenberg, Kurt. *Diego Velazquez.* N.p., n.d.

Gómez de Mora, Juan. "Relaçion de las cassas que tiene el Rey en españa y de algunas de ellas se an eccho tracas que se an de ber con esta Relaçion Ano de 1626." Biblioteca Apostolica Vaticana, Ms. Barb. lat. 4372.

———. *Relacion del Ivramento qve Hizieron los Reinos de Castilla i Leon al Serᵐᵒ· don Baltasar Carlos, Principe de las Españas, i Nuevo Mundo.* Madrid, 1632.

González de Avila, Gil. *Teatro de las grandezas de la Villa de Madrid, Corte de los Reyes Catolicos de España.* Madrid, 1623.

Harris, Enriqueta. "Angelo Michele Colonna y la decoración de San Antonio de los Portugueses." *Archivo Español de Arte* 34 (1961), 101-105.

———. "Cassiano dal Pozzo on Diego Velázquez." *Burlington Magazine* 112 (1970), 364-73.

———. "A Letter from Velázquez to Camillo Massimi." *Burlington Magazine* 102 (1960), 162-66.

———. "La misión de Velázquez en Italia." *Archivo Español de Arte* 33 (1960), 109-36.

———. "Orazio Gentileschi's 'Finding of Moses' in Madrid." *Burlington Magazine* 109 (1967), 86-89.

———. *Velázquez.* Ithaca, N.Y., 1982.

———. "Velázquez and His Ecclesiastical Benefice." *Burlington Magazine* 123 (1981), 95-96.

———. "Velázquez's Portrait of Prince Baltasar Carlos in the Riding School." *Burlington Magazine* 118 (1976), 266-75.

Haverkamp-Begemann, Egbert. "The Spanish Views of Anton van den Wyngaerde." *Master Drawings* 7 (1969), 375-99.

Held, Julius S. *The Oil Sketches of Peter Paul*

*Rubens: A Critical Catalogue*. 2 vols. Princeton, 1980.

Horn, Hendrik J. *Charles V's Conquest of Tunis: Cartoons and Tapestries by Jan Cornelisz Vermeyen*. Forthcoming.

Huemer, Frances. *Portraits*. Corpus Rubenianum Ludwig Burchard, pt. 19:1. Brussels, 1977.

Hume, Martin. *The Court of Philip IV: Spain in Decadence*. London-New York, 1907.

Hurtado de Mendoza, Antonio. *Convocacion de las Cortes de Castilla, y ivramento del Principe nuestro Señor D. Baltasar Carlos Primero deste nombre: ano 1632*. Madrid, 1632.

Iñiguez Almech, Francisco. "La Casa del Tesoro, Velázquez y las obras reales." In *Varia velázqueña: homenaje á Velázquez en el III centenario de su muerte 1660-1960*, 1:649-82. Madrid, 1960.

————. *Casas reales y jardines de Felipe II*. Cuadernos de Trabajo de la Escuela Española de la Historia y Arquelogía, 2nd ser., no. 1. Madrid, 1952.

*Inventarios reales: Testamentaría del rey Carlos II, 1701-1703*. Edited by Gloria Fernández Bayton. 2 vols. Madrid, 1975-1981.

Jacquot, Jean, ed. *Les Fêtes de la Renaissance, II: Fêtes et cérémonies au temps de Charles Quint*. Paris, 1960.

Jenkins, Mariana. *The State Portrait: Its Origins and Evolution*. Monographs on Art and Archaeology, no. 3. N.p., 1947.

Justi, Carl. *Diego Velazquez and His Times*. Translated by A. H. Keane. 2nd edn. Zurich, 1933.

————. *Diego Velazquez und sein Jahrhundert*. Zurich, 1933.

Kahr, Madlyn. "Delilah." *Art Bulletin* 54 (1972), 282-99.

————. "Velázquez and *Las Meninas*." *Art Bulletin* 57 (1975), 225-46.

————. *Velázquez: The Art of Painting*. New York, 1976.

Kamen, Henry. *Spain in the Later Seventeenth Century, 1665-1700*. London-New York, 1980.

Kaufmann, Thomas DaC. "Arcimboldo's Imperial Allegories." *Zeitschrift für Kunstgeschichte* 29 (1976), 275-96.

————. *Variations on the Imperial Theme in the Age of Maximilian II and Rudolf II*. New York-London, 1978.

Kubler, George. *Arquitectura de los siglos XVII y XVIII*. Translated by Juan-Eduardo Cirlot. Ars Hispaniae, vol. 14. Madrid, 1957.

————. *Portuguese Plain Architecture: Between Spices and Diamonds, 1521-1706*. Middletown, Conn., 1972.

La Force, Duc de. "L'Ambassade extraordinaire de Duc de Mayenne (1612): les fiançailles d'Anne d'Autriche." *Revue des Deux Mondes*, 7th ser., 14 (1923), 93-117.

Lanaja y Lamarca, Pedro. *Relacion del ivramento de los fueros de Aragon, qve hizo el Serenis$^{mo}$ Principe Don Balthasar Carlos, en la Iglesia Metropolitana de la civdad de Zaragoza, en 20. de Agosto de 1645*. Zaragoza, 1645.

León Pinelo, Antonio. *Anales de Madrid (desde el año 447 al de 1658)*. Edited by Pedro Fernández Martín. Madrid, 1971.

Levey, Michael. *Painting at Court*. London, 1971.

L'Hermite, Jehan. *Le Passetemps de J. Lhermite*, vol. 2. Edited by É. Ouverleaux and J. Petit. Antwerp, 1896.

Ligo, Larry L. "Two Seventeenth-Century Poems Which Link Rubens' Equestrian Portrait of Philip IV to Titian's Equestrian Portrait of Charles V." *Gazette des Beaux-Arts*, 6th ser., 75 (1970), 345-54.

Llaguno y Amirola, Eugenio. *Noticias de los arquitectos y arquitectura de España desde su*

*restauración*. Edited by Juan A. Ceán Bermúdez. 4 vols. 1829. Reprint. Madrid, 1977.

López de Meneses, Amada. "El Alcázar y no la Torre de los Lujanes fue la prisión madrileña de Francisco I de Francia." *Anales del Instituto de Estudios Madrileños* 7 (1971), 121-47.

López Serrano, Matilde. *Libro de la Montería del Rey de Castilla Alfonso XI: estudio preliminar*. 2nd edn. Madrid, 1974.

López-Rey, José. "A Head of Philip IV by Velázquez in a Rubens Allegorical Composition." *Gazette des Beaux-Arts*, 6th ser., 53 (1959), 35-44.

——. *Velázquez: A Catalogue Raisonné of His Oeuvre*. London, 1963.

Lunn, Margaret R., and Espinosa-Carrión, Virginia. "Los dibujos de Juan Carreño de Miranda." *Archivo Español de Arte* 52 (1979), 281-306.

MacLaren, Neil. *National Gallery Catalogues: The Spanish School*. 2nd edn., revised by Allen Braham. London, 1970.

Malvasia, Carlo C. *The Life of Guido Reni*. Translated by Catherine Enggass and Robert Enggass. University Park, Pa.-London, 1980.

Maravall, José Antonio. *La teoría española del estado en el siglo XVII*. Madrid, 1944.

Martin, John R. *The Decorations for the Pompa Introitus Ferdinandi*. Corpus Rubenianum Ludwig Burchard, pt. 16. London-New York, 1972.

——. "Rubens's Last Mythological Paintings for Philip IV." *Gentse Bijdragen* 24 (1976-1978), 113-18.

Martín González, Juan J. "El Alcázar de Madrid en el siglo XVI (nuevos datos)." *Archivo Español de Arte* 35 (1962), 1-19.

——. "Arte y artistas del siglo XVII en la corte." *Archivo Español de Arte* 31 (1958), 125-42.

——. "Sobre las relaciones entre Nardi, Carducho y Velázquez." *Archivo Español de Arte* 31 (1958), 59-66.

Martínez, Jusepe. *Discursos practicables del nobilísimo arte de la pintura, sus rudimentos, medios y fines que enseña la experiencia, con los ejemplares de obras insignes de artífices ilustres*. Edited by Valentin Carderera y Solano. Madrid, 1866.

Marzolf, Rosemary. "The Life and Work of Juan Carreño de Miranda (1614-1685)." Ph.D. dissertation, University of Michigan, 1961.

Mateos, Juan. *Origen y Dignidad de la Caça*. Madrid, 1634.

Mazón de la Torre, María A. *Jusepe Leonardo y su tiempo*. Zaragoza, 1977.

*Mémoires du Maréchal de Gramont*. Edited by A. Petitot and Monmerqué. 2 vols. Collection des Mémoires Relatifs à l'Histoire de France, 2nd ser., vol. 56, 243-480; and vol. 57, 1-118. Paris, 1826-1827.

Mezzatesta, Michael P. "Imperial Themes in the Sculpture of Leone Leoni." Ph.D. dissertation, New York University, 1980.

Moffitt, John F. "Velázquez in the Alcázar Palace in 1656: The Meaning of the *Mise-en-scène* of *Las Meninas*." *Art History* 6 (1983), 271-300.

Molina Campuzano, Miguel. *Planos de Madrid de los siglos XVII y XVIII*. Madrid, 1960.

Moran Turina, José M. "El retrato cortesano y la tradición española en el reinado de Felipe V." *Goya*, no. 159 (November-December 1980), 152-61.

Moreno Villa, José. "Cómo son y cómo eran unos Tizianos del Prado." *Archivo Español de Arte y Arqueología* 9 (1933), 113-16.

Muller, Priscilla E. "Contributions to the

Study of Spanish Drawings." *Art Bulletin* 58 (1976), 604-11.

Müller Hofstede, Justus. "Beiträge zum zeichnerischen Werk von Rubens." *Wallraf-Richartz-Jahrbuch* 27 (1965), 259-356.

Museo del Prado. *Pintura italiana del siglo XVII: exposición conmemorativa del ciento cincuenta aniversario de la fundación del Museo del Prado.* [Catalogue by Alfonso E. Pérez Sánchez.] Madrid, 1970.

"De Nalatenschap van P. P. Rubens." *Antwerpsch Archievenblad*, n.s. 2 (1900), 69-163.

Neilson, Nancy W. *Camillo Procaccini: Paintings and Drawings.* New York-London, 1979.

*Noticia del recibimiento i entrada de la Reyna nuestra Señora Doña Maria-Ana de Austria en la mvy noble i leal Villa de Madrid.* N.p., 1650.

Novoa, Matías de. *Historia de Felipe IV, Rey de España.* Edited by Marqués de la Fuensanta del Valle, José Sancho Rayon, and Francisco de Zabalburu. 4 vols. Colección de Documentos Inéditos para la Historia de España, vols. 69, 77, 80, and 86. Madrid, 1878-1886.

Orso, Steven N. "Francisco de Herrera the Younger: New Documentation." *Source: Notes in the History of Art* 1:2 (Winter 1982), 29-32.

——. "A Lesson Learned: *Las Meninas* and the State Portraits of Juan Carreño de Miranda." *Record of The Art Museum, Princeton University* 41:2 (1982), 24-34.

Pacheco, Francisco. *Arte de la pintura.* Edited by Francisco J. Sánchez Cantón. 2 vols. Madrid, 1956.

Pallucchini, Rodolfo, and Rossi, Paola. *Tintoretto: le opere sacre e profane.* 2 vols. Milan, 1982.

Palomino de Castro y Velasco, Antonio. *El museo pictórico y escala óptica.* 1715-1724. Reprint. Madrid, 1947.

Panofsky, Dora, and Panofsky, Erwin. *Pandora's Box: The Changing Aspects of a Mythical Symbol.* Rev. edn. Princeton, 1962.

Panofsky, Erwin. *Problems in Titian: Mostly Iconographic.* New York, 1969.

"Papeles varios [*noticias* for 1632-1635]." Madrid, Biblioteca Nacional, Mss. 9406.

"Papeles varios [*noticias* for 1637-1642]." Madrid, Biblioteca Nacional, Mss. 9402.

"Papeles varios [*noticias* for 1640-1642]." Madrid, Biblioteca Nacional, Mss. 8177.

Parsons, William B. *Engineers and Engineering in the Renaissance.* Baltimore, 1939.

Pellicer de Tovar, Joseph [José de Pellicer Ossau de Salas y Tovar]. *Alma de la gloria de España: eternidad, magestad, felicidad, y esperanza suya en las reales bodas: epitalamio.* Madrid, 1650.

——. *Avisos históricos.* Madrid, 1965.

——. *Svccession de los Reynos de Portugal y el Algarbe.* Logroño, 1641.

Pérez Sánchez, Alfonso E. *Pintura italiana del s. XVII en España.* Madrid, 1965.

Philip IV of Spain. "Autosemblanza de Felipe IV." In "Cartas de Sor Maria de Agreda y de Felipe IV," ed. Carlos Seco Serrano, *Biblioteca de Autores Españoles* 109 (1958), 231-36.

Pigler, Andor. *Barockthemen: Eine Auswahl von Verzeichnissen zur Ikonographie des 17. und 18. Jahrhunderts.* 3 vols. Rev. edn. Budapest, 1974.

Pita Andrade, José M. "Noticias en torno a Velázquez en el archivo de la Casa de Alba." In *Varia velázqueña: homenaje a Velázquez en el III centenario de su muerte 1660-1960,* 1:400-13. Madrid, 1960.

Plon, Eugène. *Leone Leoni, sculpteur de Charles-Quint, et Pompeo Leoni, sculpteur de Philippe*

*II: les maîtres italiens au service de la Maison d'Autriche.* Paris, 1887.

Plutarch. *Lives.* Translated by Bernadette Perrin. Loeb Classical Library. Cambridge, Mass.-London, 1946.

*Pompa Fvneral Honras y Exequias en la muerte De la muy Alta y Catolica Señora Doña Isabel de Borbon Reyna de las Españas y del Nuevo Mundo Que se celebraron en el Real Convento de S. Geronimo de la villa de Madrid.* Madrid, 1645.

Pozzo, Cassiano dal. Untitled journal of Cardinal Francesco Barberini's legation to Spain in 1626. Biblioteca Apostolica Vaticana, Ms. Barb. lat. 5689.

Quintana, Gerónimo de. *A la mvy antigua, noble y coronada Villa de Madrid. Historia de sv antigvedad, nobleza y grandeza.* Madrid, 1629.

*Relacion de la entrada, qve en la villa de Madrid, Corte, y Silla de los Catholicos Reyes de España, hizo el Excelentissimo señor Mariscal Duque de Agramont, Governador de Viarne, Burdeos y Bayona, Embaxador Extraordinario del señor Luis XIV. Christianissimo Rey de Francia, cerca de los felizes casamientos de aquella Magestad con la Serenissima señora Doña Maria Teresa Bibiana de Austria y Borbon, Infanta de Espana . . . Año de 1659.* Seville, 1659.

*Relacion de la venida y entrada en esta Corte del Excelentissimo señor Marescal Duque de Agramont, Gouernador del Principado de Viarne, Burdeos, y Vayona, Embaxador Extraordinario de Luis XIV. Christianissimo Rey de Francia, embiado à la Magestad Catolico del Rey nuestro señor.* Madrid, 1659.

"Relacion de las Capitulaçiones que se hiçieron para el Casamiento de Su Mg^d del Rey de françia con la Serenissima Infanta de Castilla Doña Ana de Austria hija del Rey Don Phe-lipe 3.º nro Señor, y de la Reyna Doña Margarita de Austria en el Real Alcaçar de la Villa de Madrid Corte de Su Mg^d en 22 de Agosto de 1612." In "Sucesos del año de 1621." Madrid, Biblioteca Nacional, Mss. 2352, fols. 581-87^v.

*Relacion de las Honras del Rey Felipe Tercero que esta en el cielo, y la solene entrada en Madrid del Rey Felipe Quarto, que Dios guarde.* Madrid, 1621.

*Relacion del Jvramento de los Fueros de Aragon, que hizo el Serenissimo Principe D. Baltasar Carlos, en la Iglesia Metropolitana de la ciudad de Zaragoza, en 20. de Agosto de 1645.* Seville, 1645.

*Relacion verdadera del acompañamiento y Baptismo, de la serenissima Princesa, Margarita, Maria, Catalina.* Madrid, 1623.

*Relacion verdadera, en qve se contiene todas las ceremonias y demas actos que passaron en la jura que se hizo al Serenissimo Principe nuestro señor Don Phelipe Quarto, en el Monesterio de San Geronymo. Dase cuenta de los trages y bizarrias de las damas y caualleros, y libreas que sacaron.* Alcalá, 1608.

*Relacion verdadera, hecha y verificada por vn testigo de vista Capellan de la Capilla Real de su Magestad, del Bautismo del Serenissimo Principe de España: celebrado dia de Pasqua de Espiritu santo deste presente año de 1605. y de la entrada que se hizo el Almirante de Inglaterra: y de las fiestas que se hizieron.* [Valladolid, 1605.]

*Relaciones breves de actos públicos celebrados en Madrid de 1541 a 1650.* Edited by José Simón Díaz. El Madrid de los Austrias, Serie Documentación, no. 1. Madrid, 1982.

"Relation d'un voyage en Espagne." Edited by C. Claverie. *Revue Hispanique* 59 (1923), 359-555.

Ripa, Cesare. *Iconologia, o vero descrittione d'ima-*

*gini delle Virtv', Vitij, Affetti, Passioni humane, Corpi celesti, Mvndo e sue parti.* 1609. Reprint. New York-London, 1976.

Rodríguez de Monforte, Pedro. *Descripcion de las honras qve se hicieron a la Catholica Mag.ᵈ de D. Phelippe quarto Rey de las Españas y del nuevo Mundo en el Real Conuento de la Encarnacion qve de horden de la Reyna nña Señora como svperintendente de las reales obras dispvso D. Baltasar Barroso de Ribera, Marques de Malpica Mayordomo y Gentilhombre de Camara de su Mag.ᵈ que Dios aya y Gouernador de la guarda Alemana.* Madrid, 1666.

Rodríguez Villa, Antonio. *La corte y la monarquía de España en los años de 1636 y 37.* Madrid, 1886.

——. *Etiquetas de la Casa de Austria.* Madrid, 1913.

Rubens, Peter Paul. *The Letters of Peter Paul Rubens.* Translated and edited by Ruth S. Magurn. Cambridge, Mass., 1955.

Saltillo, Marqués de. "Artistas madrileños 1592-1850." *Boletín de la Sociedad Española de Excursiones* 57 (1953), 137-243.

——. "Prevenciones artísticas para acontecimientos regios en el Madrid sexcentista (1646-1680)." *Boletín de la Real Academia de la Historia* 121 (1947), 365-93.

Sánchez Cantón, Francisco J. *Las Meninas y sus personajes.* Barcelona, 1943.

——. *Los pintores de cámara de los Reyes de España.* Madrid, 1916.

Sánchez de Viana, Pedro. *Anotaciones sobre los quinze libros de las Trāsformaciones de Ouidio: Con la Mithologia de las fabulas y otras cosas.* Valladolid, 1589.

Simón Díaz, José. "Fraudes en la construcción del antiguo Alcázar madrileño." *Archivo Español de Arte* 18 (1945), 347-59.

Smolderen, L. "Bacchus et les sept Planètes par Jacques Jonghelinck." *Revue des Archéologues et des Historiens d'Art de Louvain* 10 (1977), 102-43.

Soto y Aguilar, Diego. "Tratado donde se ponen en Epilogo algunas fiestas que se han hecho por casos memorables que han sucedido en España, y fuera de ella, tocantes a la monarchia de España y su Corona," Madrid, Real Academia de la Historia, Ms. 9-3-5-G-32bis.

Spear, Richard. *Domenichino.* 2 vols. New Haven-London, 1982.

Strong, Roy. *Art and Power: Renaissance Festivals 1450-1650.* Berkeley, 1984.

——. *Britannia Triumphans: Inigo Jones, Rubens and Whitehall Palace.* London, 1981.

Sullivan, Edward J. "Claudio Coello and Late Baroque Painting in Madrid." Ph.D. dissertation, New York University, 1979.

Taylor, René. "Juan Bautista Crescencio y la arquitectura cortesana española." *Academia: Boletín de la Real Academia de San Fernando* 48 (1979), 63-126.

Tietze-Conrat, Erica. "Titian's Allegory of 'Religion.'" *Journal of the Warburg and Courtauld Institutes* 14 (1951), pp. 127-32.

Tormo [y Monzó], Elías. *Las viejas series icónicas de los Reyes de España.* Madrid, 1917.

——, and Sánchez Cantón, Francisco J. *Los tapices de la Casa del Rey N. S.: notas para el catálogo y para la historia de la colección y de la fábrica.* Madrid, 1919.

Tovar Martín, Virginia. *Arquitectura madrileña del s. XVII (datos para su estudio).* Madrid, 1983.

"Tratados varios de las coronas de España." London, British Library, Ms. Add. 10,236.

Trevor-Roper, Hugh, *Princes and Artists: Patronage and Ideology at Four Habsburg Courts 1517-1633.* New York, 1976.

Valencia de Don Juan, Conde Viudo de. *Tapices de la Corona de España*. 2 vols. Madrid, 1903.

Valfrey, Jules J. *La diplomatie française au XVIIᵉ siècle: Hugues de Lionne. Ses ambassades en Espagne et en Allemagne: La Paix des Pyrénées, d'après sa correspondance conservée aux archives du Ministère des affaires étrangères*. Paris, 1881.

Varey, J. E. "L'Auditoire du Salón Dorado de l'Alcázar de Madrid au XVIIᵉ siècle." In *Dramaturgie et societé: rapports entre l'oeuvre théâtrale, son interprétation et son public aux XVIᵉ et XVIIᵉ siècles*, ed. Jean Jacquot with Élie Konigson and Marcel Oddon, 1:77-91. Paris, 1968.

——. "Further Notes on the Processional Ceremonial of the Spanish Court in the Seventeenth Century." *Iberoromania*, n.s., 1 (1974), 71-79.

——. "La mayordomía mayor y los festejos palaciegos del siglo XVII." *Anales del Instituto de Estudios Madrileños* 4 (1969), 145-68.

——. "Processional Ceremonial of the Spanish Court in the Seventeenth Century." In *Studia Iberica: Festschrift für Hans Flasche*, ed. Karl-Hermann Körner and Klaus Rühl, 643-52. Bern-Munich, 1973.

——, and Salazar, A. M. "Calderón and the Royal Entry of 1649." *Hispanic Review* 34 (1966), 1-26.

——, and Shergold, N. E., eds. *Los celos hacen estrellas*, by Juan Vélez de Guevara. London, 1970.

Vargas Machuca, Juan de. *Informe a la Magestad de Filipe Qvarto, el Grande el Piadoso, Rey de las Españas, y Emperador de las Indias: En Memoria de los Tres Filipos, Gloriosa Succession de Carlos: En Obseqvio de Carlos, Florida Esperanza de los Tres Filipos*. Madrid, 1662.

*Varia velázqueña: homenaje á Velázquez en el III centenario de su muerte 1660-1960*. 2 vols. Madrid, 1960.

Velasco, Miguel. "Iconografía y transformaciones del Alcázar de Madrid (de la Exposición del Antiguo Madrid)." *Arte Español* 8 (1927), 225-30.

*Viaje de Cosme de Médicis por España y Portugal (1668-1669)*. Edited by Angel Sánchez Rivero and Angela Mariutti de Sánchez Rivero. 2 vols. Madrid, n.d.

Villars, Pierre, Marquis de. *Mémoires de la cour d'Espagne de 1679 à 1681*. Edited by M. A. Morel-Fatio. Paris, 1893.

Villaverde Prado y Salazar, Manuel de. *Relacion escrita a un amigo ausente desta Corte, de la entrada que hizo la Reyna N. S. Dᵃ Mariana de Austria, Lunes 15 Noviembre 1649, desde el Retiro a su Real Palacio de Madrid*. Madrid, [1649].

Volk, Mary C. "On Velázquez and the Liberal Arts." *Art Bulletin* 58 (1978), 69-86.

——. "Rubens in Madrid and the Decoration of the King's Summer Apartments." *Burlington Magazine* 123 (1981), 513-29.

——. "Rubens in Madrid and the Decoration of the Salón Nuevo in the Palace." *Burlington Magazine* 122 (1980), 168-80.

——. *Vicencio Carducho and Seventeenth Century Castilian Painting*. New York-London, 1977.

Von Barghahn, Barbara. "The Pictorial Decoration of the Buen Retiro during the Reign of Philip IV." Ph.D. dissertation, New York University, 1979.

Wedgwood, C. V. *The Political Career of Peter Paul Rubens*. London, 1975.

Wethey, Harold E. *The Paintings of Titian: Complete Edition*. 3 vols. London, 1969-1975.

Wittkower, Rudolf. "Titian's Allegory of 'Re-

ligion Succoured by Spain.' " *Journal of the Warburg and Courtauld Institutes* 3 (1939), 138-40.

Yates, Frances A. *Astraea: The Imperial Theme in the Sixteenth Century.* London-Boston, 1975.

"Ynventario de los Bienes muebles y menaxe de cassa que al Presente estan en la cassa Real del pardo para serbicio de su mag.<sup>d</sup> que son a cargo de carlos baldouin conserje de la dicha cassa." Simancas, Archivo General, Tribunal Mayor de Cuentas, leg. 1560.

# INDEX

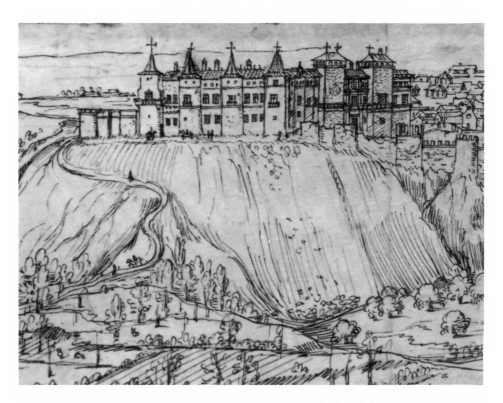

1. Detail from Anton van den Wyngaerde, *Madrid and the Alcázar from the Southwest* (Vienna, Oesterreichische Nationalbibliothek)

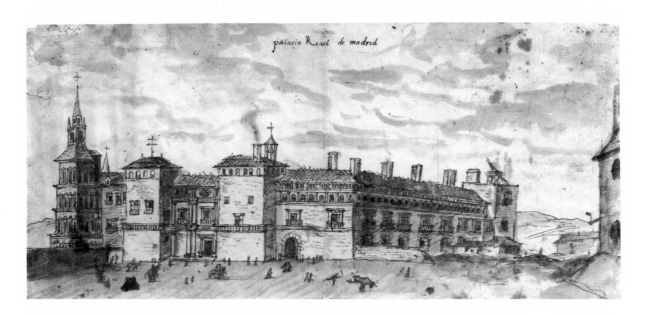

2. Anton van den Wyngaerde, *The Alcázar of Madrid from the Southeast* (Vienna, Oesterreichische Nationalbibliothek)

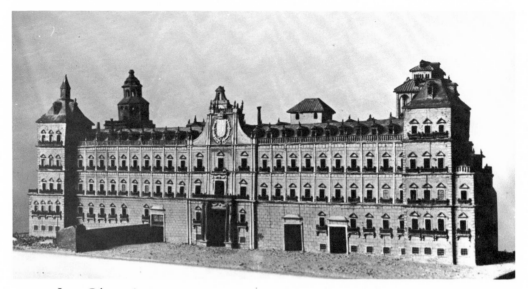

3. Juan Gómez de Mora, *Maquette for the South Façade of the Alcázar of Madrid*
(Madrid, Museo Municipal)

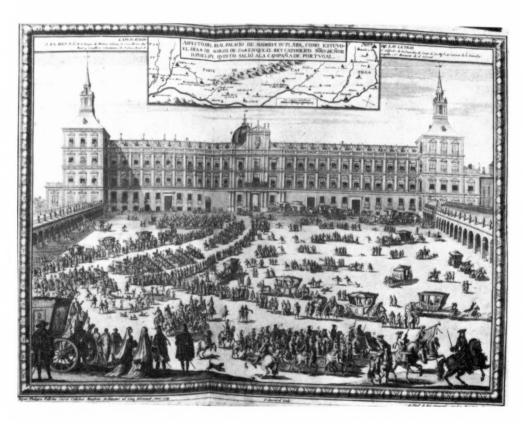

4. Nicolas Guérard after Felipe Pallota, *Philip V Leaves the Alcázar of Madrid
for the Campaign in Portugal (March 4, 1704)* (Madrid, Museo Municipal)

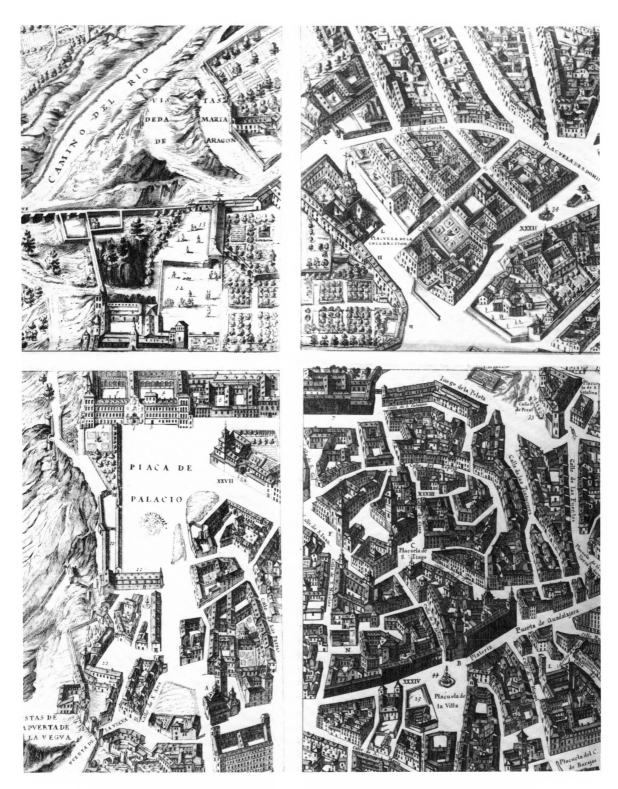

5. Detail from Pedro de Teixeira, *Map of Madrid* (1656) showing the Alcázar and its environs (Madrid, Biblioteca Nacional)

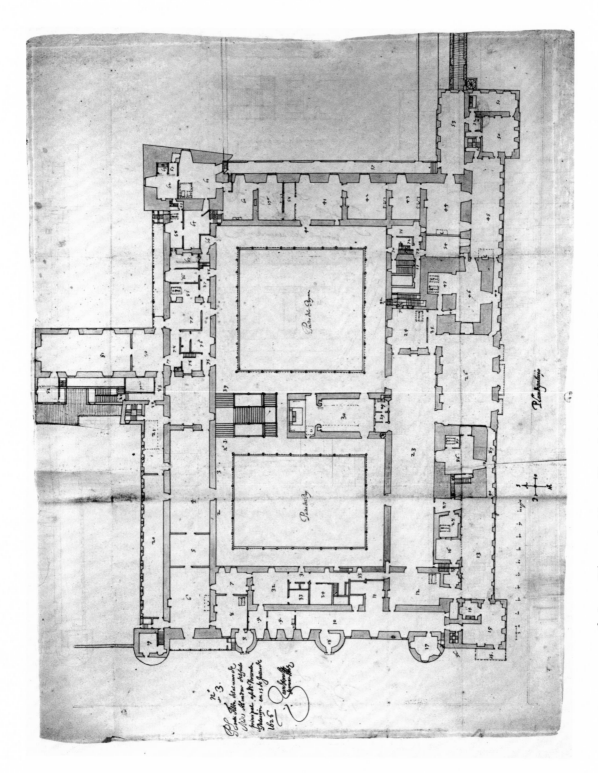

6. Juan Gómez de Mora, *Plan of the Main Floor (Third Story) of the Alcázar of Madrid* (Vatican, Biblioteca Apostolica)

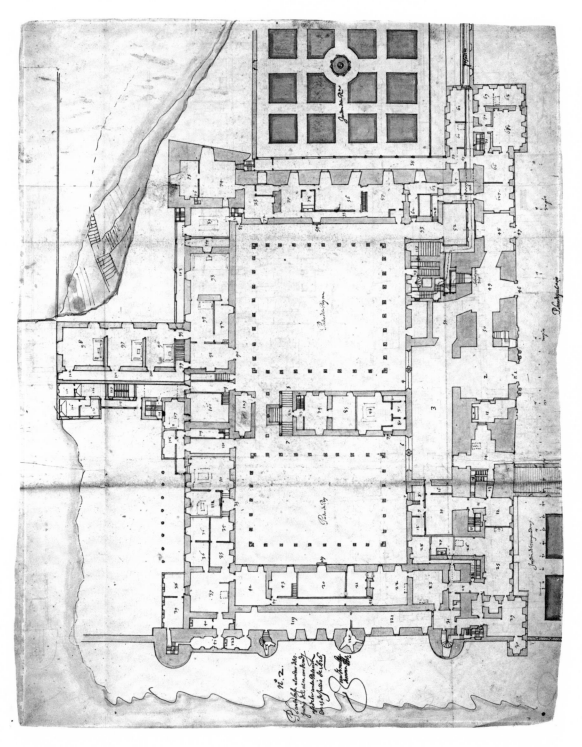

7. Juan Gómez de Mora, *Plan of the Second Story of the Alcázar of Madrid* (Vatican, Biblioteca Apostolica)

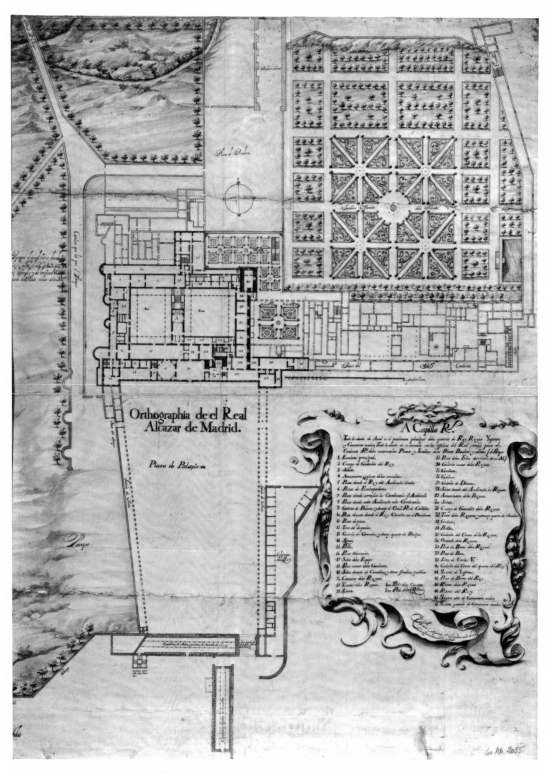

8. Teodoro Ardemans, *Plan of the Alcázar of Madrid and Its Environs* (Paris, Bibliothèque Nationale)

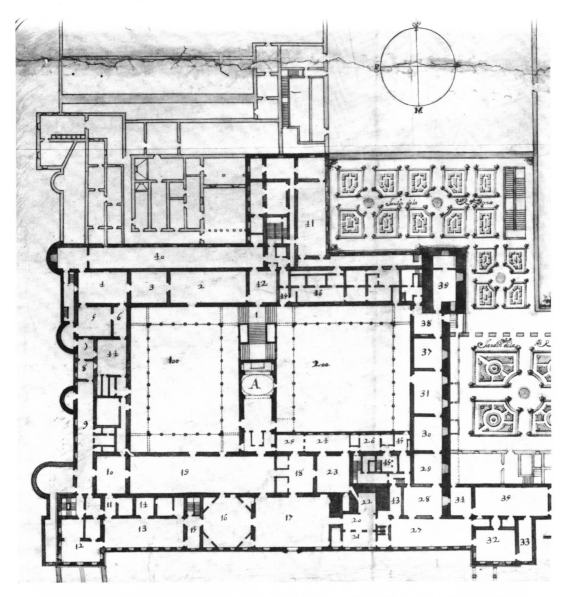

9. Detail from Teodoro Ardemans, *Plan of the Alcázar of Madrid and Its Environs* (Paris, Bibliothèque Nationale)

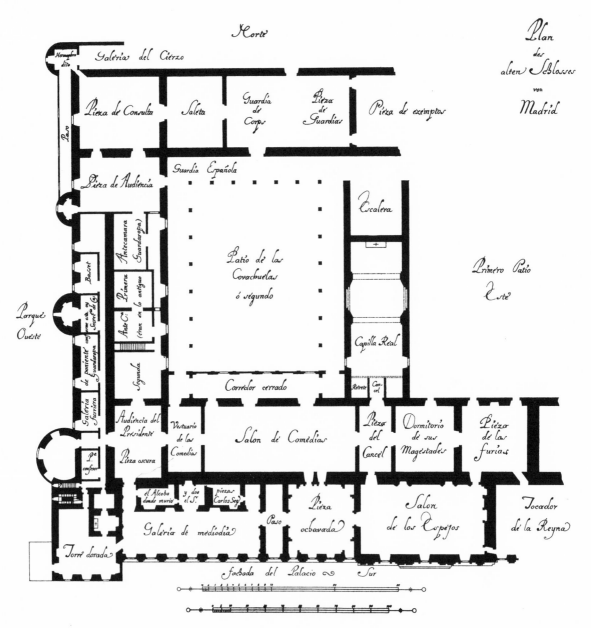

10. Anonymous, *Partial Plan of the Main Floor of the Alcázar of Madrid ("Justi Plan")* (location unknown)

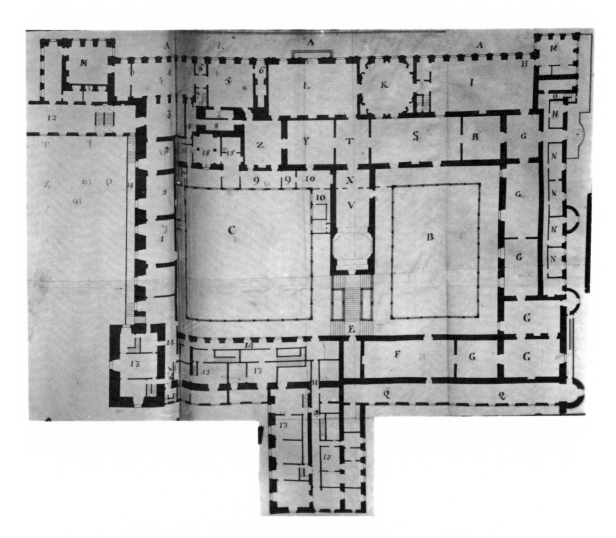

11. Antoine du Verger, *Plan of the Main Floor of the Alcázar of Madrid* (Paris, Bibliothèque Nationale)

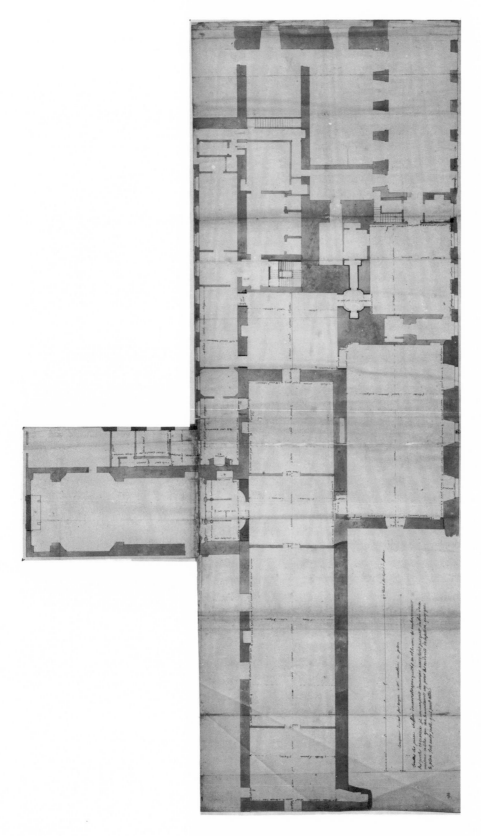

12. Anonymous, *Partial Plan of the Main Floor of the Alcázar of Madrid* (*"Parquet Plan"*) (Paris, Bibliothèque Nationale)

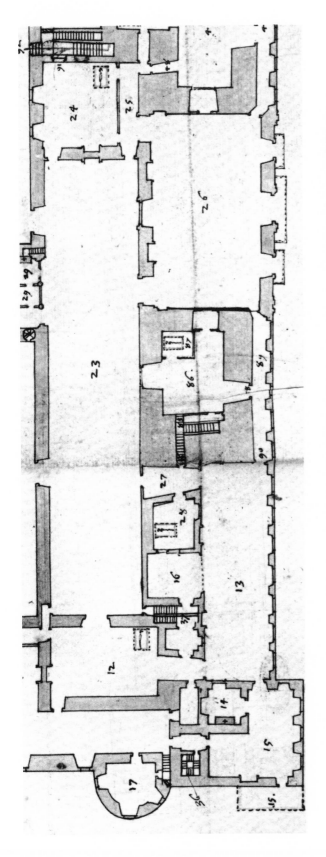

13. Detail of Juan Gómez de Mora, *Plan of the Main Floor (Third Story) of the Alcázar of Madrid* (Vatican, Biblioteca Apostolica). Rooms shown include the king's office (15); his oratory (14); the South Gallery (13); the New Room, later called the Hall of Mirrors (26); the Room of the *Furias* (24); the Great Hall, later called the Gilded Hall (23); and the Dark Room (12). The apartment of the Cardinal-Infante Ferdinand in the Homage Tower (86) later became the Octagonal Room.

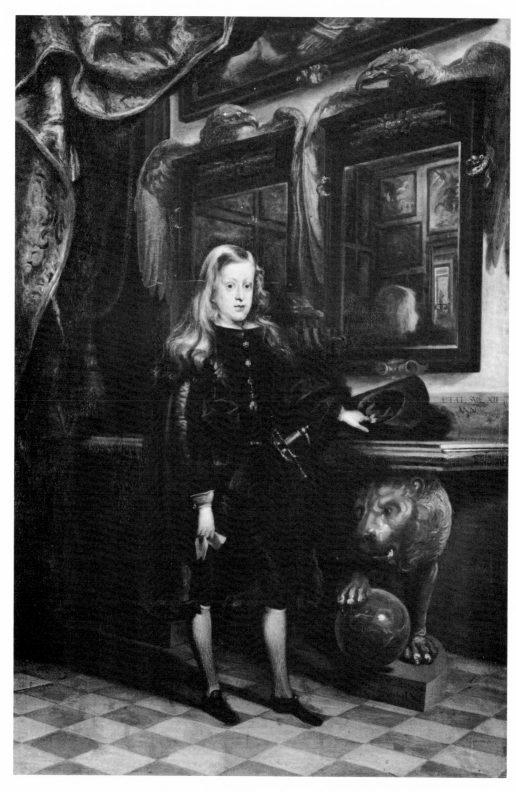

14. Juan Carreño de Miranda, *Charles II* (Berlin, Staatliche
Museen, Gemäldegalerie)

15. Juan Carreño de Miranda, *Mariana of Austria*
(Madrid, Prado)

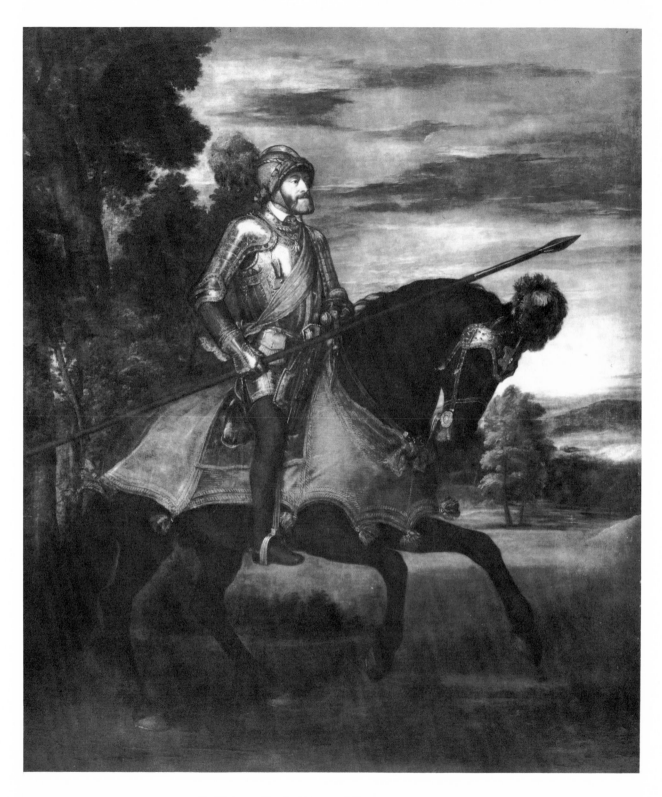

16. Titian, *Charles V at Mühlberg* (Madrid, Prado)

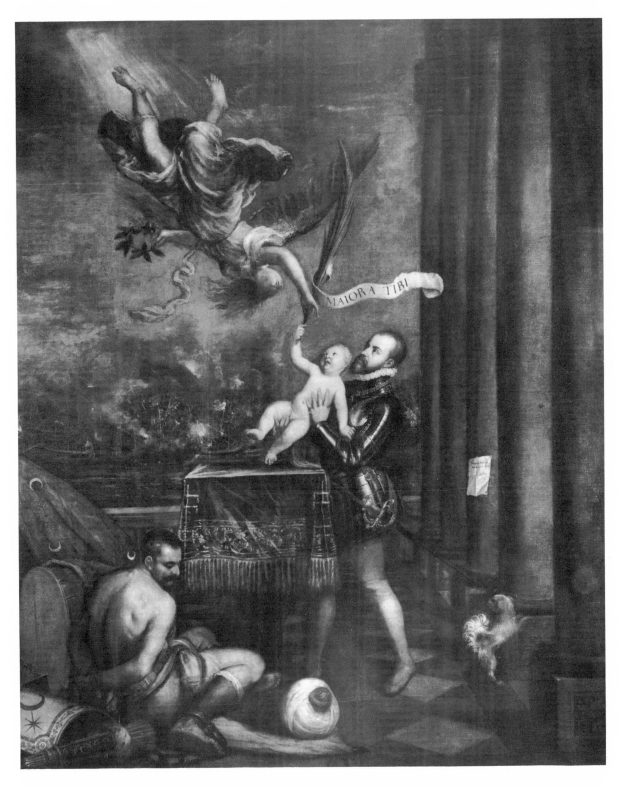

On the banner: MAIORA TIBI

17. Titian, *Allegorical Portrait of Philip II after the Battle of Lepanto* (Madrid, Prado)

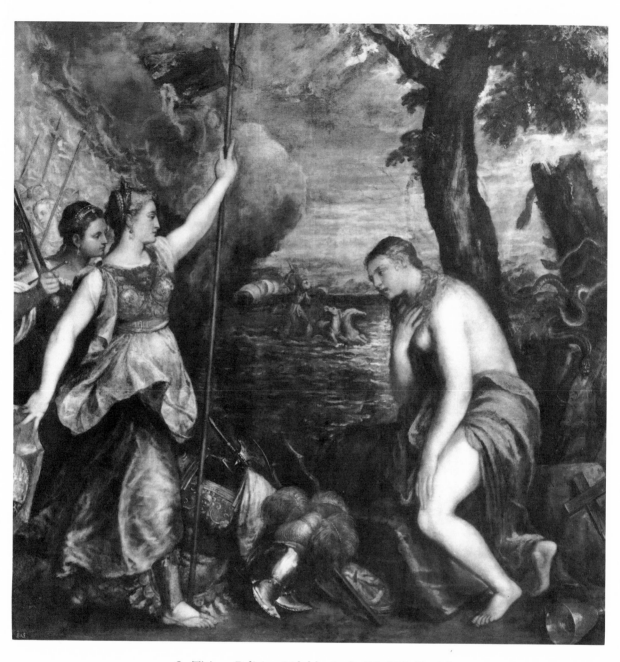

18. Titian, *Religion Aided by Spain* (Madrid, Prado)

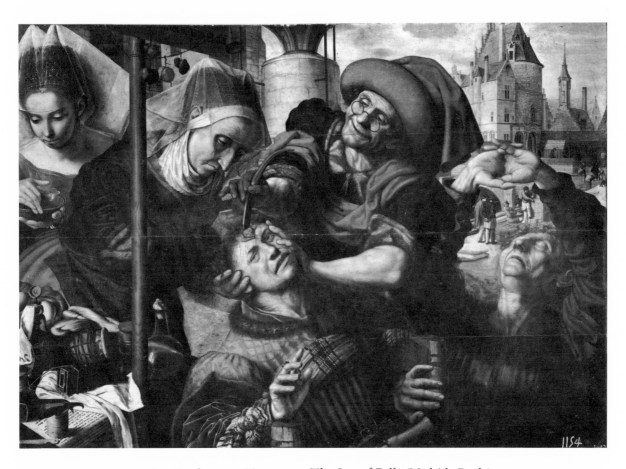

19. Jan Sanders van Hemessen, *The Cure of Folly* (Madrid, Prado)

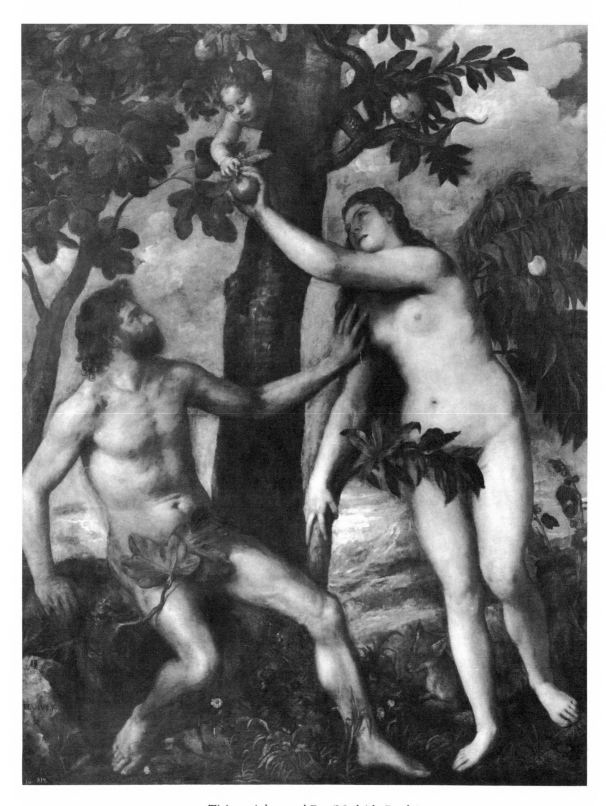

20. Titian, *Adam and Eve* (Madrid, Prado)

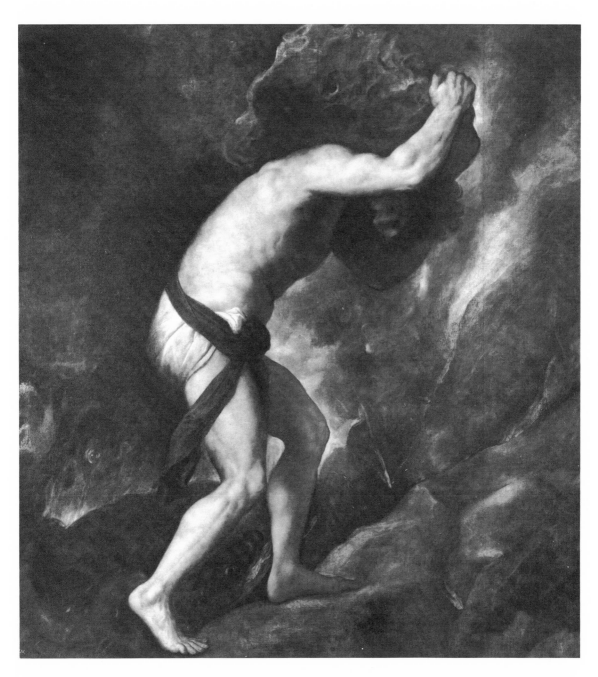

21. Titian, *Sisyphus* (Madrid, Prado)

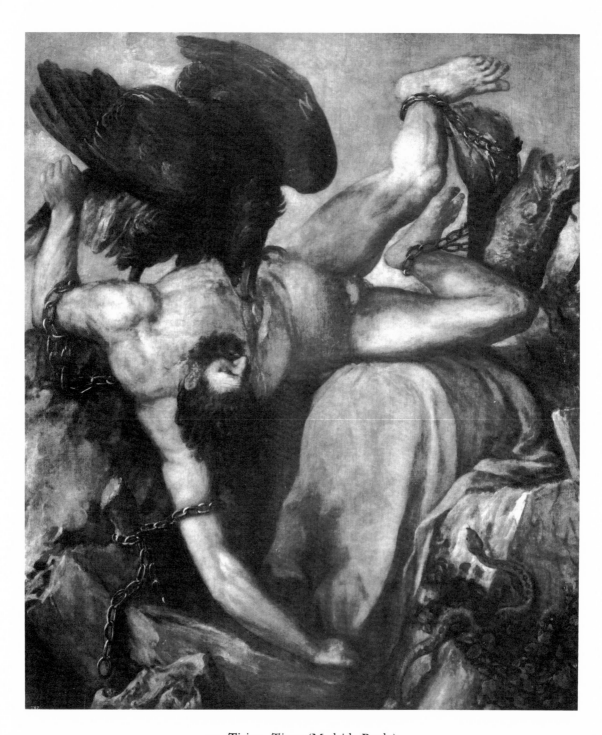

22. Titian, *Tityus* (Madrid, Prado)

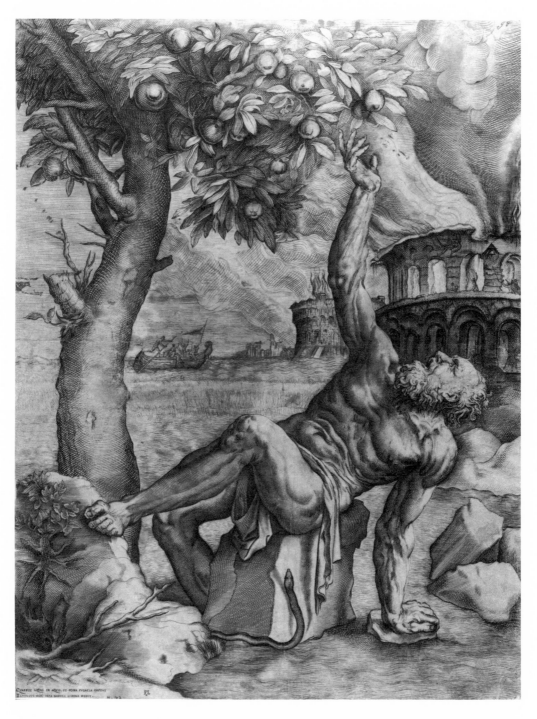

23. Giulio Sanuto after Titian, *Tantalus* (London, British Museum. Reproduced by courtesy of the Trustees)

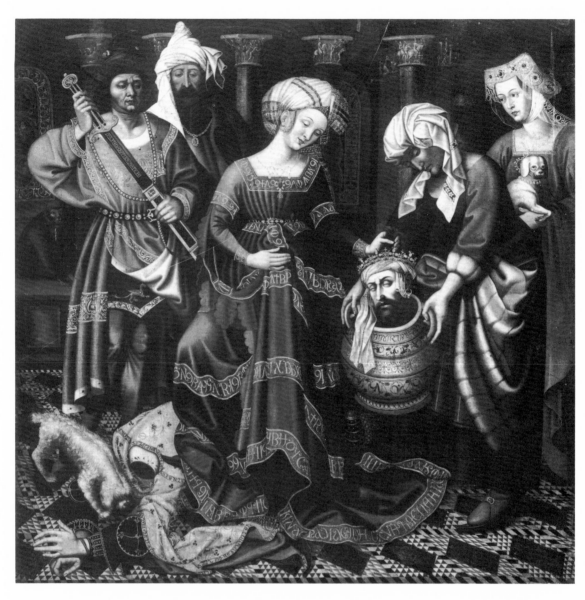

24. Anonymous artist after the Master of Flémalle, *Queen Tomyris with the Head of Cyrus* (formerly Berlin, Kaiser-Friedrich Museum)

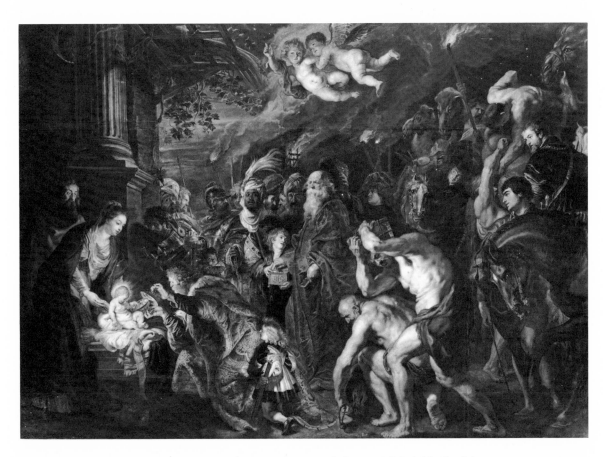

25. Peter Paul Rubens, *Adoration of the Magi* (Madrid, Prado)

26. Peter Paul Rubens and Anthony van Dyck, *Ulysses Discovers Achilles among the Daughters of Lycomedes* (Madrid, Prado)

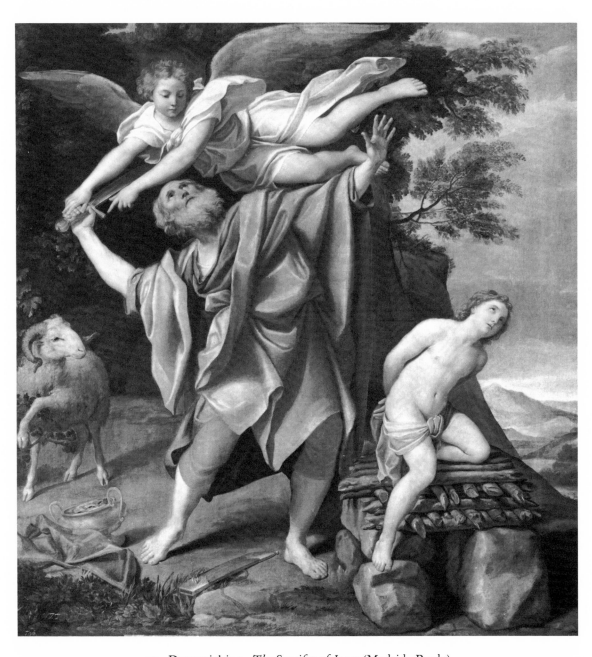

27. Domenichino, *The Sacrifice of Isaac* (Madrid, Prado)

28. Domenichino, *Solomon and the Queen of Sheba* (Windsor, Royal Library, Print Room. Copyright reserved. Reproduced by gracious permission of Her Majesty Queen Elizabeth II)

29. Camillo Procaccini, *Cain Slaying Abel* (Venice, Accademia)

30. Peter Paul Rubens, *The Reconciliation of Jacob and Esau* (Schloss Schleissheim, on deposit from Munich, Bayerischen Staatsgemäldesammlungen)

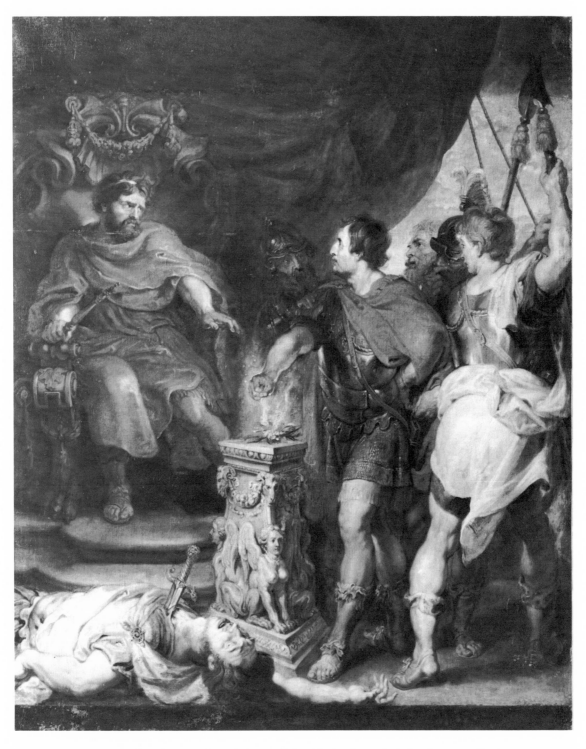

31. Peter Paul Rubens and workshop, *Gaius Mucius Scaevola before Porsenna* (Budapest,
Szépművészeti Múzeum)

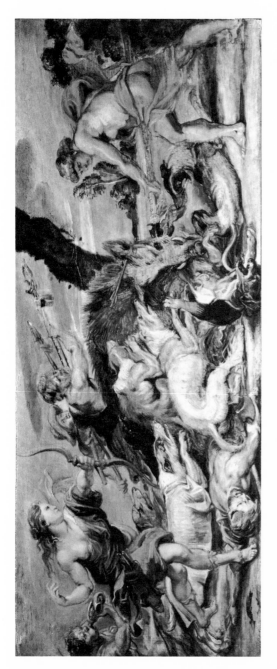

32. Peter Paul Rubens, *Hunt of Meleager and Atalanta (Boar Hunt)* (Switzerland, private collection)

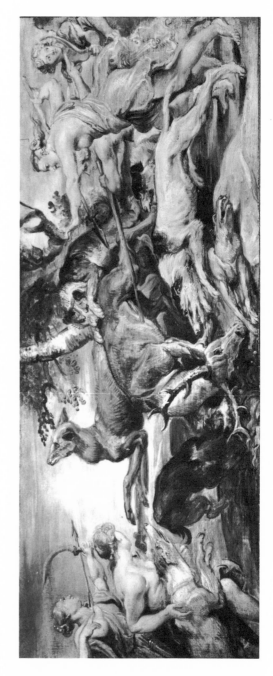

33. Peter Paul Rubens, *Hunt of Diana (Deer Hunt)* (Switzerland, private collection)

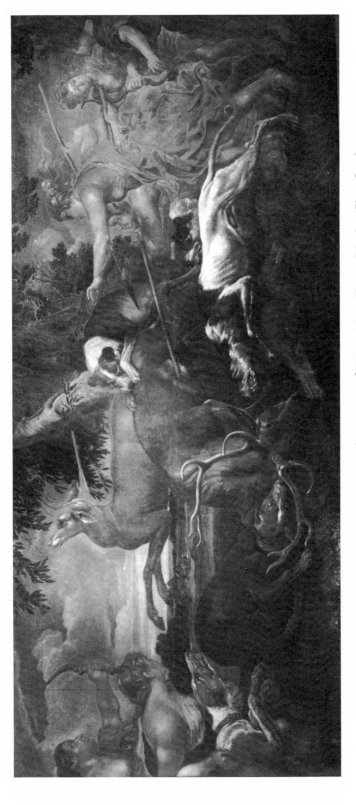

34. Peter Paul Rubens and Frans Snyders, *Hunt of Diana (Deer Hunt)* (Mexico City, Instituto Nacional de Bellas Artes, Museo de San Carlos)

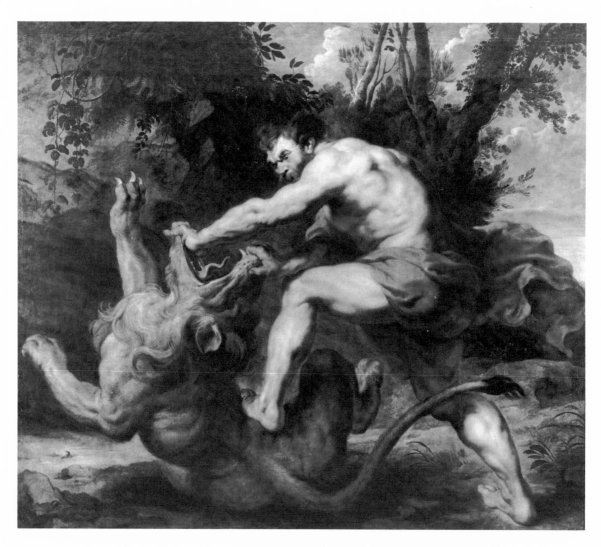

35. Peter Paul Rubens, *Samson Breaking the Jaws of a Lion* (Madrid, private collection)

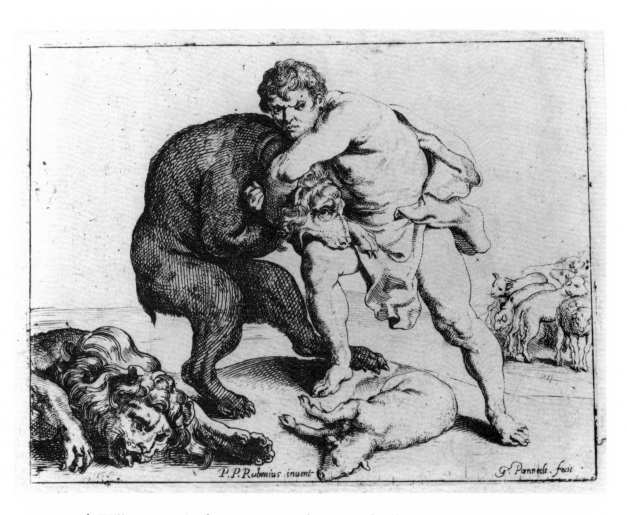

36. Willem Panneels after Peter Paul Rubens, *David Killing a Bear* (London, British Museum. Reproduced by courtesy of the Trustees)

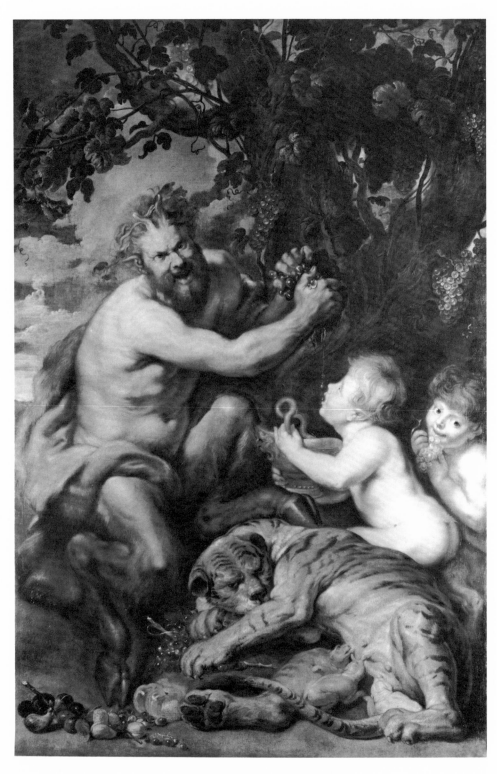

37. Workshop of Peter Paul Rubens, *A Satyr Squeezing Grapes* (Dresden,
Staatliche Kunstsammlungen, Gemäldegalerie Alte Meister)

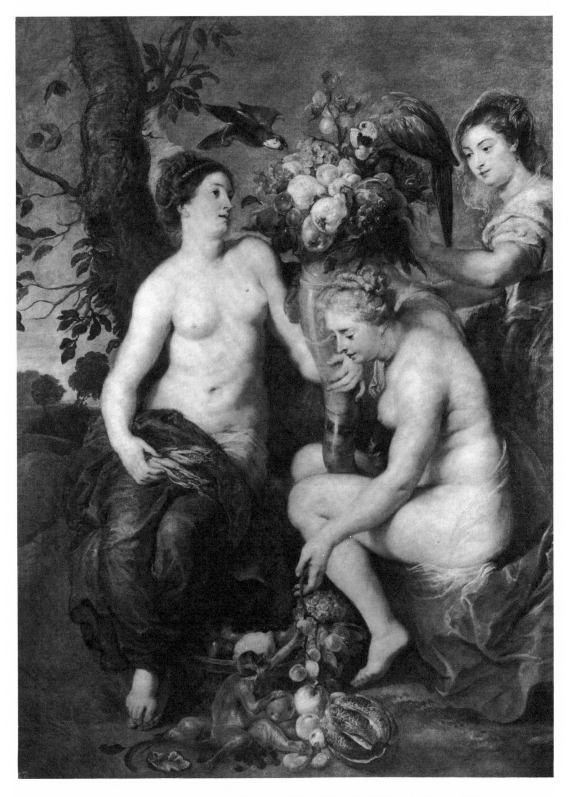

38. Peter Paul Rubens and Frans Snyders, *Three Nymphs Filling the Horn of Plenty*
(Madrid, Prado)

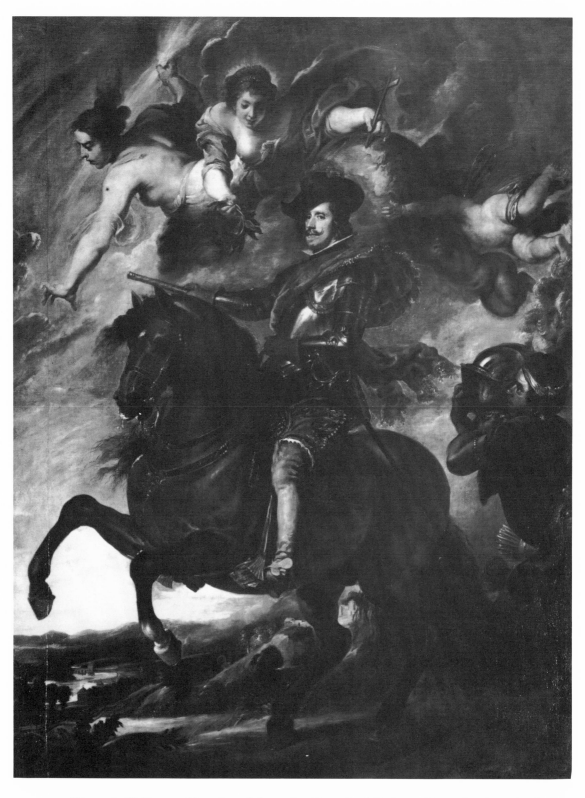

39. Diego de Velázquez (?) and workshop after Peter Paul Rubens, *Equestrian Portrait of Philip IV* (Florence, Uffizi)

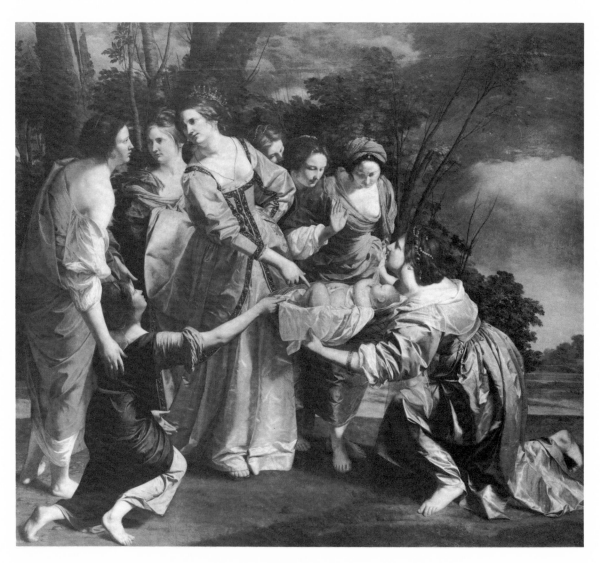

40. Orazio Gentileschi, *The Finding of Moses* (Madrid, Prado)

41. Jusepe de Ribera, *Samson and Delilah* (Córdoba, Museo Provincial de Bellas Artes)

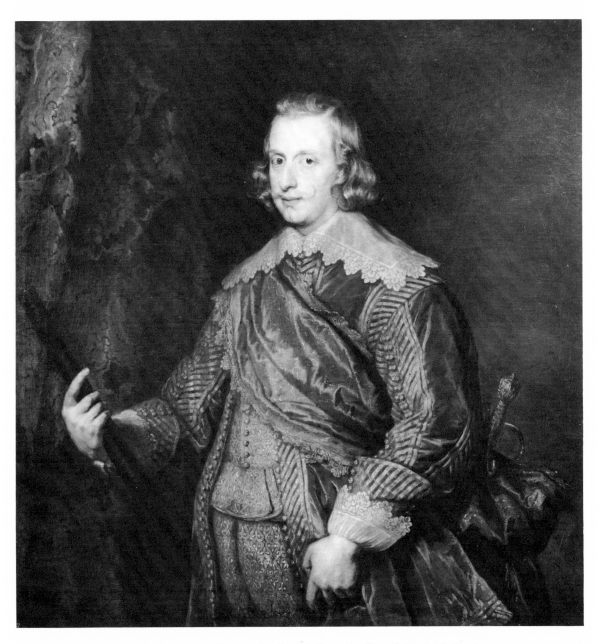

42. Anthony van Dyck, *Cardinal-Infante Ferdinand* (Madrid, Prado)

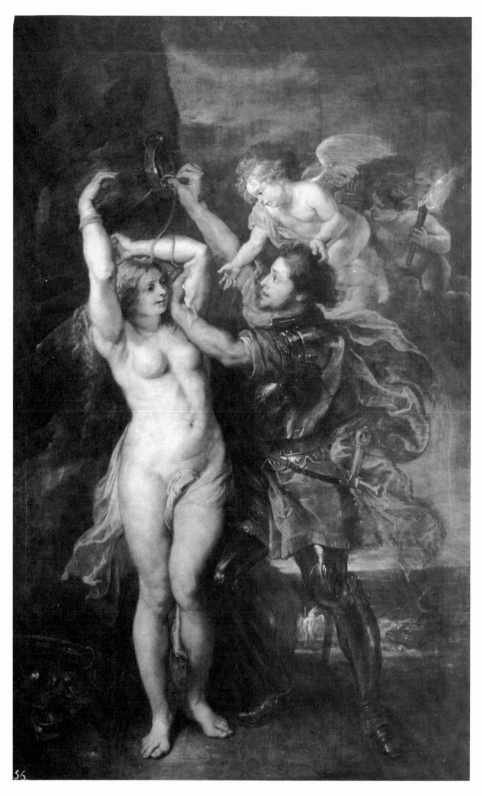

43. Peter Paul Rubens and Jacob Jordaens, *Perseus and Andromeda* (Madrid, Prado)

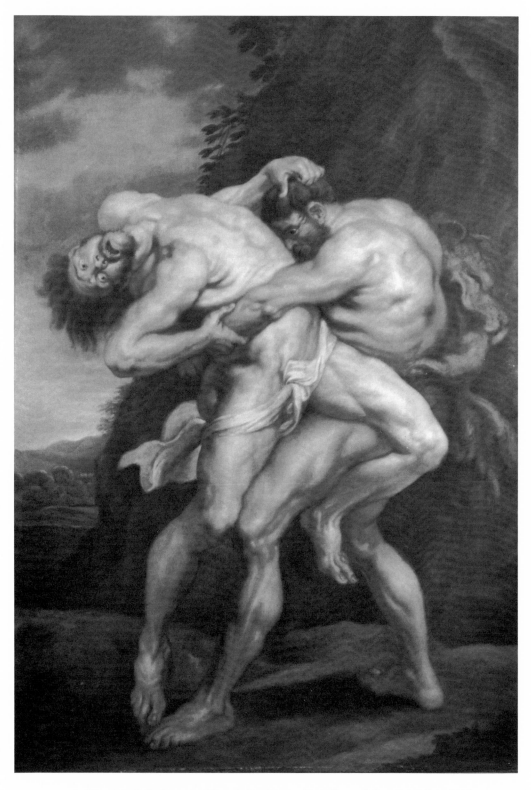

44. Peter Paul Rubens and Jacob Jordaens, *Hercules and Antaeus* (New York, Central Picture Galleries)

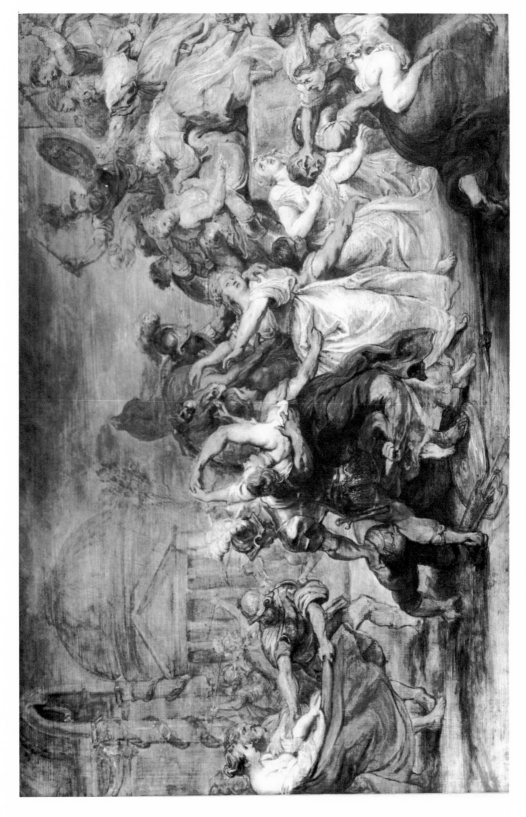

45. Peter Paul Rubens, *The Abduction of the Sabine Women* (Antwerp, Banque de Paris et des Pays-Bas, Maison Osterrieth)

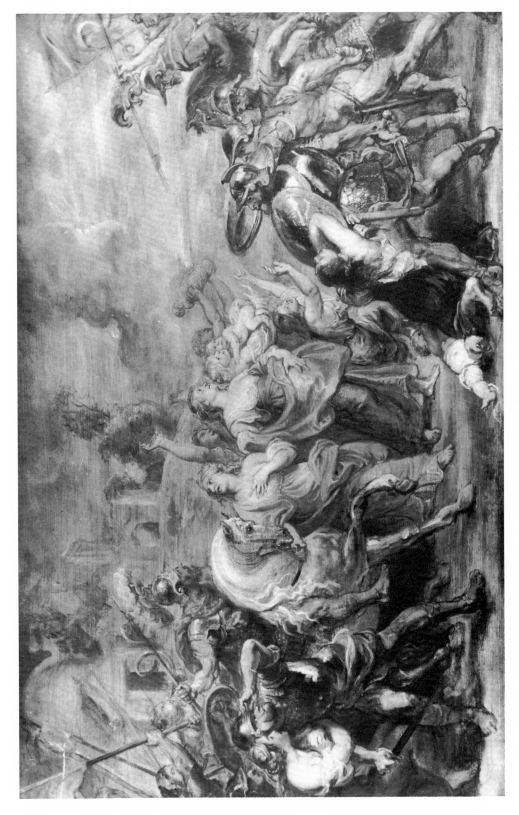

46. Peter Paul Rubens, *The Reconciliation of the Romans and the Sabines* (Antwerp, Banque de Paris et des Pays-Bas, Maison Osterrieth)

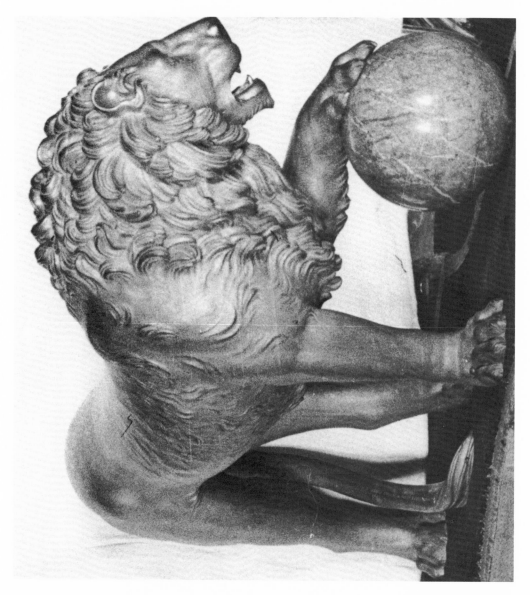

47. Giuliano Finelli, *A Lion* (Madrid, Palacio Real)

48. Agostino Mitelli and Angelo Michele Colonna, *Preparatory Study for a Ceiling Fresco in the Palace of the Buen Retiro* (Madrid, Museo Municipal, on deposit from Madrid, Prado)

49. Jacopo Tintoretto, *Judith and Holofernes* (Madrid, Prado)

50. Jacopo Tintoretto, *A Battle of Christians and Turks* (Madrid, Prado)

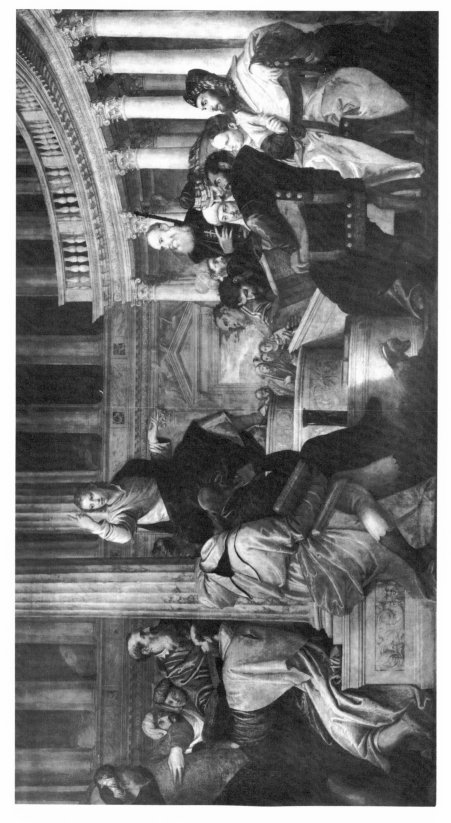

51. Paolo Veronese, *The Christ Child among the Doctors* (Madrid, Prado)

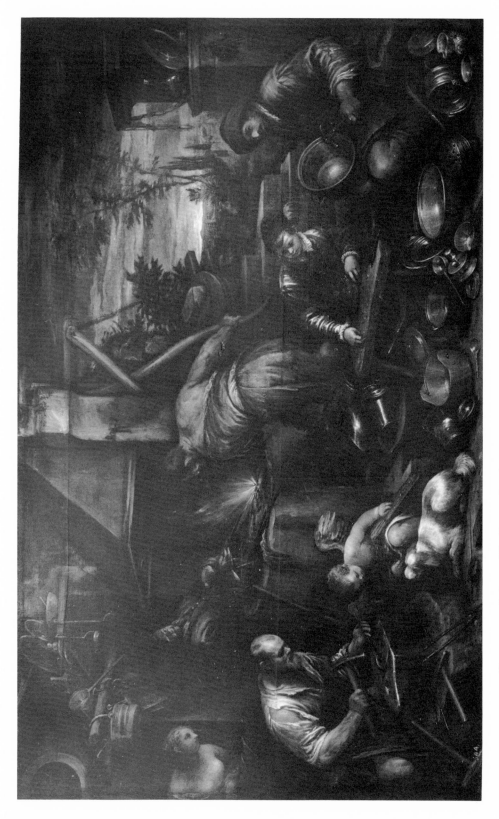

52. Bassano workshop, *The Forge of Vulcan* (Barcelona, Universidad, on deposit from Madrid, Prado)

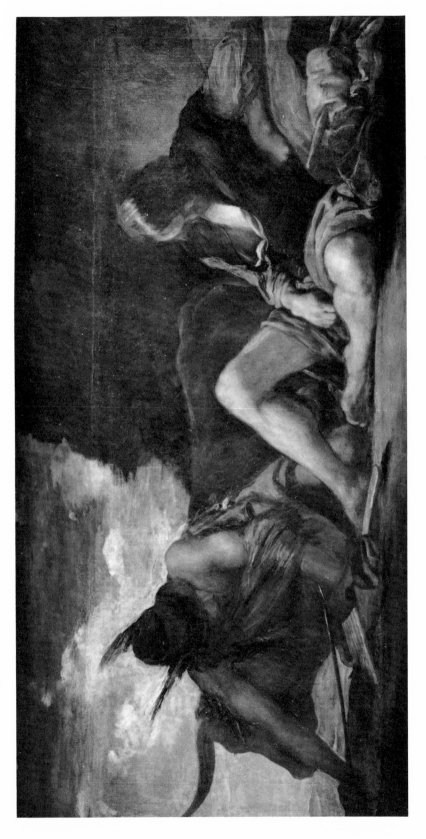

53. Diego de Velázquez, *Mercury and Argus* (Madrid, Prado)

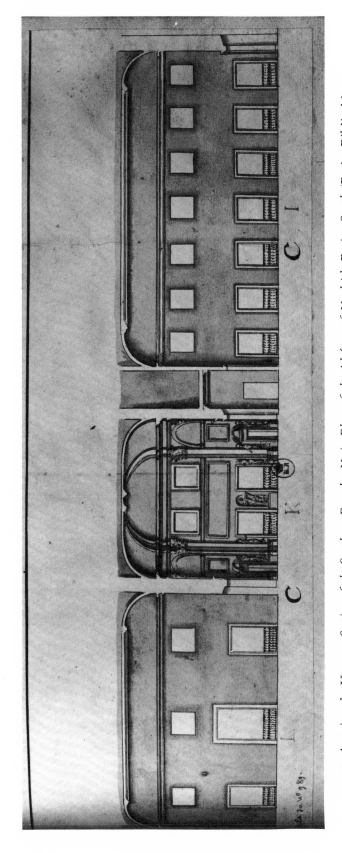

54. Antoine du Verger, *Section of the Southern Façade, Main Floor of the Alcázar of Madrid, Facing South* (Paris, Bibliothèque Nationale). The rooms shown include the Hall of Mirrors (L), the Octagonal Room (K), and the South Gallery (I).

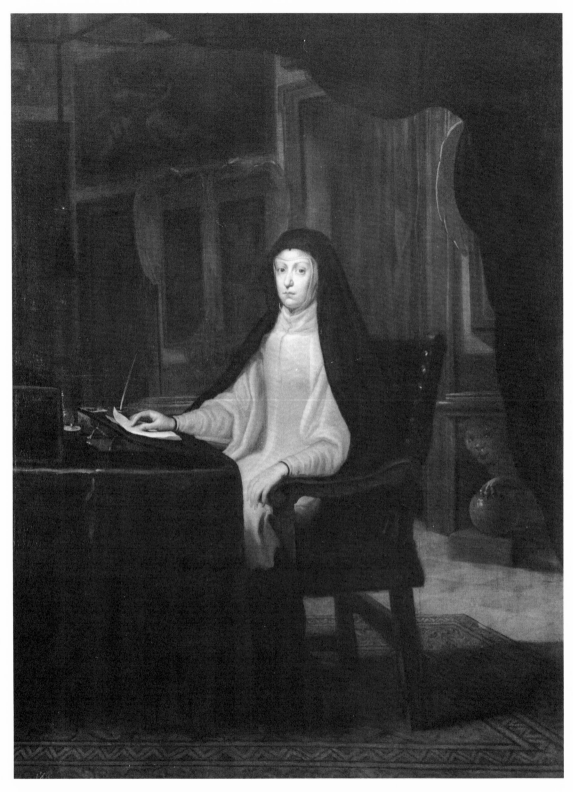

55. Juan Carreño de Miranda, *Mariana of Austria* (Madrid, Real Academia de Bellas Artes de San Fernando)

56. Copy after Juan Carreño de Miranda, *Mariana of Austria* (London, British Museum. Reproduced by courtesy of the Trustees)

57. Detail from Juan Carreño de Miranda, *Charles II* (Berlin, Staatliche Museen, Gemäldegalerie)

58. Detail of anonymous, *Partial Plan of the Main Floor of the Alcázar of Madrid ("Parquet Plan")* (Paris, Bibliothèque Nationale)

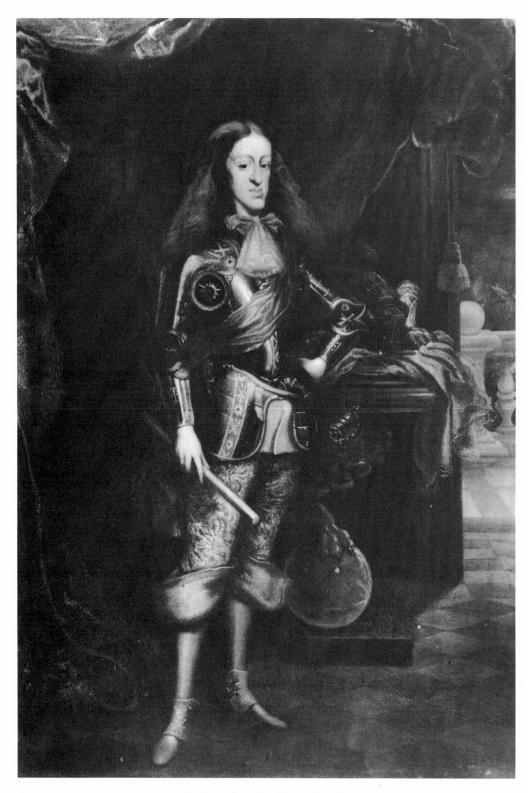

59. Juan Carreño de Miranda, *Charles II* (Guadalupe, Monasterio)

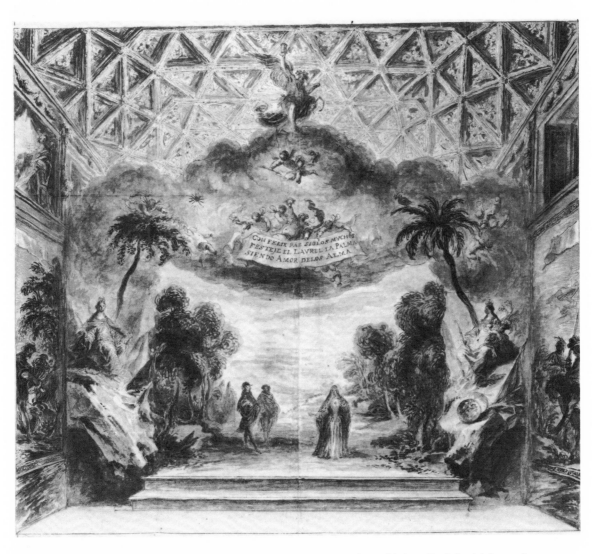

60. Francisco de Herrera the Younger, *A Stage in the Gilded Hall of the Alcázar of Madrid* (Vienna, Oesterreichische Nationalbibliothek)

61. Alonso Cano, *A King of Castile* (Madrid, Prado)

62. Alonso Cano, *Two Kings of Castile* (Madrid, Prado)

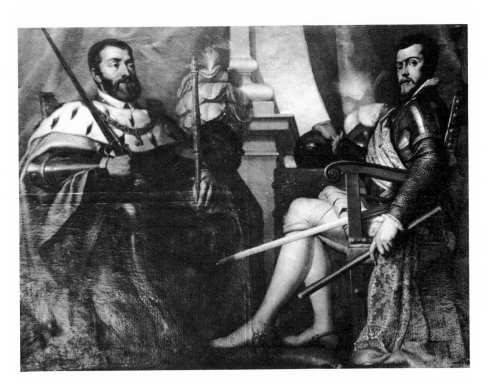

63. Antonio Arias Fernández, *Charles V and Philip II* (Granada, Universidad, Hospital Real, on deposit from Madrid, Prado)

66. Anonymous, *Ferdinand II of Aragon* (from Elías Tormo, *Las viejas series icónicas de los Reyes de España*)

65. Antonio Pereda, *Agila* (Lérida, Seminario Conciliar, on deposit from Madrid, Prado)

64. Anonymous, *Giovanni Galeazo Maria Sforza* (Madrid, Museo del Ejército, on deposit from Madrid, Prado)

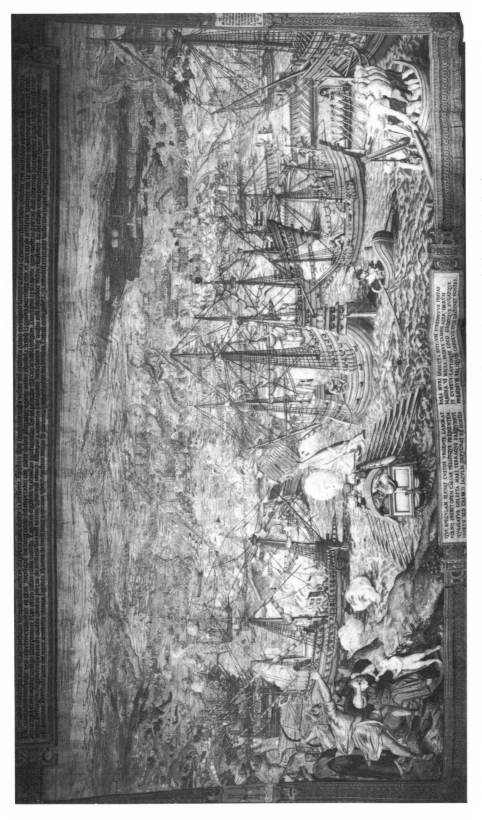

67. Tapestry after Jan Vermeyen, *The Capture of La Goletta* (Madrid, Palacio Real)

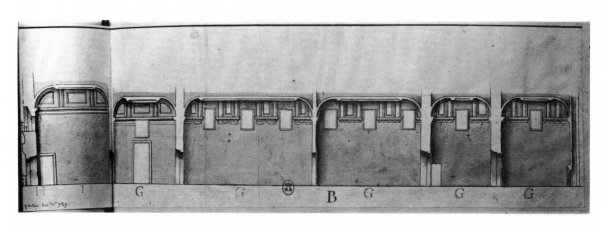

68. Antoine du Verger, *Section of the West Wing, Main Floor of the Alcázar of Madrid, Facing West* (Paris, Bibliothèque Nationale)

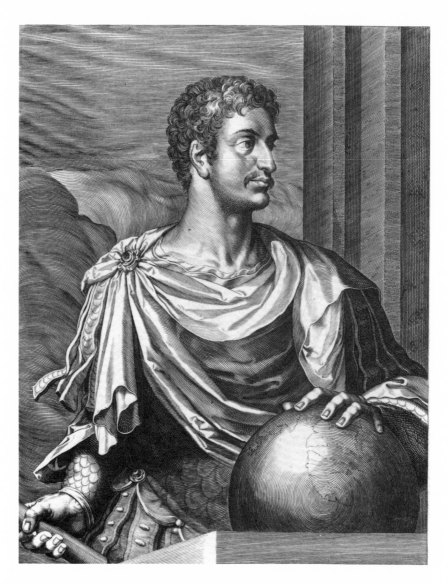

69. Aegidius Sadeler after Titian, *Augustus* (London, British Museum. Reproduced by courtesy of the Trustees)

70. Leone Leoni and Pompeo Leoni,
*Charles V* (Madrid, Prado)

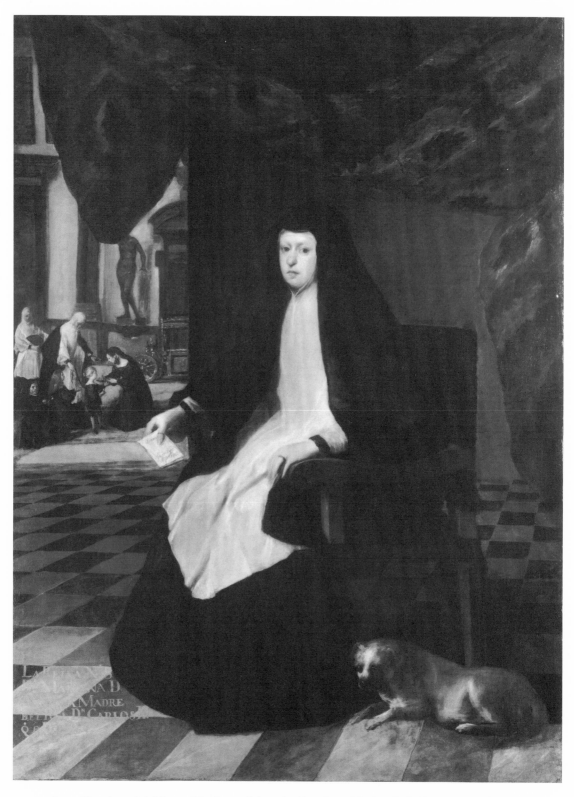

71. Juan Bautista del Mazo, *Mariana of Austria* (London, National Gallery. Reproduced by courtesy of the Trustees)

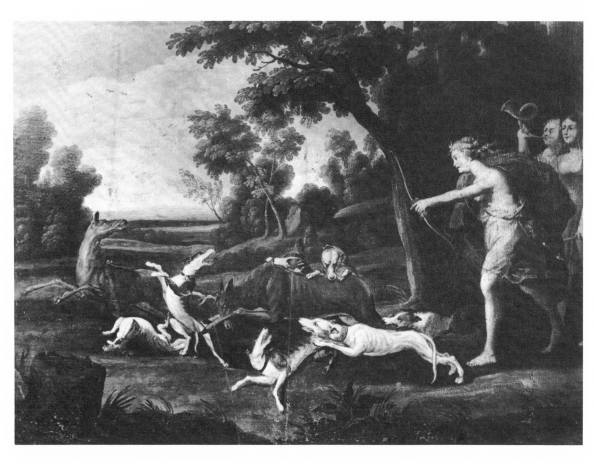

72. Juan Bautista del Mazo after Peter Paul Rubens and Frans Snyders, *Diana and Nymphs Hunting* (Barcelona, Universidad, on deposit from Madrid, Prado)

73. Jacques Jonghelinck, *Mercury* (Madrid, Palacio Real)

74. Jacques Jonghelinck, *The Moon (Diana)* (Madrid, Palacio Real)

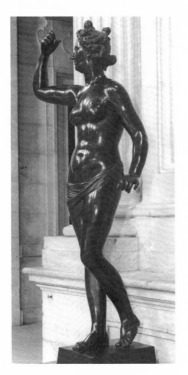

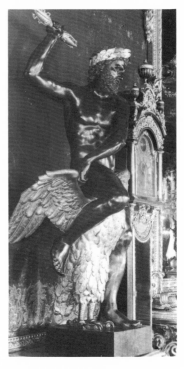

75. Jacques Jonghelinck, *Venus* (Madrid, Palacio Real)

76. Jacques Jonghelinck, *Jupiter* (Madrid, Palacio Real)

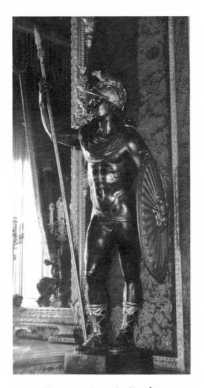 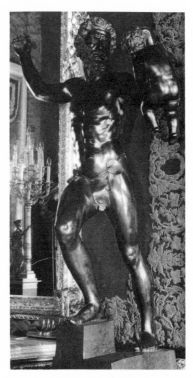

77. Jacques Jonghelinck,
*Mars* (Madrid, Palacio Real)

78. Jacques Jonghelinck,
*Saturn* (Madrid, Palacio Real)

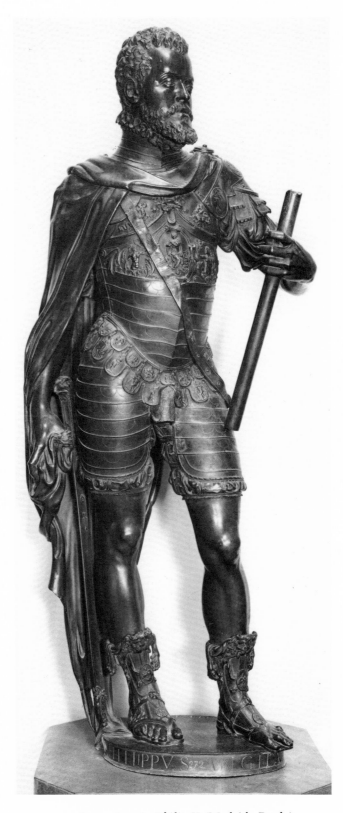

79. Leone Leoni, *Philip II* (Madrid, Prado)

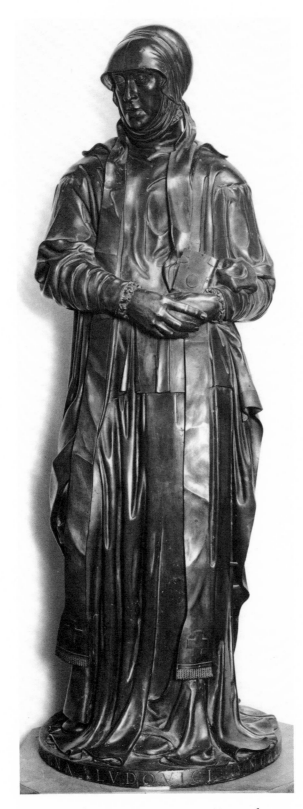

80. Leone Leoni, *Mary, Queen of Hungary* (Madrid, Prado)

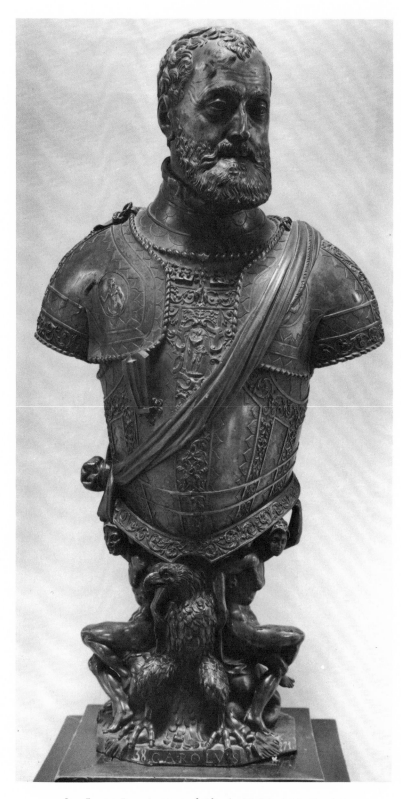

81. Leone Leoni, *Bust of Charles V* (Madrid, Prado)

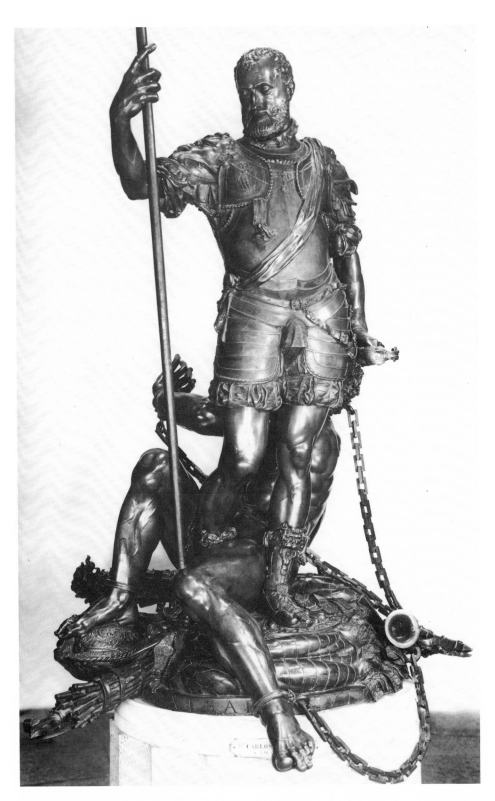

82. Leone Leoni, *Charles V and Fury Restrained*
(Madrid, Prado)

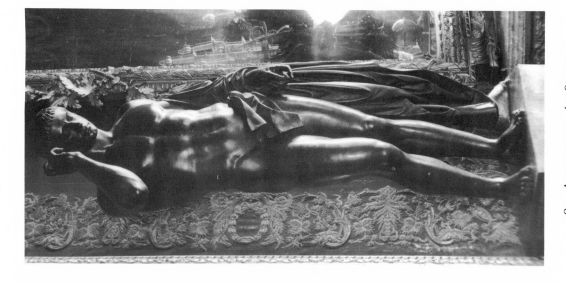

84. Anonymous, *An Orator*
(Madrid, Palacio Real)

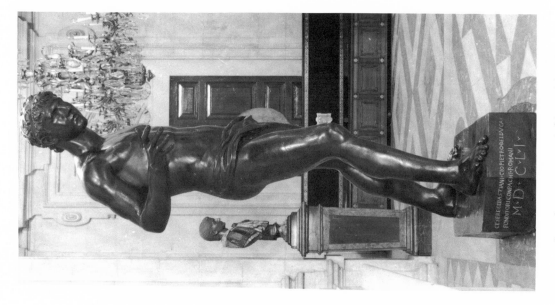

83. Anonymous, *Athlete with a*
*Discus* (Madrid, Palacio Real)

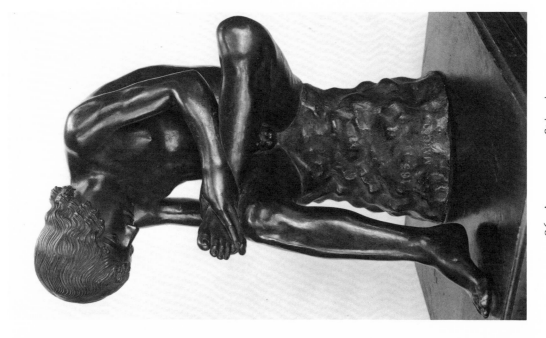

86. Anonymous, *Spinario* (Madrid, Prado)

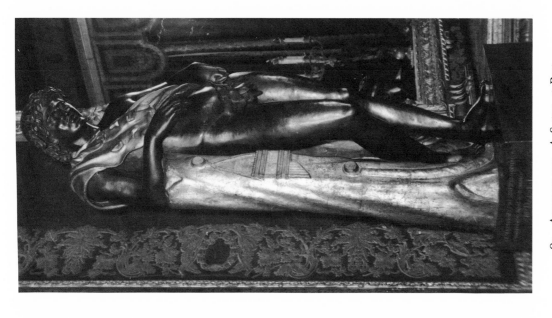

85. Anonymous, *A Satyr at Rest* (Madrid, Palacio Real)

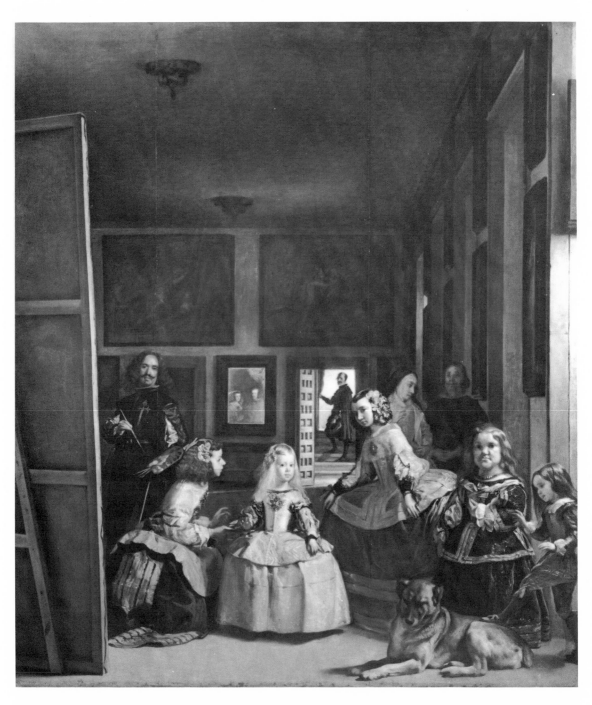

87. Diego de Velázquez, *Las Meninas* (Madrid, Prado)

88. Juan Bautista del Mazo after Jacob Jordaens (after Peter Paul Rubens), *The Contest of Pan and Apollo* (Madrid, Prado)

89. Peter Paul Rubens, *Minerva and Arachne* (Richmond, Virginia Museum of Fine Arts)

90. Juan Bautista del Mazo after Peter Paul Rubens, *The Abduction of Proserpina* (Barcelona, Universidad, on deposit from Madrid, Prado)

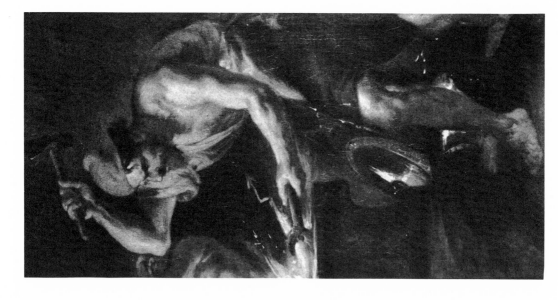

92. Juan Bautista del Mazo after Peter Paul Rubens, *Vulcan Forging Thunderbolts* (Zaragoza, Museo Municipal, on deposit from Madrid, Prado)

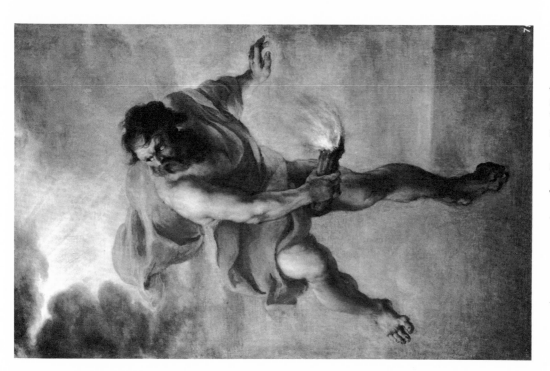

91. Anonymous artist after Peter Paul Rubens, *Prometheus Stealing Fire* (Madrid, Prado)

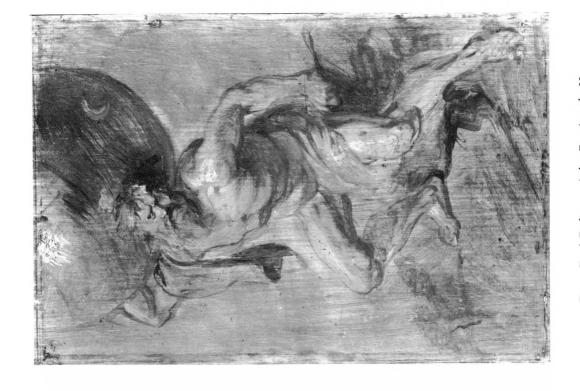

94. Peter Paul Rubens, *Atlas Bearing the Heavens* (London, Courtauld Institute Galleries, Princes Gate Collection)

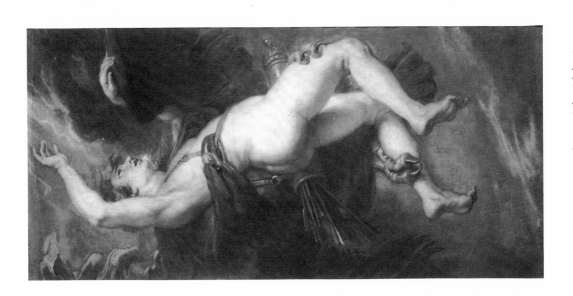

93. Peter Paul Rubens, *The Abduction of Ganymede* (Madrid, Prado)

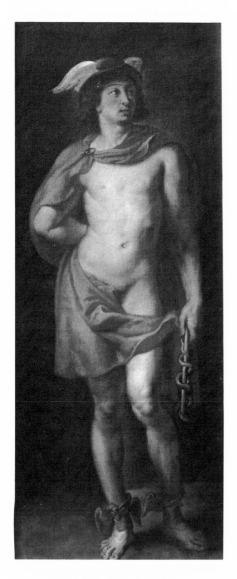

95. Juan Bautista del Mazo after
Peter Paul Rubens, *Mercury*
(Madrid, Prado)

96. Anonymous (Sebastián de Herrera
Barnuevo?), *Charles II* (Madrid,
Museo Lázaro Galdiano)